IP-124 13×11 (07)
 17×14

W9-DIG-990

Street World

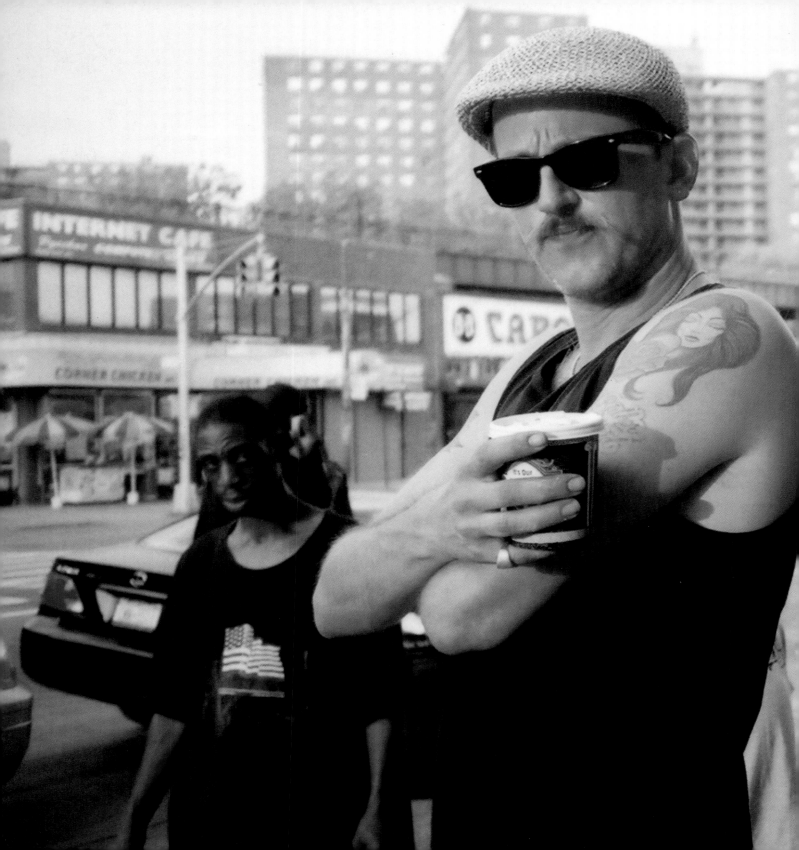

Street World
Urban Art and Culture from Five Continents

Roger Gastman

Caleb Neelon

Anthony Smyrski

Drawings by Alex Lukas

Abrams, New York

AURORA PUBLIC LIBRARY

The photographs on pp. 64–67 contain counterfeit goods. The publisher
in no way endorses the production and sale of these goods which clearly
infringe the intellectual property rights of the manufacturers of these
products. These photographs are included in this book as a commentary
on a social phenomenon and one aspect of street culture.

First published in the United Kingdom in 2007 by
Thames & Hudson Ltd, London
Editor: Rebecca Pearson
Designer: Anthony Smyrski
Production Manager: Sadie Butler

Library of Congress Cataloging-in-Publication Data

Gastman, Roger.
 Street world : urban culture and art from five continents / by Roger
Gastman, Caleb Neelon, and Anthony Smyrski.
 p. cm.
 ISBN-13: 978-0-8109-9438-6 (hardcover with jacket)
 ISBN-10: 0-8109-9438-0 (hardcover with jacket)
 1. Street life. 2. Street art. 3. City and town life. 4.
Streets--Social aspects. 5. Counterculture. I. Neelon, Caleb. II.
Smyrski, Anthony. III. Title.

 HT119.G37 2007
 307.76--dc22

 2007018595

Copyright © 2007 Roger Gastman, Caleb Neelon and
Anthony Smyrski

Published in 2007 by Abrams,
an imprint of Harry N. Abrams, Inc.
All Rights Reserved. No portion of this book may be reproduced, stored
in a retrieval system, or transmitted in any form or by any means,
mechanical, electronic, photocopying, recording, or otherwise, without
written permission from the publisher.

Printed and bound in Singapore
10 9 8 7 6 5 4 3 2 1

HNA
harry n. abrams, inc.
a subsidiary of La Martinière Groupe
115 West 18th Street
New York, NY 10011
www.hnabooks.com

Contents

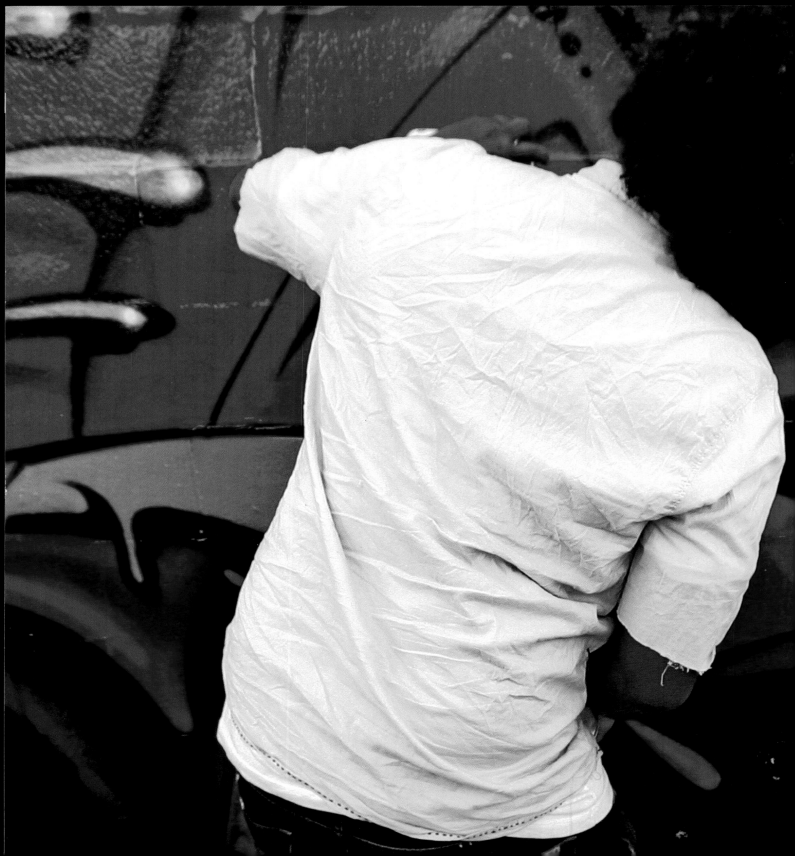

Whether you're gathering your bearings in the heart of a city or staring at its skyline from miles away, you can usually tell where you are by looking at the unique landscape of any city. The common threads that run through so many urban environments—tall buildings, crowded sidewalks, street vendors—are always interwoven with the distinct features that come with a city's geography, architecture, and, most importantly, its residents. Cities become epicenters of culture when their hippest citizens get together and create grassroots movements that eventually become the trends that spread to their suburbs and beyond. Eventually, the efforts of those people all come together to give each city its unique character. After all, what is a city, if not a manmade creation?

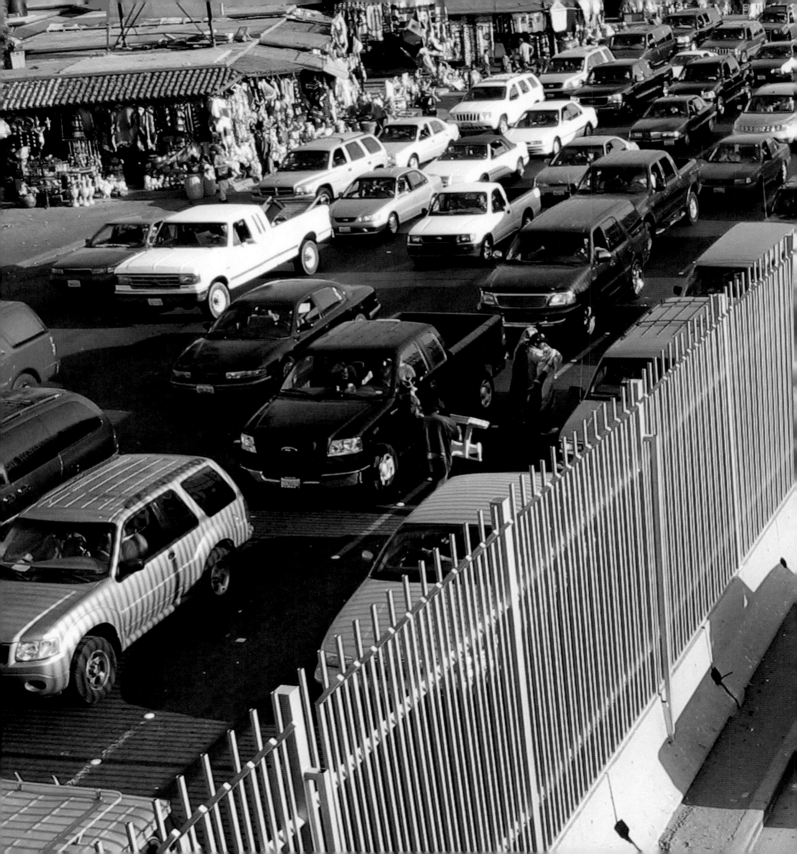

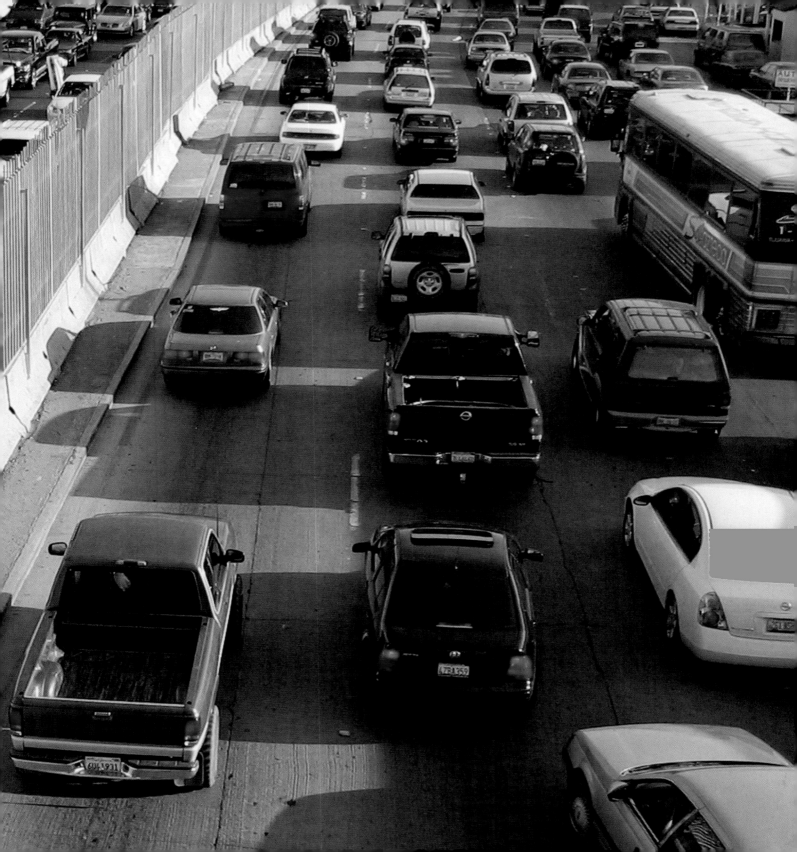

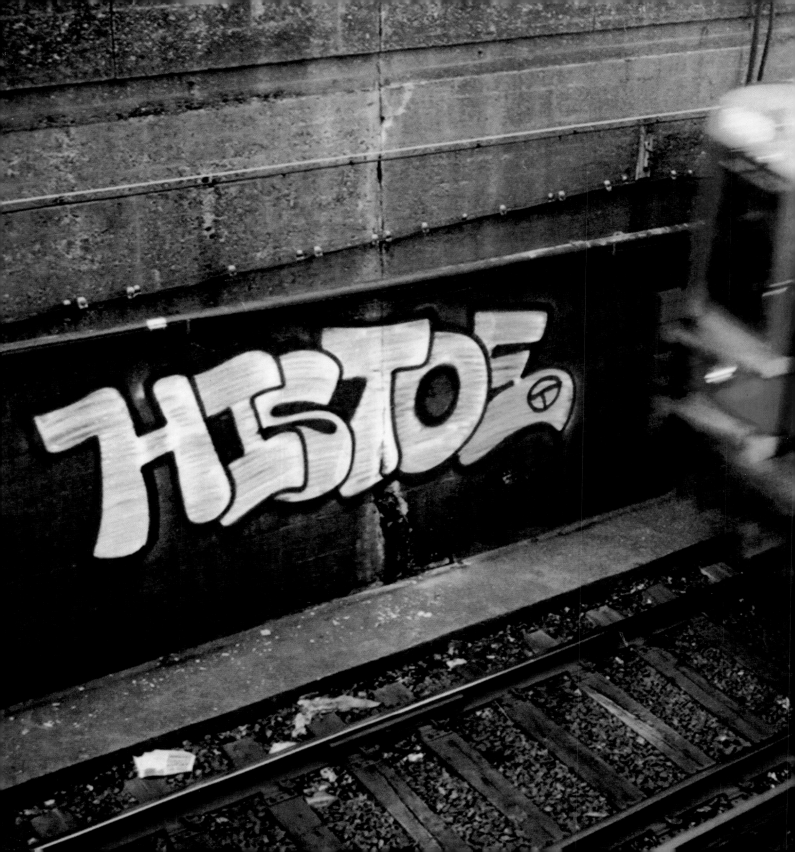

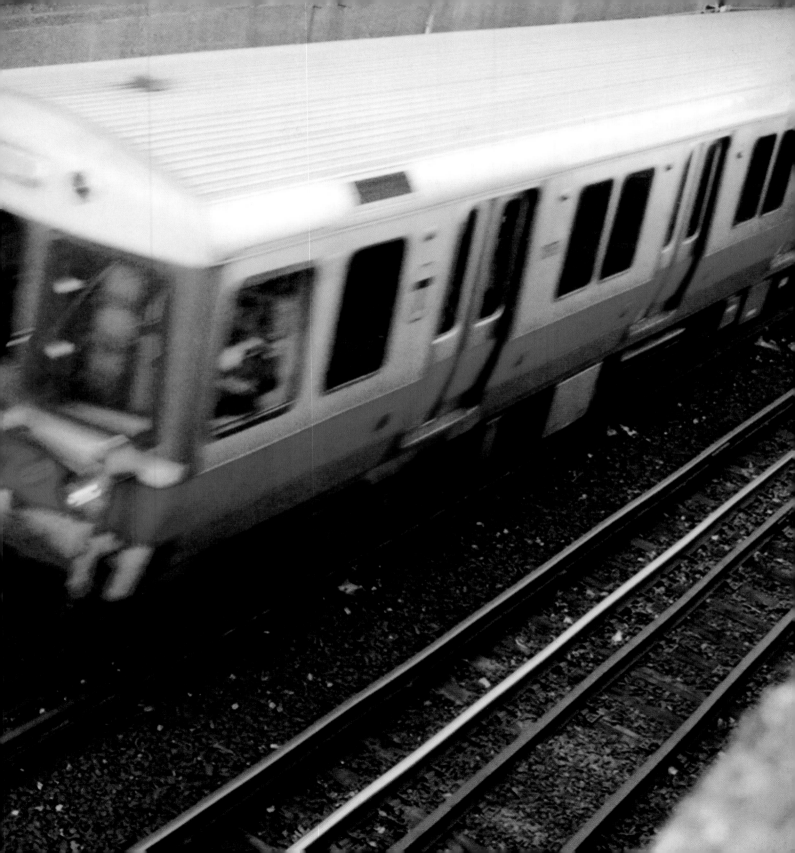

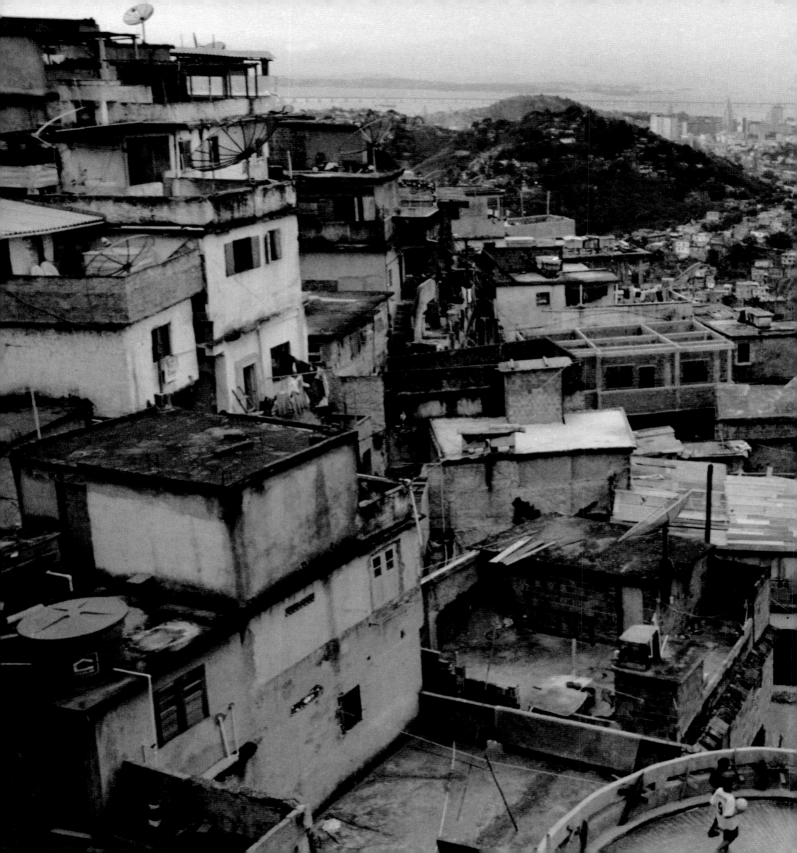

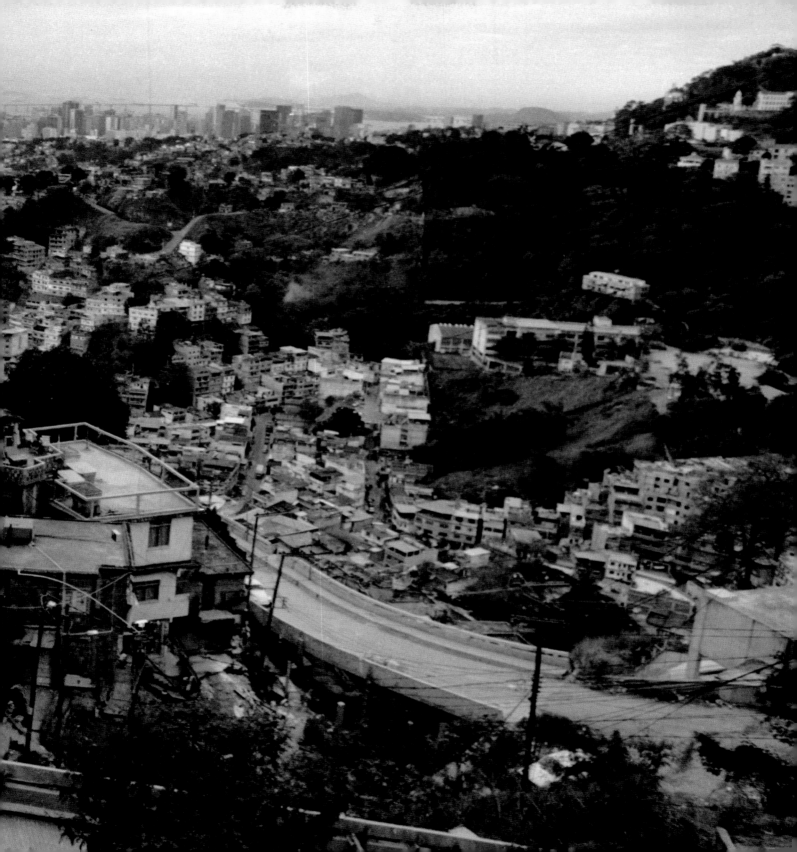

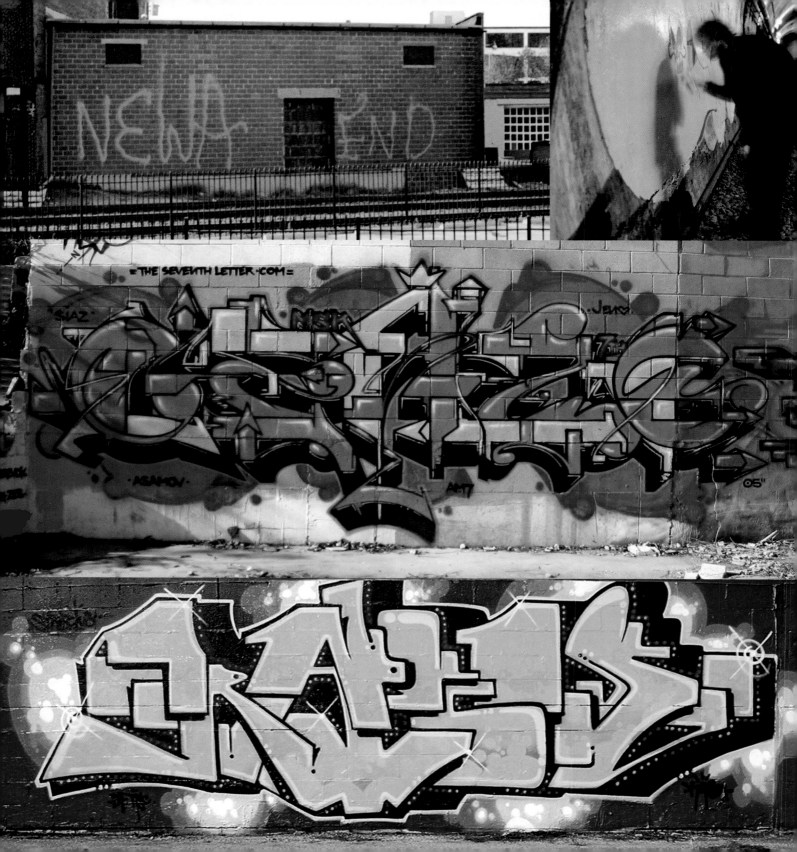

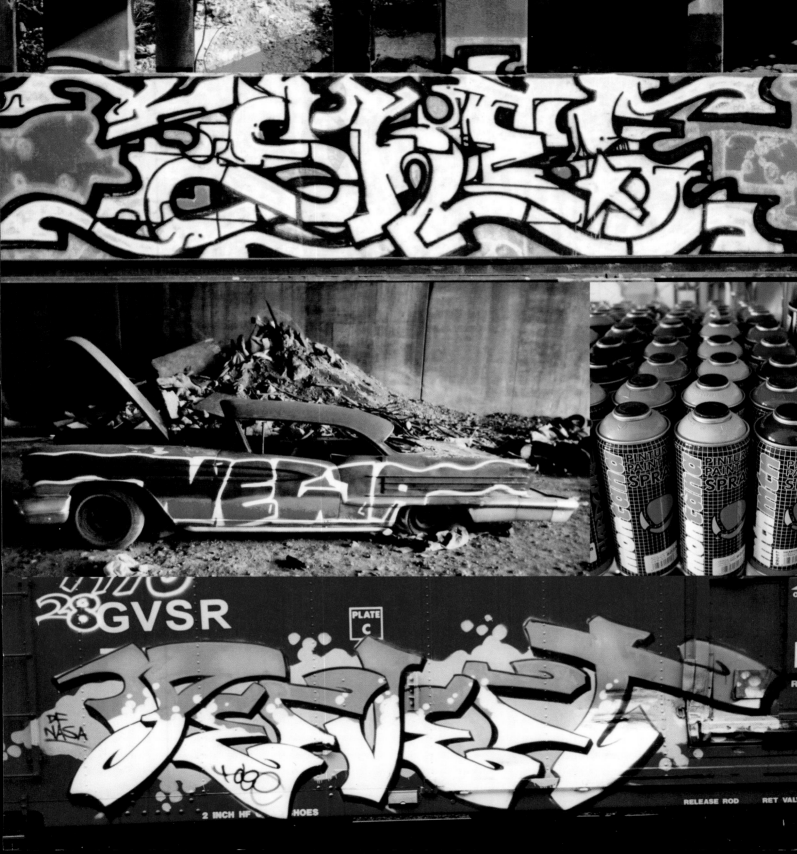

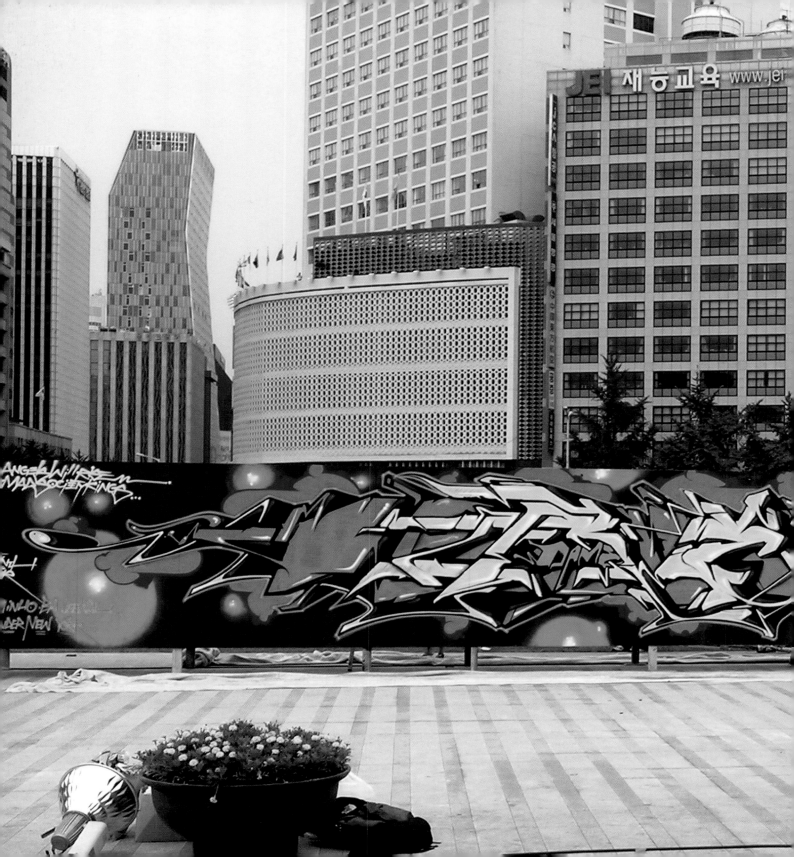

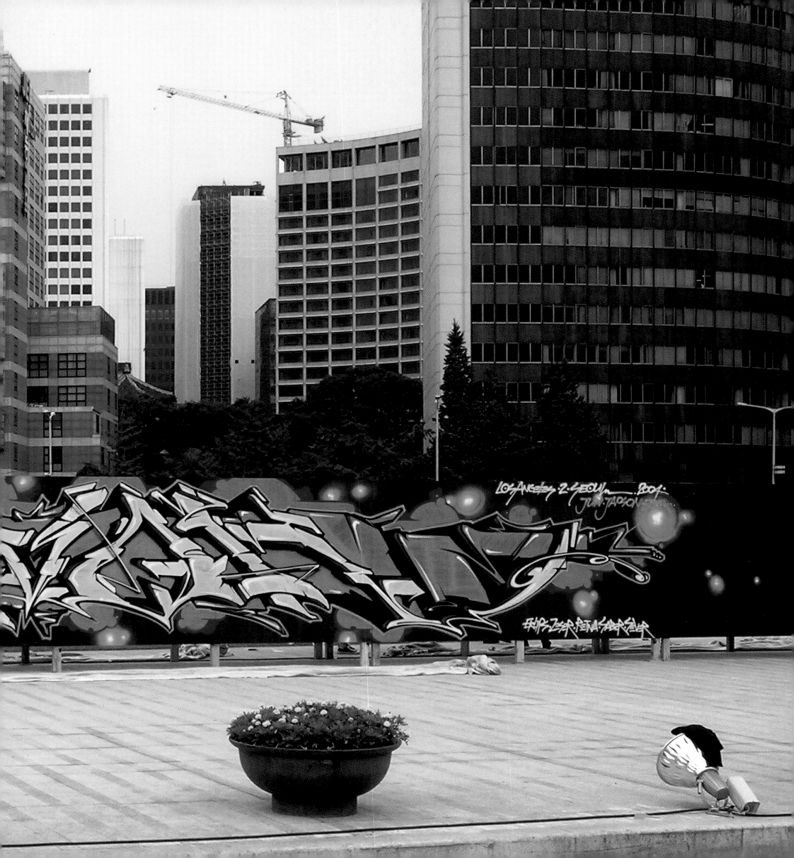

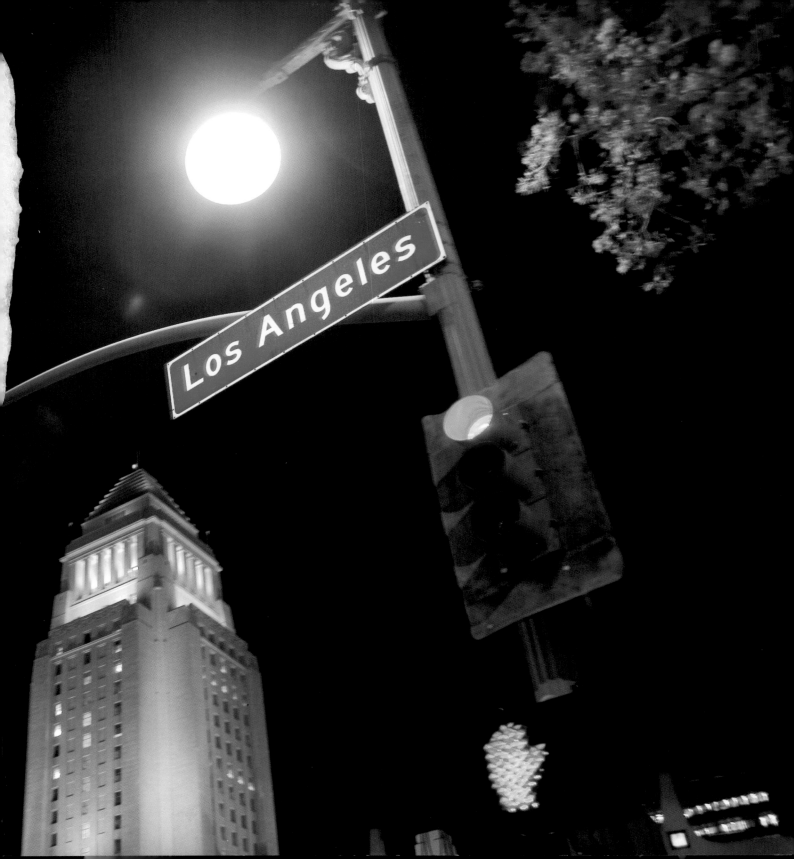

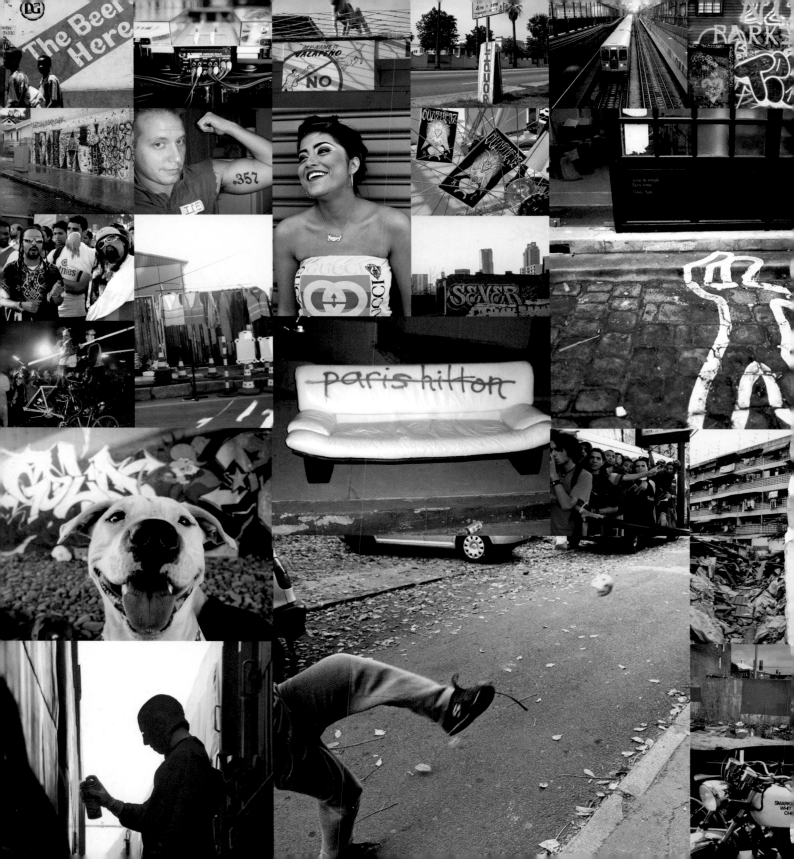

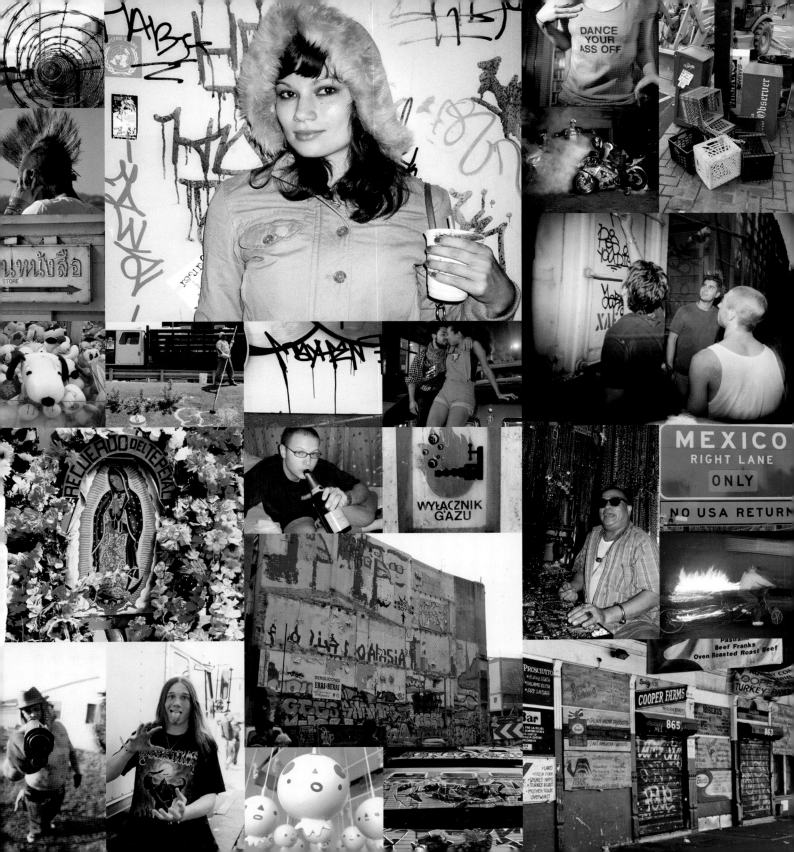

Introduction

Within the past fifteen years, many urban subcultures have joined together to become something larger, more powerful, and more pervasive than ever before. This new street culture encompasses juggernauts like hip-hop and punk as well as much smaller but equally inspiring subcultures endemic to the streets of the Brazilian mega-cities, South African townships, and the crowds of Mumbai. Sharing the streets, the subcultures of the world—both old and new—merge into something ever more powerful.

From the skateboarders projecting themselves off every corner and surface to the graffiti and street artists risking arrest to put their work on them, the frenetic evolution of fashion rising from punk and hip-hop's many subcultures to the constant backdrop of music, cityscapes, and travel, this book encapsulates the most inspirational and visually creative moments of today. Our new global urban culture—street culture at its broadest—is its focus.

The more than 1,000 photographs featured here together form a journey, a record, and an inspiration. The world's streets are its most vibrant sites of visual creativity, and amid their crush and jumble are photographers, documenting, creating, and collectively bringing this book to you. They come from near and far, from dozens of countries and from all of the habitable continents. They range from photographers at the top of their fields to people whose jobs are far from creatively based, but who just happen to capture great images when they do pick up a camera. For some of our contributors, photography is a vocation; for others, something else: a pastime, a reflex, or a part of their greater creative whole as designers, skateboarders, artists, writers, or publishers. They are a diverse group, as diverse as the many street cultures that they record, preserve, and share. Their stories are the stories of the interconnectedness of global street culture.

Street culture is a traveler, whether it's a ubiquitous global force such as hip-hop or a small phenomenon endemic to a particular region, such as South Africa's tricked-out tombstones for those who die young. Spreading by visitors to cultural hotspots who come from afar or residents of those hotspots fanning out around the globe, street cultures never stay entirely localized. Just as every street leads to another until all roads meet, street cultures eventually collide, whether in person or in print, as you see before you now.

Some of the most pervasive and popular street cultures, such as hip-hop and skateboarding, began in particular cities and at identifiable points in time. At the same time, when looked at more broadly, their roots are as old as any in recorded history. Looking at hip-hop through the narrow lens, for instance, we can see it starting in the late 1960s into the 1970s with

neighborhood block parties and James Brown's famous rap-speak. But through a broader lens, as extensions of visual art, dance, music, and poetry, hip-hop is a far older creature. The idea of riding a plank held up by wheels must be nearly as old as the wheel itself, but skateboards in name themselves date to California in the 1950s, when surfers took to the streets and fused their sport with rollerskating.

These are hardly the only examples. Tattooing has been around as a part of various tribal cultures for thousands of years, yet was only introduced to the West in the 1800s, when Westerners began traveling to the Far East and brought pieces of that culture home with them. Tattooing only exploded in popularity out of subcultural status in more recent years, and only then because it became widely accepted as an art form and not strictly reserved for sailors, bikers, punks, and the like. Covering oneself in bling jewelry is a modern trend but certainly not a new practice—just one that's no longer reserved for royalty. The mass-produced street art poster campaigns of visionaries such as Shepard Fairey may be a recent explosion, but the person perhaps more responsible for the movement was printing pioneer Johannes Gutenberg. There is at the same time nothing, and everything, new under the sun.

More than mere activities or fashions, street cultures are lifestyles, and the commonalities shared by their members extend to their tastes in music, clothing, transportation, and even drugs. Oftentimes, new cultures arise when people with different lifestyles share tastes in the most transcendent medium: music. The lightest travelers, after all, are ideas, and there is no better way to transmit them than through lyrics. A culture's worth of ideas can travel in a pocket as a fourth-generation mixtape or as a stream of ones and zeros from computer to computer, spreading the buzzwords, anthems, slang, and rallying cries of one group of people to another, all in the most effortlessly infectious way.

Street culture is everywhere, and spreads whenever it finds new kindred spirits, often regardless of their nationality or political history. Over the past fifteen years, subcultures previously limited only to pockets of the Western world have made their ways to places that only a few years before would have seemed unthinkable. Graffiti blossomed out of the New York subways around the world, but in the 1990s it exploded into new territory in the former Soviet Bloc states of Eastern Europe. It made perfect sense, since graffiti had been knocking on Communism's very door—the Berlin Wall—for decades. Of course, it was just one of many cultural juggernauts making their way around the world, vying for space, finding new arenas, and bringing generations of young people with fresh ideas and techniques into play. In return, the tiny street cultures of the world's hidden cities creep their way into the most attentively watched.

The power and visibility of the street's stage have brought the world's diverse subcultures together to share the same space. Within that, the cultural bridge-builders are those astute people whose vision extends beyond their own niche, finding the global phenomena that are family members who have not yet met. The individuals responsible are often the urban travelers: bike messengers whose routes sometimes take them away from city downtowns; skateboarders looking for a new spot; graffiti writers on all-city missions; and DJs and fashionistas scouring every small neighborhood store for rare finds. Often, street cultures are old-meets-new phenomena, and their originators are the individuals who manage to find inspiration from both the relics that linger in cities and the innovations that spring forth from those communities.

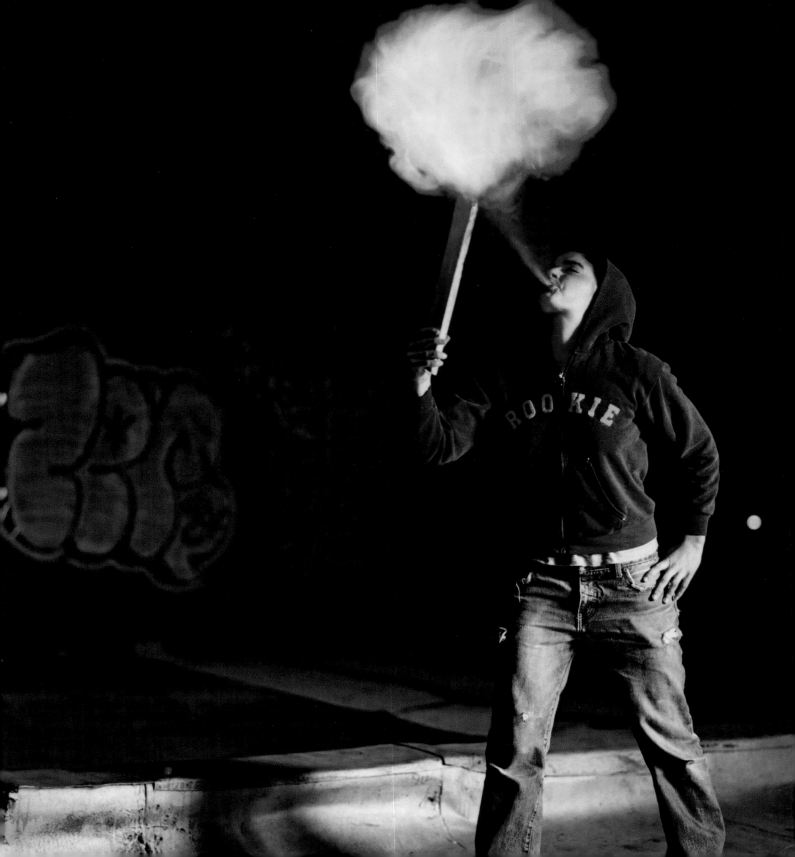

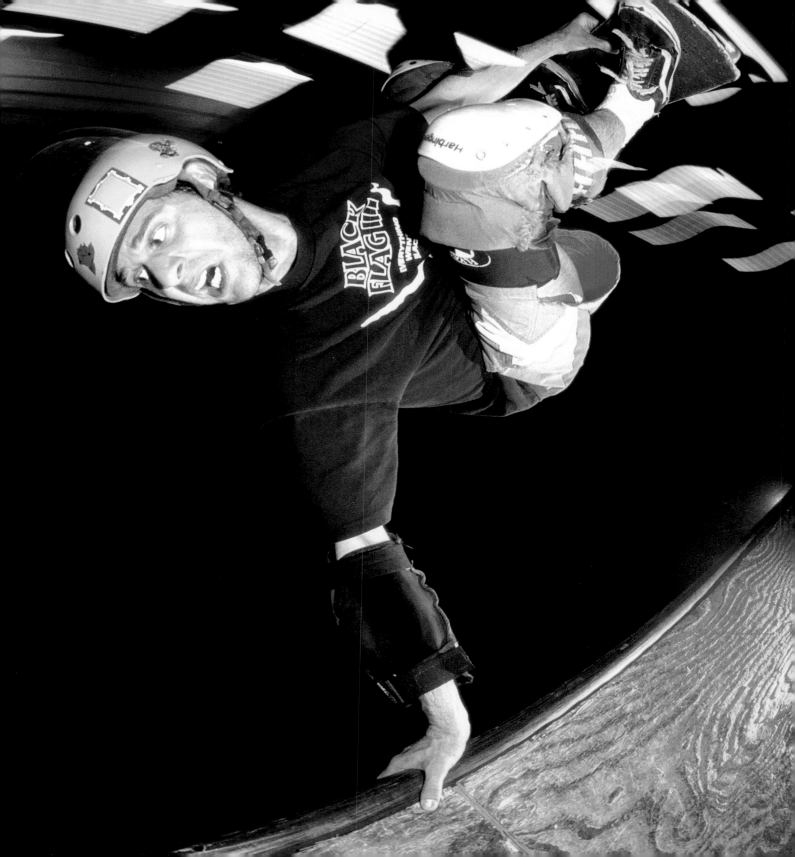

Frequently, this exploration comes from the search for a new urban neighborhood in which artists and creative professions are not yet priced out: places that are invariably collections of old and new and collections of cultures and spaces. Urban finders search their cities and often find themselves a part of many seemingly distinct scenes at once. As they do so, the walls between individual pockets of activity sometimes disappear, as formerly separate subcultures merge, while others remain independent and apart.

Street culture today is crowded with influences from subcultures the world over. The spread of user-controlled media has made the transmission of messages, styles, and art of all kinds easier than ever. The fashions and styles of skaters, gangsters, b-boys, and punks are everywhere. The artwork of graffiti and street artists covers everything from walls and trains to legitimately commissioned advertisements and T-shirt logos. The travelers of the world spread street cultures like viruses, leaving a little of their own and bringing new strains back to their hometown. The streets of the world's cities are the mixing ground, a place where subcultural boundaries are blurred, and sometimes even dissolved.

New cultures have radiated out of media-saturated cities such as New York, London, Tokyo, and Los Angeles and gone on to be among the most vital global phenomena in the world. Other recent cultural phenomena have stayed largely endemic to one particular city, perhaps Rio de Janeiro, Mumbai, or Johannesburg, only emerging as the travelers of the world spread their ideas.

Oftentimes, a subculture will be introduced to a new city but cannot map on exactly, with its residents freely changing and adapting it rather than adopting it with precision. Hip-hop gave rise to London grime—but, in turn, grime turned hip-hop on its head by delving deeply into the accents of Londoners rather than New Yorkers. Similarly, Japanese youth have embraced America's biker gang culture, but rather than riding Harley-Davidsons and brandishing pistols, the *bosozoku*, as they're called, ride Yamahas and Suzukis and carry swords. Similar forms of assimilation and adaptation have been repeated around the world countless times. Even when a subculture appears identical in different locations, there is always a local flair to it beneath the surface.

The constant in all of these ever-evolving cultures is the urban street, the place of collision and coexistence among so many disparate people living together in one place. In the most densely populated cities, street culture is simply everywhere, due to small living spaces. In more spread-out cities, street culture clusters around gathering points such as beaches or markets. In many senses, these locations are the arbiters of urban culture as much as the people who populate them: if a certain street culture doesn't function well in the streets of a certain city, it won't do well there. It could be as simple as a means of transportation: the flat terrain of Miami and Los Angeles loved the low-rider car; the hills of San Francisco proved a perfect challenge for the track bike. But it's more than that, of course. The streets of the world let the truly revolutionary ideas, styles, and movements rise to the top and spread around the globe.

Travel and exploration are near the essence of street cultures, and the travelers who have used their passions to cross the boundaries of nations are at the heart of the process of cultural exchange. Each passion has some ideal site, ideal experience—the equivalent of the surfer's perfect wave—and the chase after it is enough to impel people around the world. At the same time, each culture has its own Mecca, and to the initiated it's perfectly reasonable to save money for a year to finance a trip to skateboard in Los Angeles or to risk deportation by painting a subway train in the tunnels of New York City. The expense and possible risk are no match for any serious passion, of course. Most importantly for these travelers, there are waiting communities of like-minded participants—future friends—for them in every city, often with a bed and food to share. These networks of young people have only grown stronger and broader in recent years.

What has enabled these global communities to flourish and connect? Between cities, countries, and continents, the street's stage expands even further, as travelers, commerce, and media all converge to make the world's cultures all the more accessible. Computers have made publishing small-scale niche magazines and books easier than ever. Specially targeted businesses have emerged, with products ranging from designer cases for portable music players to specialty spraypaint catering to the technical needs of graffiti artists. In the mid-1990s, the Internet and email quickly became vital networking and information-sharing tools, and right after that came major commerce, as everything from cellular phone companies to shoes to automobiles realized that street culture was the biggest thing going.

Once a particular subculture reaches the mass media, it spreads almost instantaneously across the far reaches of its originating country, and before long it becomes a global phenomenon. Somewhere along the line, a universal code of coolness is informally established, as people realize that the popularity of a subculture evolves from its unique and interesting perspective on urban life, from the respect-through-violence mindset of biker gangs to the prettification philosophy of guerrilla gardeners who illegally plant flowers amid the concrete jungle of the city.

Of course, nothing stays popular and interesting forever. Sooner or later, most subcultures become a bit too popular for the tastes of their most creative participants, who inevitably strike out on their own to create the newest addition to the swirling, astonishingly creative world that we call street culture. The attention to the newest developments and mutations of street culture, however, hasn't slowed, but only intensified. The result is a broader global reach than ever. When a subculture from São Paulo, Kingston, or Berlin is independently able to capture the attention of a young person on the other side of the planet, we know that we are onto something very powerful.

This book is a celebration of that power. In it, you will find things that you have no doubt been a part of, to which you have contributed in one way or another. You'll also find many of the other roots and branches of the tree of the world's street culture.

Explore, enjoy, inspire, and be inspired.

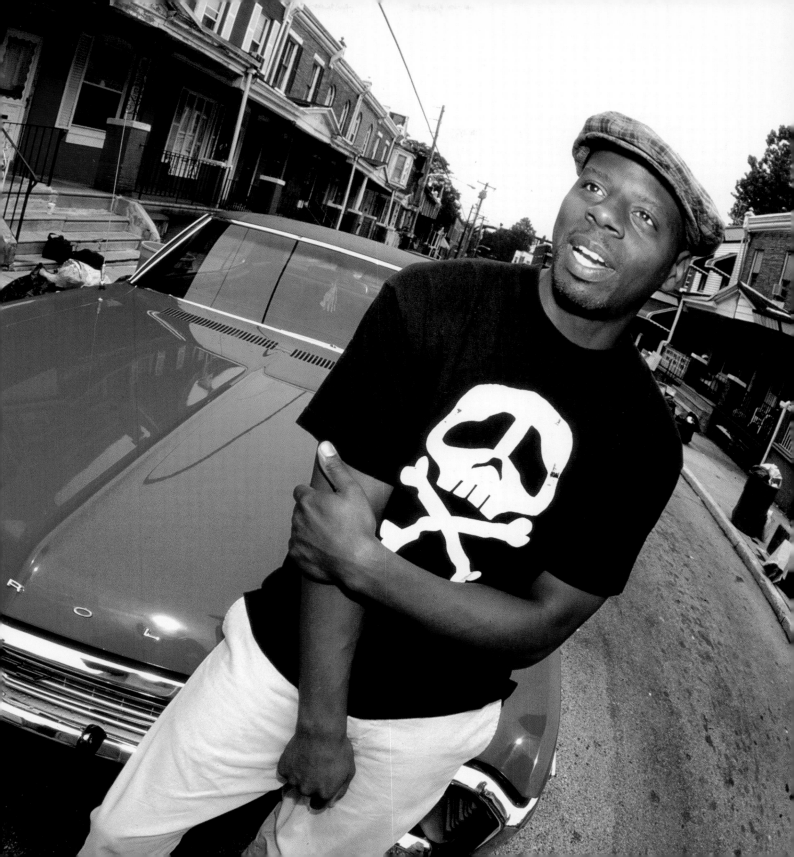

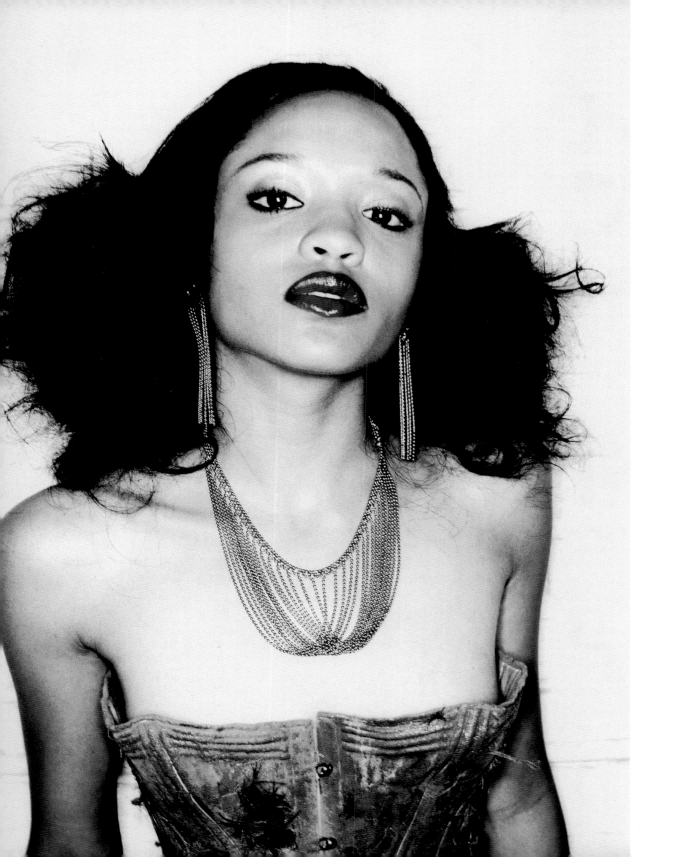

LOOKING GOOD •

Fashion is one of the most basic and integral elements of street culture. People dress themselves every day, and every day, how they dress is an extension of who they are, what they believe in, and where their tastes fall in relation to the rest of the crowd's. Fashion is a big, greedy, shameless robber, and it's all the more awesome for it. Runways at haute couture shows in New York, Paris, and Milan routinely mix and match looks from all social strata. These high-end designs that cost thousands might end up paired with discount or thrift store finds that cost next to nothing. Sooner or later, every high-end item ends up as fodder for bootleggers who make spot-on designer knockoffs, selling them off the backs of trucks and generally fooling a great many people at first glance. Fashion, perhaps more than any other art form, is based on swiping ideas from others. Sharp fashion eyes can spot a grabbable idea on any subsection of society's dress patterns, whether it's gangsters or crazy people. It might be the way they wear a hat or tie a bandanna, but there's always something that pops out as stylish to another group, and that stylish nugget is the gold of the fashion world. It could be a $100,000 diamond-studded set of fronts or magic marker on a plain white T-shirt. They might even look good together. And that's one of the great things about being human.

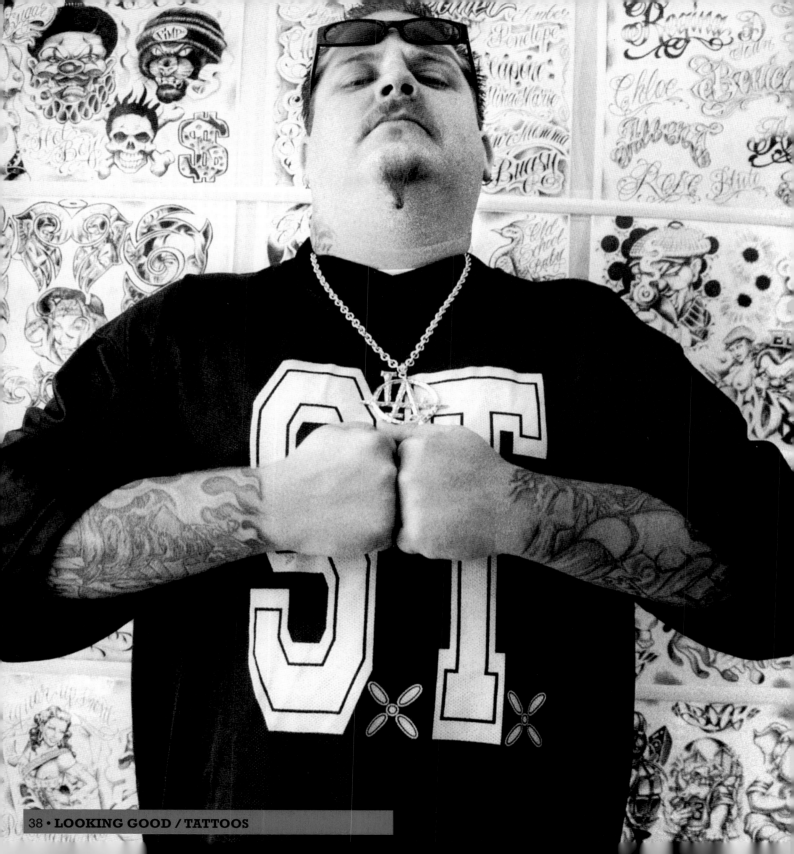

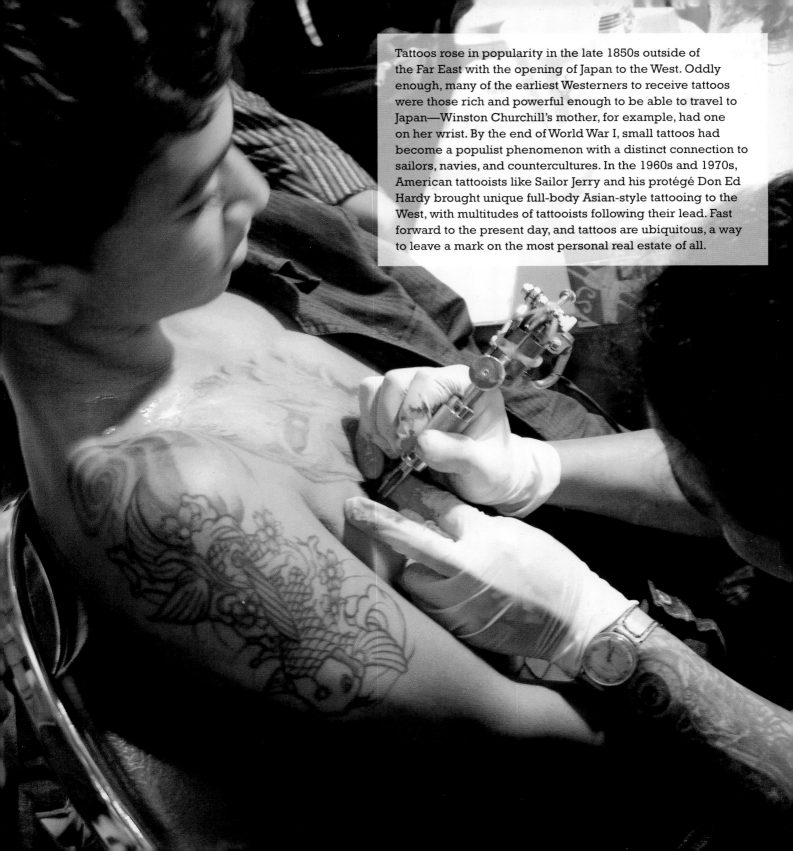

Tattoos rose in popularity in the late 1850s outside of the Far East with the opening of Japan to the West. Oddly enough, many of the earliest Westerners to receive tattoos were those rich and powerful enough to be able to travel to Japan—Winston Churchill's mother, for example, had one on her wrist. By the end of World War I, small tattoos had become a populist phenomenon with a distinct connection to sailors, navies, and countercultures. In the 1960s and 1970s, American tattooists like Sailor Jerry and his protégé Don Ed Hardy brought unique full-body Asian-style tattooing to the West, with multitudes of tattooists following their lead. Fast forward to the present day, and tattoos are ubiquitous, a way to leave a mark on the most personal real estate of all.

Albuquerque-based tattooist Mike Giant was first a goofy, skateboarding kid, and later a graffiti artist renowned for his precise, clean lines. For a short time, he was an architecture student. When he began to tattoo in the mid-1990s, he picked up the art form as quickly as anyone, putting his distinctive spin on the classic flash imagery of tattooing—its repeated designs and motifs. Today, Mike Giant divides his time between illustration, tattoos, graffiti, and track bikes.

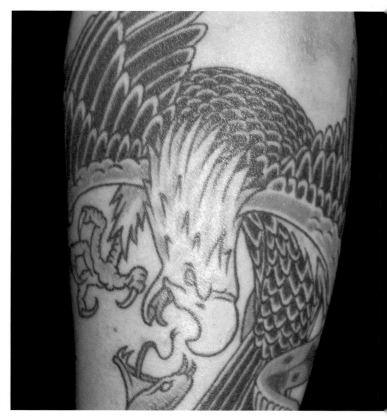

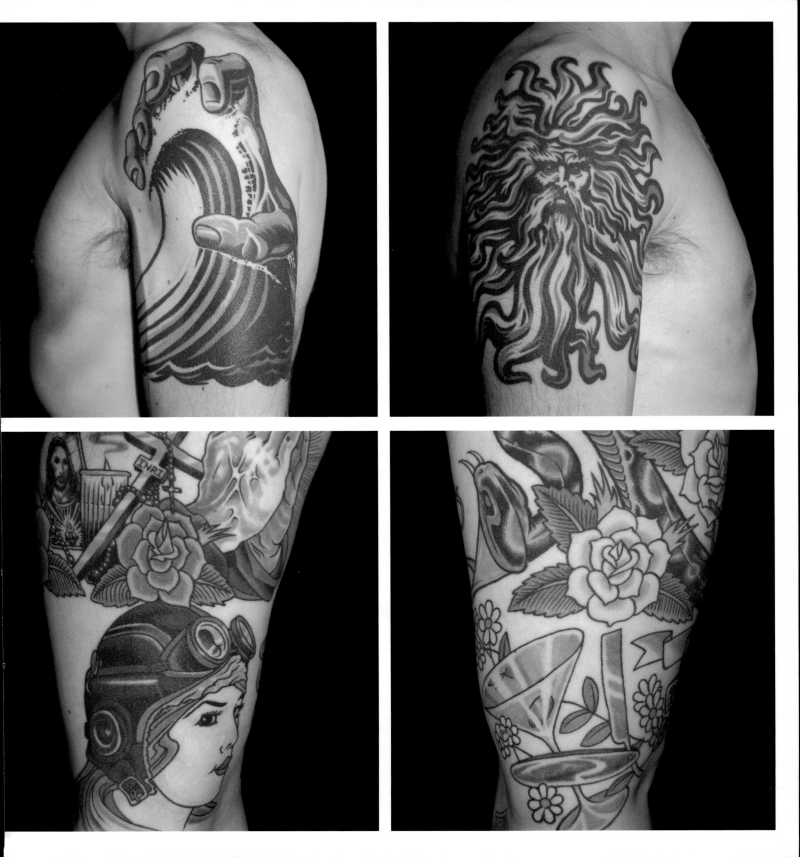

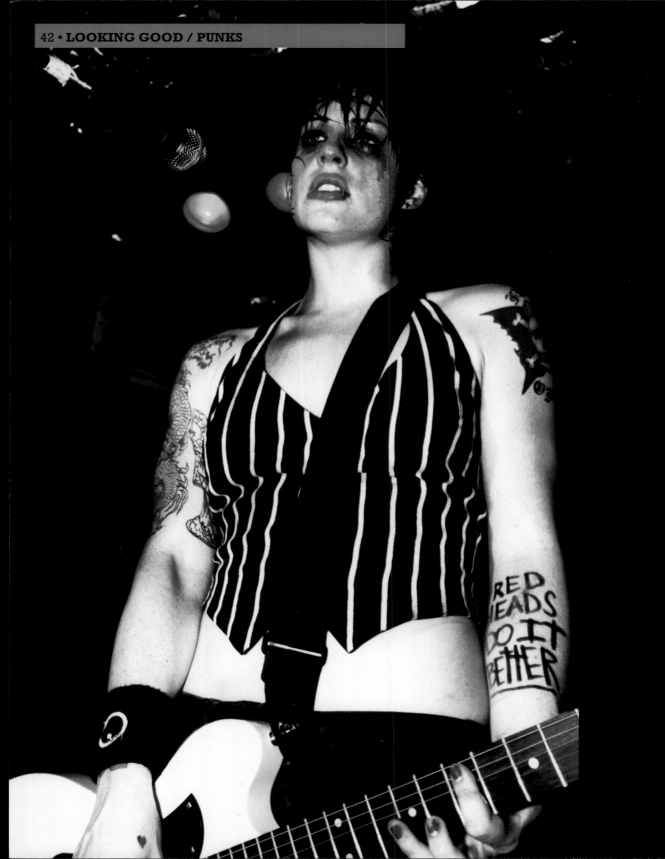

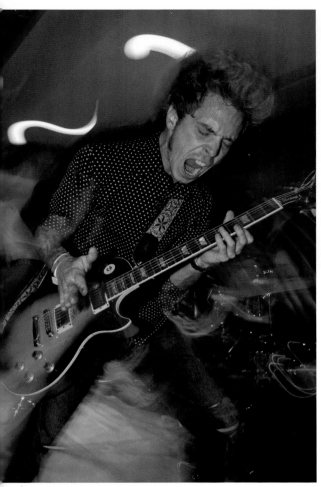

Every generation has its rebels, and in every generation since the 1970s a large segment of those rebels have been punk rockers. Punk rock music was the loud, pugnacious kid who crashed parties, crashed cars, and crashed on friends' couches. No matter how old or new it is, the music always has a way of speaking to disenchanted youth who find themselves at odds with society's rigid structures and values. Punk rock also has its own ethic, a culture of shunning commercial services in favor of doing things yourself. Everything punk, from clothing to album artwork and concert flyers, is made by punks themselves. Because punks refuse to conform and cooperate with authority and the customs of their own societies, it seems that they have far more in common with their fellow punks around the world than their own neighbors.

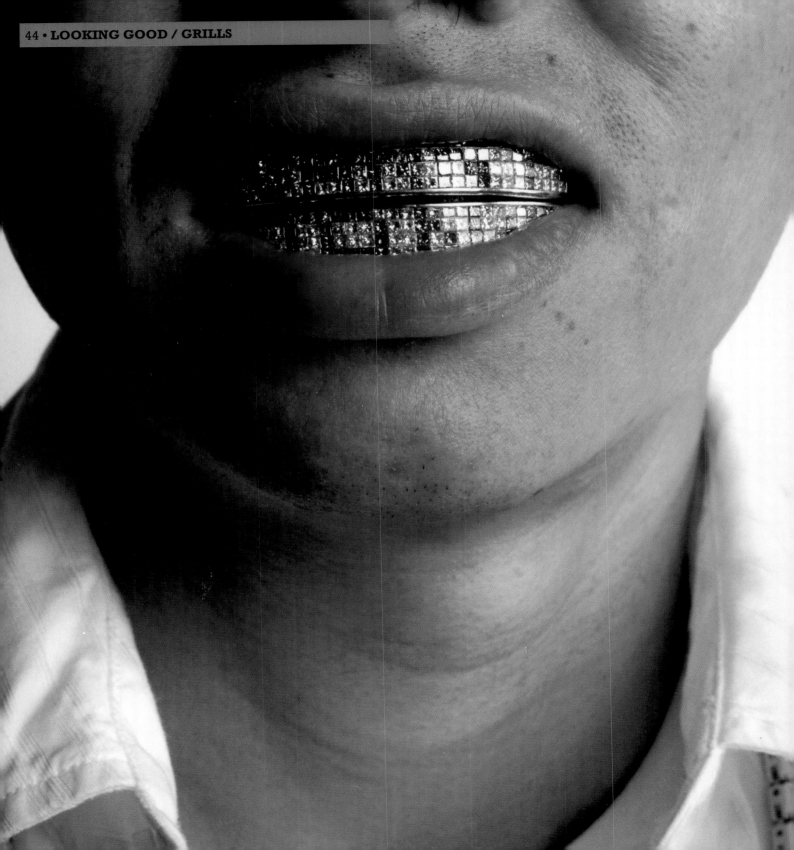

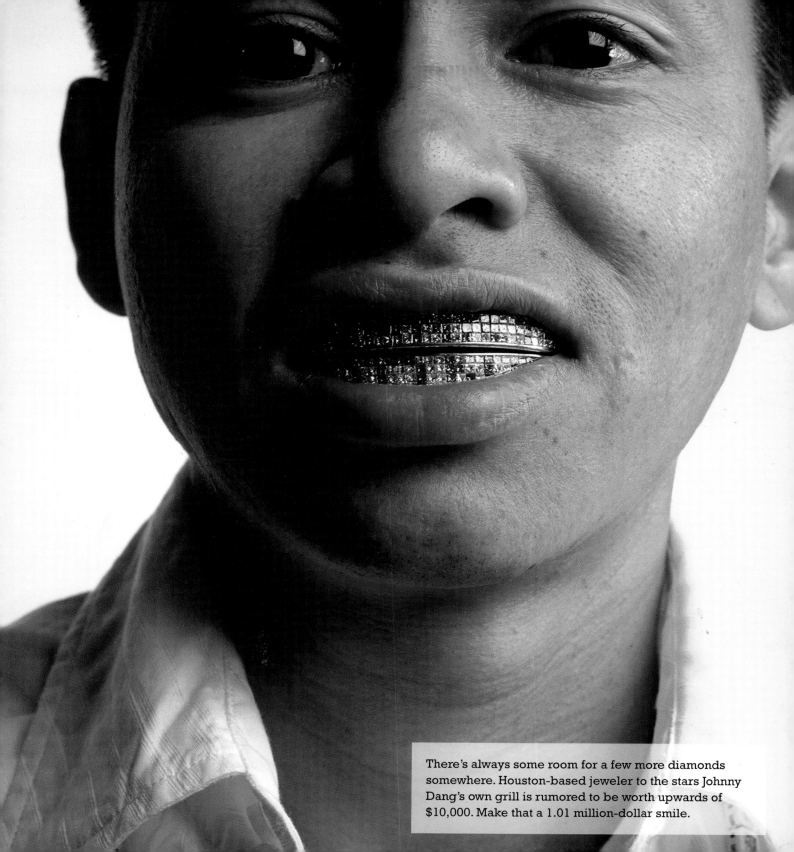

There's always some room for a few more diamonds somewhere. Houston-based jeweler to the stars Johnny Dang's own grill is rumored to be worth upwards of $10,000. Make that a 1.01 million-dollar smile.

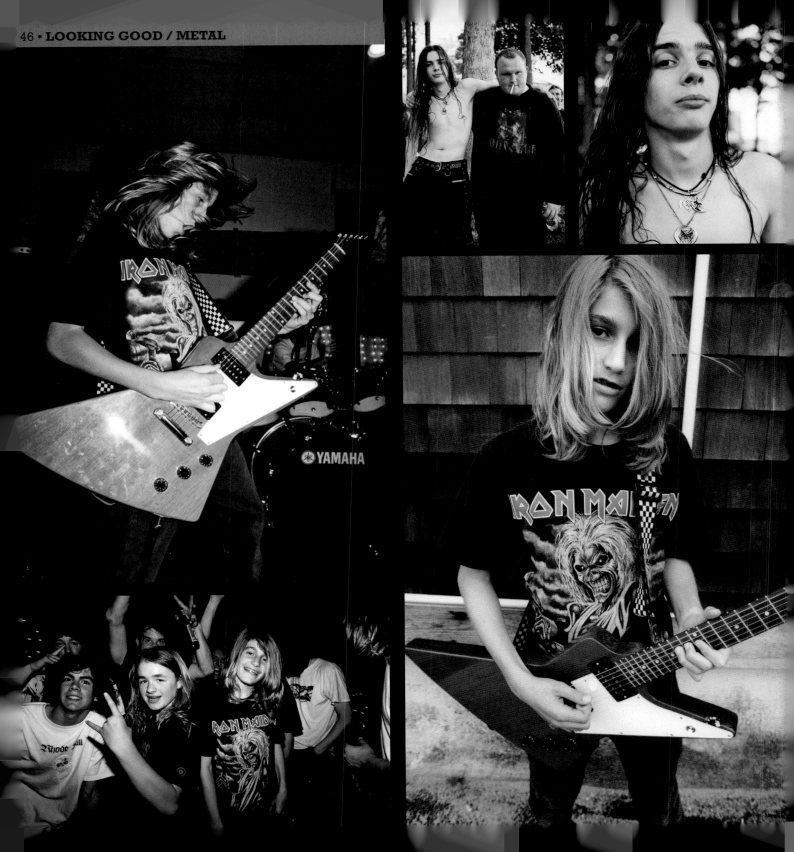

avy metal music has been a major influence
he lives of teenagers all over the world since
emergence in the early 1970s. If you need
dence, just take a look at the scrawls on
hschool desks and bathroom walls—you'll no
abt find countless Black Sabbath, Iron Maiden,
1 Motörhead logos. For countercultural kids,
avy metal has everything they could possibly
at in music: distorted guitars, thunderous
ms, and lyrics that range from political
antastical.

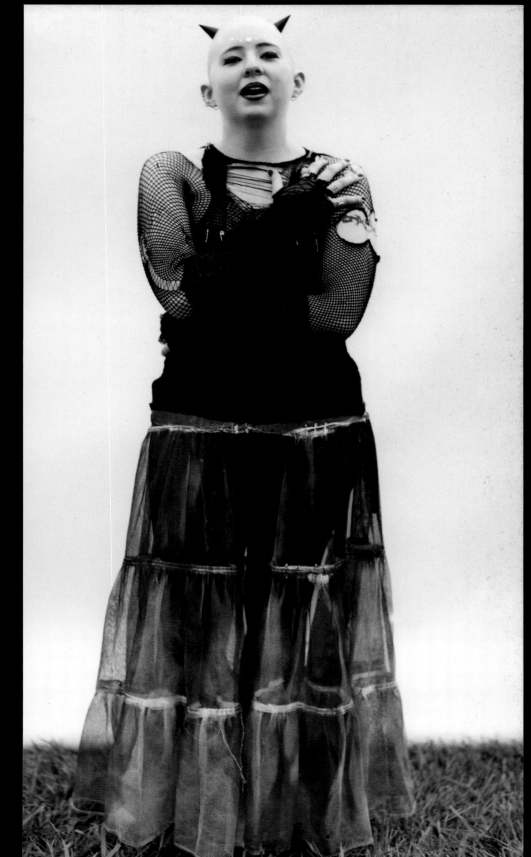

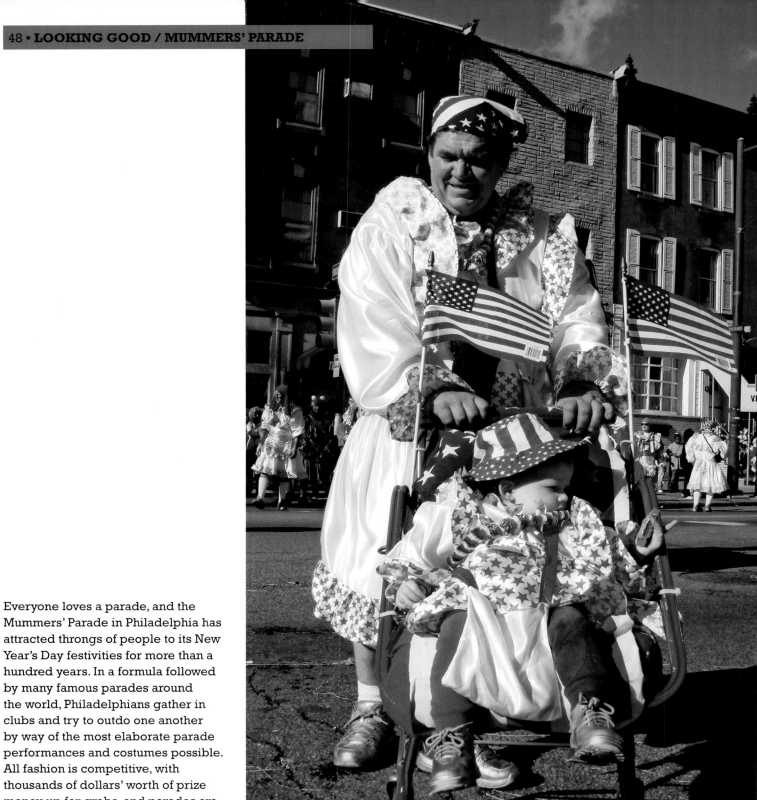

Everyone loves a parade, and the Mummers' Parade in Philadelphia has attracted throngs of people to its New Year's Day festivities for more than a hundred years. In a formula followed by many famous parades around the world, Philadelphians gather in clubs and try to outdo one another by way of the most elaborate parade performances and costumes possible. All fashion is competitive, with thousands of dollars' worth of prize money up for grabs, and parades are fashion week in a day.

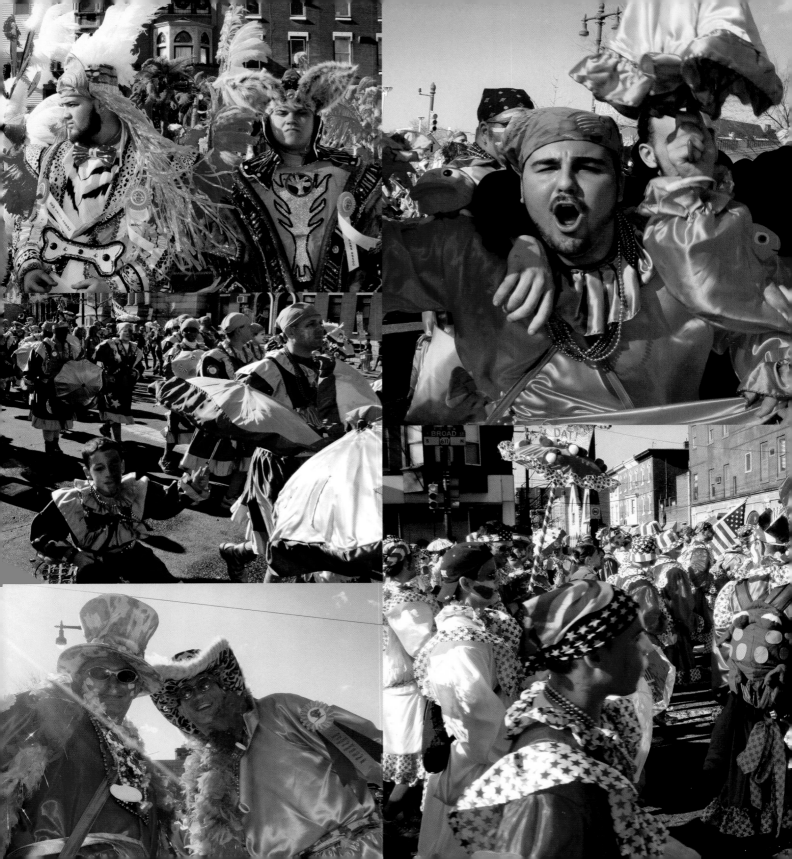

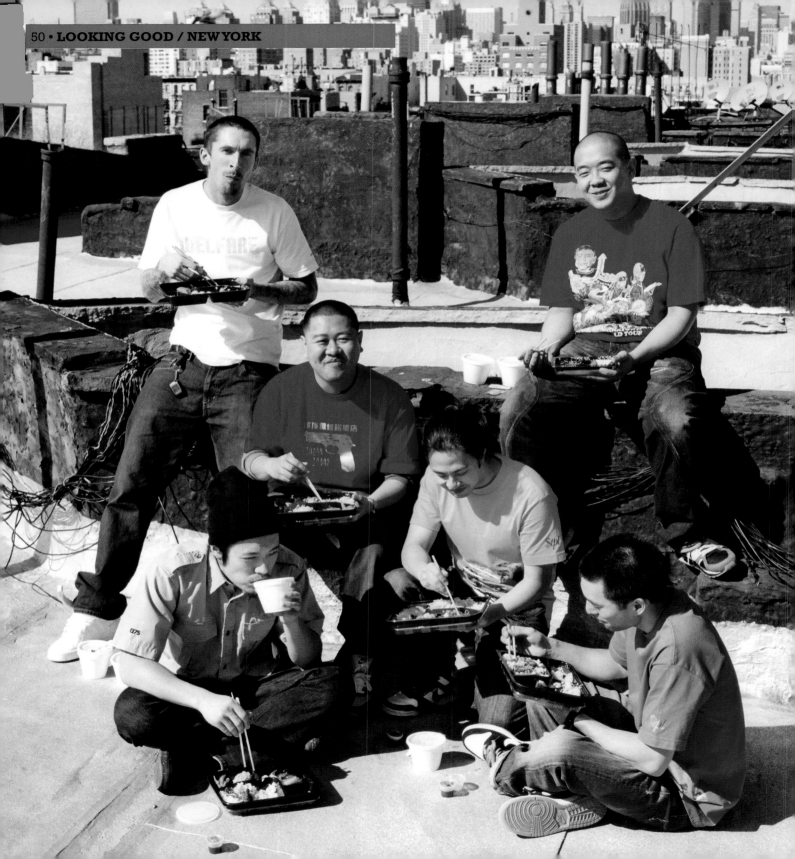

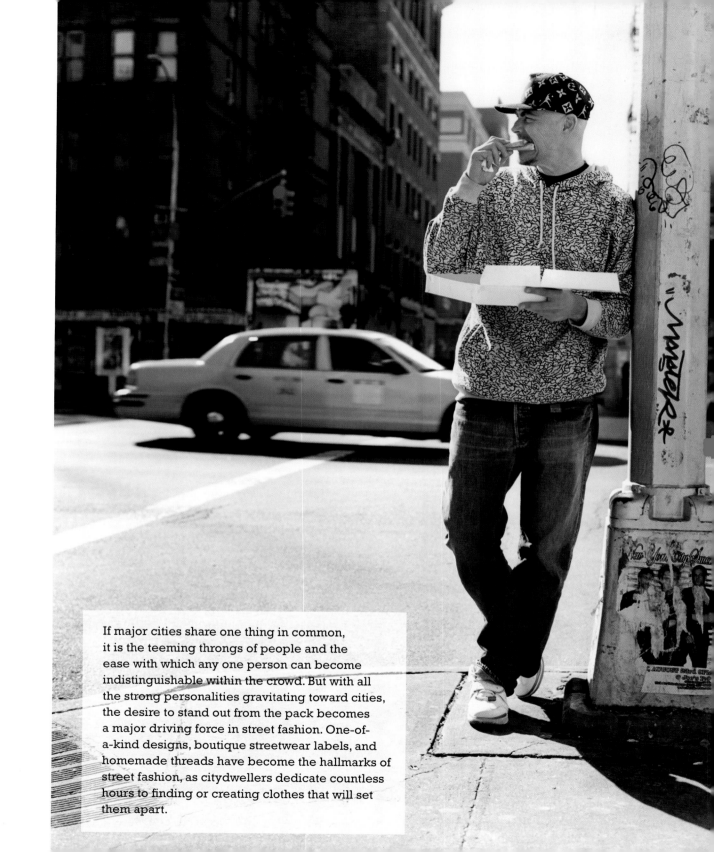

If major cities share one thing in common, it is the teeming throngs of people and the ease with which any one person can become indistinguishable within the crowd. But with all the strong personalities gravitating toward cities, the desire to stand out from the pack becomes a major driving force in street fashion. One-of-a-kind designs, boutique streetwear labels, and homemade threads have become the hallmarks of street fashion, as citydwellers dedicate countless hours to finding or creating clothes that will set them apart.

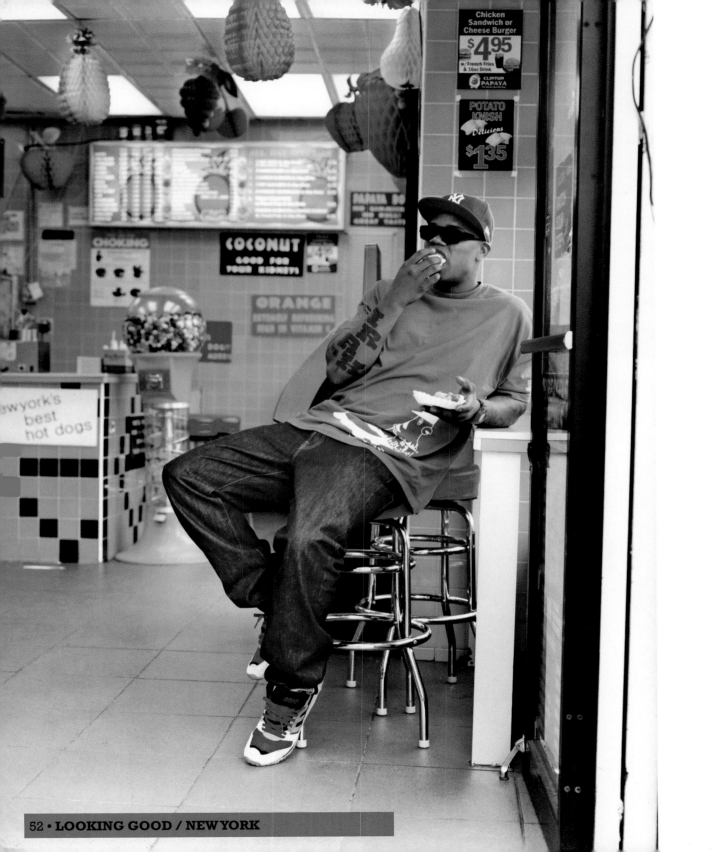

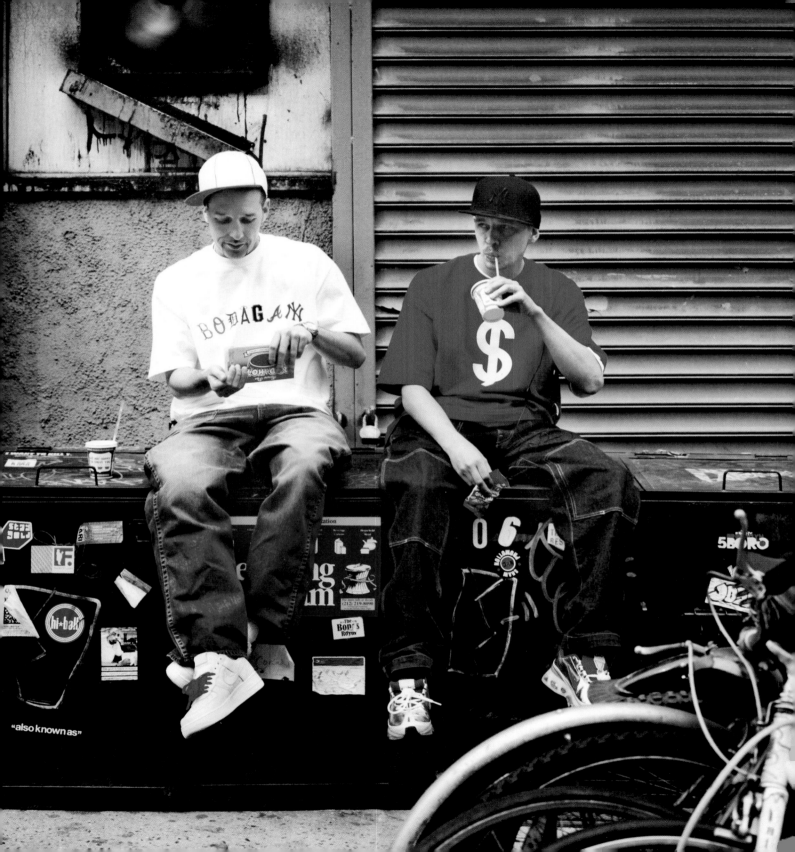

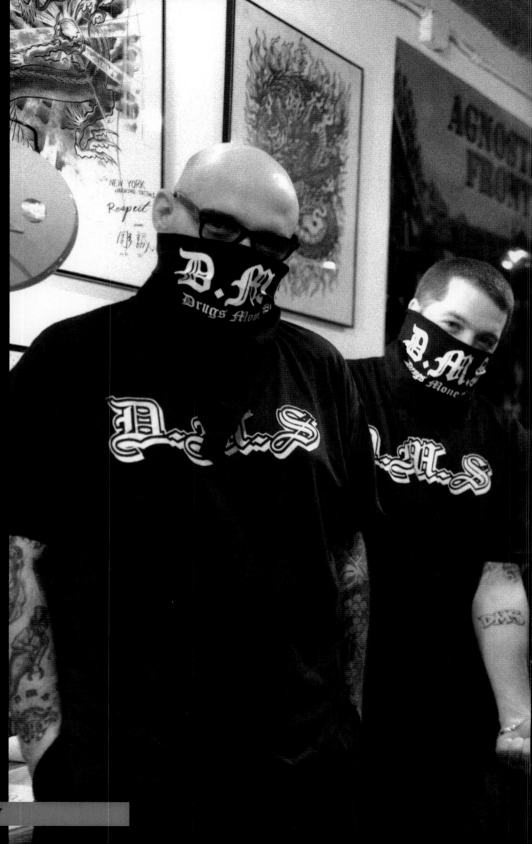

The DMS crew emerged as a force in New York City's scene in the mid and late 1980s, with its membership including a slew of hardcore bands and notorious graffiti writers. Today, the Dirty Money Syndicate is still going strong in both music and graffiti with no signs of slowing down.

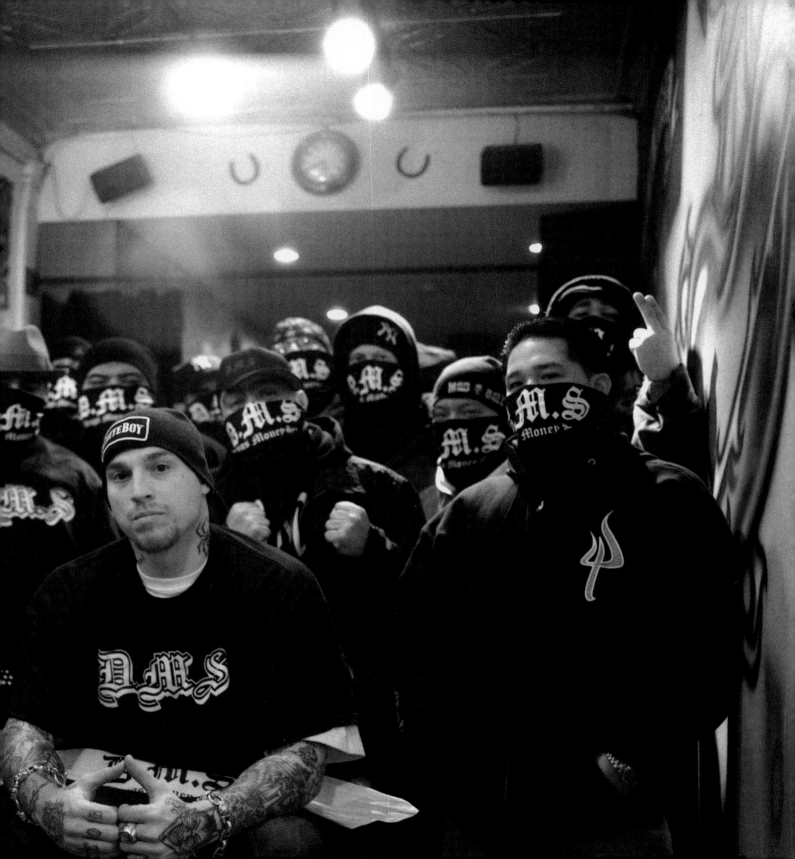

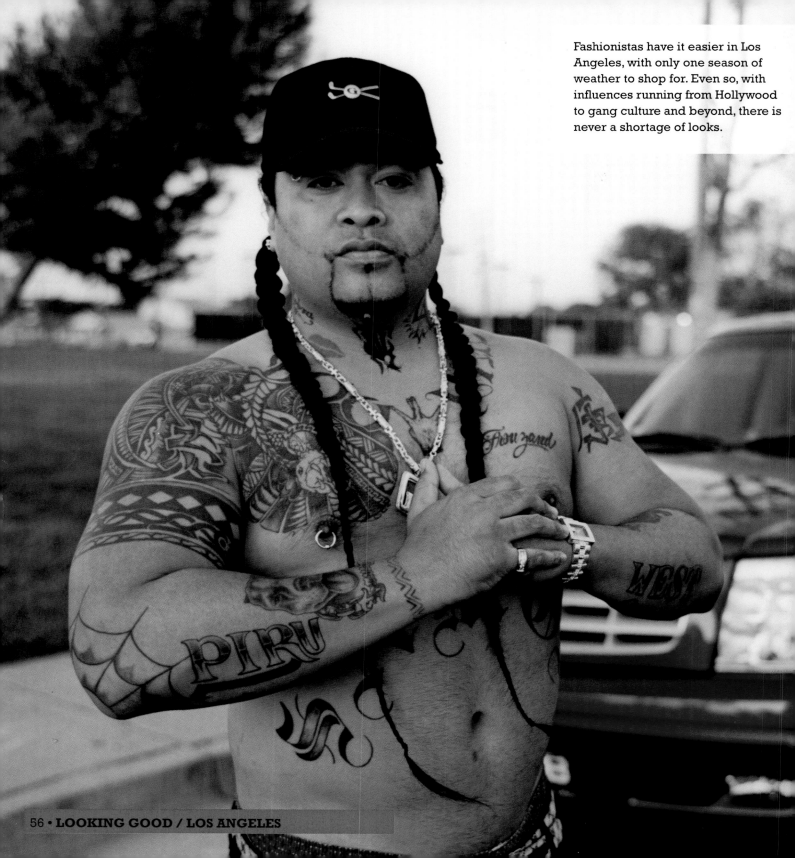

Fashionistas have it easier in Los Angeles, with only one season of weather to shop for. Even so, with influences running from Hollywood to gang culture and beyond, there is never a shortage of looks.

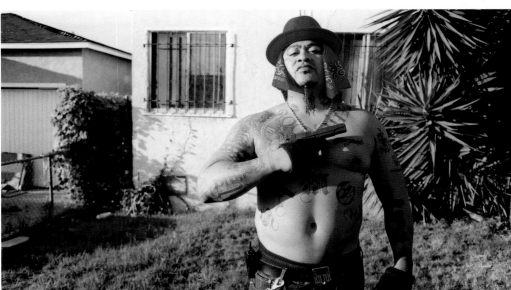
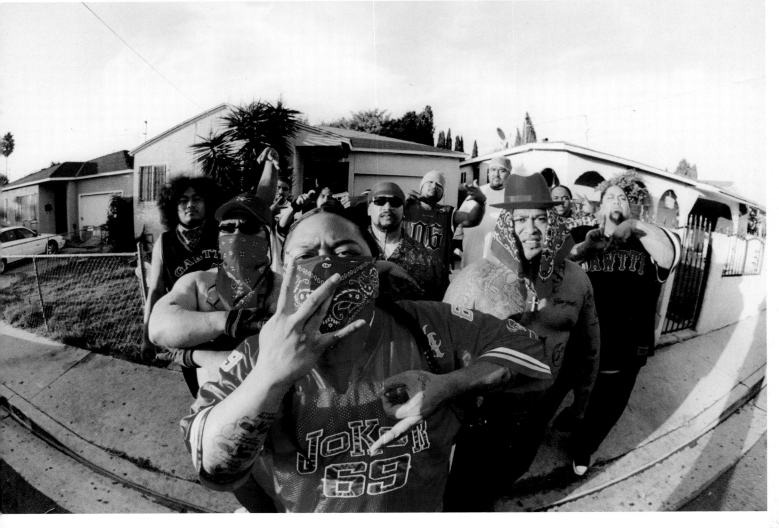

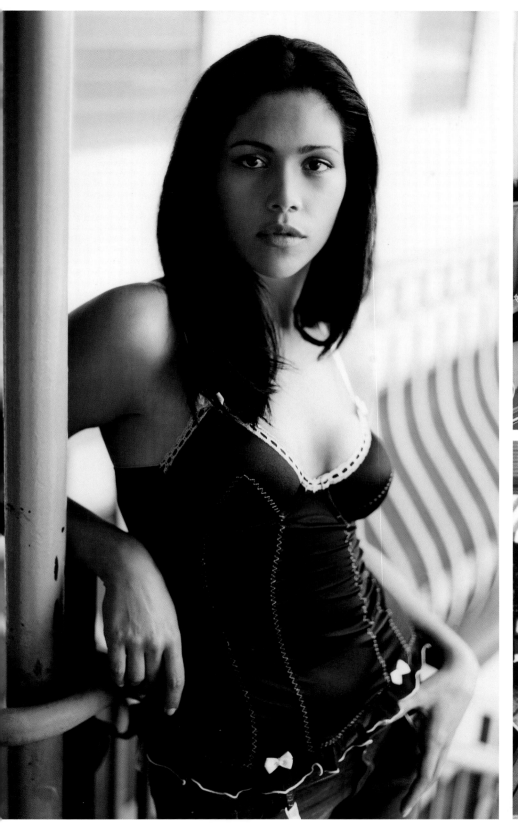
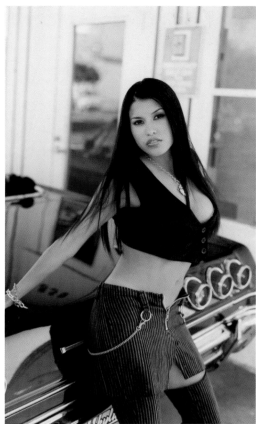

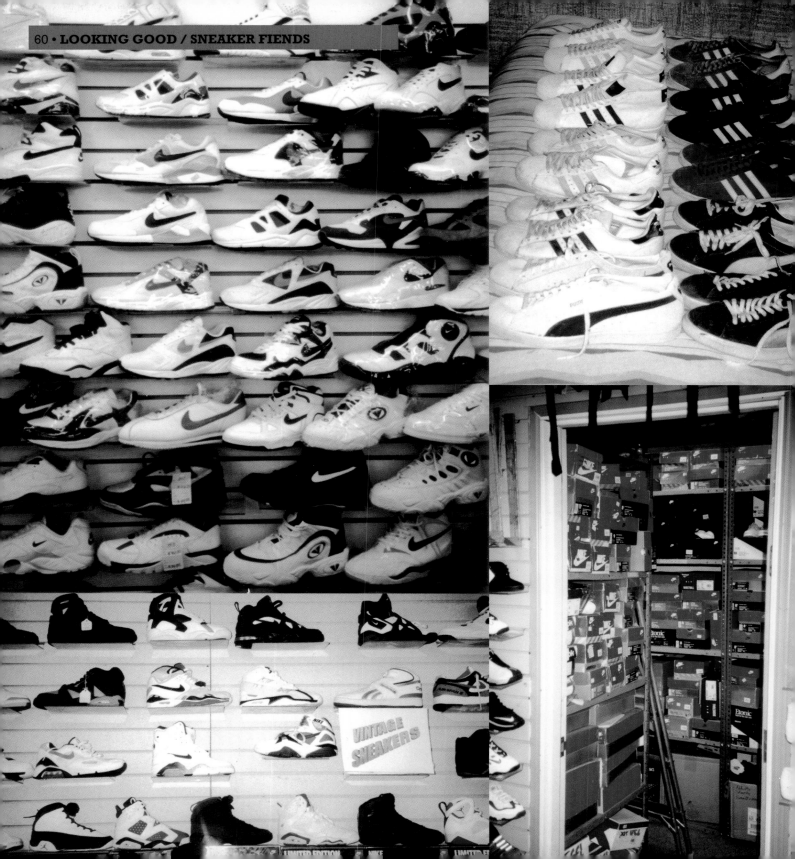

VINTAGE SNEAKERS

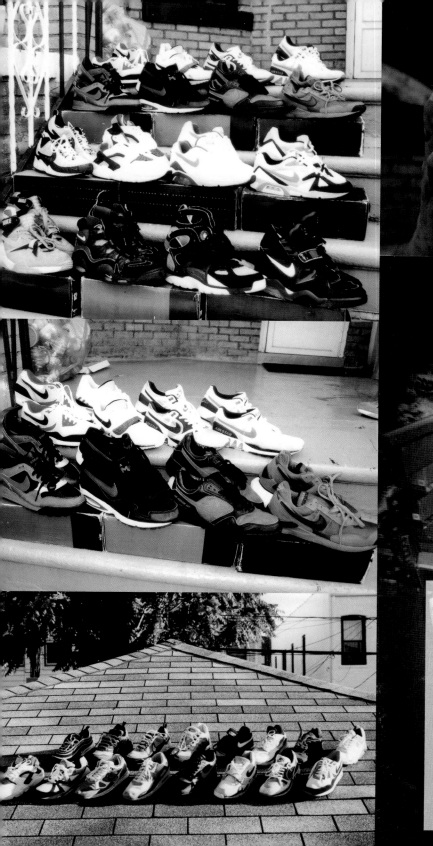

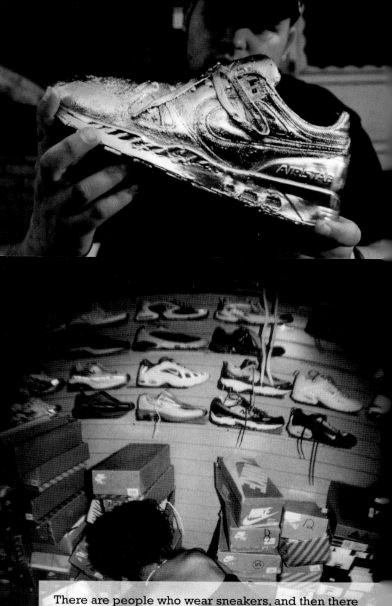

There are people who wear sneakers, and then there are people who own sneakers. These "sneaker fiends" can be seen lined up on city sidewalks early in the morning outside their favorite sneaker shops, wanting to be the first to get in and cop the hottest, rarest, and most colorful sneakers on the market. Their closets are often lined with shoeboxes filled with their treasured finds, from the old-school to the brand new. The sneaker of choice for many of them is the Nike Dunk, just one shoe model that can be found in countless different colorways, courtesy of thousands of different designers who lend their unique interpretations to the Dunk, from New York graffiti legends such as Stash and Futura to metal artist Pushead.

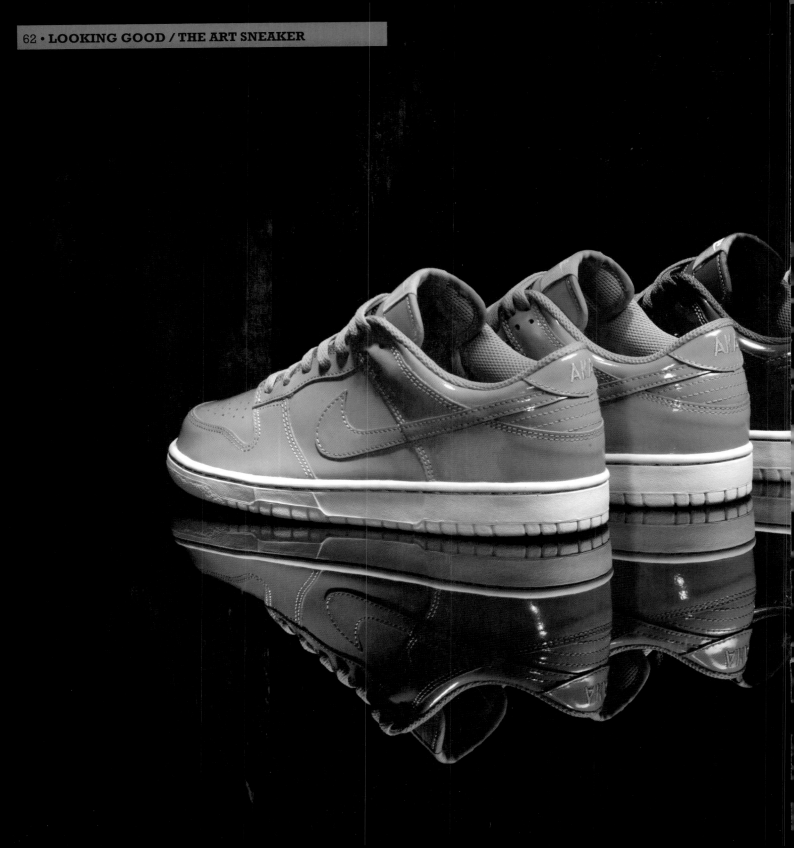

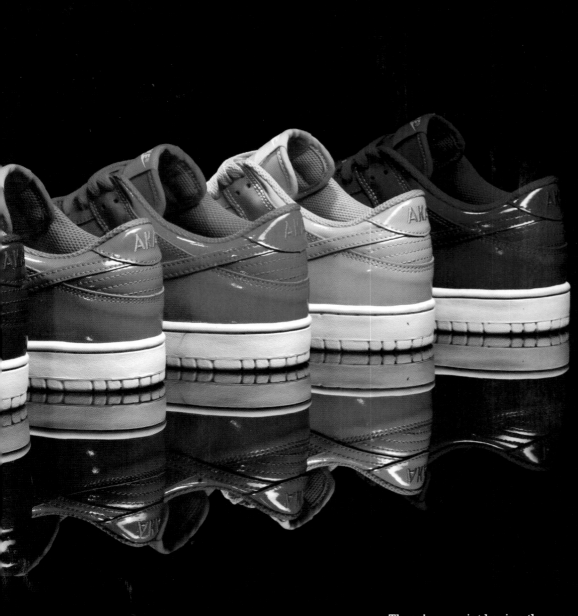

There's no point having the same shoes as everyone else, and people have taken that to glorious extremes. Witness the development of the sneaker as fine art, in this case the 2006 AKA Wet Look Nike Dunk Lo pack, inspired by vintage spraypaint colors and executed in brilliant patent leather. This is one of only five sets made, one of which was auctioned for an arts education charity—for a staggering $14,900, after frenzied bidding by some of the most crazed and affluent sneaker fiends around.

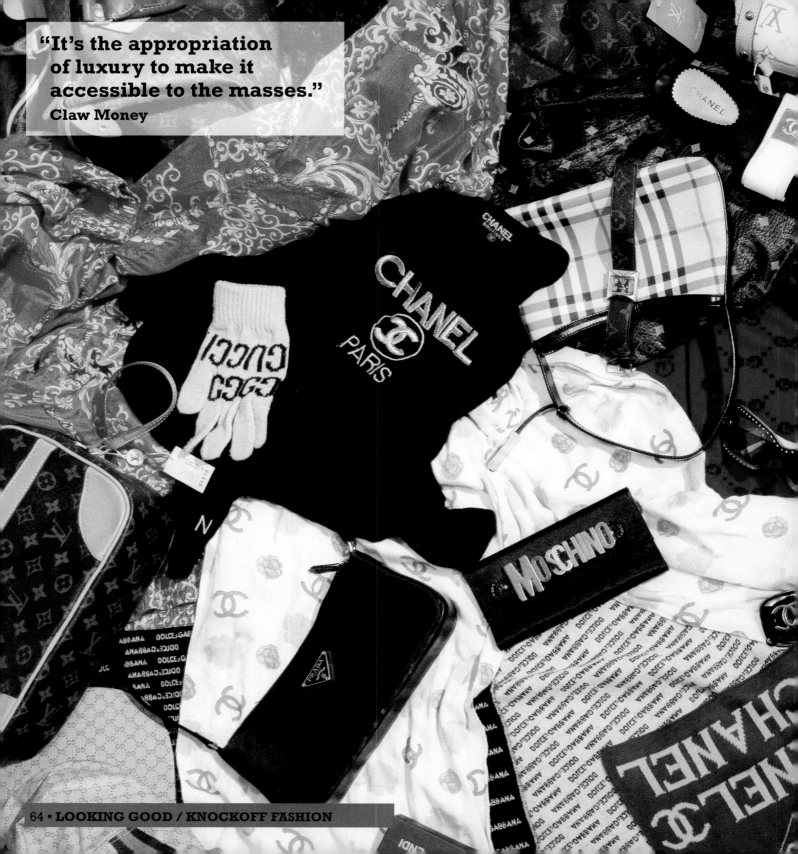

"It's the appropriation of luxury to make it accessible to the masses."
Claw Money

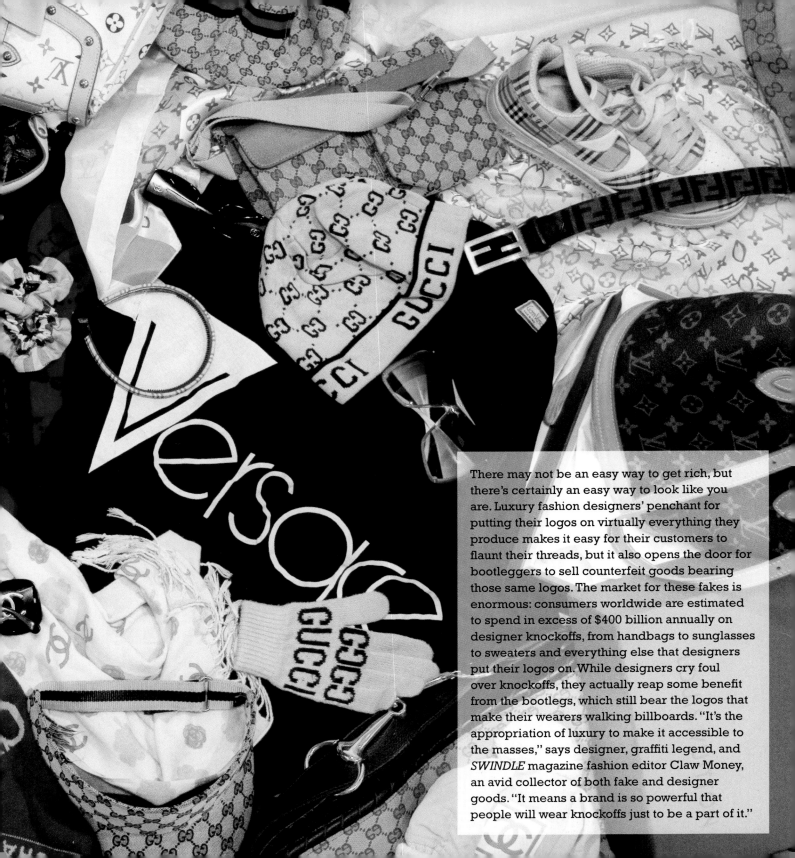

There may not be an easy way to get rich, but there's certainly an easy way to look like you are. Luxury fashion designers' penchant for putting their logos on virtually everything they produce makes it easy for their customers to flaunt their threads, but it also opens the door for bootleggers to sell counterfeit goods bearing those same logos. The market for these fakes is enormous: consumers worldwide are estimated to spend in excess of $400 billion annually on designer knockoffs, from handbags to sunglasses to sweaters and everything else that designers put their logos on. While designers cry foul over knockoffs, they actually reap some benefit from the bootlegs, which still bear the logos that make their wearers walking billboards. "It's the appropriation of luxury to make it accessible to the masses," says designer, graffiti legend, and *SWINDLE* magazine fashion editor Claw Money, an avid collector of both fake and designer goods. "It means a brand is so powerful that people will wear knockoffs just to be a part of it."

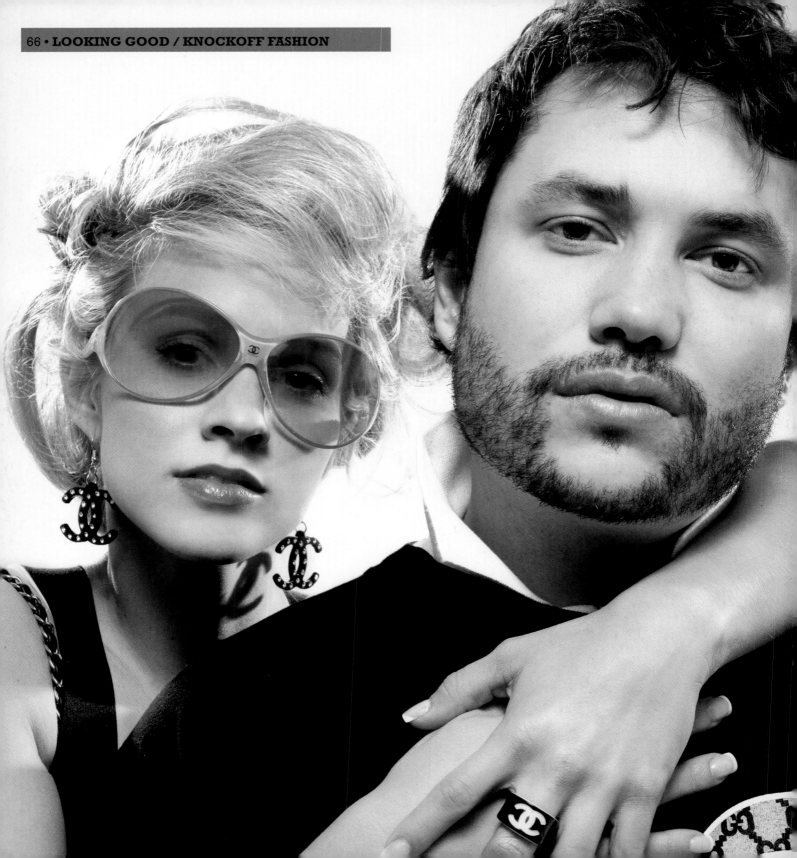

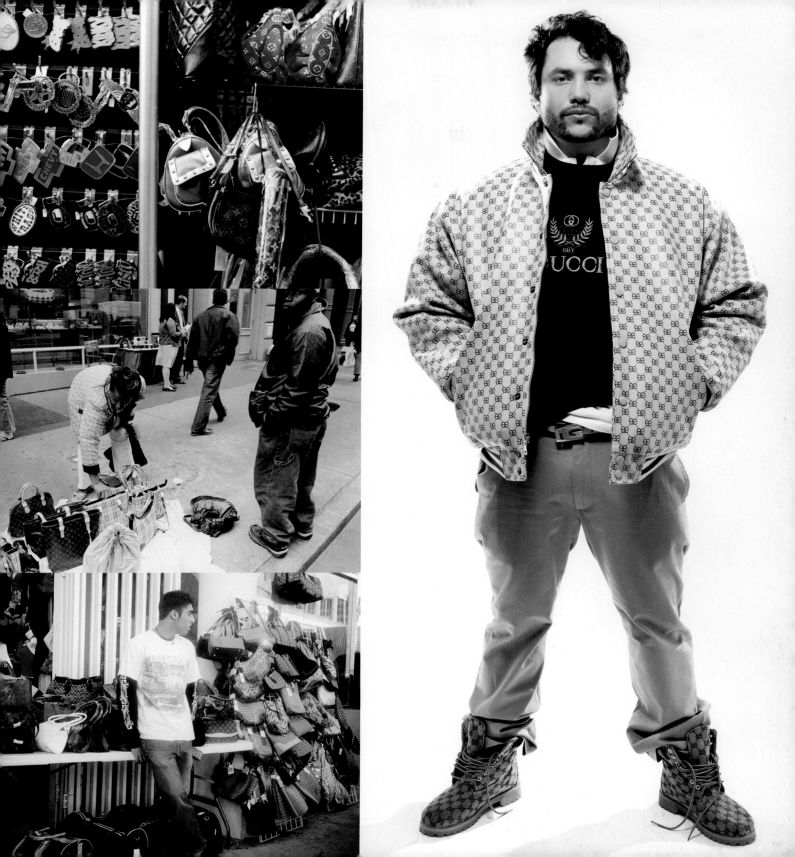

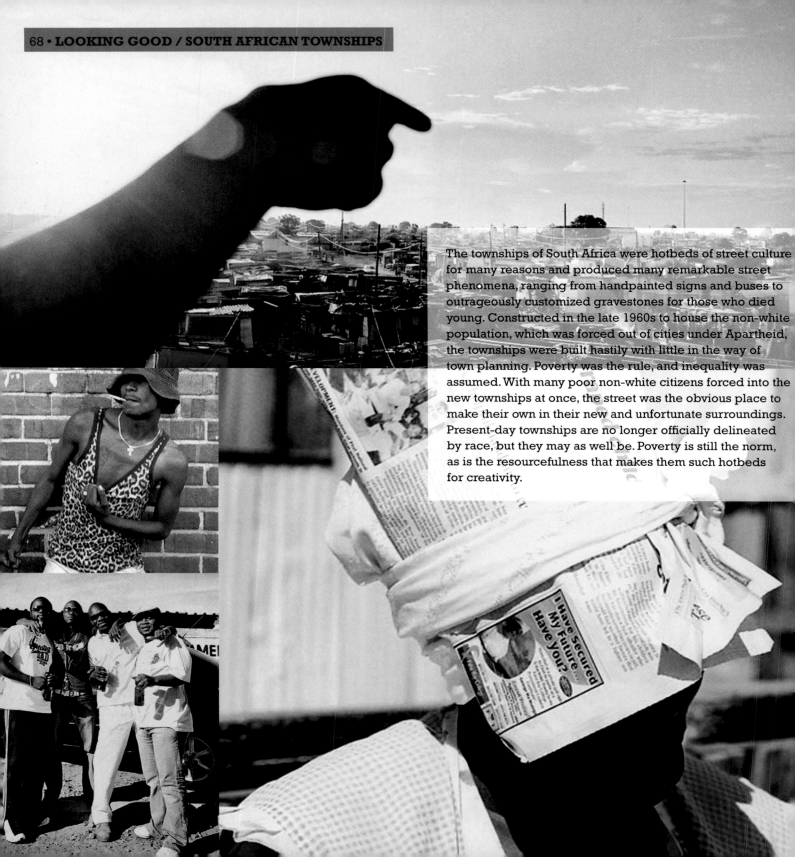

The townships of South Africa were hotbeds of street culture for many reasons and produced many remarkable street phenomena, ranging from handpainted signs and buses to outrageously customized gravestones for those who died young. Constructed in the late 1960s to house the non-white population, which was forced out of cities under Apartheid, the townships were built hastily with little in the way of town planning. Poverty was the rule, and inequality was assumed. With many poor non-white citizens forced into the new townships at once, the street was the obvious place to make their own in their new and unfortunate surroundings. Present-day townships are no longer officially delineated by race, but they may as well be. Poverty is still the norm, as is the resourcefulness that makes them such hotbeds for creativity.

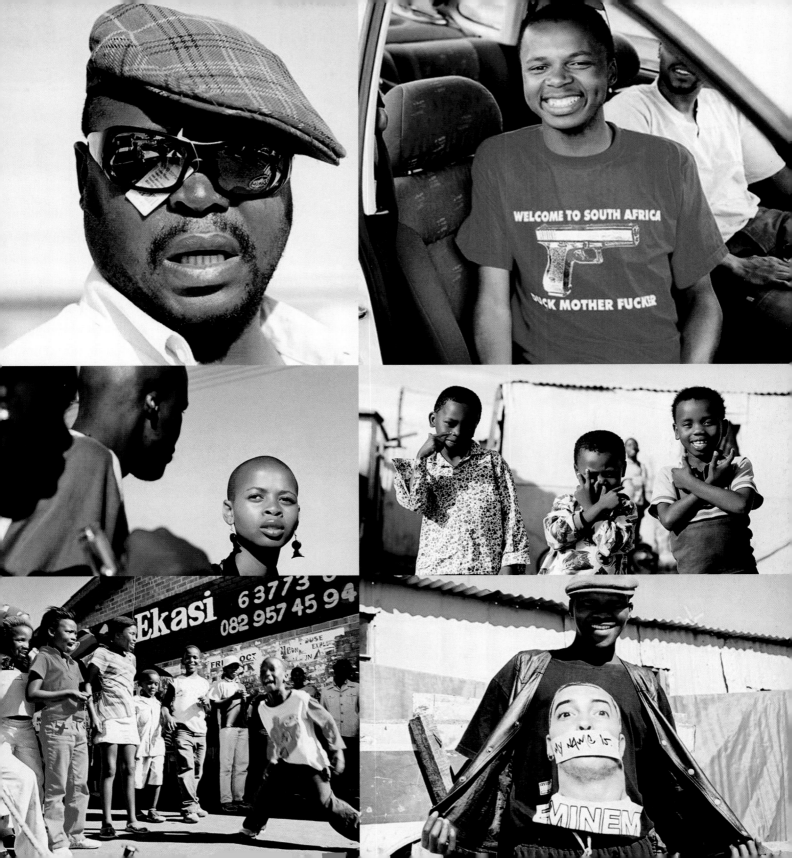

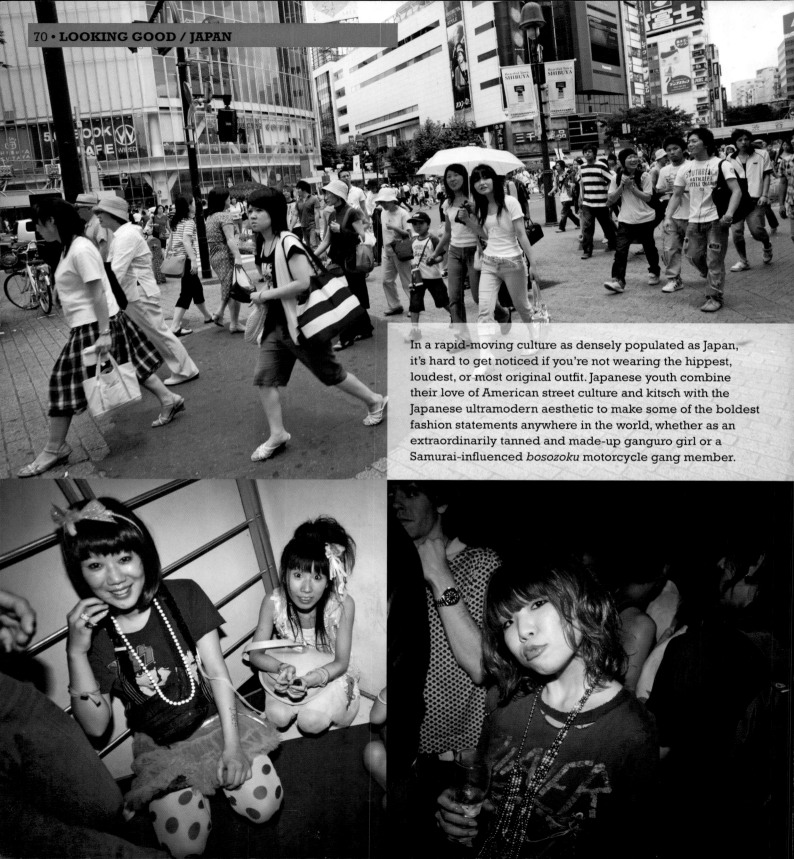

In a rapid-moving culture as densely populated as Japan, it's hard to get noticed if you're not wearing the hippest, loudest, or most original outfit. Japanese youth combine their love of American street culture and kitsch with the Japanese ultramodern aesthetic to make some of the boldest fashion statements anywhere in the world, whether as an extraordinarily tanned and made-up ganguro girl or a Samurai-influenced *bosozoku* motorcycle gang member.

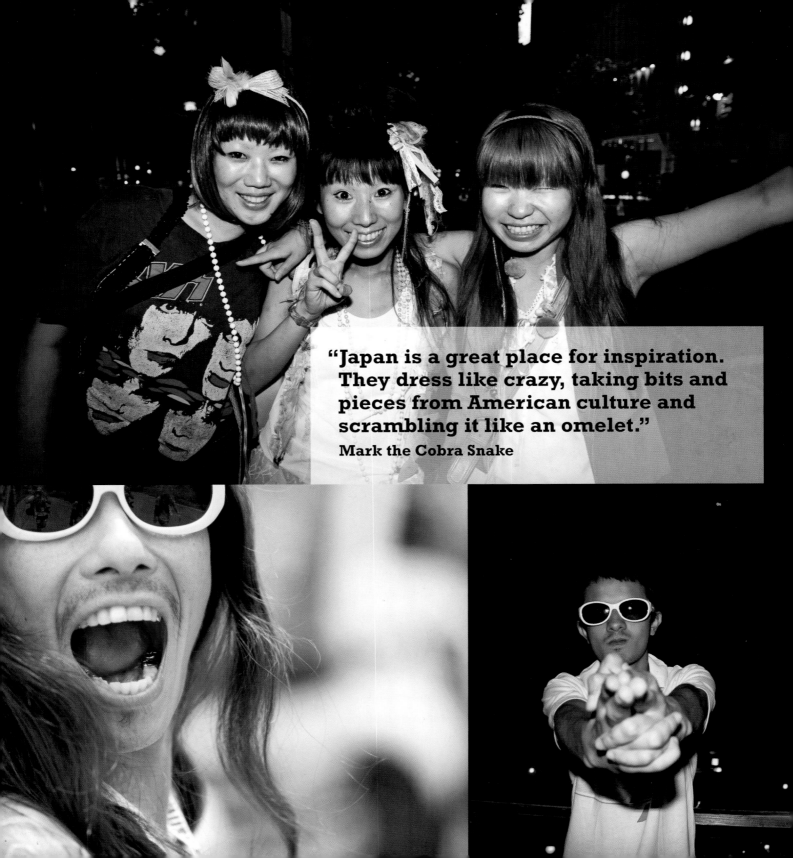

"Japan is a great place for inspiration. They dress like crazy, taking bits and pieces from American culture and scrambling it like an omelet."
Mark the Cobra Snake

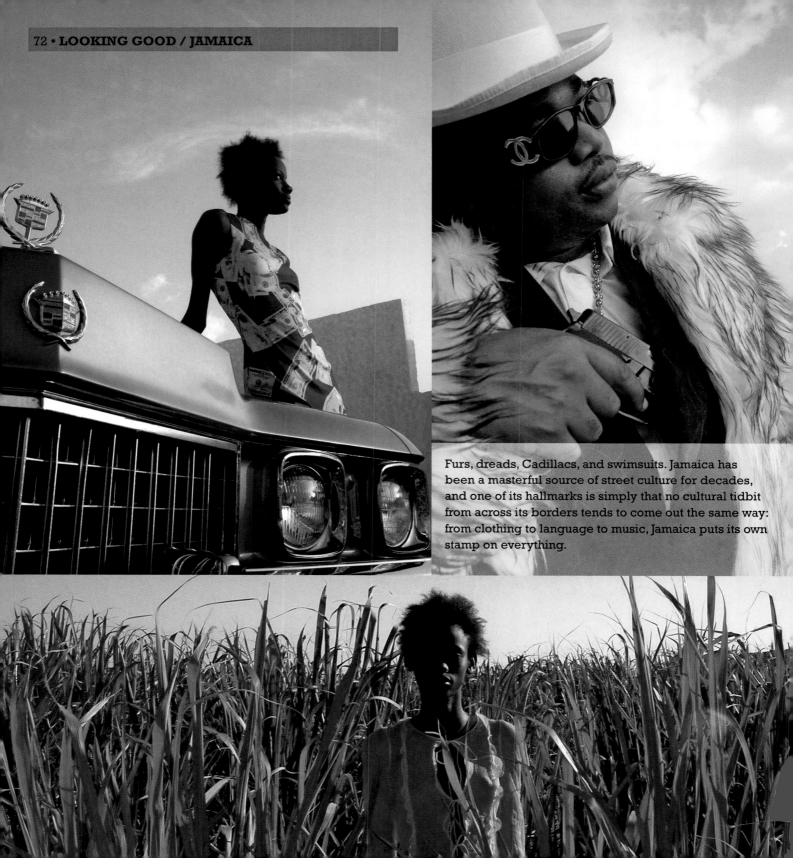

Furs, dreads, Cadillacs, and swimsuits. Jamaica has been a masterful source of street culture for decades, and one of its hallmarks is simply that no cultural tidbit from across its borders tends to come out the same way: from clothing to language to music, Jamaica puts its own stamp on everything.

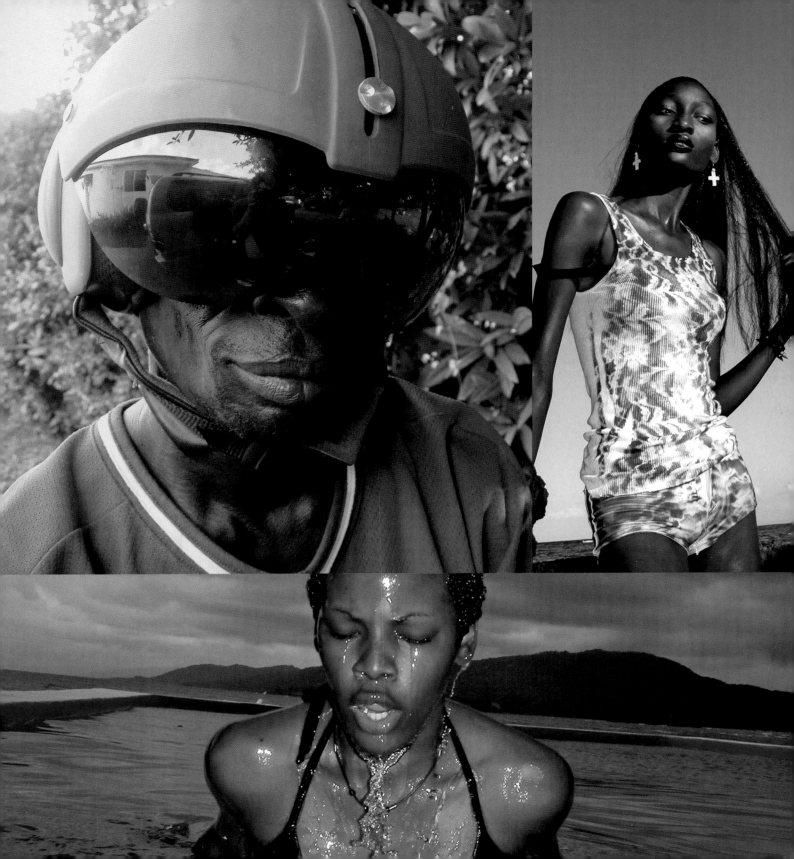

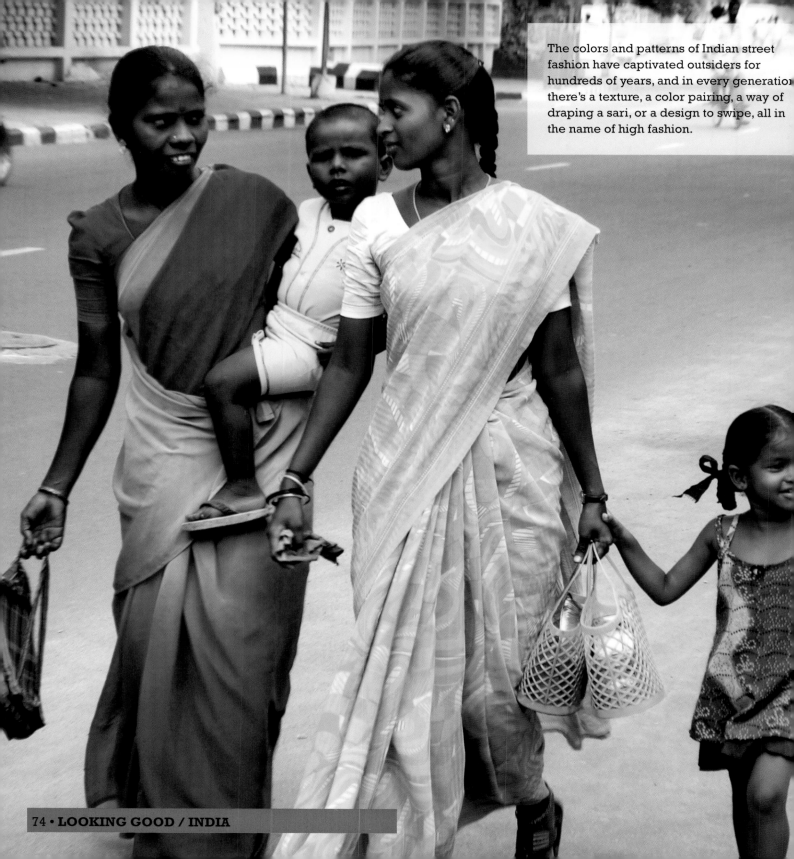

The colors and patterns of Indian street fashion have captivated outsiders for hundreds of years, and in every generation there's a texture, a color pairing, a way of draping a sari, or a design to swipe, all in the name of high fashion.

In the mid-1970s, black residents of one U.S. city found a new groove and a movement, and they called it "go-go." New Orleans has jazz, Chicago has blues, Detroit has motown, Memphis has rock 'n' roll, Nashville has country, New York has hip-hop, and Washington, DC, has go-go. This "go-go" has nothing to do with bootclad erotic dancers at a club. Rather, it is is a music and a culture that emerged in DC and has never left. Go-go's godfather—Chuck Brown—still plays, along with various incarnations of other pioneering go-go bands, including E.U. (Experience Unlimited), Trouble Funk, Rare Essence and the Junkyard Band, and dozens of others. As with any musical genre, there's a fashion sense that goes with it, often expressed with high-end custom jackets from DC's Universal Madness, along with camouflage, sneakers, and baseball hats.

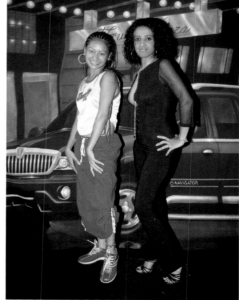

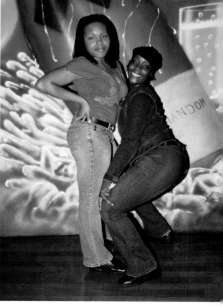

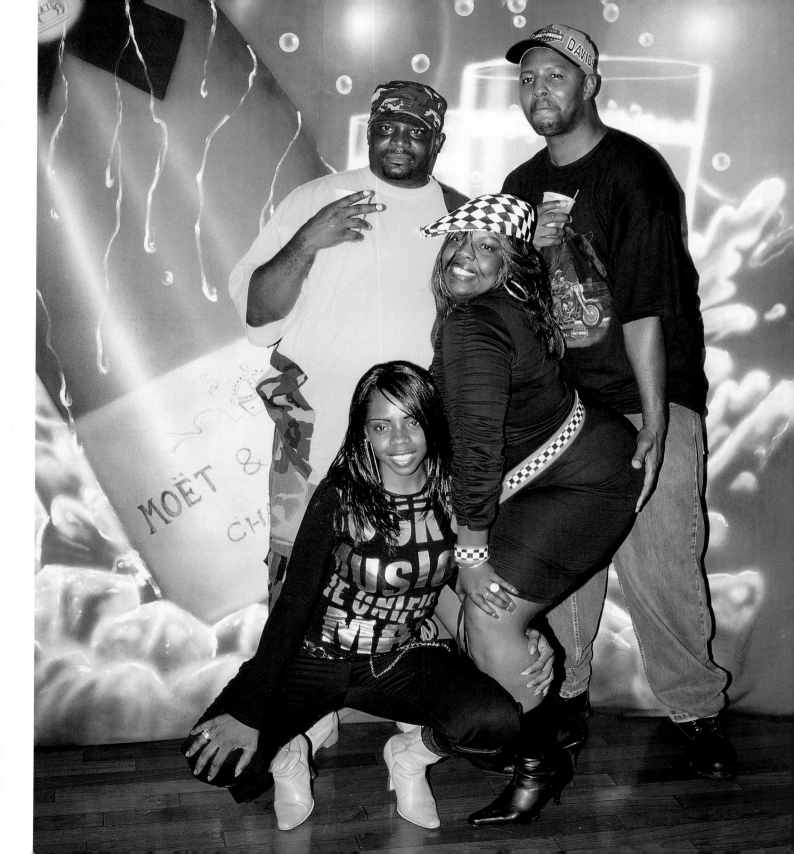

Dre&
Eazy&
Cube&
Ren.

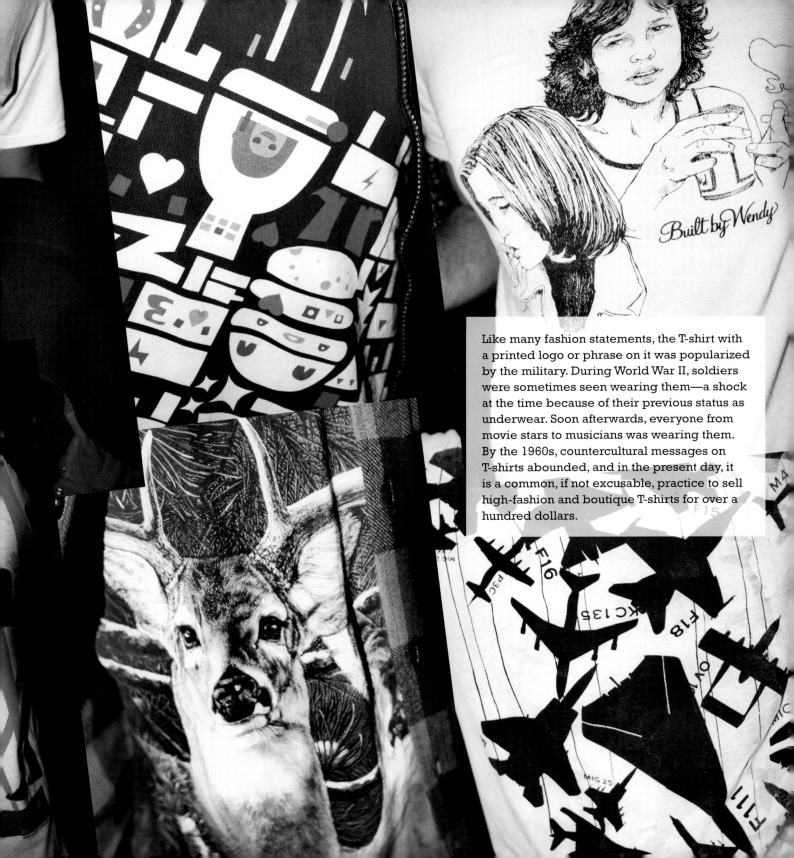

Built by Wendy

Like many fashion statements, the T-shirt with a printed logo or phrase on it was popularized by the military. During World War II, soldiers were sometimes seen wearing them—a shock at the time because of their previous status as underwear. Soon afterwards, everyone from movie stars to musicians was wearing them. By the 1960s, countercultural messages on T-shirts abounded, and in the present day, it is a common, if not excusable, practice to sell high-fashion and boutique T-shirts for over a hundred dollars.

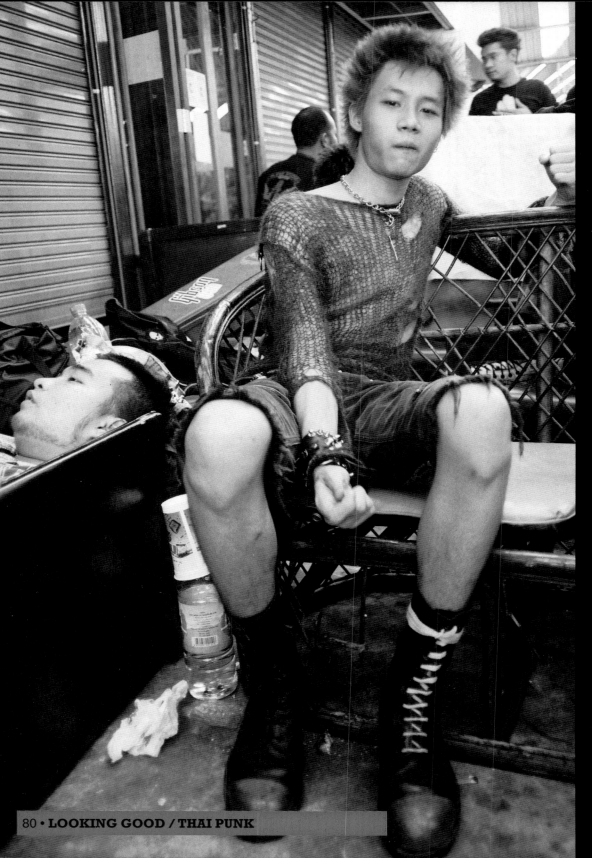

In the mid-1990s, there emerged a small but powerful punk scene in Thailand. Playing wherever they could, bands like Rambo have taken the punk ethic to new latitudes, playing in Bangkok clubs like the Chilling House. The style, the pit, and the attitude are all familiar.

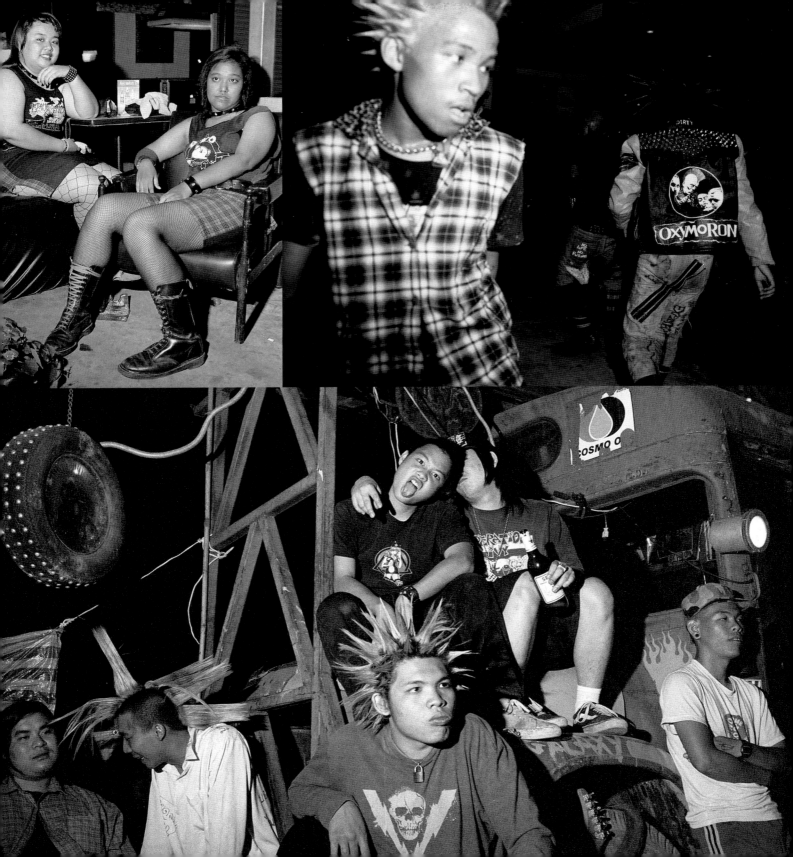

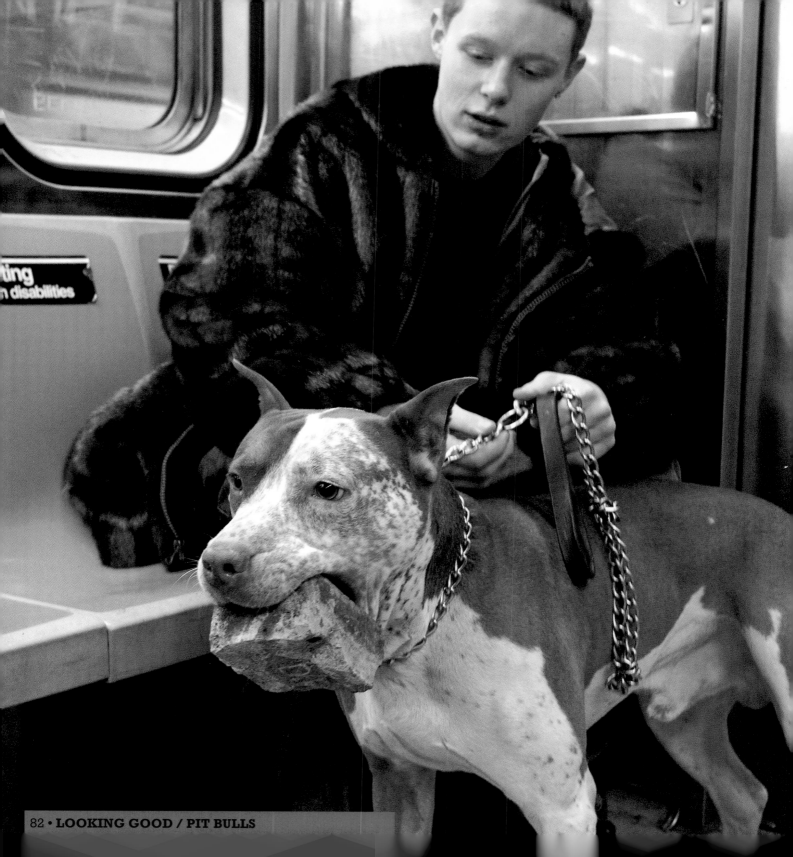

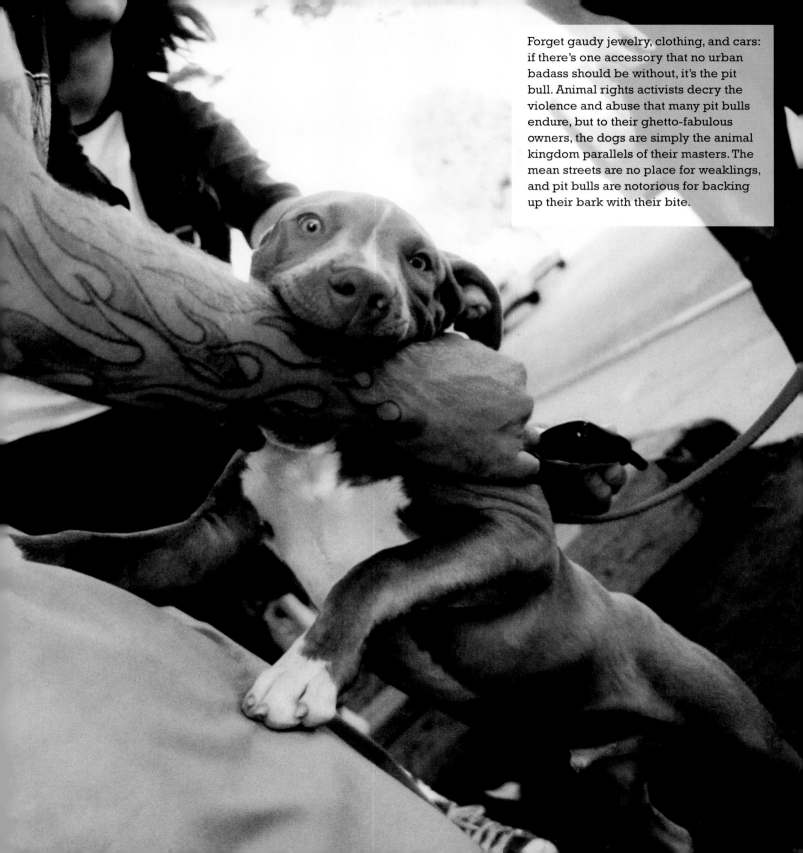

Forget gaudy jewelry, clothing, and cars: if there's one accessory that no urban badass should be without, it's the pit bull. Animal rights activists decry the violence and abuse that many pit bulls endure, but to their ghetto-fabulous owners, the dogs are simply the animal kingdom parallels of their masters. The mean streets are no place for weaklings, and pit bulls are notorious for backing up their bark with their bite.

GETTING AROUND

• GETTING AROUND

As long as people have had vehicles, they've used them as extensions of themselves, endlessly customizing them by building them up or wearing them down.

Spend hours poring over skateboard decks to carefully choose the graphics that look the best; then immediately scratch and obliterate their decorated surfaces by grinding curbs and planters.

Find just the right bicycle and take a blowtorch to it, adding on parts and pieces of others until it's distinctive enough to be worth riding.

Car, truck, scooter…transportation just doesn't mean anything until you make it your own.

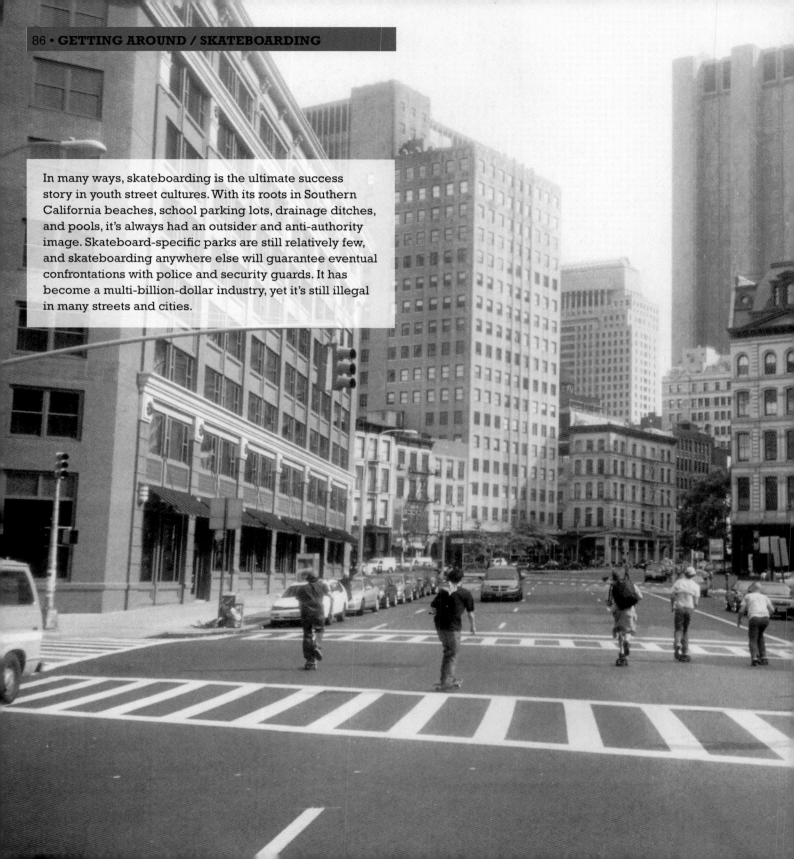

In many ways, skateboarding is the ultimate success story in youth street cultures. With its roots in Southern California beaches, school parking lots, drainage ditches, and pools, it's always had an outsider and anti-authority image. Skateboard-specific parks are still relatively few, and skateboarding anywhere else will guarantee eventual confrontations with police and security guards. It has become a multi-billion-dollar industry, yet it's still illegal in many streets and cities.

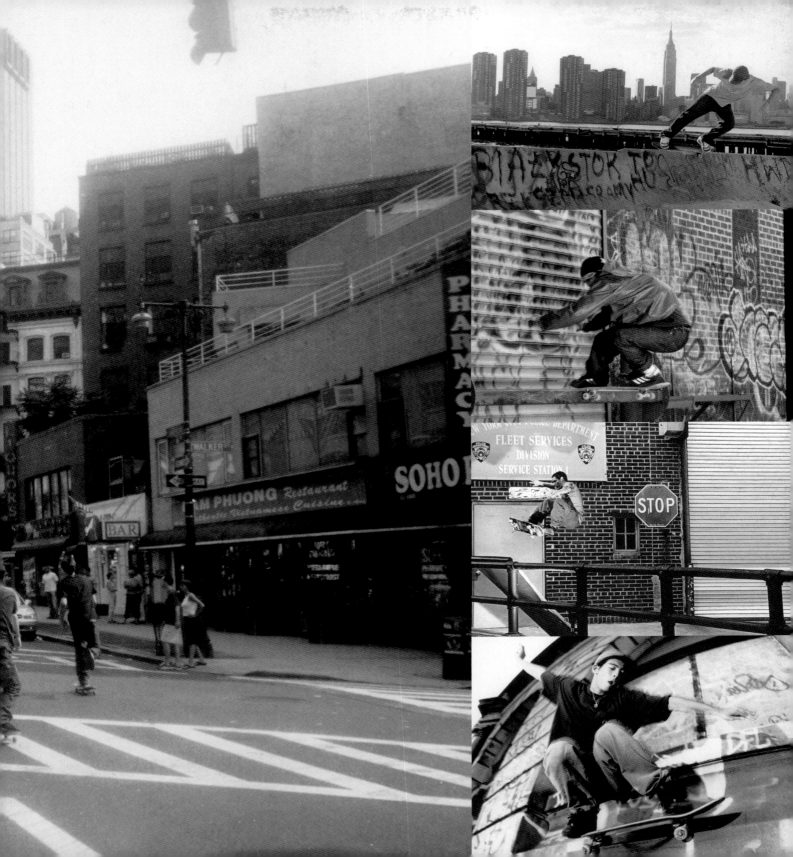

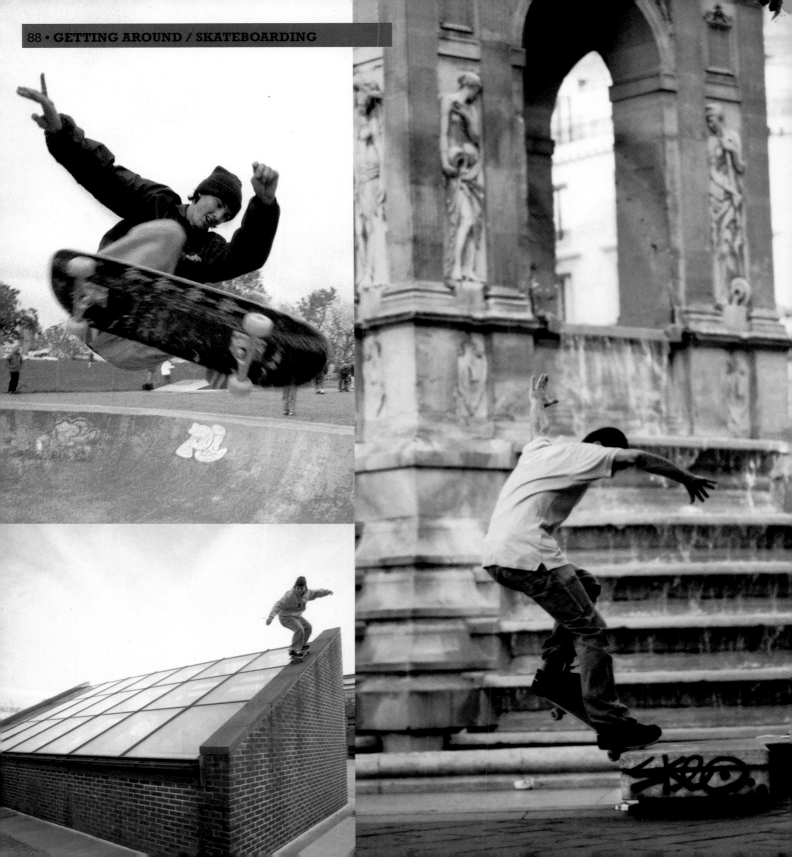

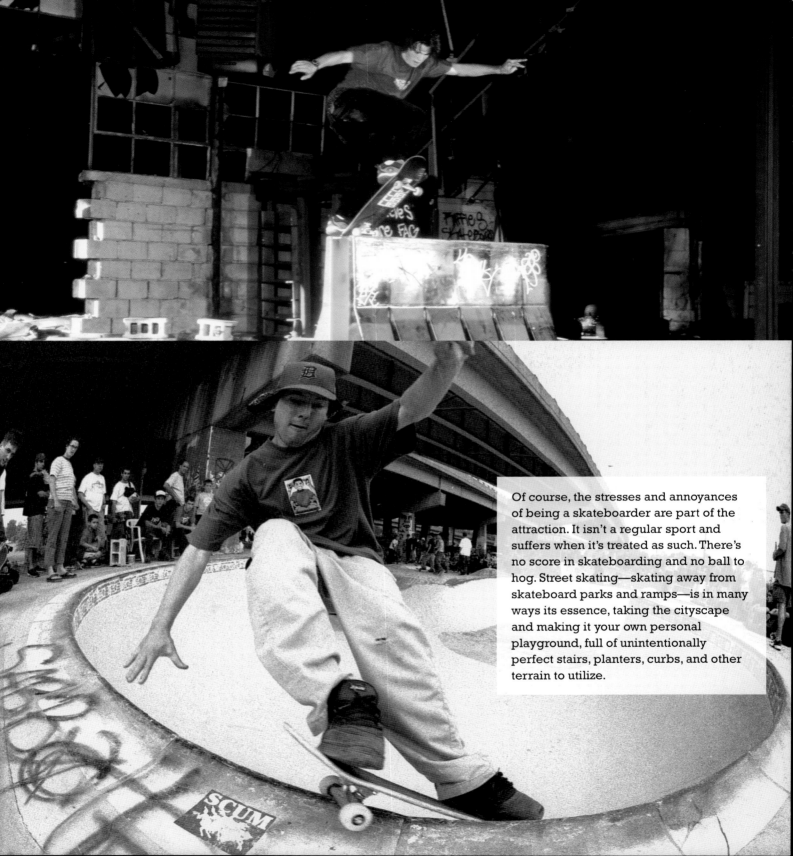

Of course, the stresses and annoyances of being a skateboarder are part of the attraction. It isn't a regular sport and suffers when it's treated as such. There's no score in skateboarding and no ball to hog. Street skating—skating away from skateboard parks and ramps—is in many ways its essence, taking the cityscape and making it your own personal playground, full of unintentionally perfect stairs, planters, curbs, and other terrain to utilize.

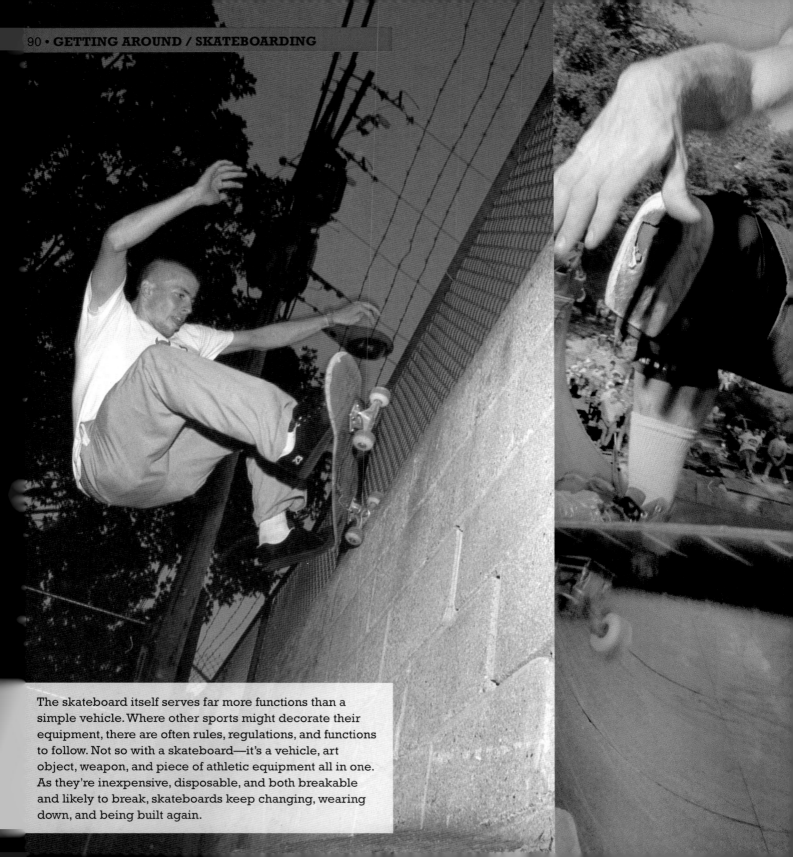

The skateboard itself serves far more functions than a simple vehicle. Where other sports might decorate their equipment, there are often rules, regulations, and functions to follow. Not so with a skateboard—it's a vehicle, art object, weapon, and piece of athletic equipment all in one. As they're inexpensive, disposable, and both breakable and likely to break, skateboards keep changing, wearing down, and being built again.

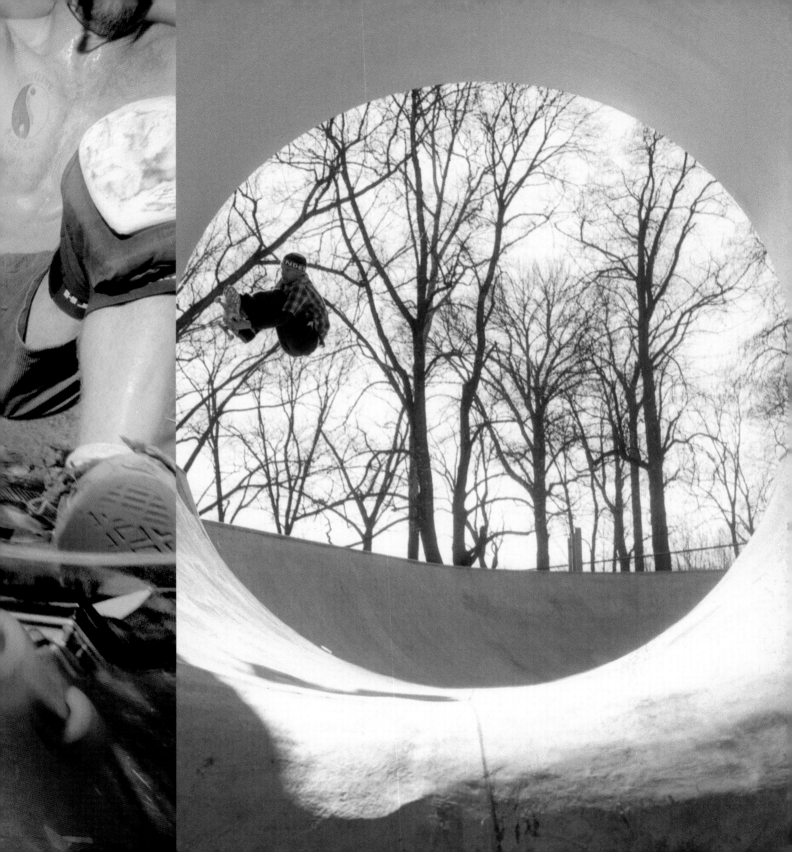

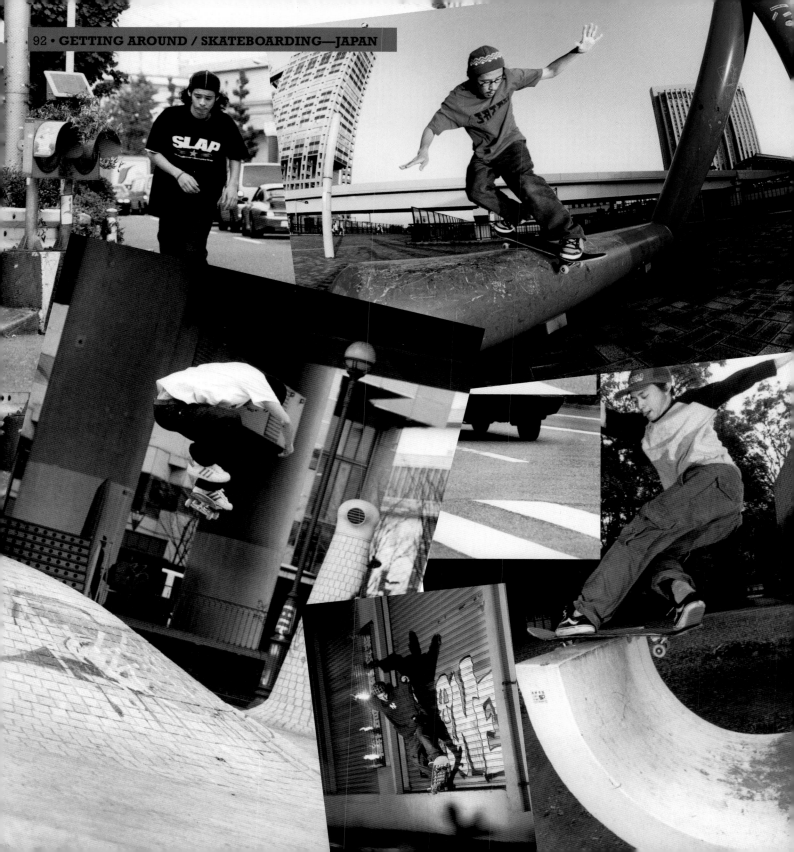

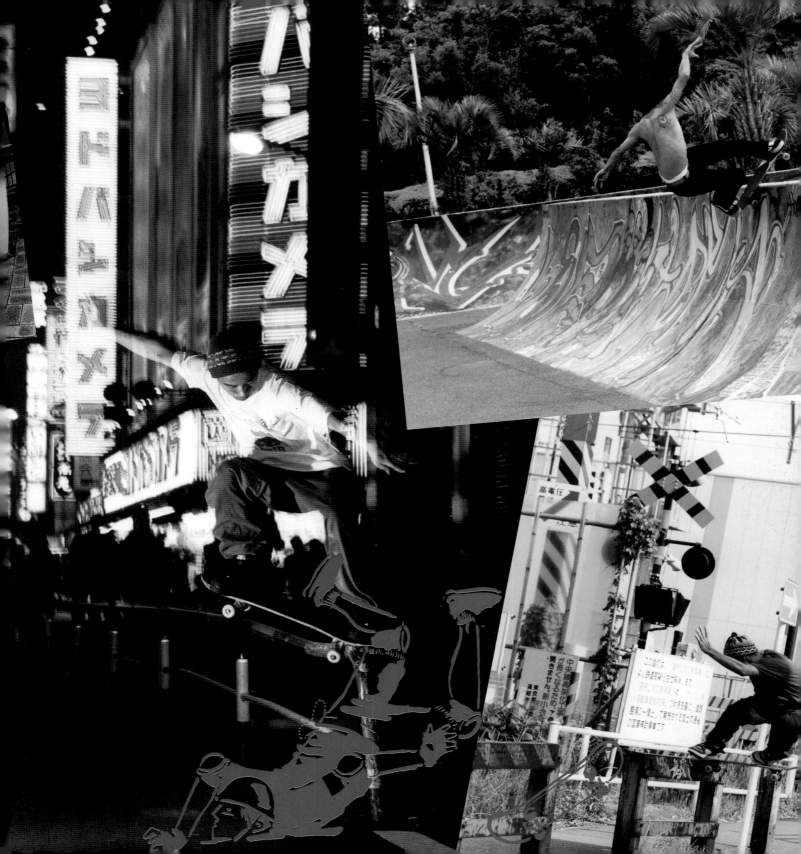

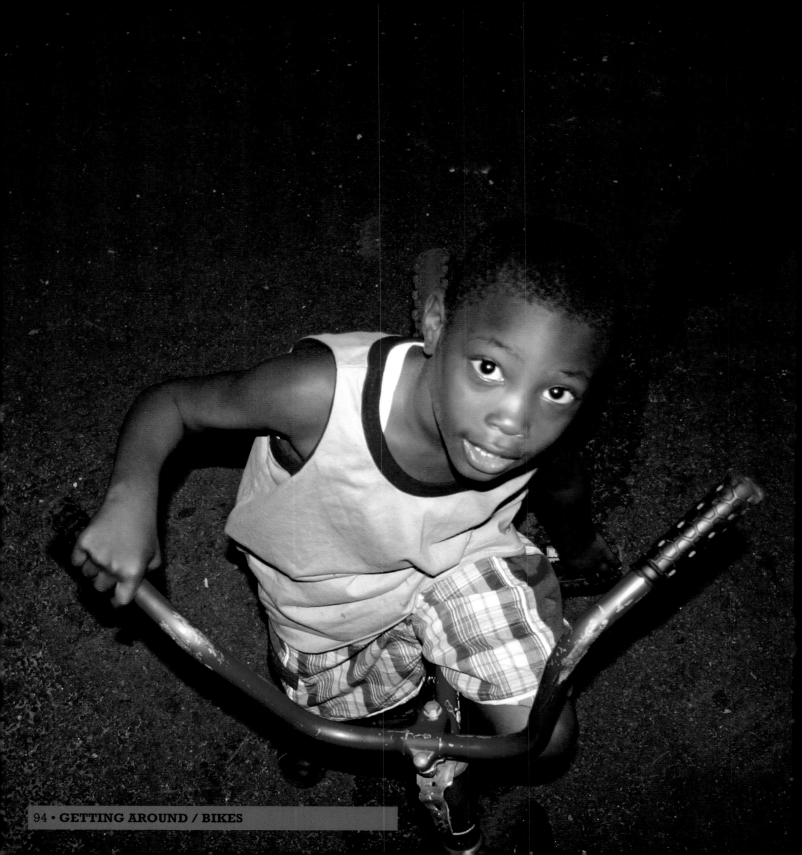

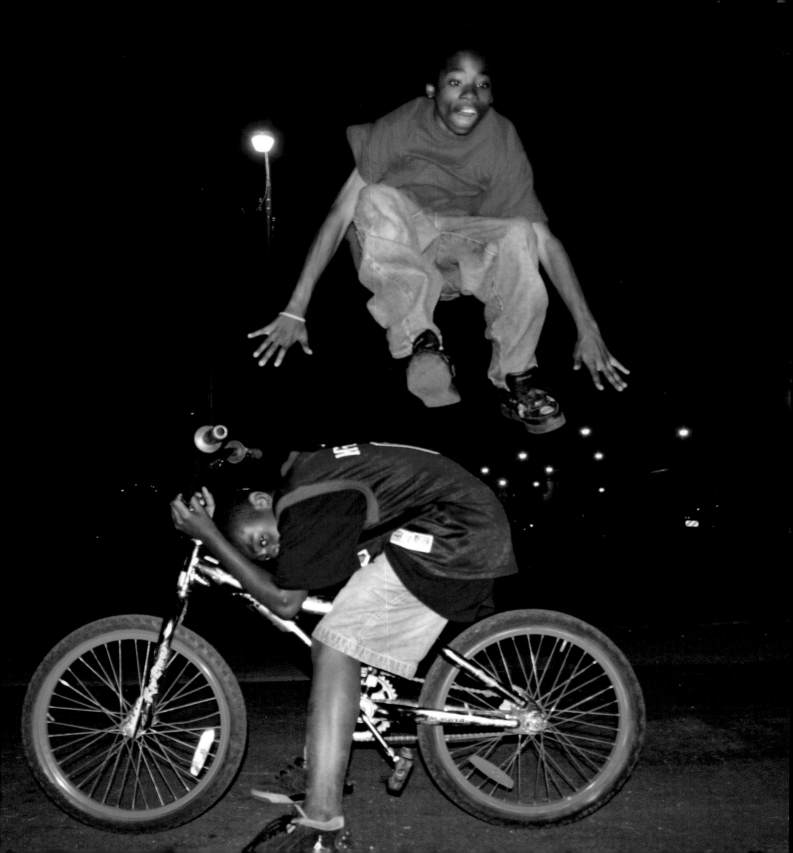

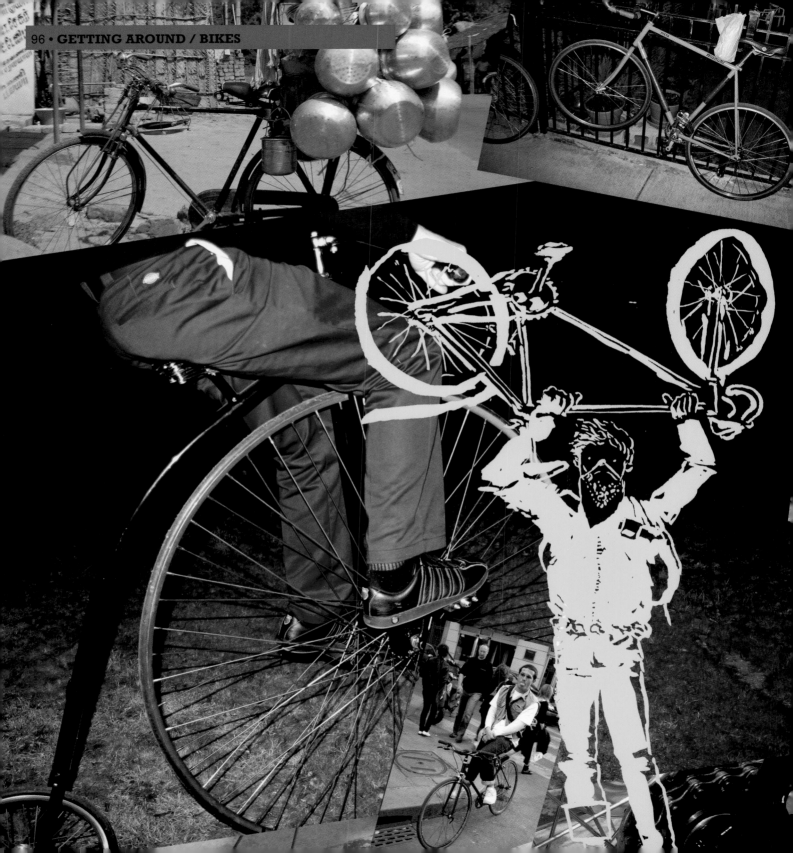

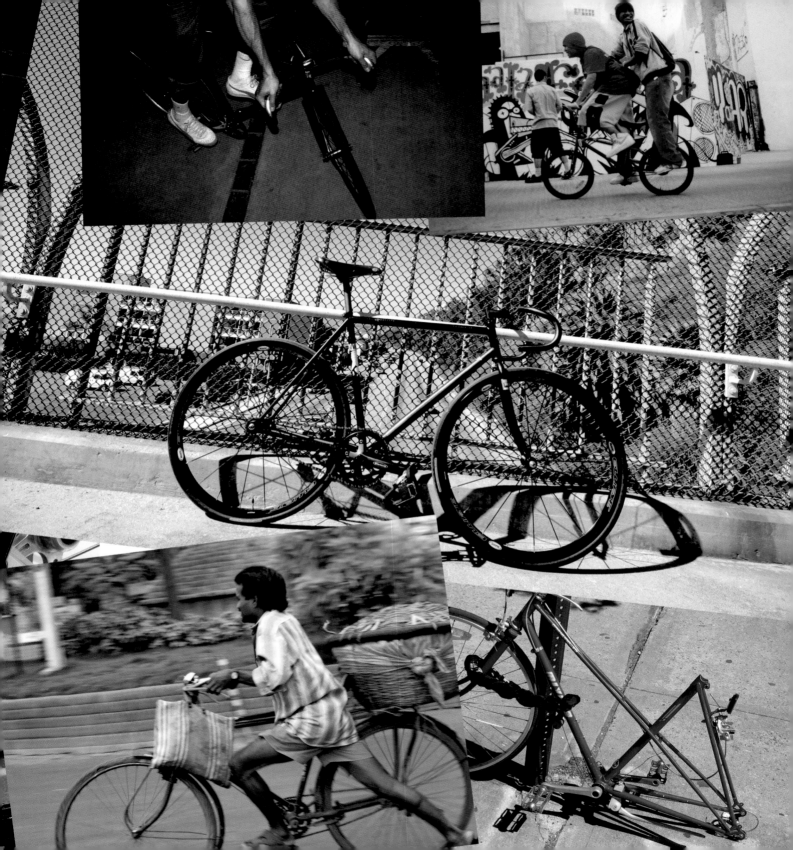

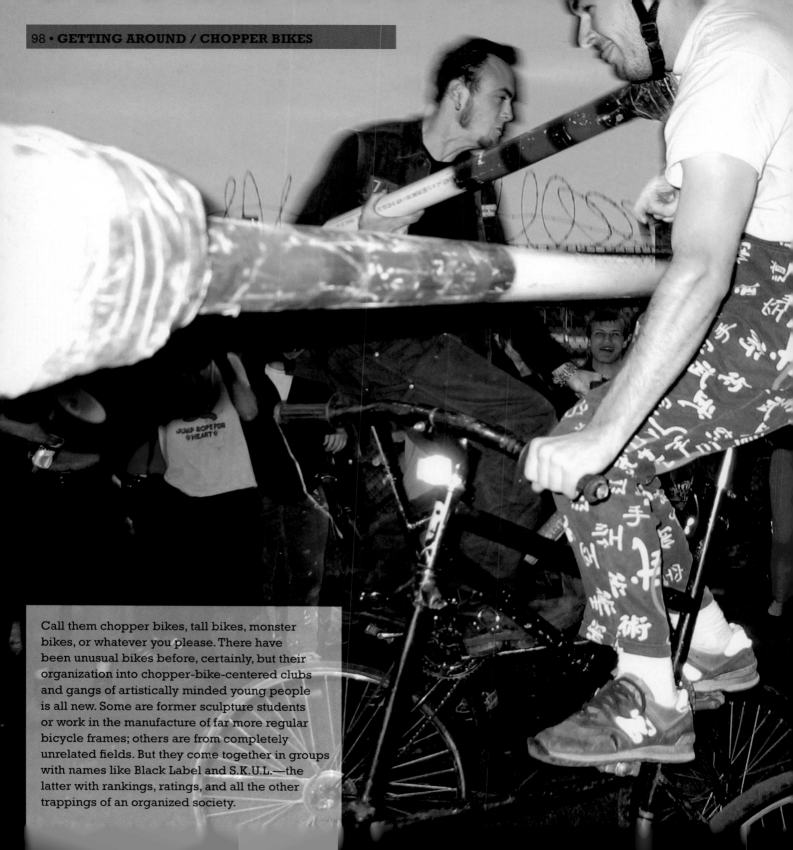

Call them chopper bikes, tall bikes, monster bikes, or whatever you please. There have been unusual bikes before, certainly, but their organization into chopper-bike-centered clubs and gangs of artistically minded young people is all new. Some are former sculpture students or work in the manufacture of far more regular bicycle frames; others are from completely unrelated fields. But they come together in groups with names like Black Label and S.K.U.L.—the latter with rankings, ratings, and all the other trappings of an organized society.

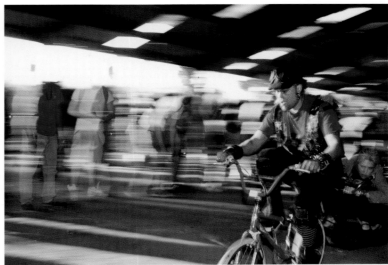
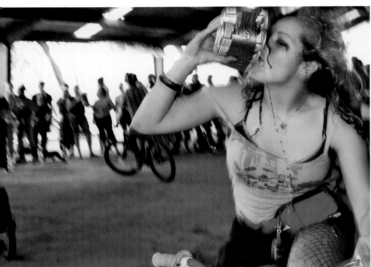
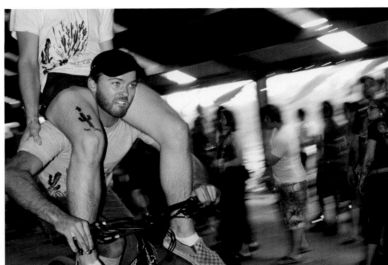
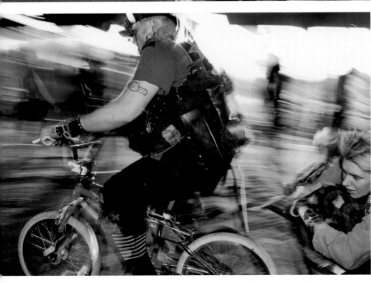

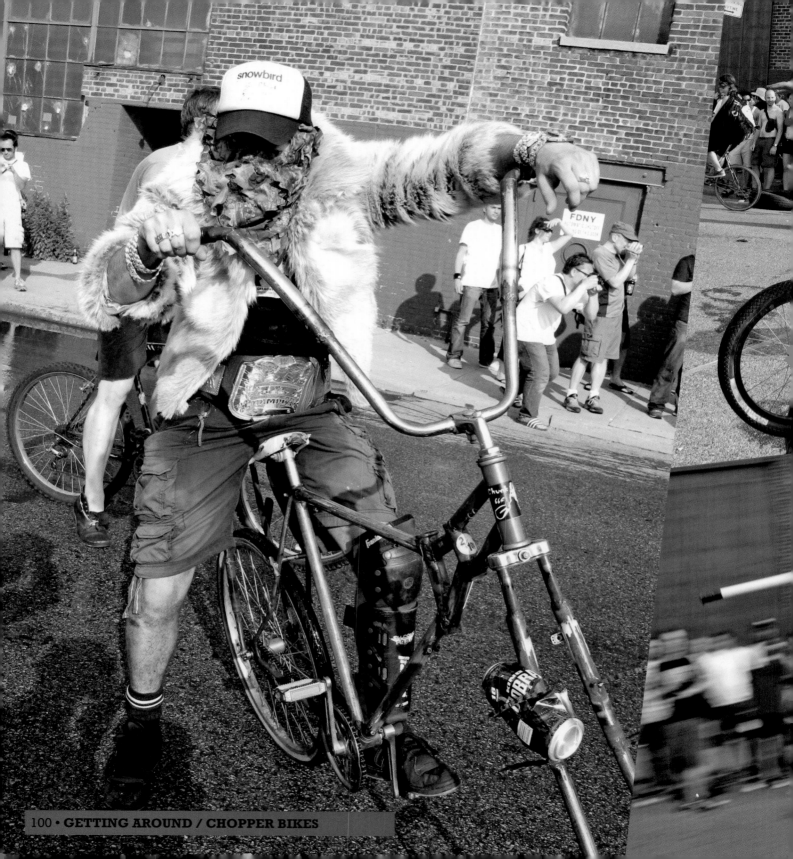

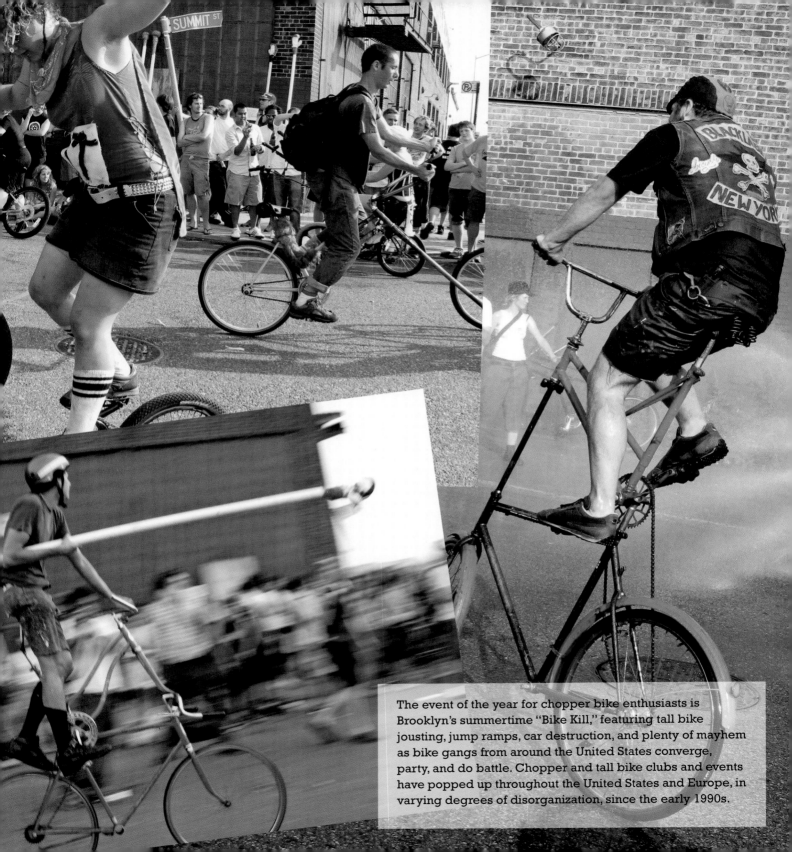

The event of the year for chopper bike enthusiasts is Brooklyn's summertime "Bike Kill," featuring tall bike jousting, jump ramps, car destruction, and plenty of mayhem as bike gangs from around the United States converge, party, and do battle. Chopper and tall bike clubs and events have popped up throughout the United States and Europe, in varying degrees of disorganization, since the early 1990s.

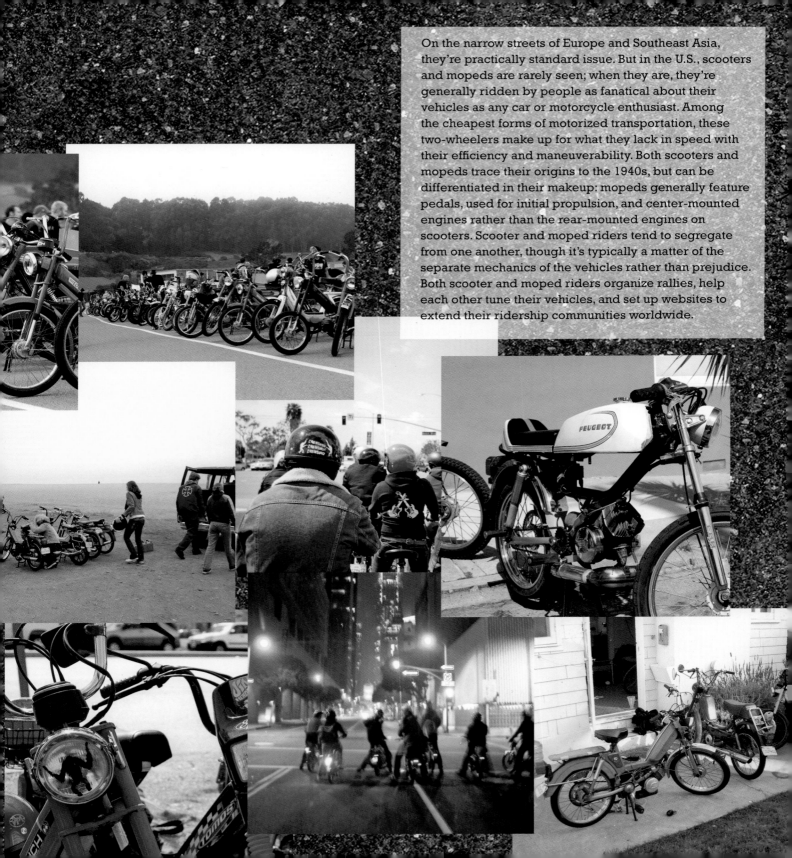

On the narrow streets of Europe and Southeast Asia, they're practically standard issue. But in the U.S., scooters and mopeds are rarely seen; when they are, they're generally ridden by people as fanatical about their vehicles as any car or motorcycle enthusiast. Among the cheapest forms of motorized transportation, these two-wheelers make up for what they lack in speed with their efficiency and maneuverability. Both scooters and mopeds trace their origins to the 1940s, but can be differentiated in their makeup: mopeds generally feature pedals, used for initial propulsion, and center-mounted engines rather than the rear-mounted engines on scooters. Scooter and moped riders tend to segregate from one another, though it's typically a matter of the separate mechanics of the vehicles rather than prejudice. Both scooter and moped riders organize rallies, help each other tune their vehicles, and set up websites to extend their ridership communities worldwide.

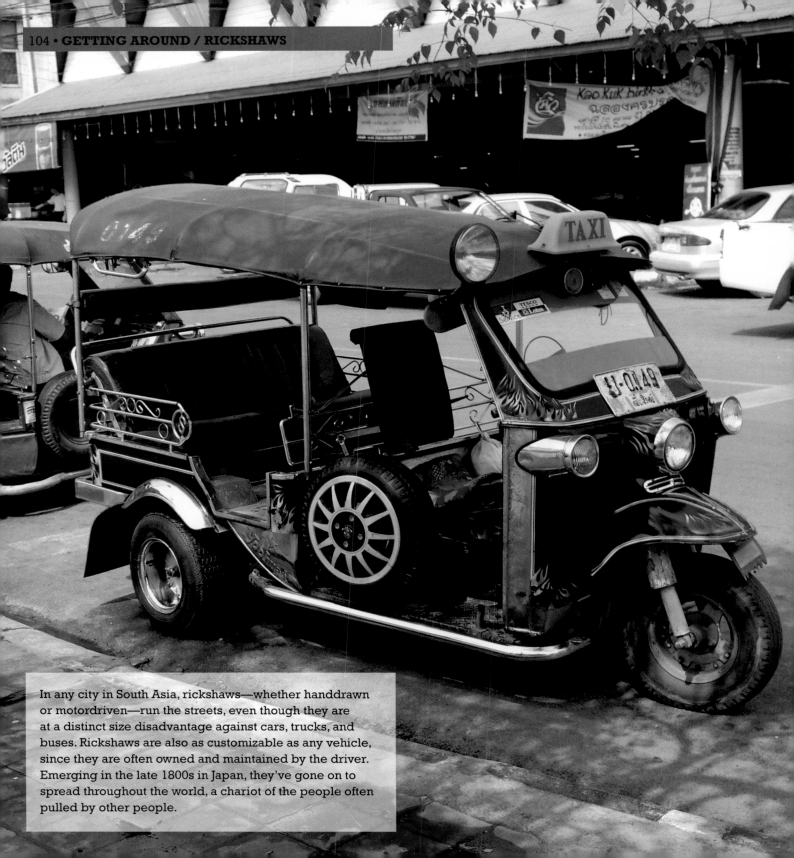

In any city in South Asia, rickshaws—whether handdrawn or motordriven—run the streets, even though they are at a distinct size disadvantage against cars, trucks, and buses. Rickshaws are also as customizable as any vehicle, since they are often owned and maintained by the driver. Emerging in the late 1800s in Japan, they've gone on to spread throughout the world, a chariot of the people often pulled by other people.

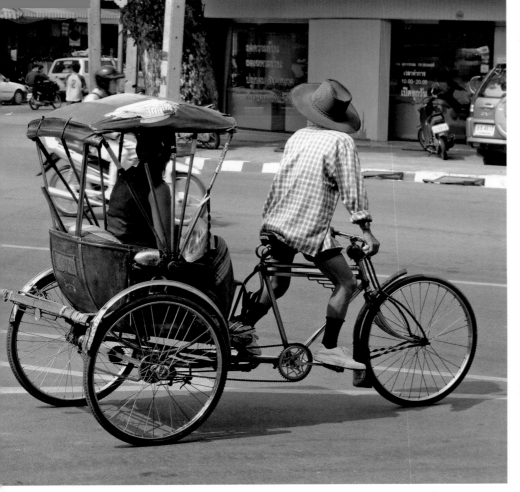
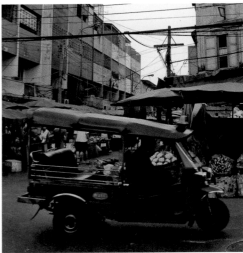

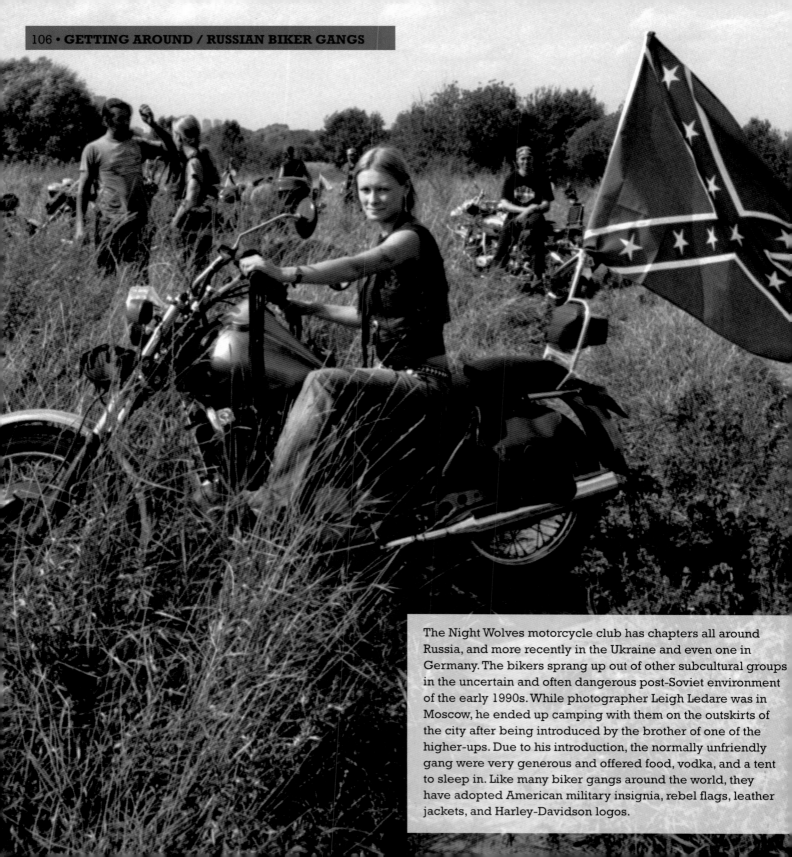

The Night Wolves motorcycle club has chapters all around Russia, and more recently in the Ukraine and even one in Germany. The bikers sprang up out of other subcultural groups in the uncertain and often dangerous post-Soviet environment of the early 1990s. While photographer Leigh Ledare was in Moscow, he ended up camping with them on the outskirts of the city after being introduced by the brother of one of the higher-ups. Due to his introduction, the normally unfriendly gang were very generous and offered food, vodka, and a tent to sleep in. Like many biker gangs around the world, they have adopted American military insignia, rebel flags, leather jackets, and Harley-Davidson logos.

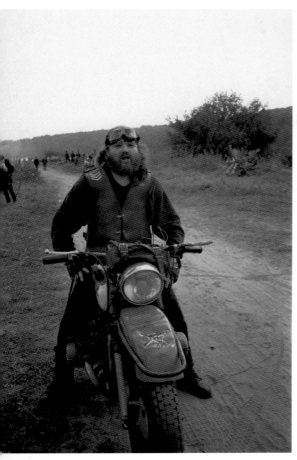

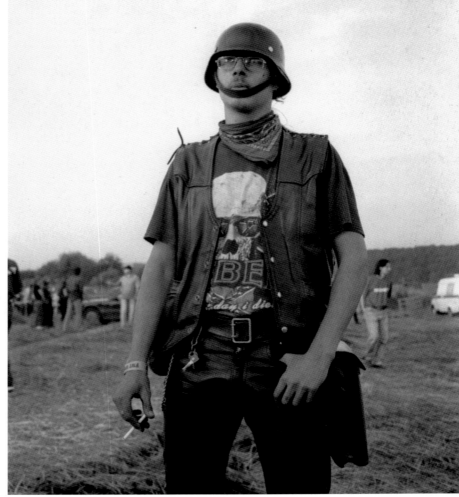

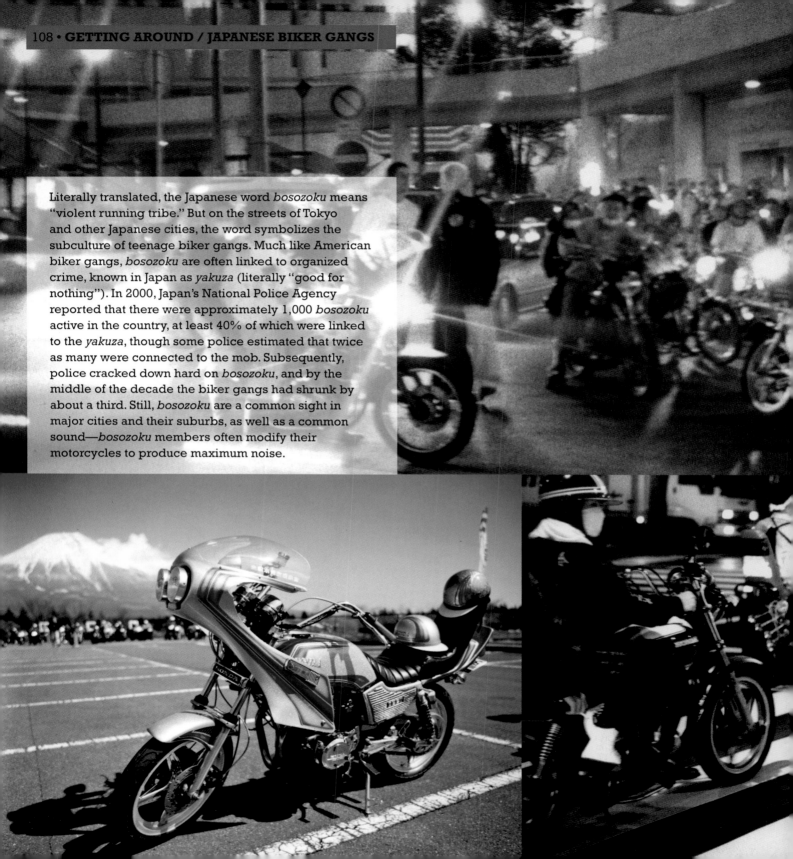

Literally translated, the Japanese word *bosozoku* means "violent running tribe." But on the streets of Tokyo and other Japanese cities, the word symbolizes the subculture of teenage biker gangs. Much like American biker gangs, *bosozoku* are often linked to organized crime, known in Japan as *yakuza* (literally "good for nothing"). In 2000, Japan's National Police Agency reported that there were approximately 1,000 *bosozoku* active in the country, at least 40% of which were linked to the *yakuza*, though some police estimated that twice as many were connected to the mob. Subsequently, police cracked down hard on *bosozoku*, and by the middle of the decade the biker gangs had shrunk by about a third. Still, *bosozoku* are a common sight in major cities and their suburbs, as well as a common sound—*bosozoku* members often modify their motorcycles to produce maximum noise.

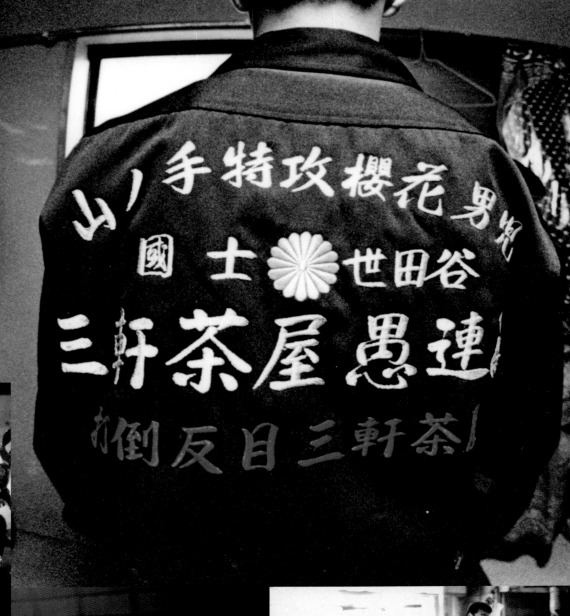

If a city's citizens are its lifeblood, public transportation makes up its veins and arteries, moving people quickly and efficiently. Buses are always buses wherever you go, from the city to the countryside, but subways always represent the identity of a true urban area. Many cities boast subway stations that are architecturally unique, and are rarely referred to simply as "the subway." In many cities such as Paris, Los Angeles, and Washington, DC, they call it the Metro; in London, it's the Tube; in Chicago, it's the El; in New York, it's simply the train. Whatever it's called, the subway system is the heart of a city, where people truly interact with the urban environment as well as each other.

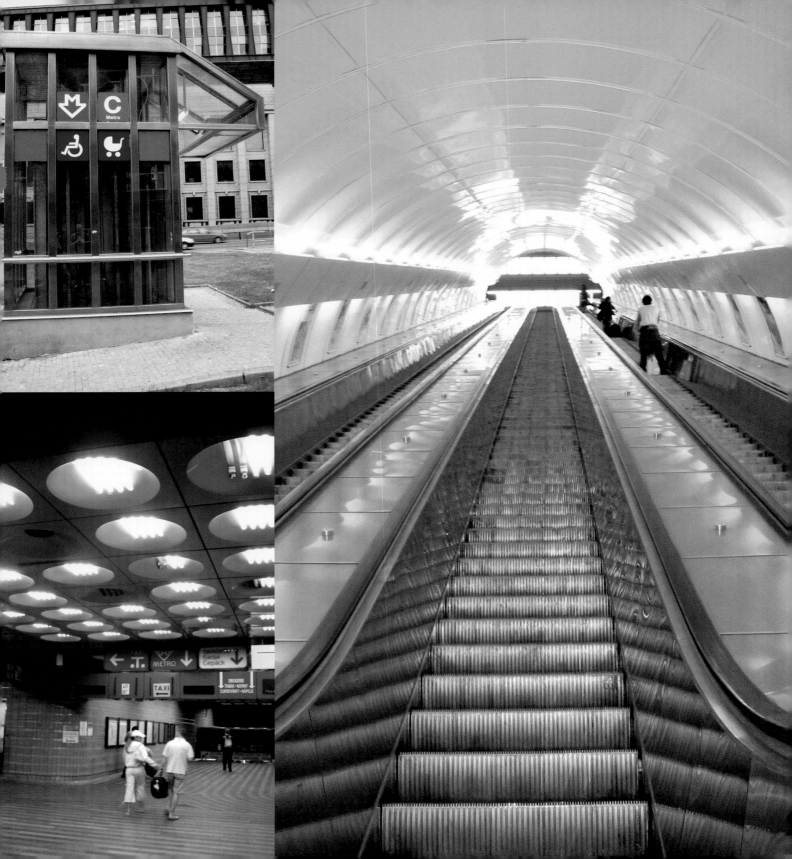

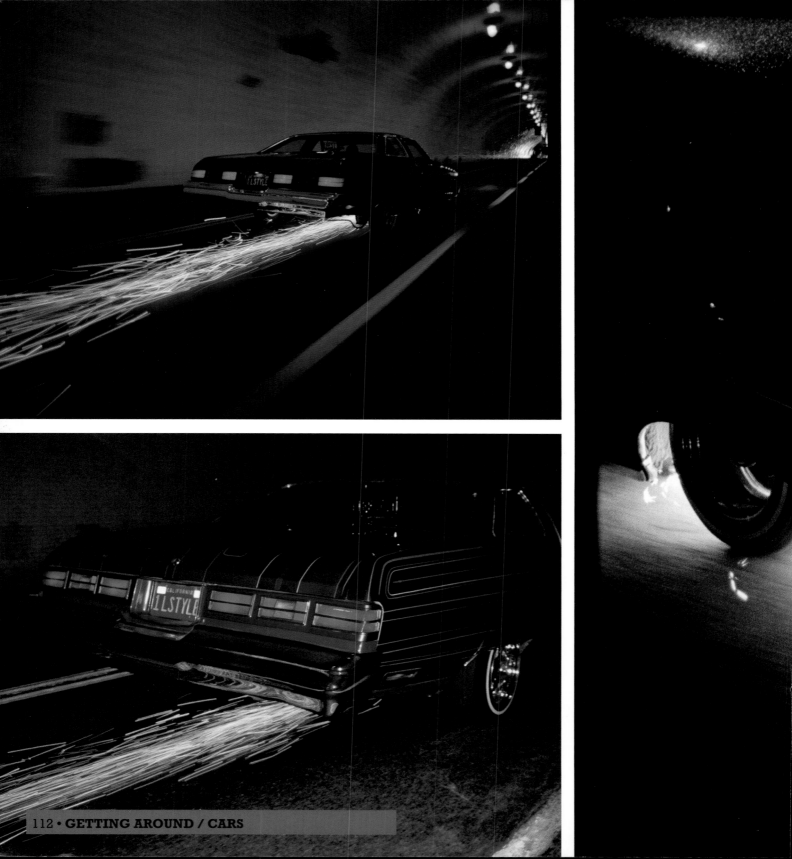

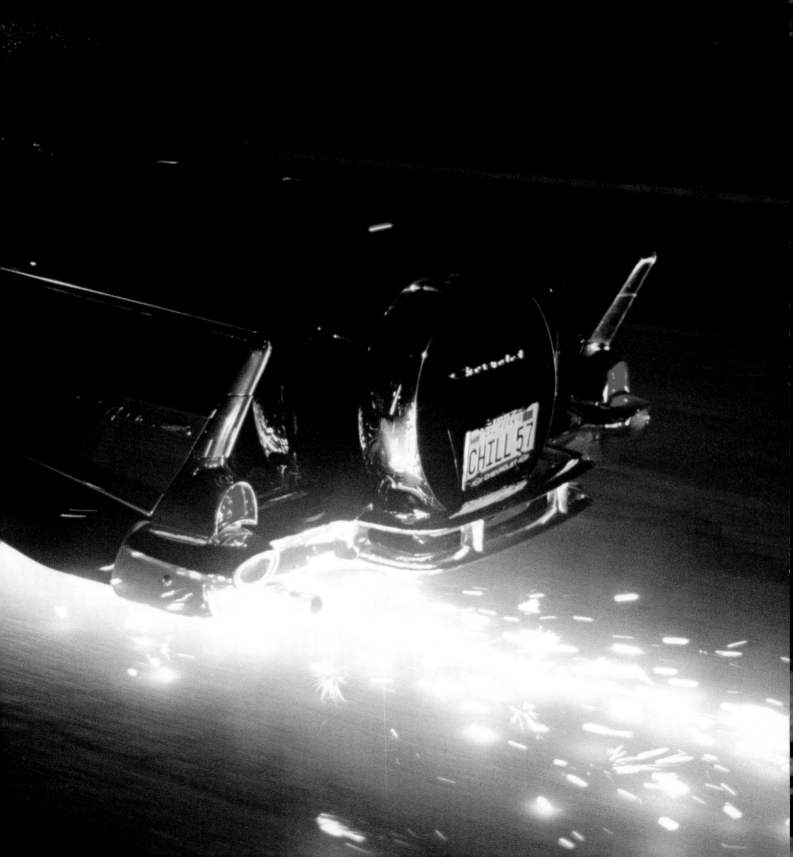

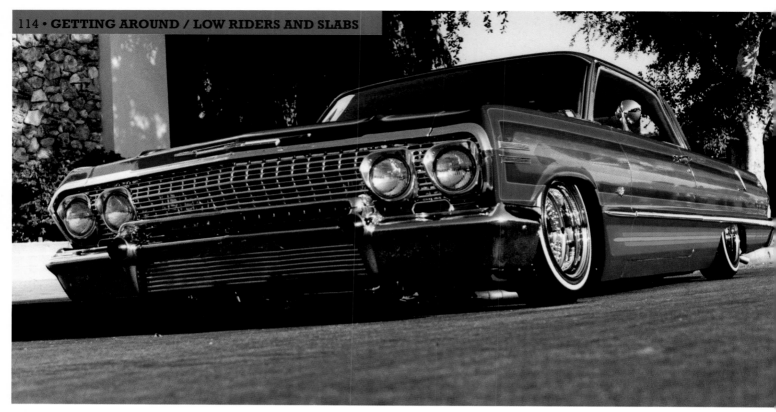

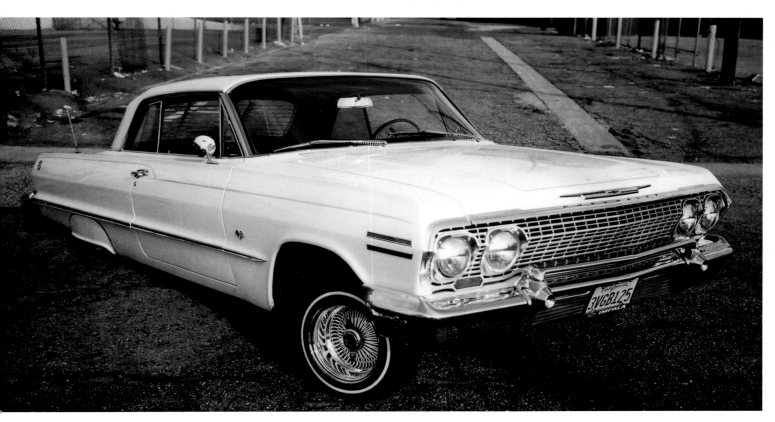

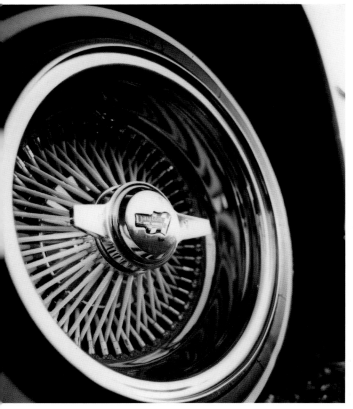

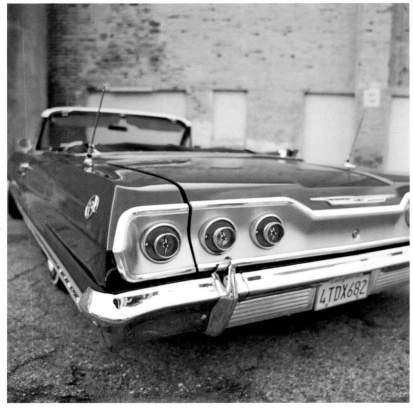

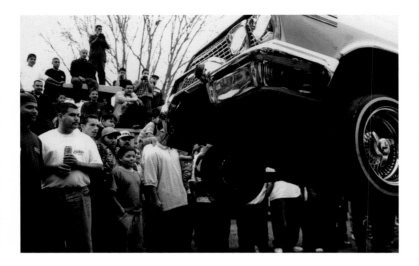

With customization taking over every detail and suspension systems adjusted to turn cars into bouncing rabbits, low riders have been a fixture of Chicano and Latino culture for decades. Adding in driver-controlled hydraulic suspensions can allow for the raising, lowering, and bouncing of any corner or side of the car in an act known as hitting or flipping switches. As far as the cost, the sky is the limit, with custom upholstery, wheels, engine, paint job, and sound system being just a few of the more tempting options.

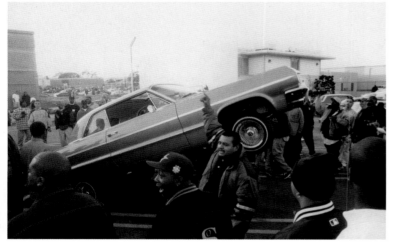

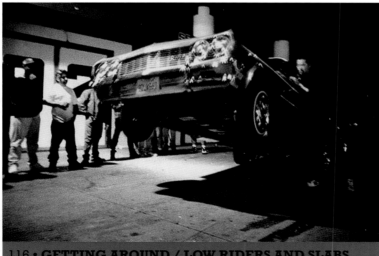

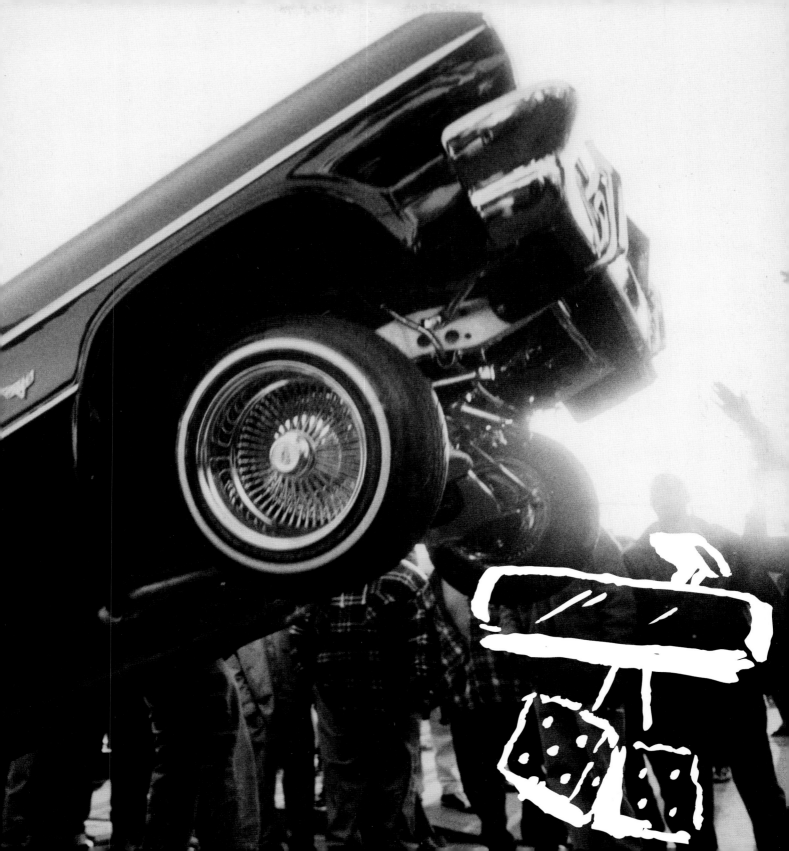

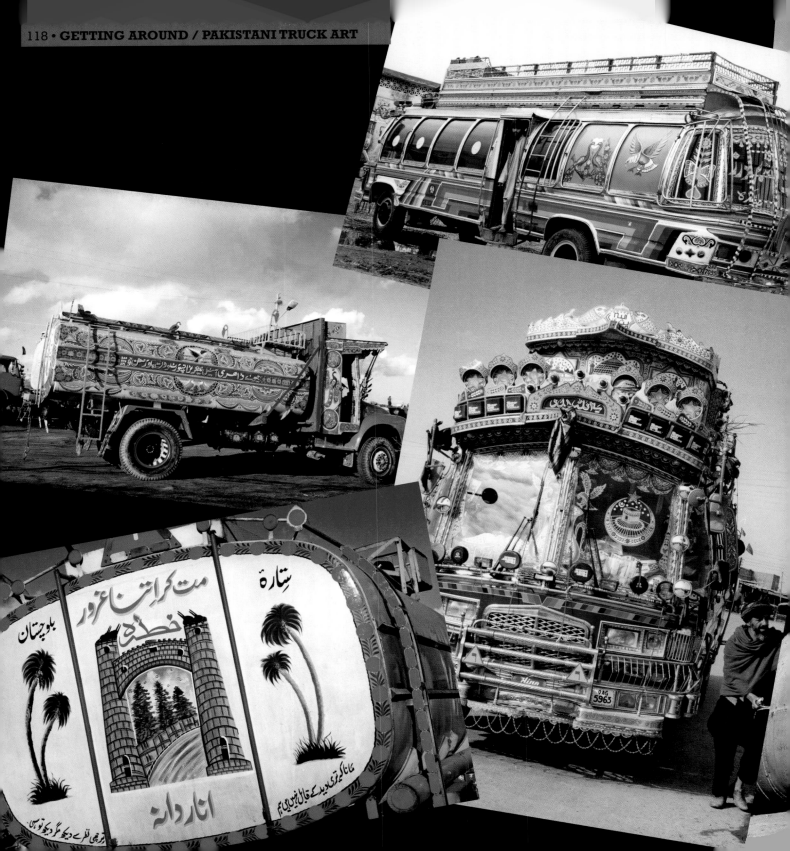

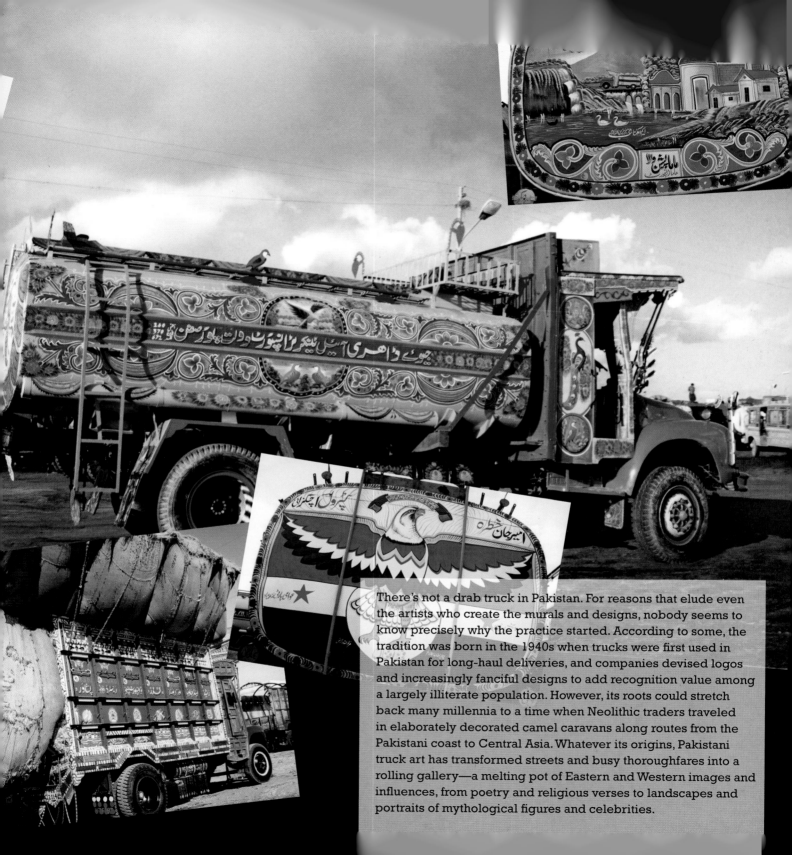

There's not a drab truck in Pakistan. For reasons that elude even the artists who create the murals and designs, nobody seems to know precisely why the practice started. According to some, the tradition was born in the 1940s when trucks were first used in Pakistan for long-haul deliveries, and companies devised logos and increasingly fanciful designs to add recognition value among a largely illiterate population. However, its roots could stretch back many millennia to a time when Neolithic traders traveled in elaborately decorated camel caravans along routes from the Pakistani coast to Central Asia. Whatever its origins, Pakistani truck art has transformed streets and busy thoroughfares into a rolling gallery—a melting pot of Eastern and Western images and influences, from poetry and religious verses to landscapes and portraits of mythological figures and celebrities.

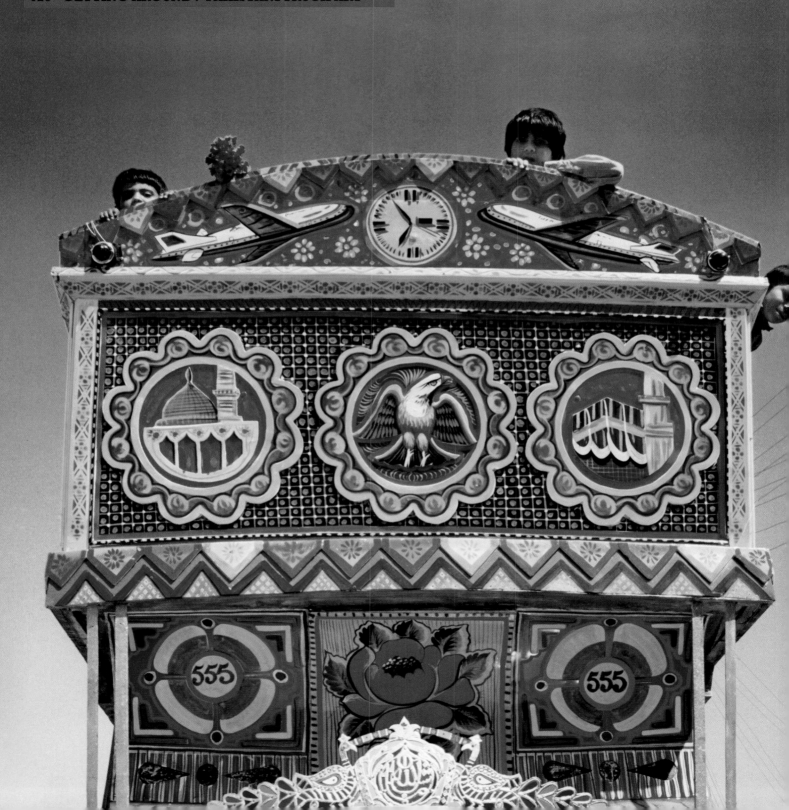

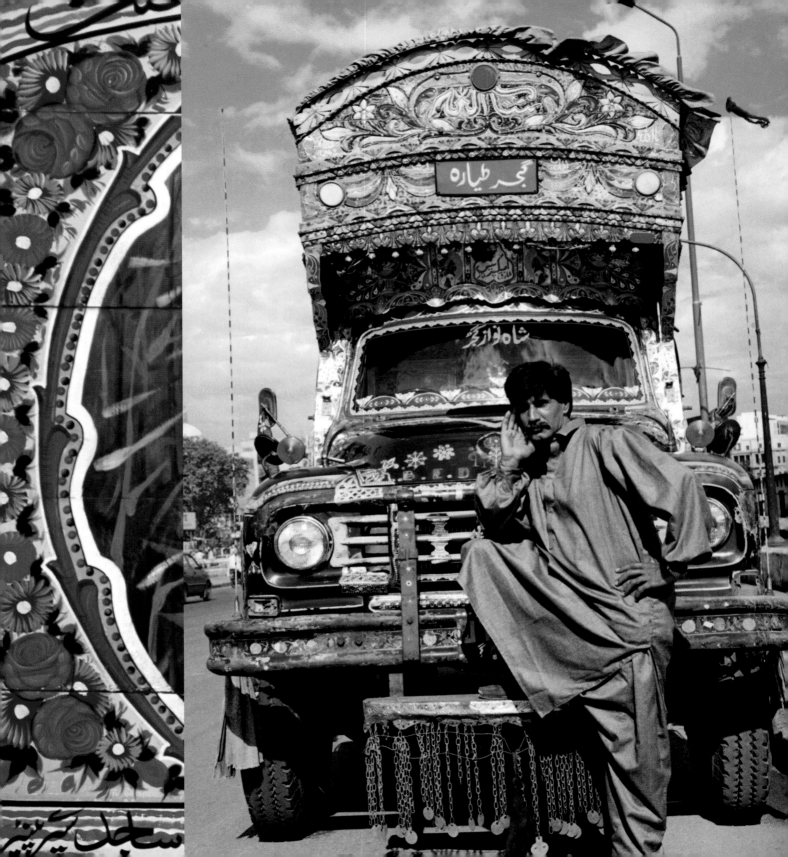

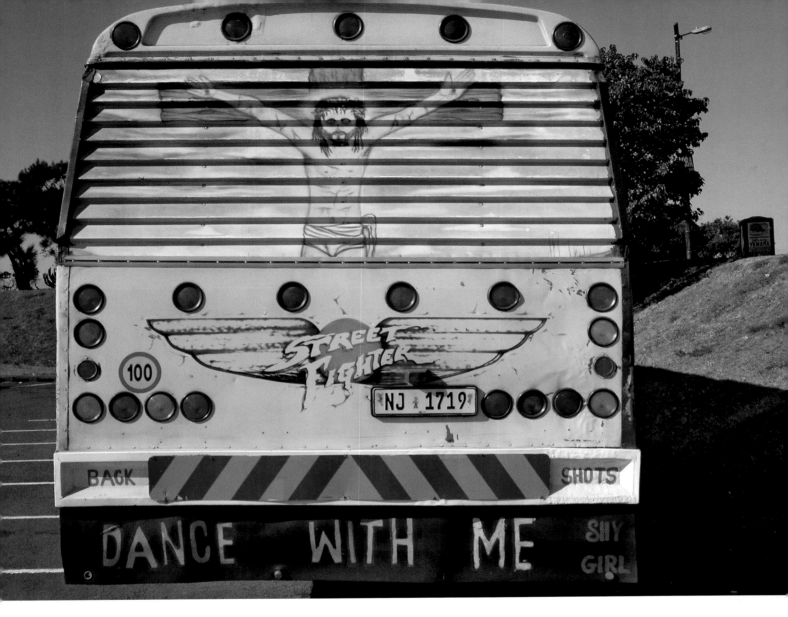

The buses in South Africa are far from the homogeneous and boring standard-issue shuttles of the public to be found in Western Europe and America. Rather, each tends to be painted at the direction of its driver and owner, with widely diverging, and often quite topical and current messages.

GETTING UP •

It's a reaction. Everywhere, there is advertising,
signage, and visual overload. The backlash began
with writing a stylish name all over the city, and
more than forty years later, graffiti and its siblings
in postering, street art, and murals make the streets
far more democratic, as everyone fights for space
and the attention of the public. Around the world,
a networked and loosely organized culture adds to
the visual chaos of the street, resulting in friendships,
court cases, and a whole lot of art.

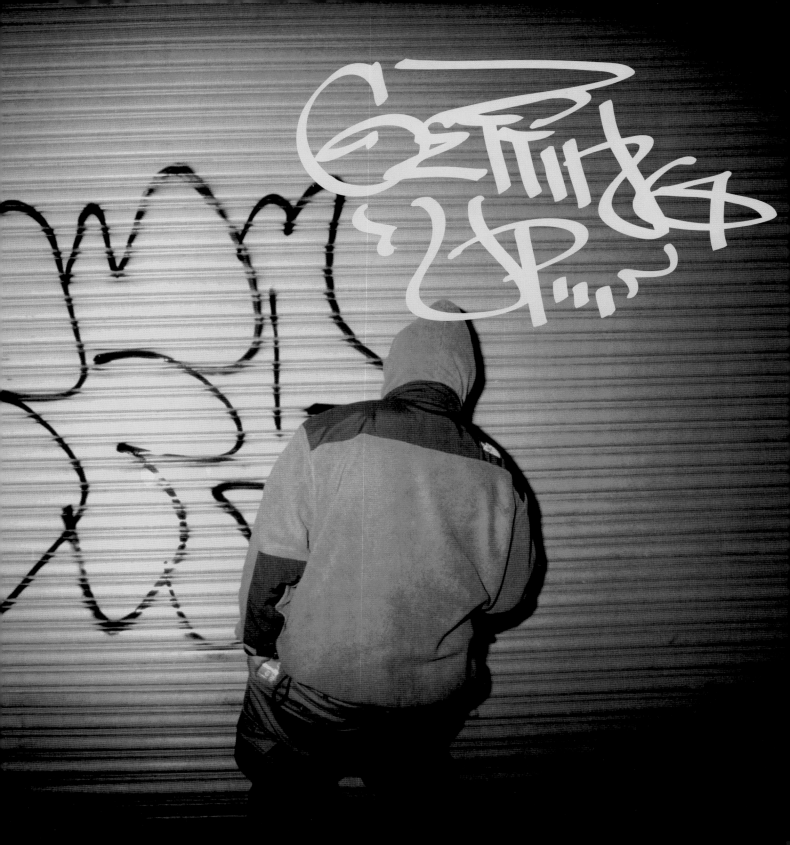

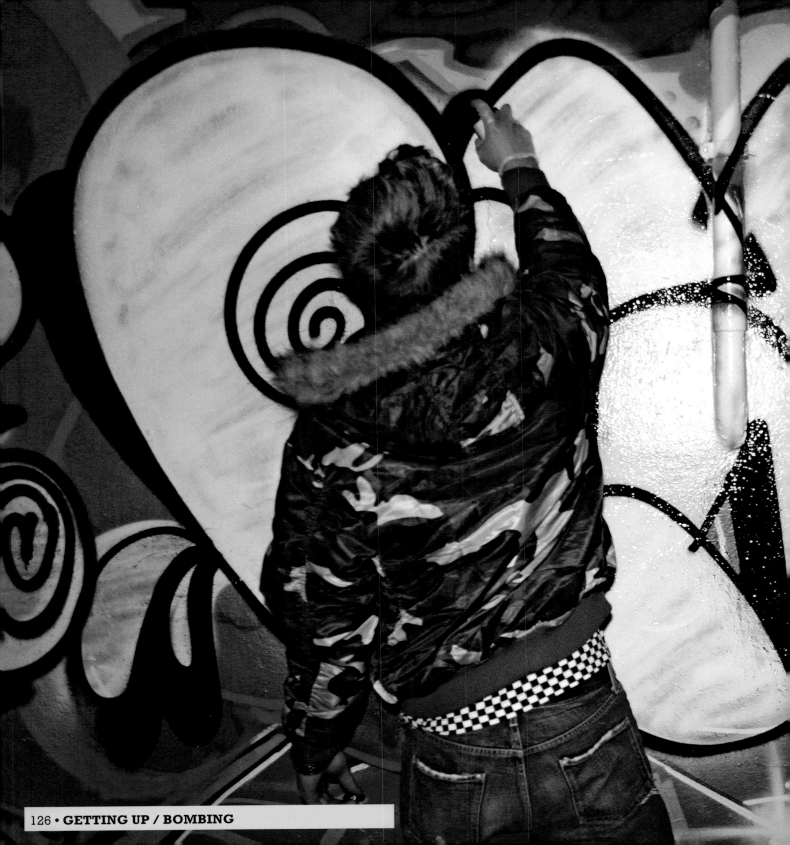

Graffiti is a continuum from the unabashedly ugly to the unavoidably beautiful. The grimy, dirty, dripping tag signature comes from the same hands as the enormous, multicolored mural. The throwup, landing between the two, combines speed, style, and size, and Pose, shown here, has a nice one. Bombing—the act of getting your name up illegally and irrespective of the pretense of making "art"—remains the core of graffiti. It's a duality that makes it impossible to dismiss the dripping tag as pure vandalism, and impossible to embrace the multicolored mural as entirely safe art. Art and crime in perfect harmony—graffiti wouldn't have it any other way.

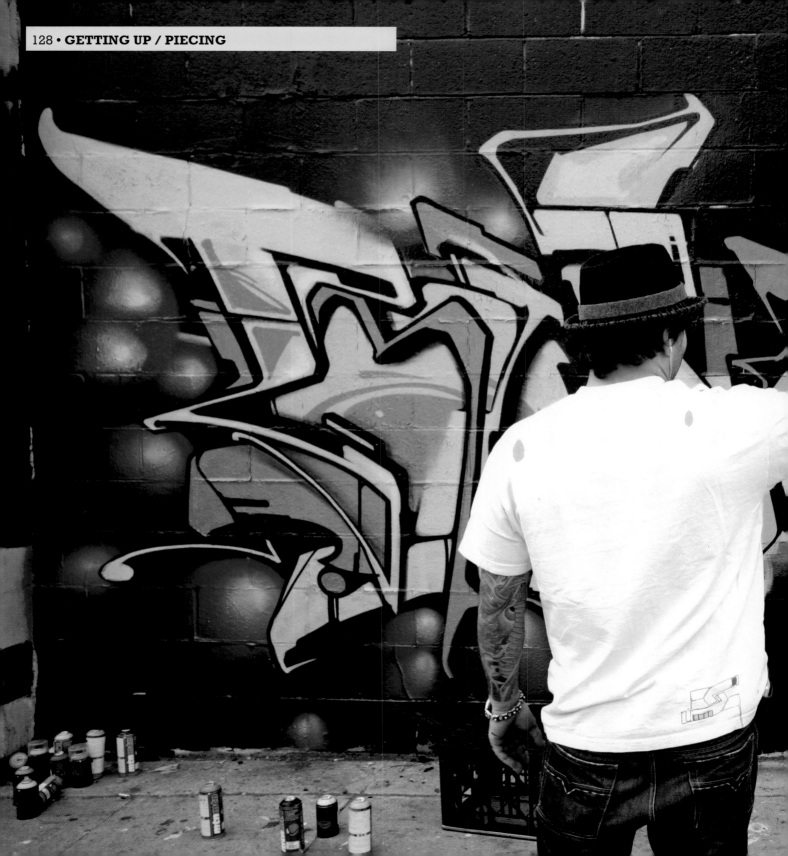

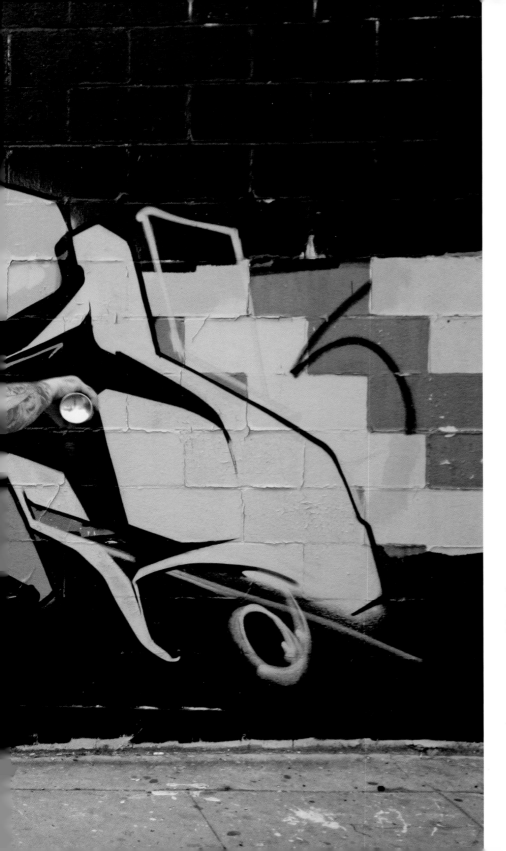

The artistic core of graffiti is the typographical design of the letter, and purists pay closest attention to it, with all of the colors, ornamentations, and embellishments simply aftermarket accessories. Still, its lettering is nowhere more developed, refined, and shown off than in a well-executed graffiti piece. A graffiti writer is generally expected to be proficient in lettering styles from simple to complex, and from large-scale, time-consuming work on down to the tag that takes seconds. Revok, shown here, is as good as they come at them all.

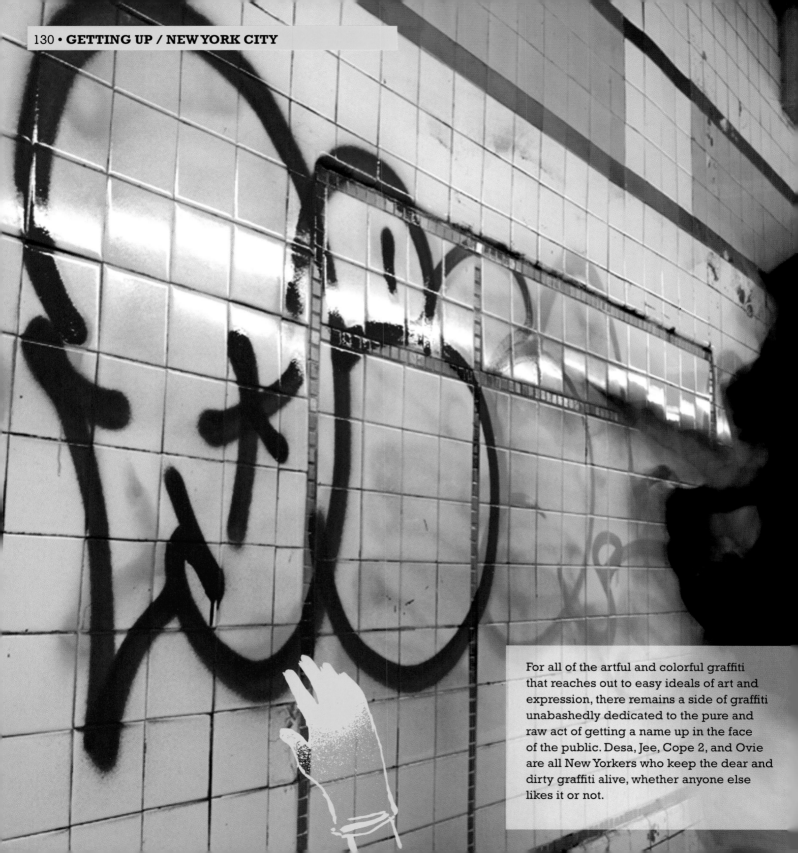

For all of the artful and colorful graffiti that reaches out to easy ideals of art and expression, there remains a side of graffiti unabashedly dedicated to the pure and raw act of getting a name up in the face of the public. Desa, Jee, Cope 2, and Ovie are all New Yorkers who keep the dear and dirty graffiti alive, whether anyone else likes it or not.

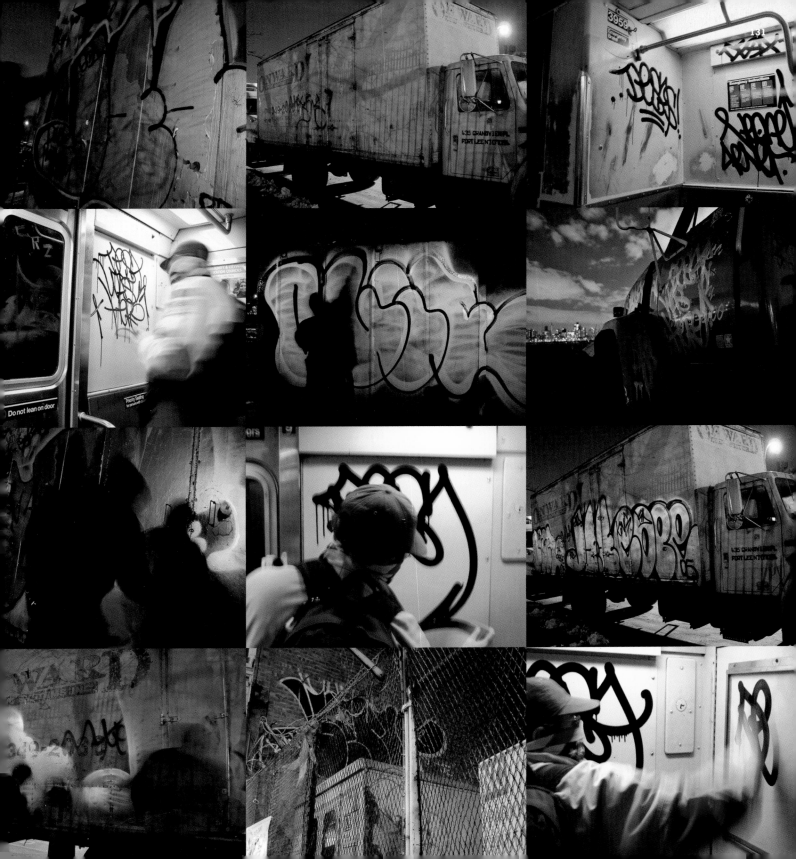

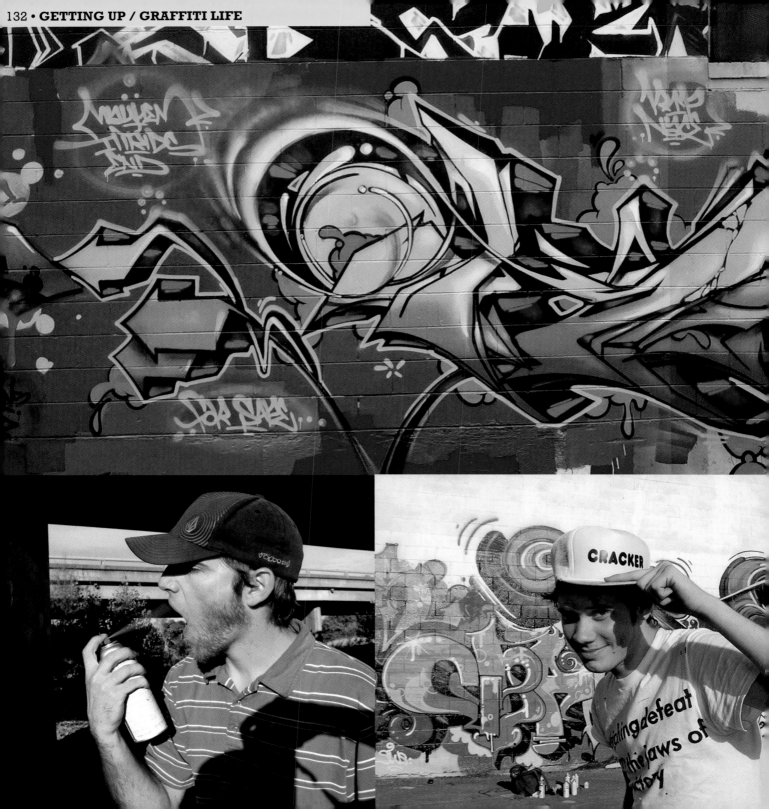

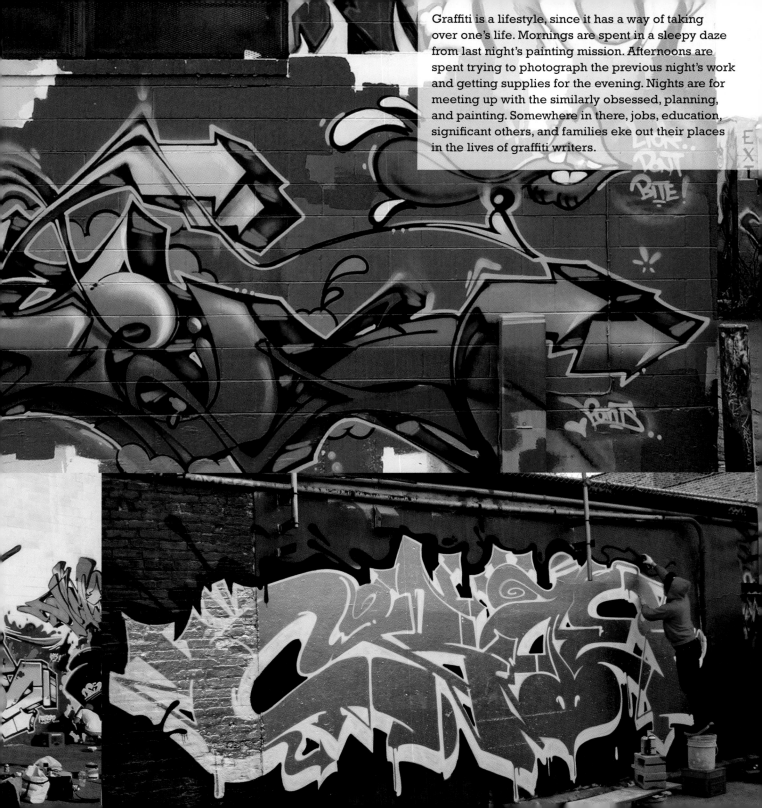

Graffiti is a lifestyle, since it has a way of taking over one's life. Mornings are spent in a sleepy daze from last night's painting mission. Afternoons are spent trying to photograph the previous night's work and getting supplies for the evening. Nights are for meeting up with the similarly obsessed, planning, and painting. Somewhere in there, jobs, education, significant others, and families eke out their places in the lives of graffiti writers.

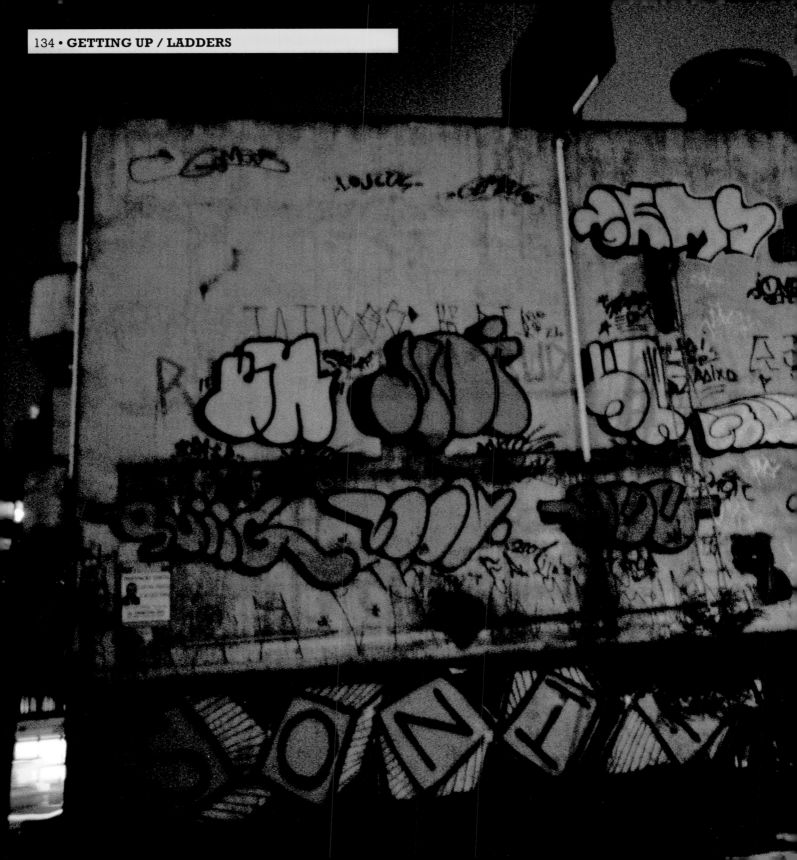

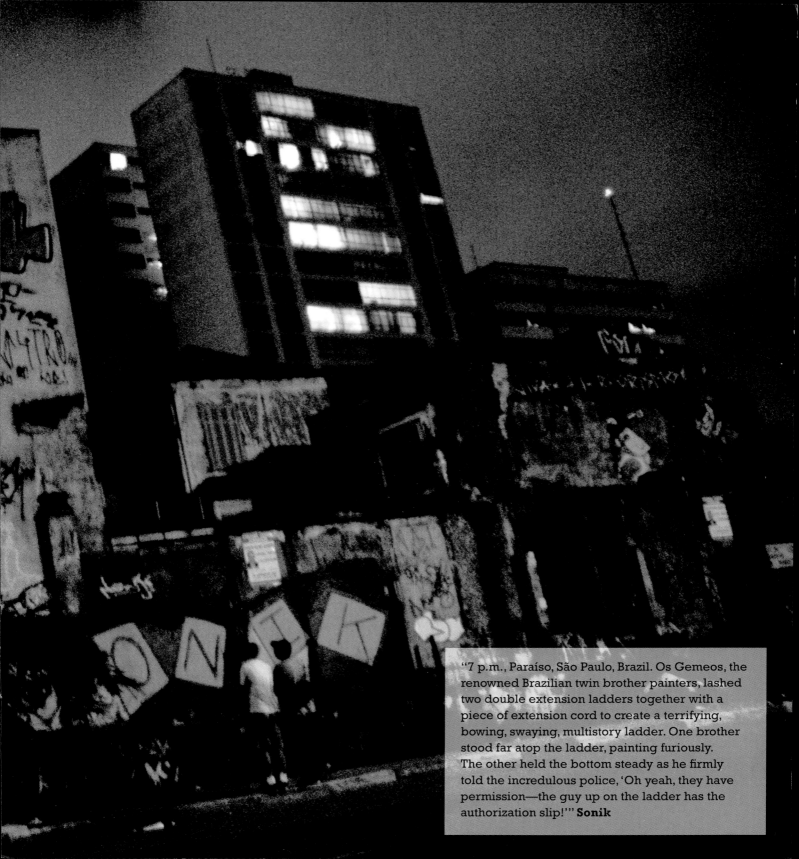

"7 p.m., Paraíso, São Paulo, Brazil. Os Gemeos, the renowned Brazilian twin brother painters, lashed two double extension ladders together with a piece of extension cord to create a terrifying, bowing, swaying, multistory ladder. One brother stood far atop the ladder, painting furiously. The other held the bottom steady as he firmly told the incredulous police, 'Oh yeah, they have permission—the guy up on the ladder has the authorization slip!'" **Sonik**

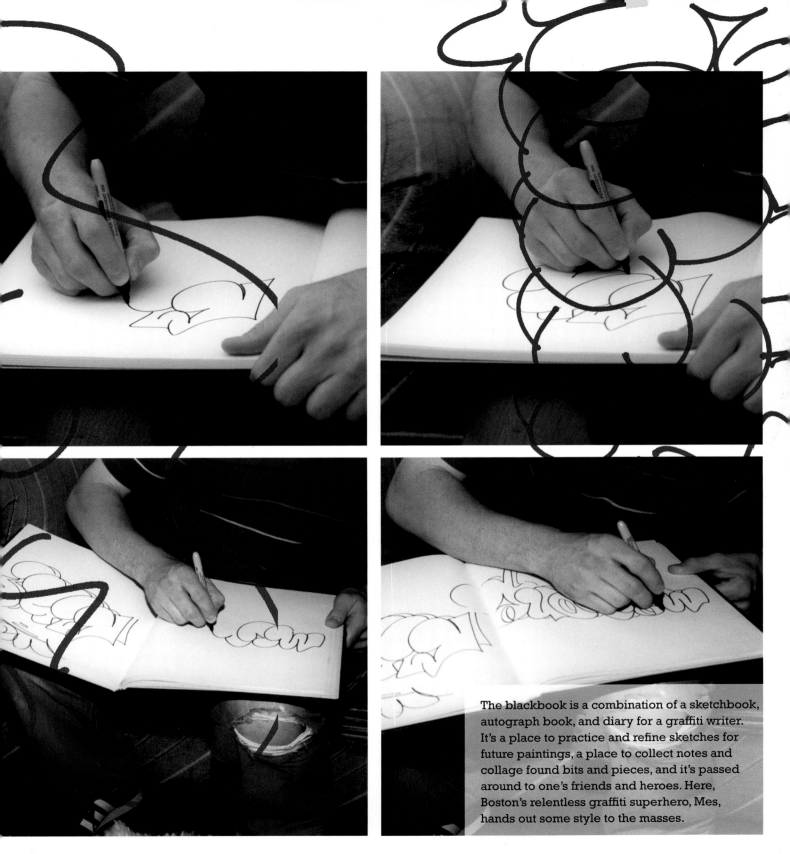

The blackbook is a combination of a sketchbook, autograph book, and diary for a graffiti writer. It's a place to practice and refine sketches for future paintings, a place to collect notes and collage found bits and pieces, and it's passed around to one's friends and heroes. Here, Boston's relentless graffiti superhero, Mes, hands out some style to the masses.

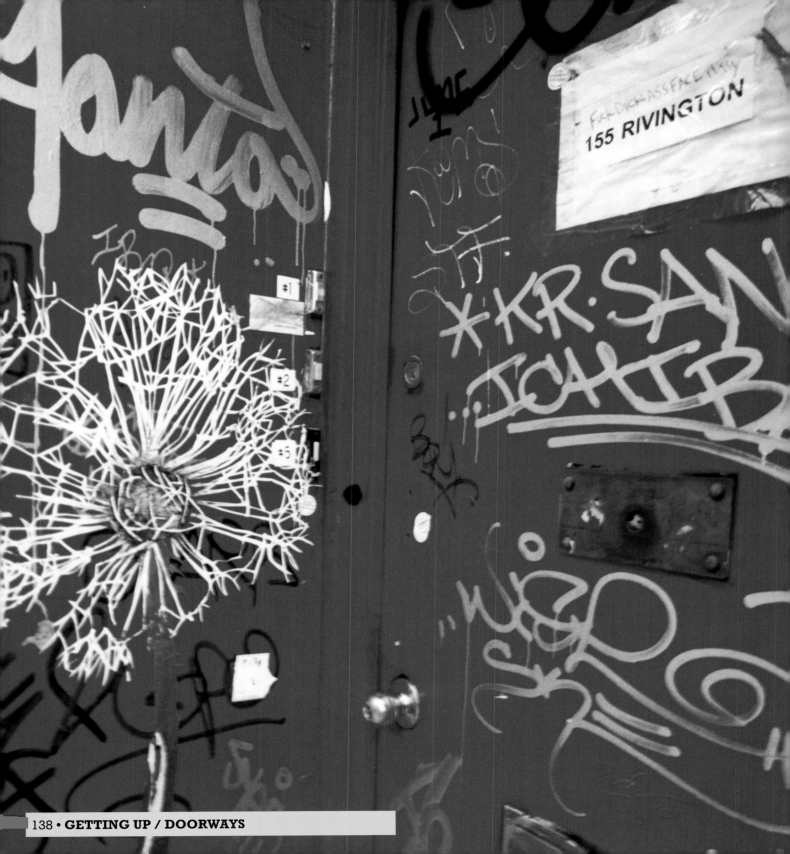

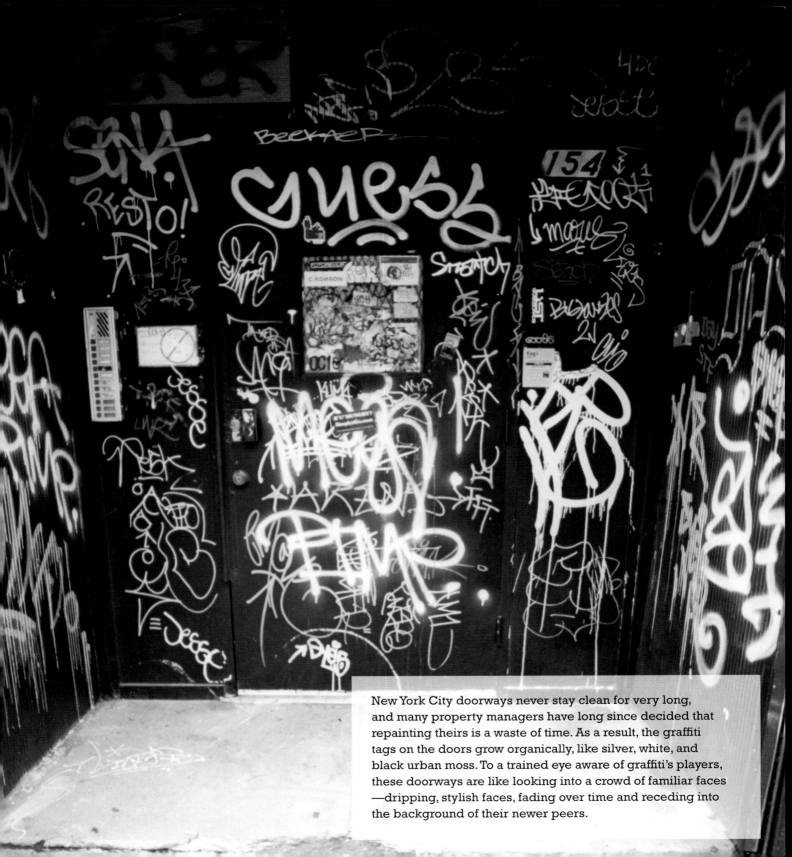

New York City doorways never stay clean for very long, and many property managers have long since decided that repainting theirs is a waste of time. As a result, the graffiti tags on the doors grow organically, like silver, white, and black urban moss. To a trained eye aware of graffiti's players, these doorways are like looking into a crowd of familiar faces —dripping, stylish faces, fading over time and receding into the background of their newer peers.

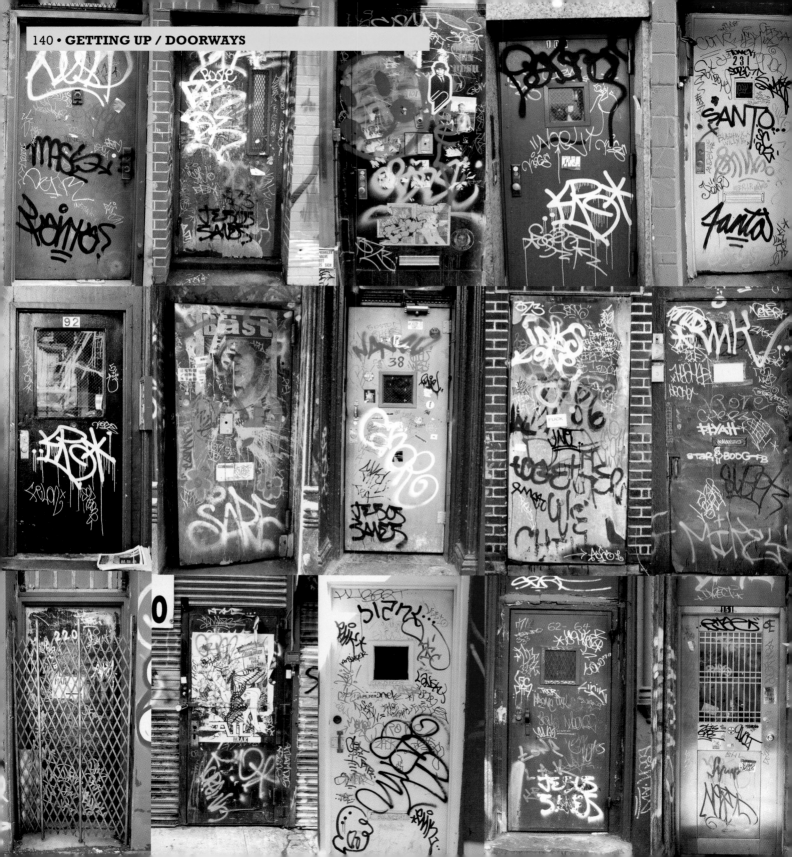

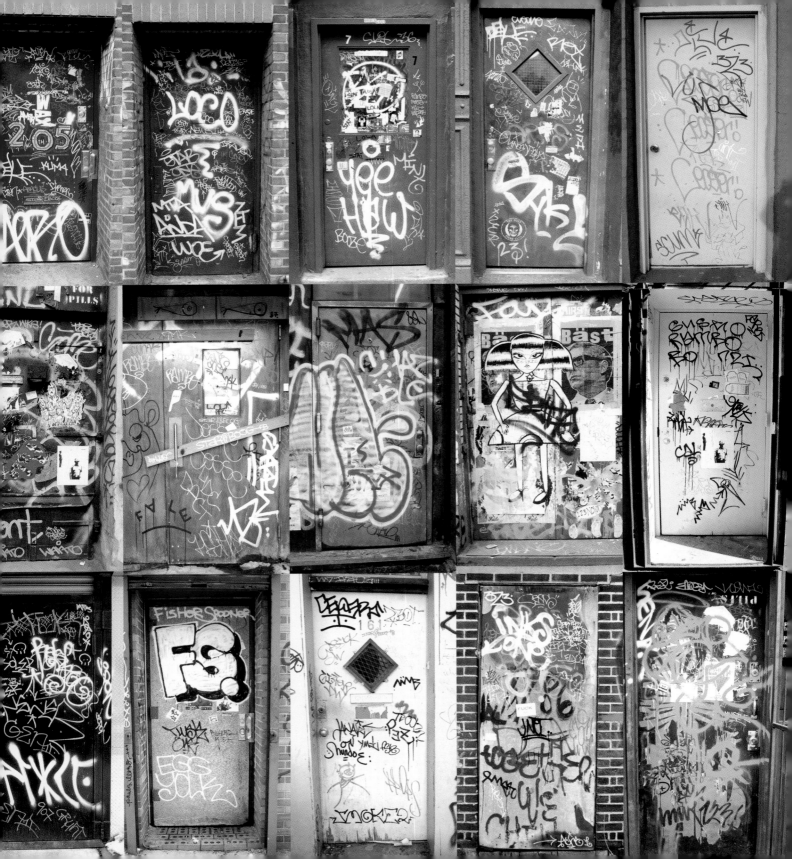

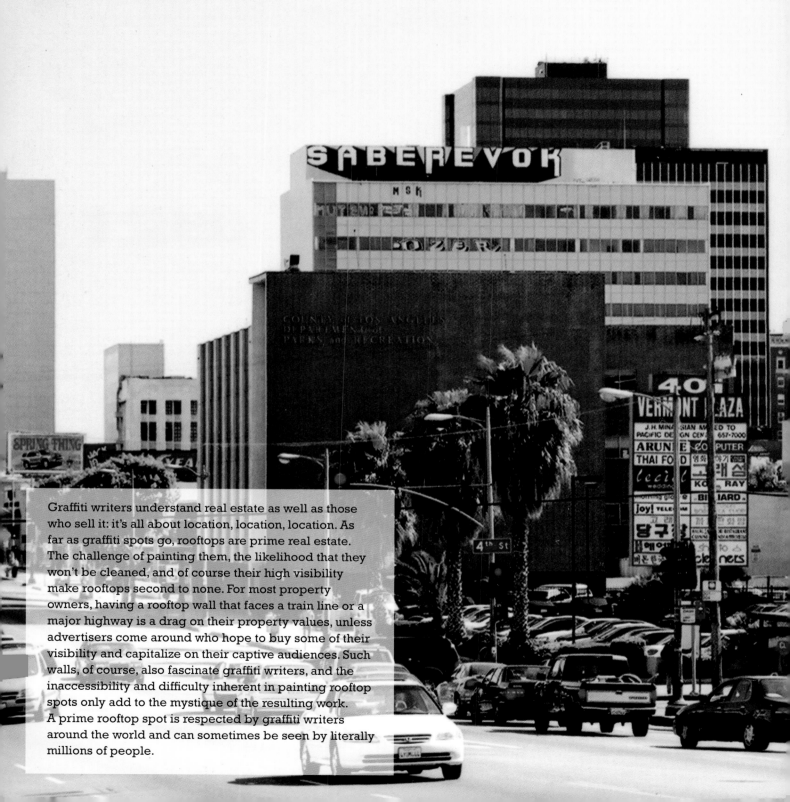

Graffiti writers understand real estate as well as those who sell it: it's all about location, location, location. As far as graffiti spots go, rooftops are prime real estate. The challenge of painting them, the likelihood that they won't be cleaned, and of course their high visibility make rooftops second to none. For most property owners, having a rooftop wall that faces a train line or a major highway is a drag on their property values, unless advertisers come around who hope to buy some of their visibility and capitalize on their captive audiences. Such walls, of course, also fascinate graffiti writers, and the inaccessibility and difficulty inherent in painting rooftop spots only add to the mystique of the resulting work. A prime rooftop spot is respected by graffiti writers around the world and can sometimes be seen by literally millions of people.

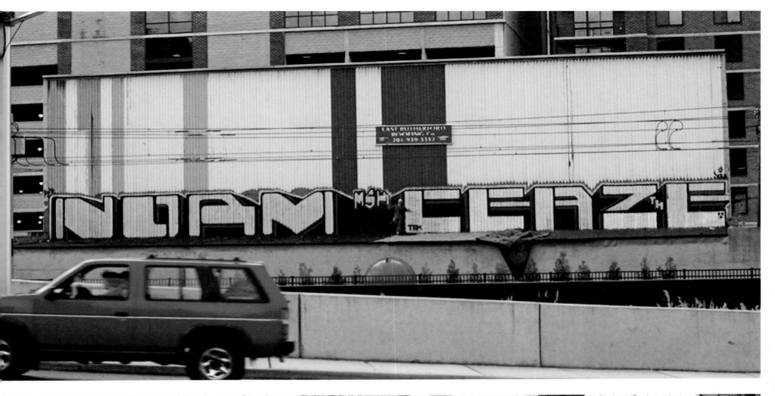

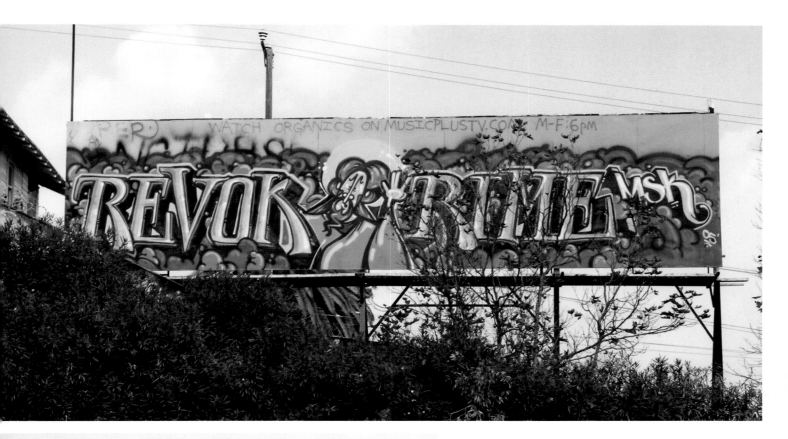

Billboards are purpose-built to deliver a message to the maximum number of people. Whether they currently are blank or carry an advertiser's message, billboards all practically beg graffiti writers to scale their supports and get to work. Naturally, such high-visibility spots are risky, as high visibility cuts both ways—it's also much easier to be spotted. Of course, graffiti writers are among the best people in the world at being sneaky.

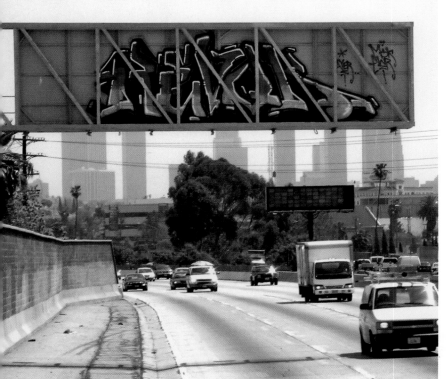

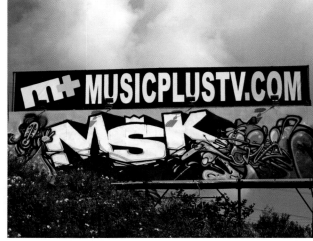

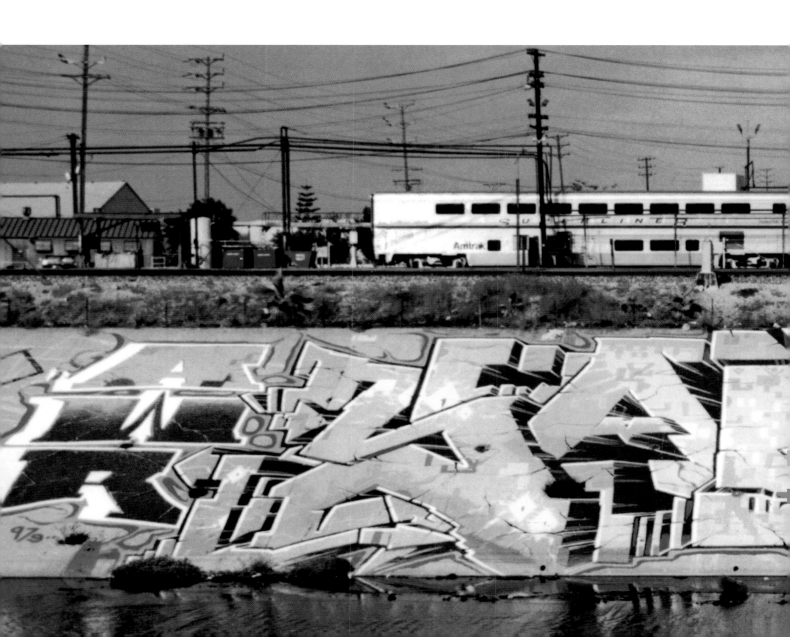

ffiti doesn't keep a *Guinness Book of World Records*, but if
d, Saber would top the "Biggest" category. He was already
ving legend of Los Angeles graffiti, but when in 1997 he
cuted the largest graffiti painting ever created, his reputation
t global. His painting along the sloping cement banks of the
Angeles River bed measured nearly the size of a football
d, and took 97 gallons of paint and a year of carefully planned
hts to complete.

All of the supplies for the painting had to be hauled over barbed
wire and through gangland, then applied without attracting the
attention of either the Amtrak or Los Angeles police departments,
both of whom patrol the area from the ground and the air. After
a year of work, Saber had blown out his knee working on the
slanted surface, but completed the painting. His father crept into
the desolate area across the river and, after several chases from
gangsters eager to relieve him of his camera, took photos of his
son, striding across the surface of his own artwork. Saber is not
a small guy, but he doesn't even fill one of the small holes in the
"B" at the center of his name.

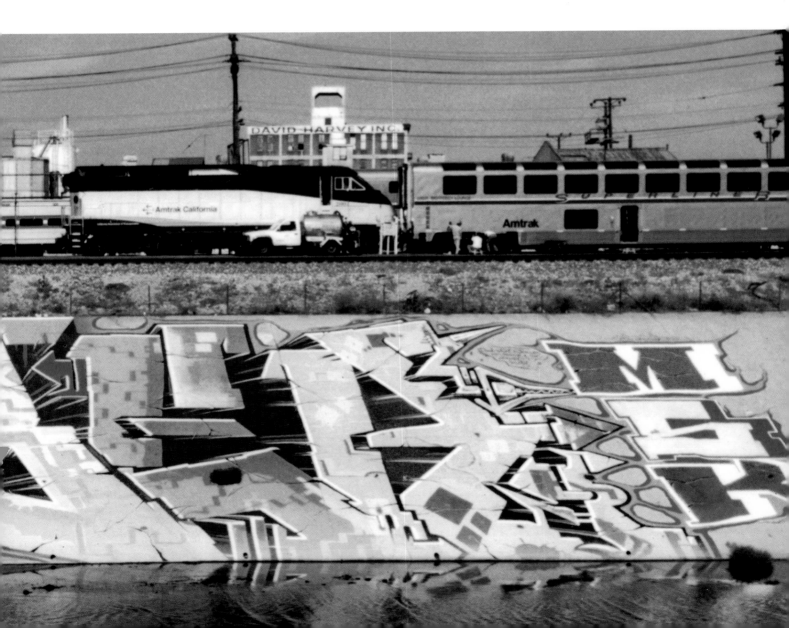

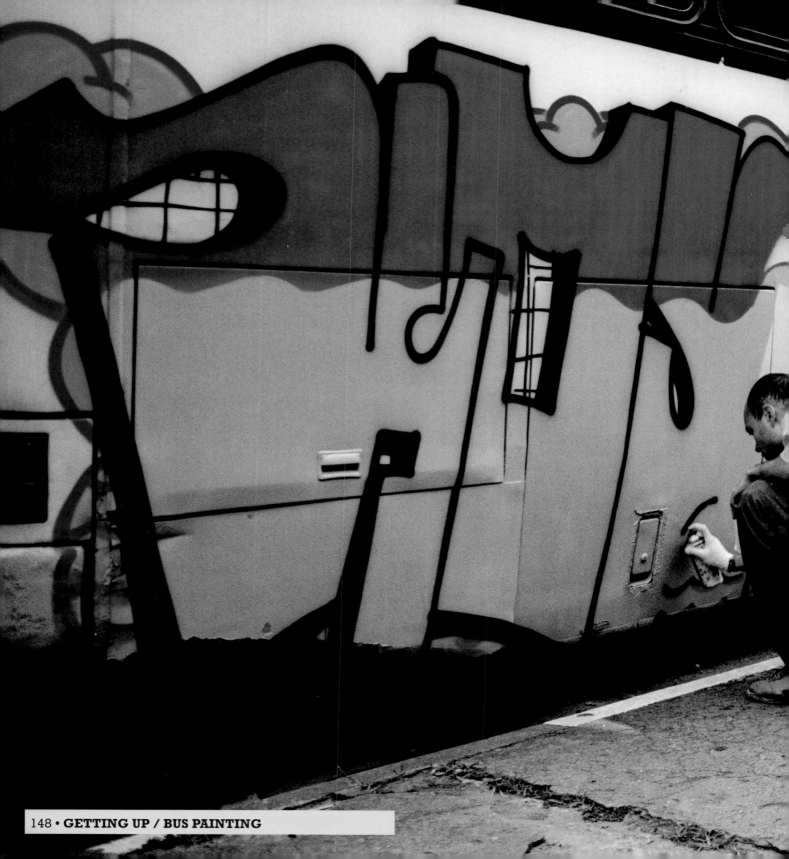

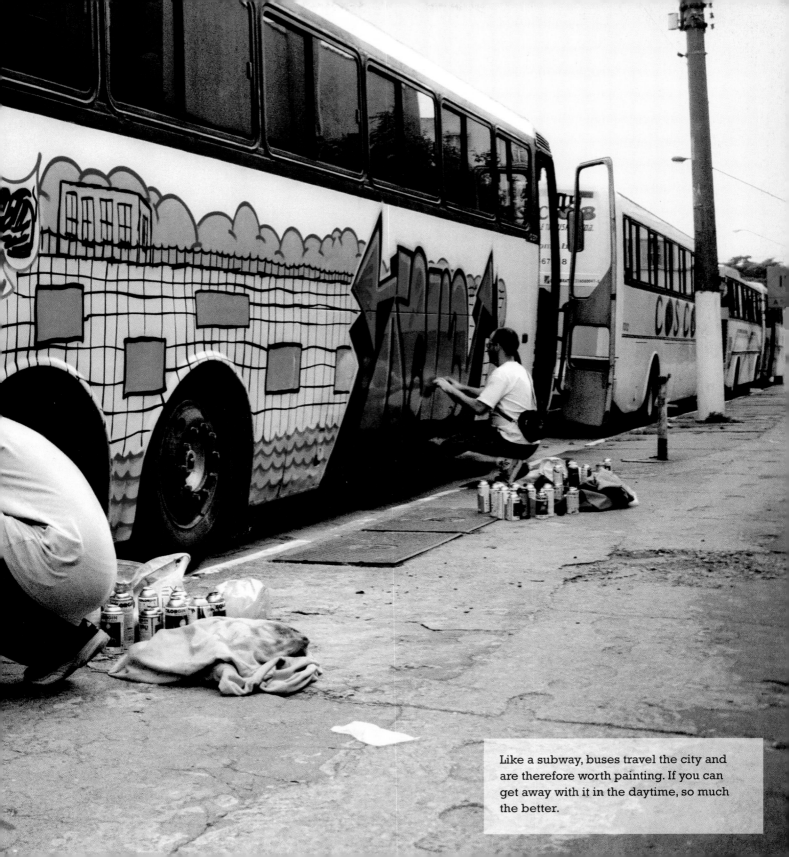

Like a subway, buses travel the city and are therefore worth painting. If you can get away with it in the daytime, so much the better.

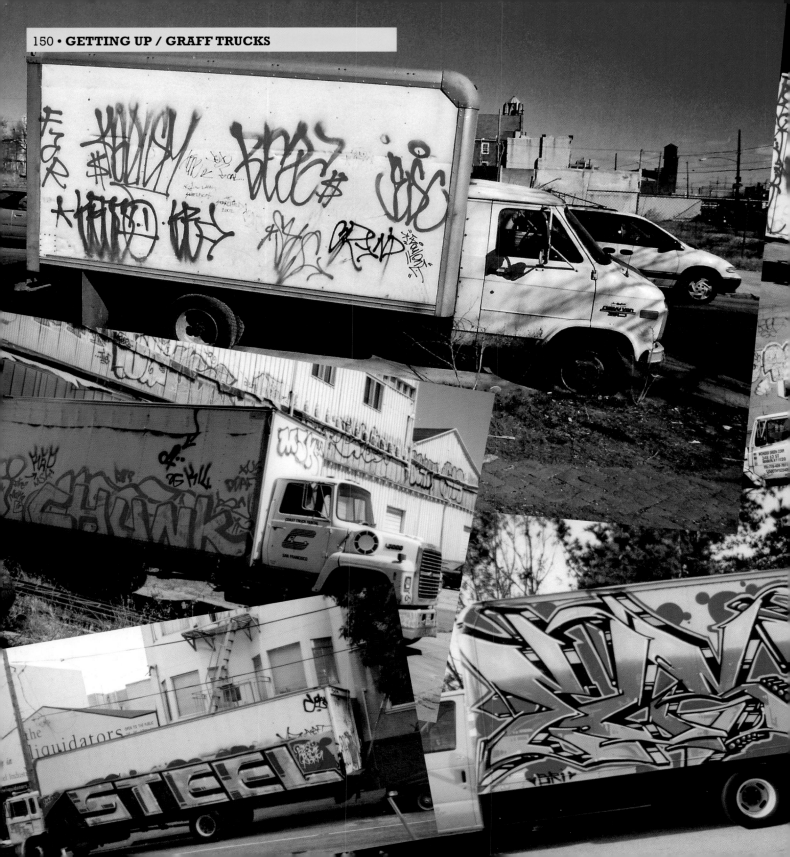

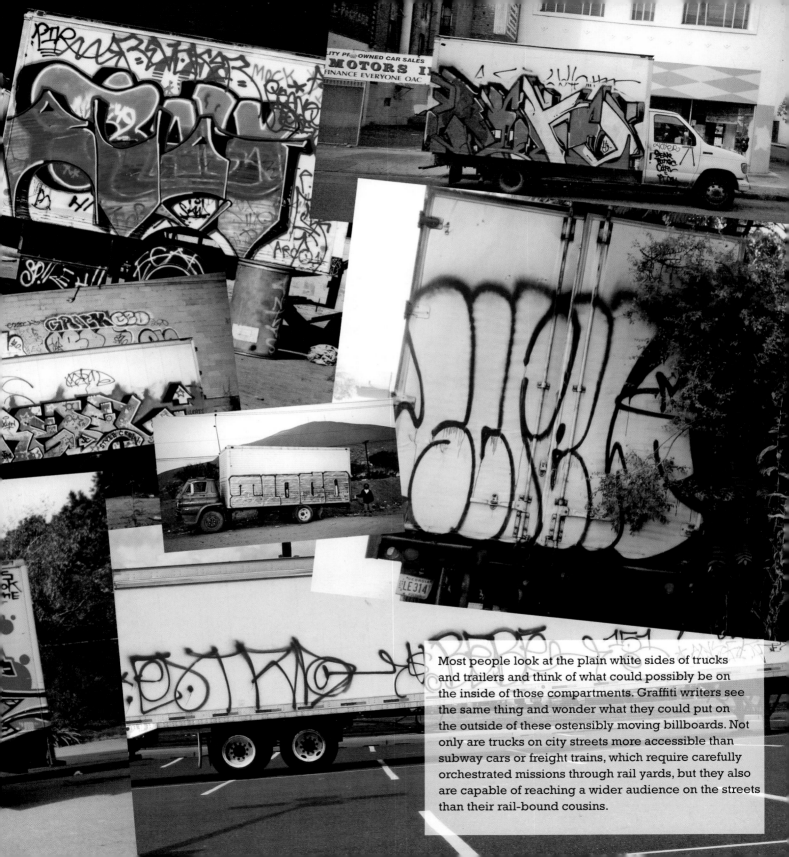

Most people look at the plain white sides of trucks and trailers and think of what could possibly be on the inside of those compartments. Graffiti writers see the same thing and wonder what they could put on the outside of these ostensibly moving billboards. Not only are trucks on city streets more accessible than subway cars or freight trains, which require carefully orchestrated missions through rail yards, but they also are capable of reaching a wider audience on the streets than their rail-bound cousins.

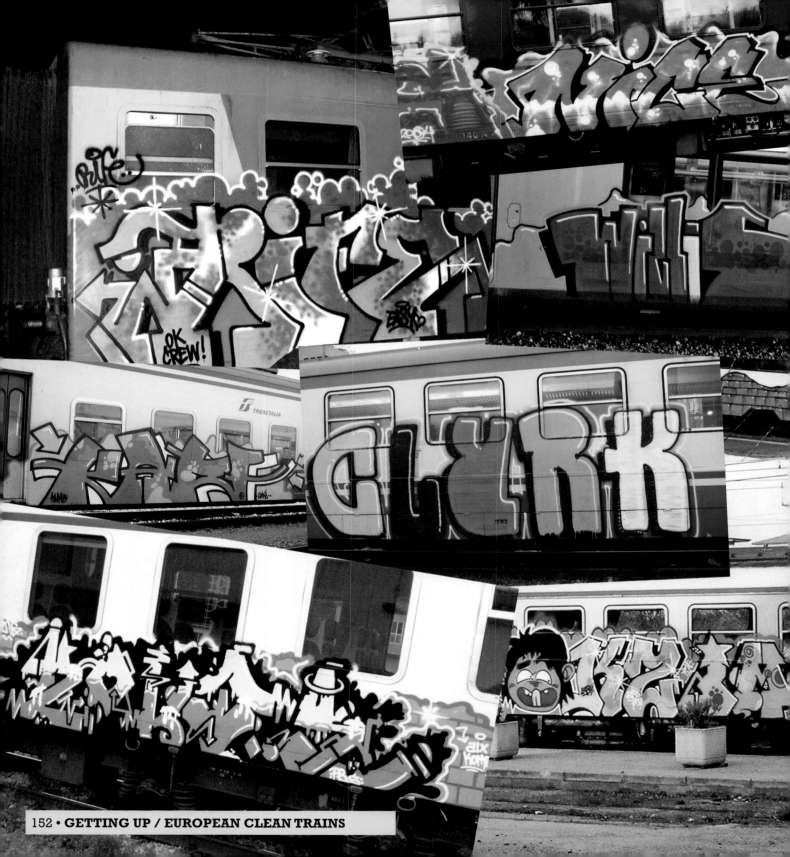

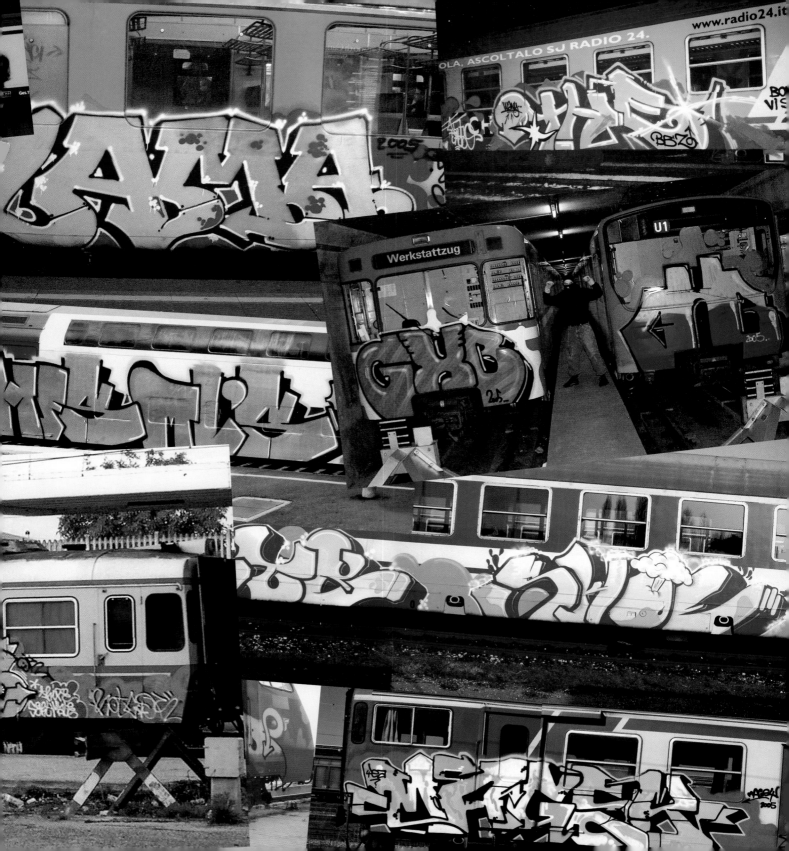

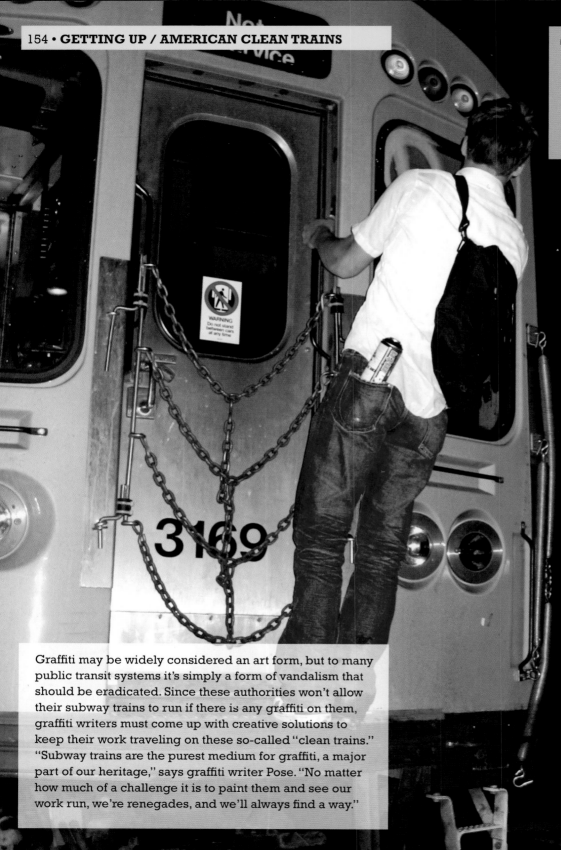

"Subway trains are the purest medium for graffiti, a major part of our heritage."
Pose

3169

Graffiti may be widely considered an art form, but to many public transit systems it's simply a form of vandalism that should be eradicated. Since these authorities won't allow their subway trains to run if there is any graffiti on them, graffiti writers must come up with creative solutions to keep their work traveling on these so-called "clean trains." "Subway trains are the purest medium for graffiti, a major part of our heritage," says graffiti writer Pose. "No matter how much of a challenge it is to paint them and see our work run, we're renegades, and we'll always find a way."

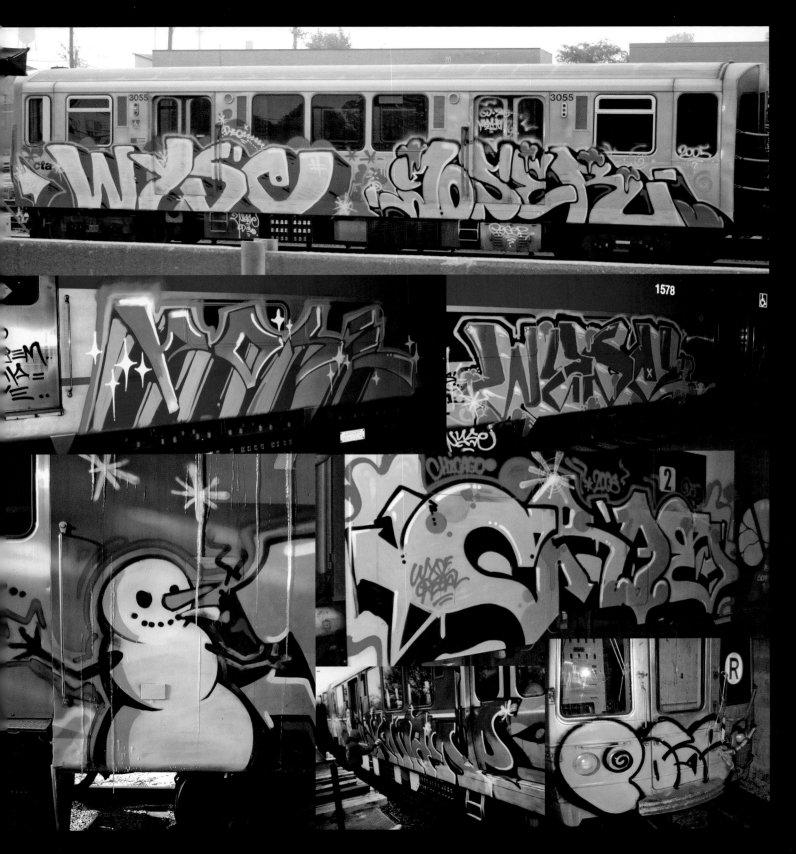

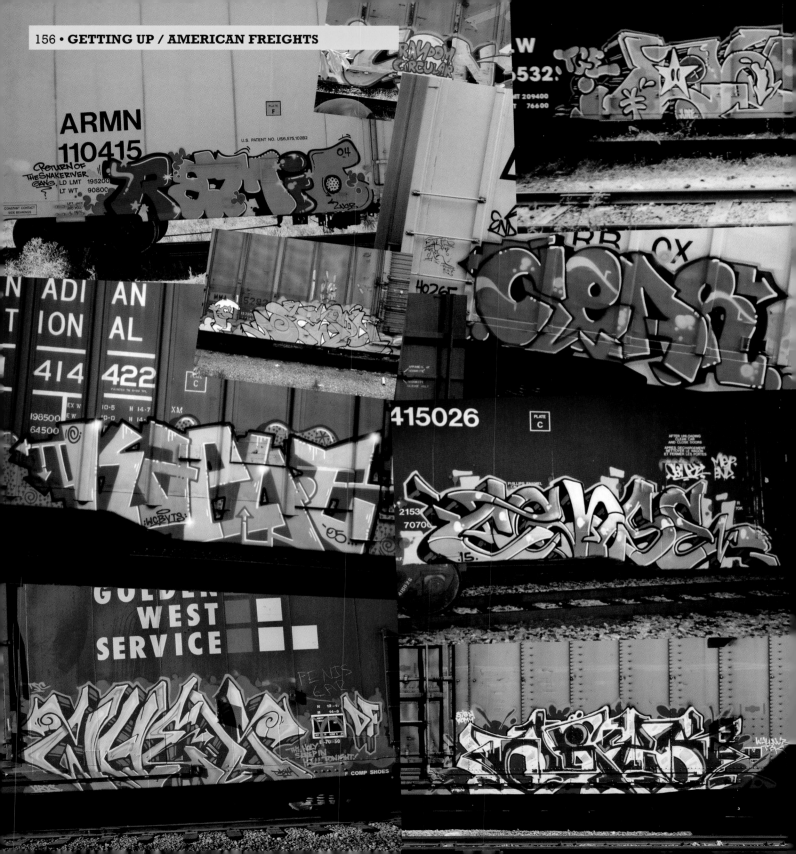

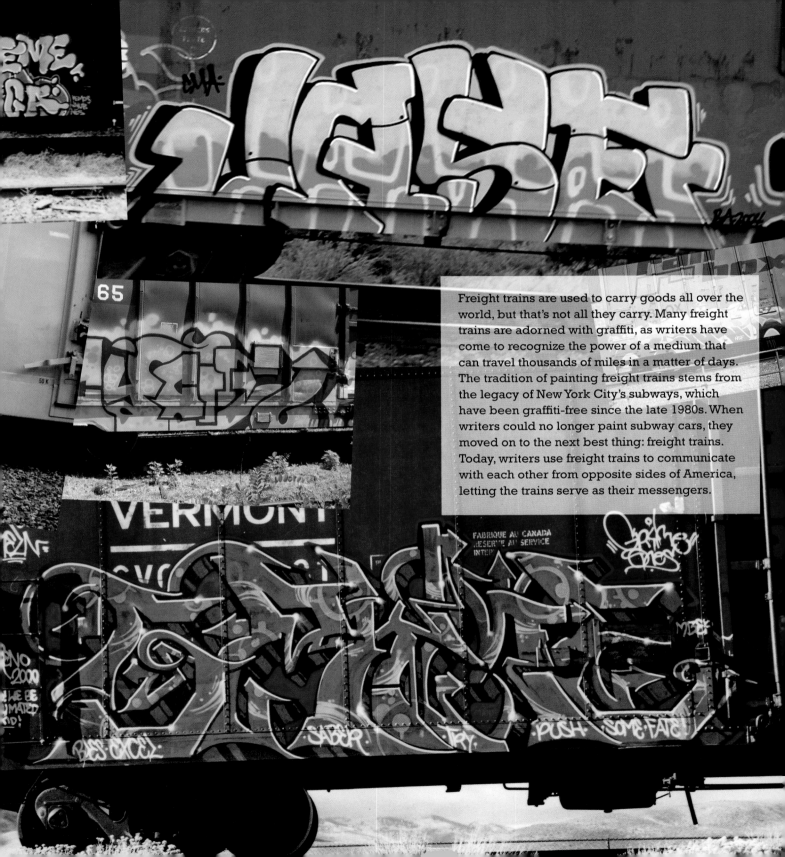

Freight trains are used to carry goods all over the world, but that's not all they carry. Many freight trains are adorned with graffiti, as writers have come to recognize the power of a medium that can travel thousands of miles in a matter of days. The tradition of painting freight trains stems from the legacy of New York City's subways, which have been graffiti-free since the late 1980s. When writers could no longer paint subway cars, they moved on to the next best thing: freight trains. Today, writers use freight trains to communicate with each other from opposite sides of America, letting the trains serve as their messengers.

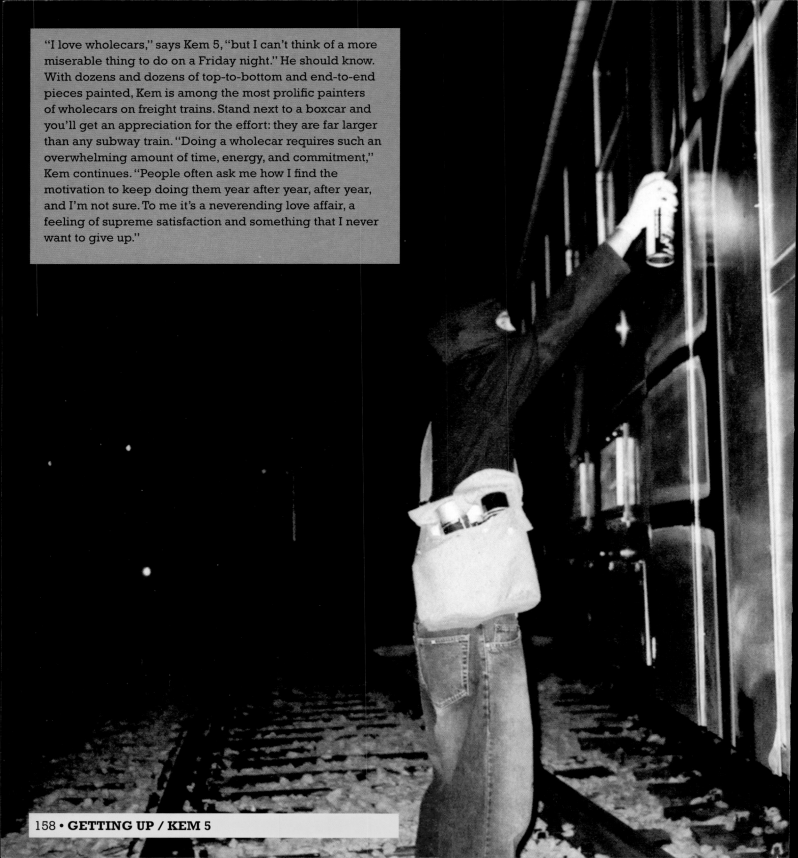

"I love wholecars," says Kem 5, "but I can't think of a more miserable thing to do on a Friday night." He should know. With dozens and dozens of top-to-bottom and end-to-end pieces painted, Kem is among the most prolific painters of wholecars on freight trains. Stand next to a boxcar and you'll get an appreciation for the effort: they are far larger than any subway train. "Doing a wholecar requires such an overwhelming amount of time, energy, and commitment," Kem continues. "People often ask me how I find the motivation to keep doing them year after year, after year, and I'm not sure. To me it's a neverending love affair, a feeling of supreme satisfaction and something that I never want to give up."

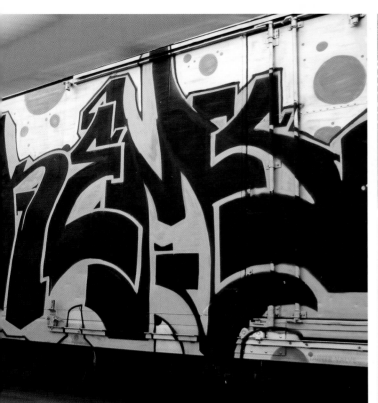

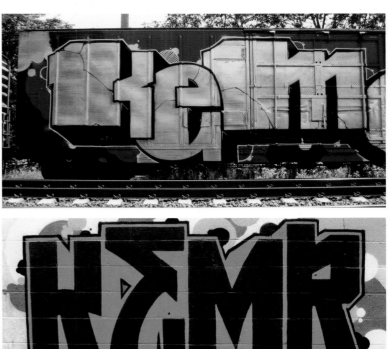

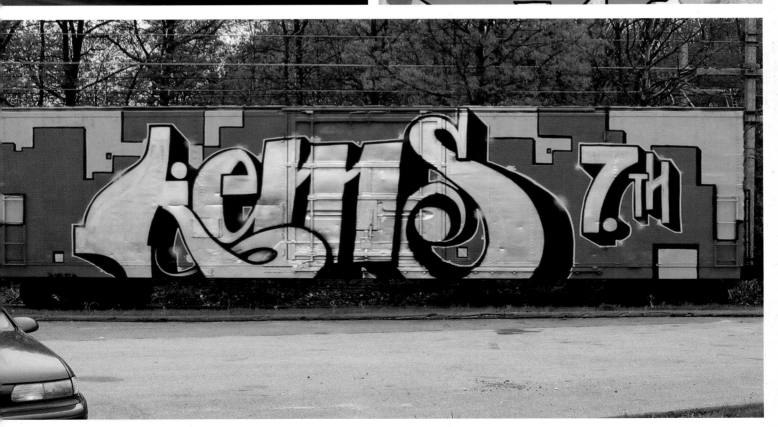

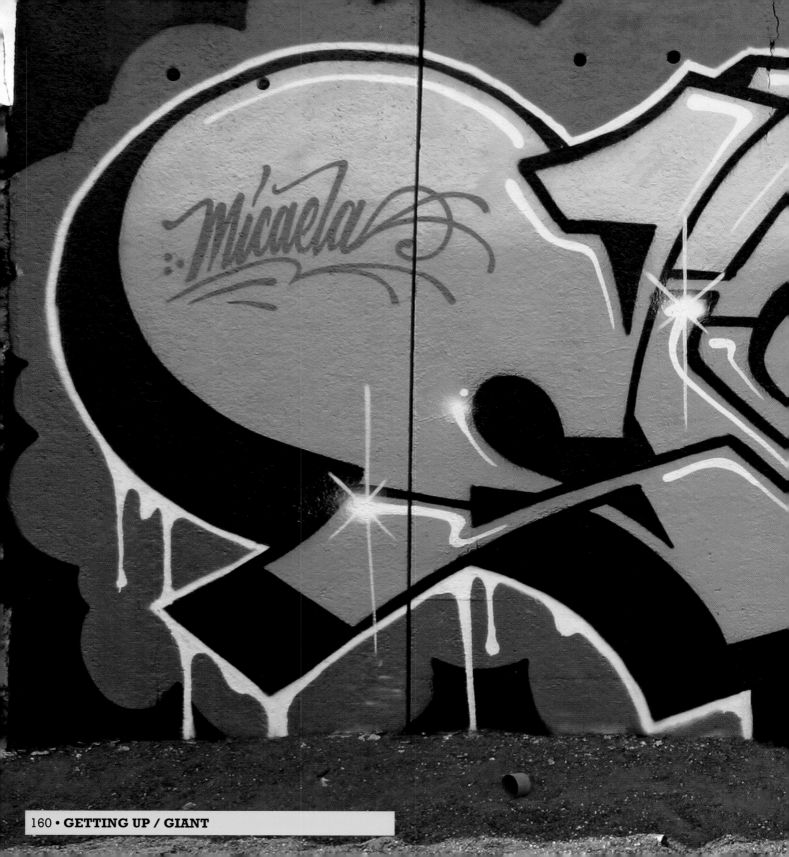

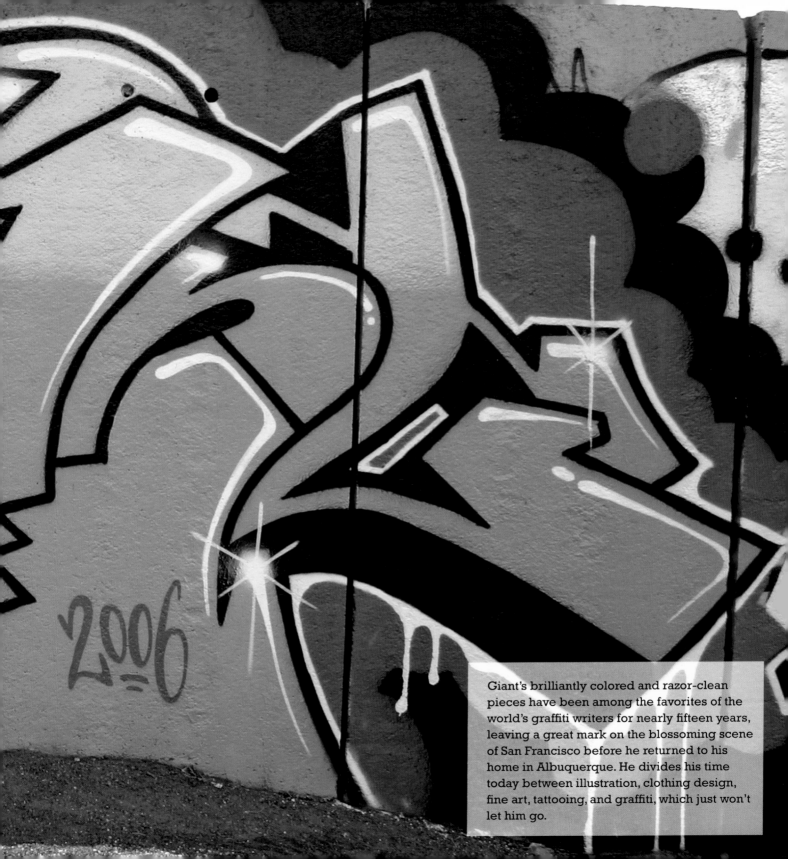

Giant's brilliantly colored and razor-clean pieces have been among the favorites of the world's graffiti writers for nearly fifteen years, leaving a great mark on the blossoming scene of San Francisco before he returned to his home in Albuquerque. He divides his time today between illustration, clothing design, fine art, tattooing, and graffiti, which just won't let him go.

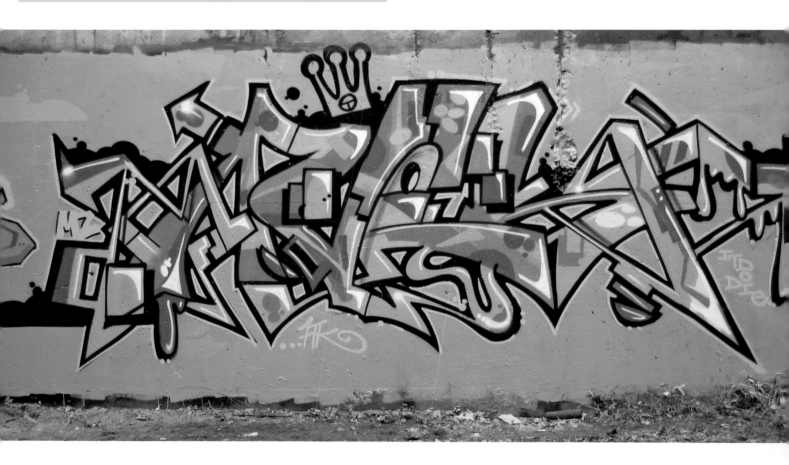

Despite graffiti's many common threads and global scene, at its best, it still holds an intensely local nature. "There's some kind of local aesthetic that all major cities have that differentiates them from each other," explains Aves, who grew up in Lowell, a forty-five-minute drive from Boston. His observations about Boston's scene highlight the diversity of styles within the world of graffiti: any city worth its graffiti salt has its own distinct and individual characteristics.

"What I like about Boston is how you can break styles down all the way to different neighborhoods and surrounding cities within the metro area. The variations can go from slight to more evident, but they are noticeable. At the same time, there are certain letter styles, tag styles, and painting techniques that are particular to the overall Boston scene and can be seen running through mostly everything being done here to varying degrees.

"Tagging has always been important here: having good handstyles, tagging up a lot, and always having a marker on you. The kids that write graffiti here put tagging up on the same level as other factions of graffiti like piecing skills, hitting spots, and bombing.

"What I think is interesting about Boston is that writers here real don't take influence from beyond what is done here or what has been brought here either from locals moving away for some tim then bringing back things they picked up while they were away, or from writers who've moved here and hooked up with local writers. When styles are cross-pollinated properly through actu human contact, crew connections, and friendships, the results come off a lot more genuinely than by taking the approach of seeing what's on the Internet or in a magazine and copying it with no real entitlement."

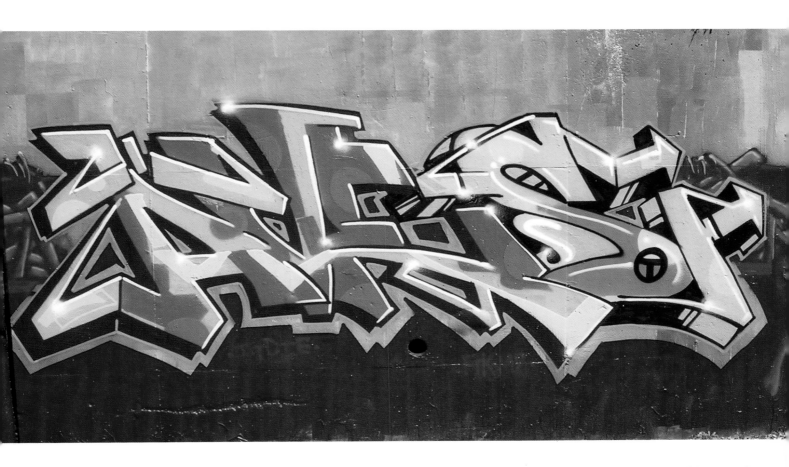

Above, left: "I did this piece on the fly. I had the day off from work and a few hours before class. I only had one can to outline with, so I doubled up the outline and didn't do a 3D. I freestyled a style I'd started messing with a year earlier, where I was trying to loosen up and add more fluidity to the 1980s Boston and NYC-inspired bar styles I'd been doing for a few years before that. I was playing with the shape of the letters more, adding more curves in the letters, playing with bar width, and trying to go beyond just the bare bars, but still keeping it somewhat angular and having connections grounded in classic bar styles."

Above, right: "This was one of the earlier pieces where I started to move away from the standard 'bar' styles. I gave my AVE a lean and switched up my 'S' to a different style and colors to add a little flizz to it. Playing with the shape and flow of my first three letters and countering it with my last letter being different was something I'd been doing a lot around that time."

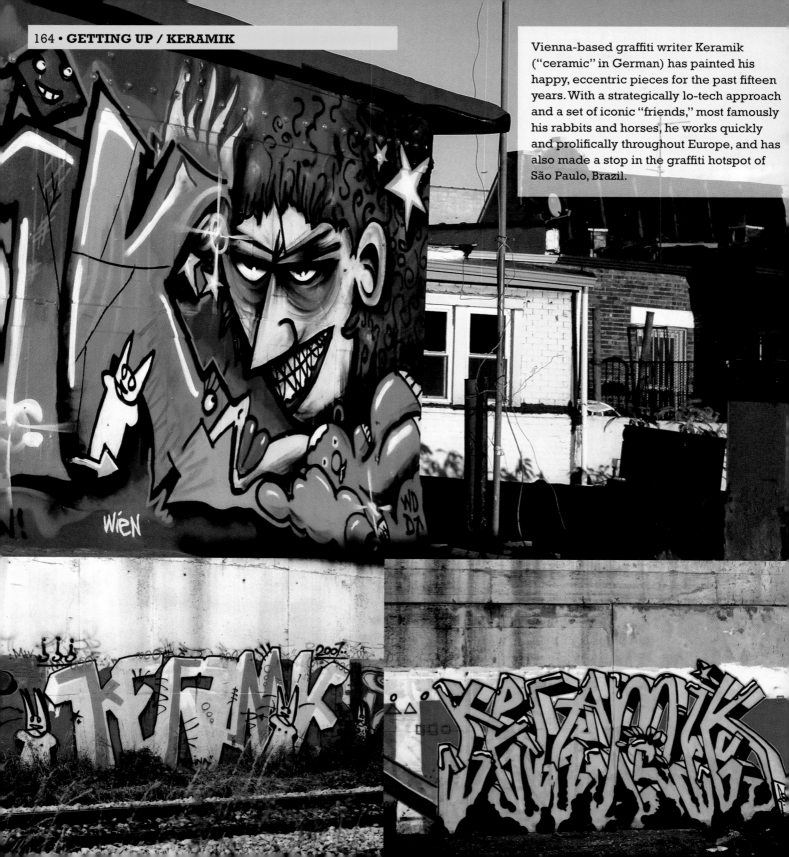

Vienna-based graffiti writer Keramik ("ceramic" in German) has painted his happy, eccentric pieces for the past fifteen years. With a strategically lo-tech approach and a set of iconic "friends," most famously his rabbits and horses, he works quickly and prolifically throughout Europe, and has also made a stop in the graffiti hotspot of São Paulo, Brazil.

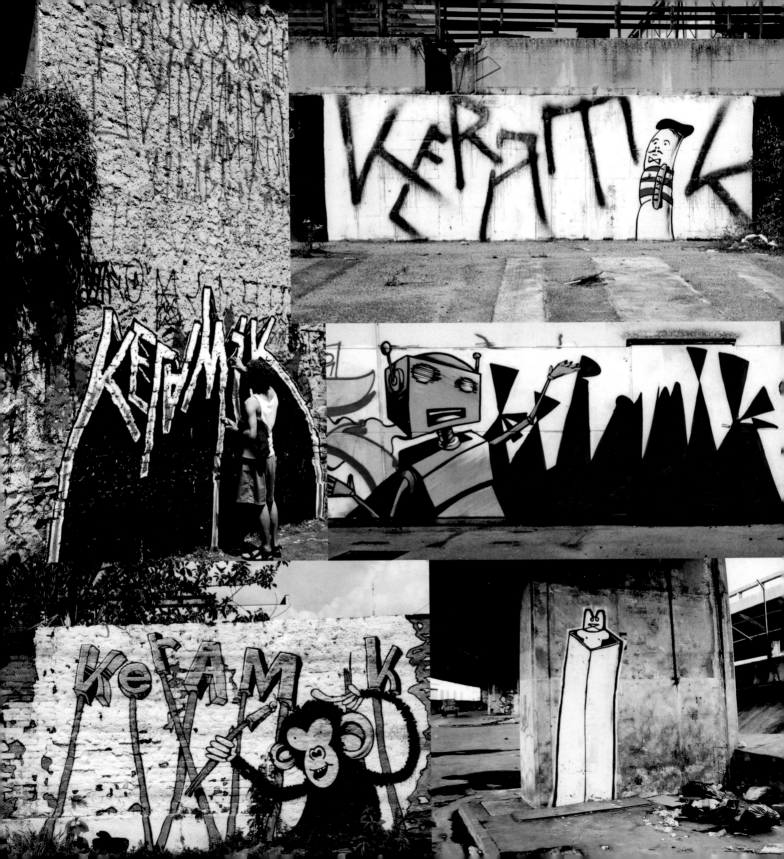

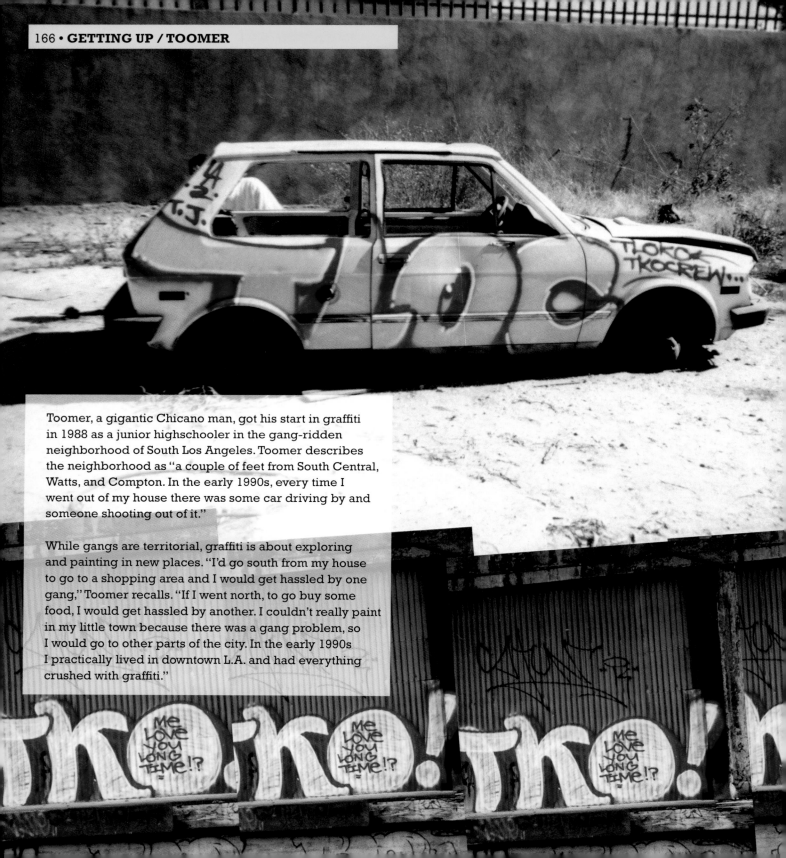

Toomer, a gigantic Chicano man, got his start in graffiti in 1988 as a junior highschooler in the gang-ridden neighborhood of South Los Angeles. Toomer describes the neighborhood as "a couple of feet from South Central, Watts, and Compton. In the early 1990s, every time I went out of my house there was some car driving by and someone shooting out of it."

While gangs are territorial, graffiti is about exploring and painting in new places. "I'd go south from my house to go to a shopping area and I would get hassled by one gang," Toomer recalls. "If I went north, to go buy some food, I would get hassled by another. I couldn't really paint in my little town because there was a gang problem, so I would go to other parts of the city. In the early 1990s I practically lived in downtown L.A. and had everything crushed with graffiti."

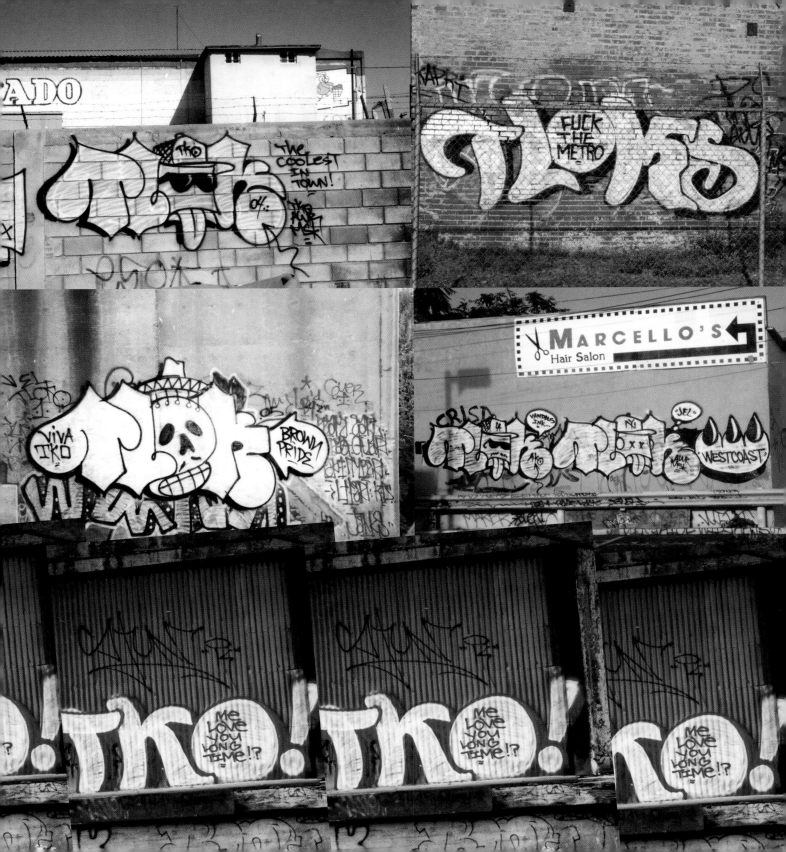

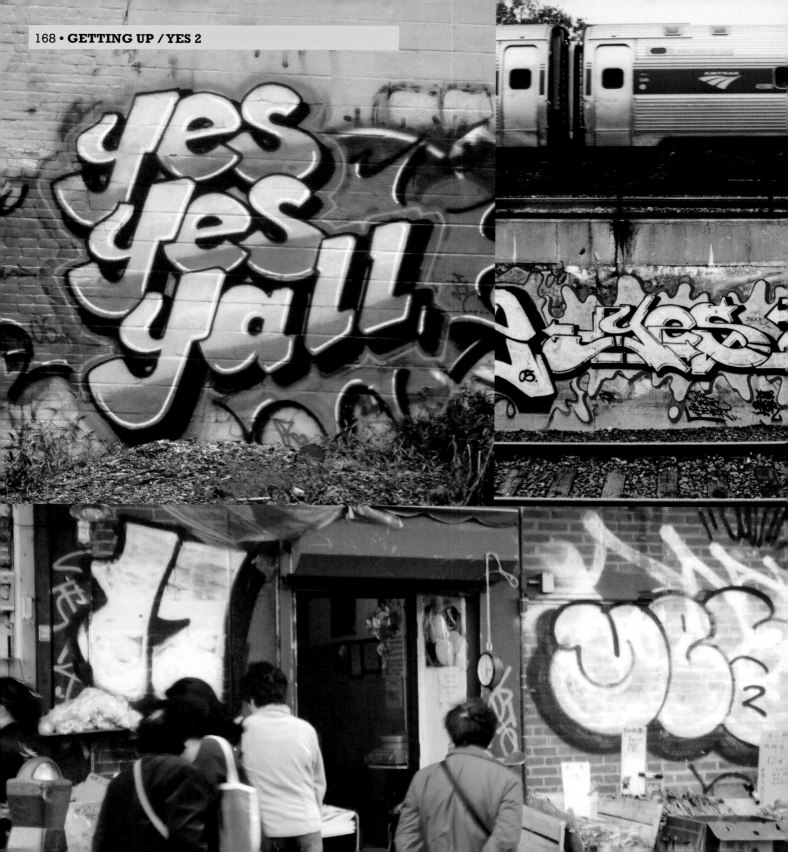

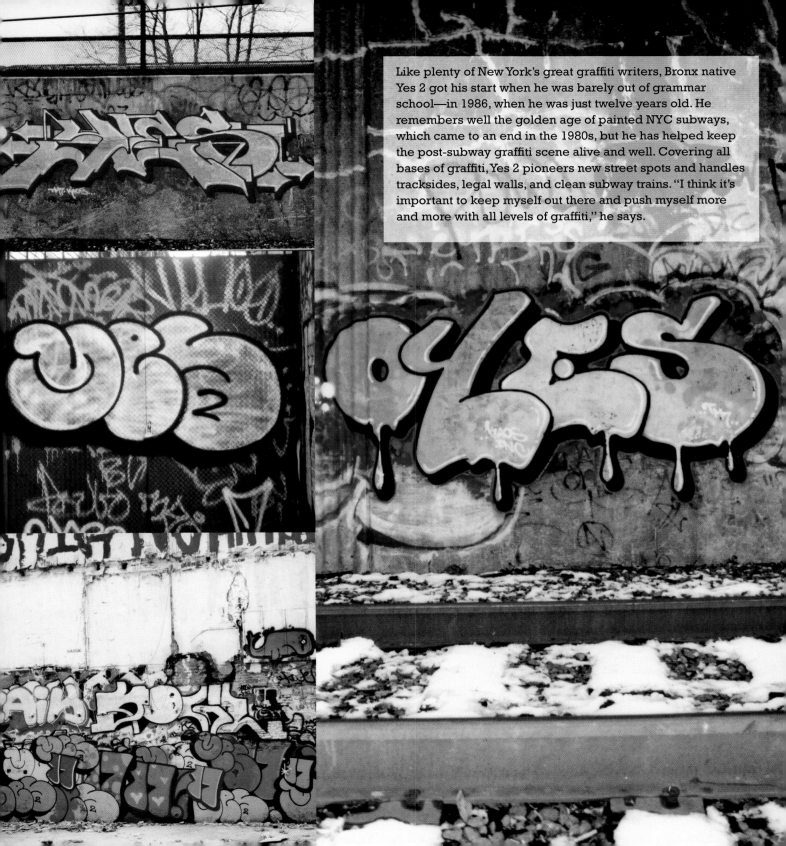

Like plenty of New York's great graffiti writers, Bronx native Yes 2 got his start when he was barely out of grammar school—in 1986, when he was just twelve years old. He remembers well the golden age of painted NYC subways, which came to an end in the 1980s, but he has helped keep the post-subway graffiti scene alive and well. Covering all bases of graffiti, Yes 2 pioneers new street spots and handles tracksides, legal walls, and clean subway trains. "I think it's important to keep myself out there and push myself more and more with all levels of graffiti," he says.

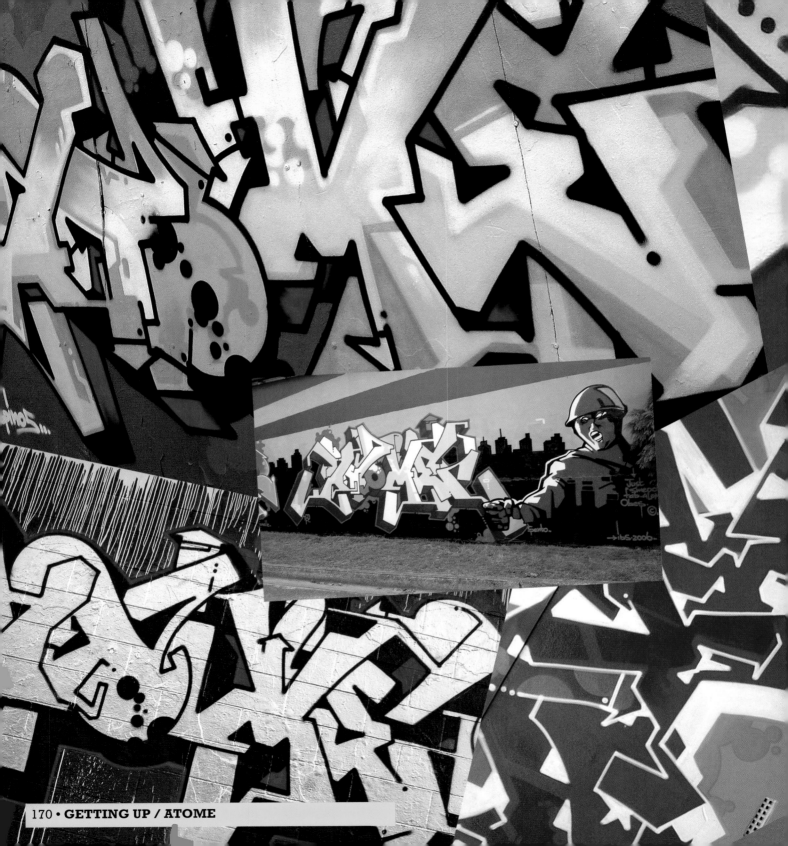

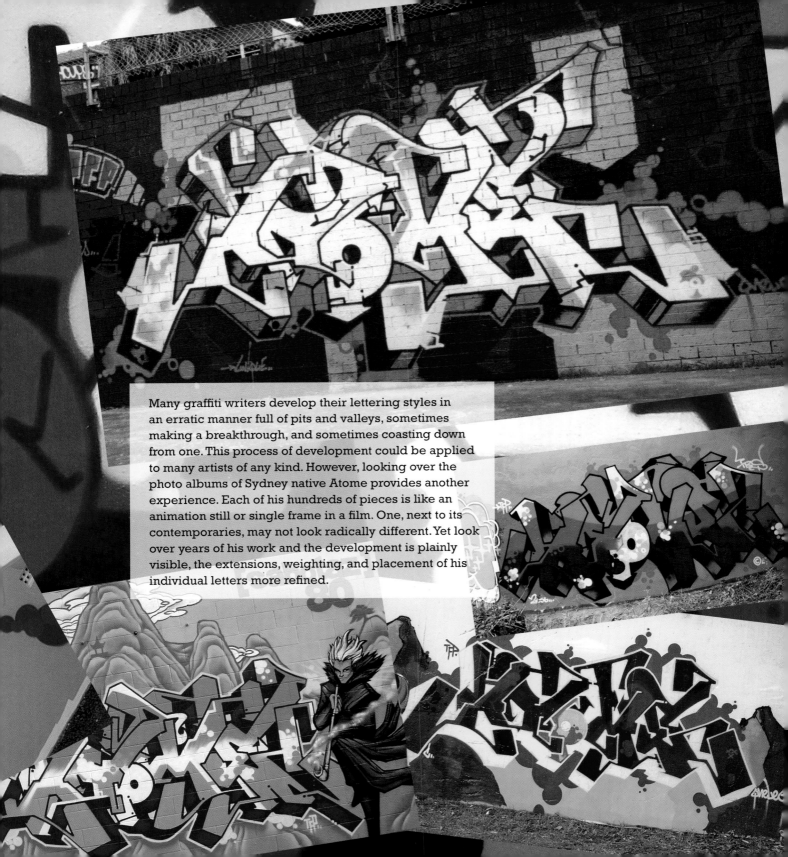

Many graffiti writers develop their lettering styles in an erratic manner full of pits and valleys, sometimes making a breakthrough, and sometimes coasting down from one. This process of development could be applied to many artists of any kind. However, looking over the photo albums of Sydney native Atome provides another experience. Each of his hundreds of pieces is like an animation still or single frame in a film. One, next to its contemporaries, may not look radically different. Yet look over years of his work and the development is plainly visible, the extensions, weighting, and placement of his individual letters more refined.

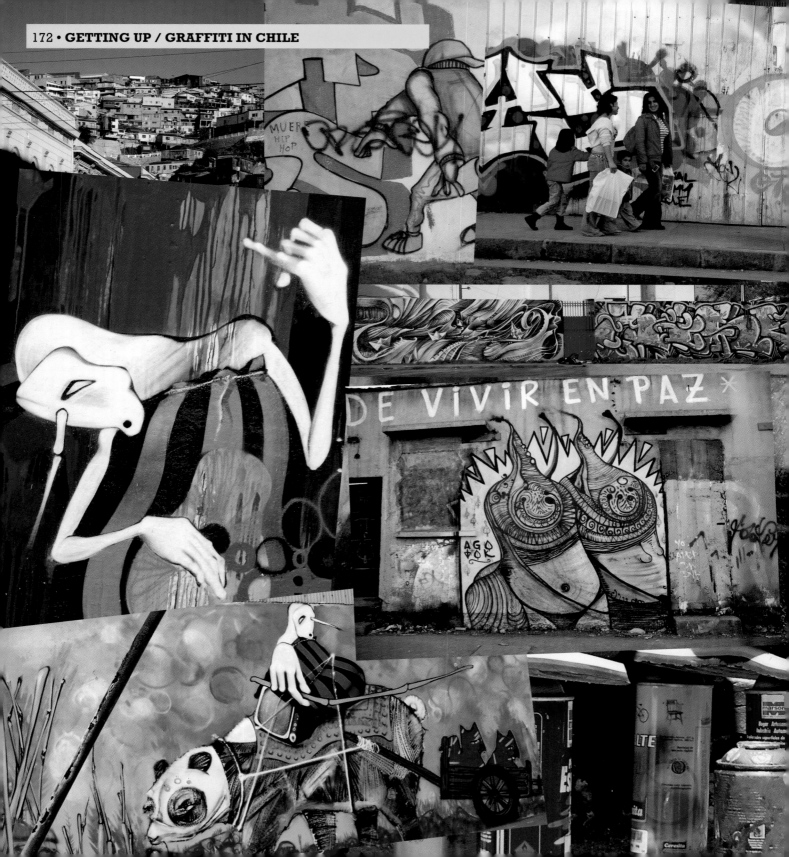

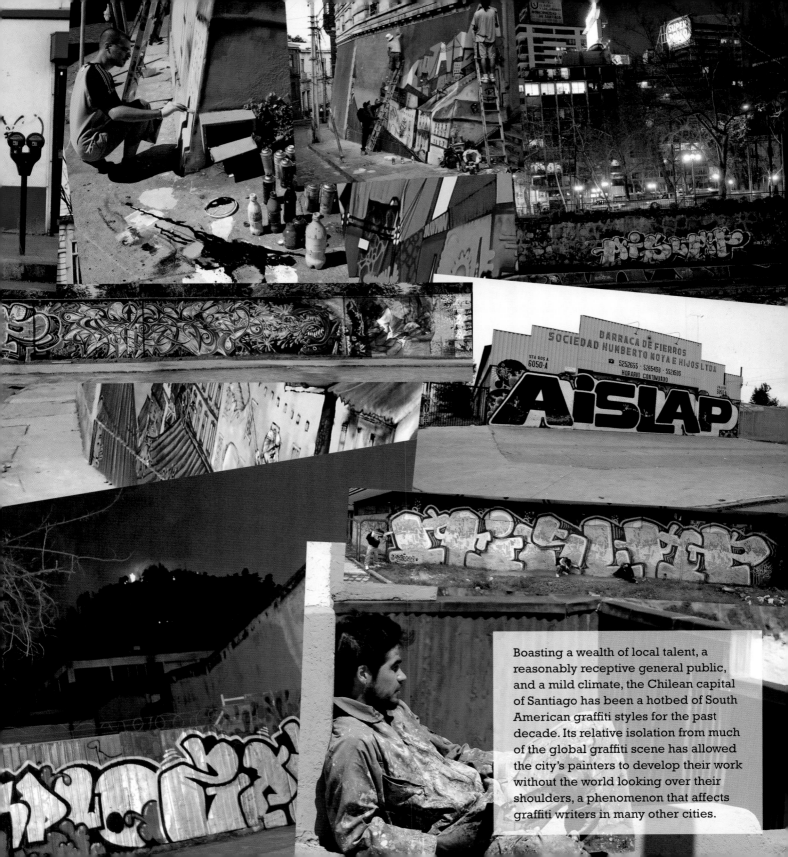

Boasting a wealth of local talent, a reasonably receptive general public, and a mild climate, the Chilean capital of Santiago has been a hotbed of South American graffiti styles for the past decade. Its relative isolation from much of the global graffiti scene has allowed the city's painters to develop their work without the world looking over their shoulders, a phenomenon that affects graffiti writers in many other cities.

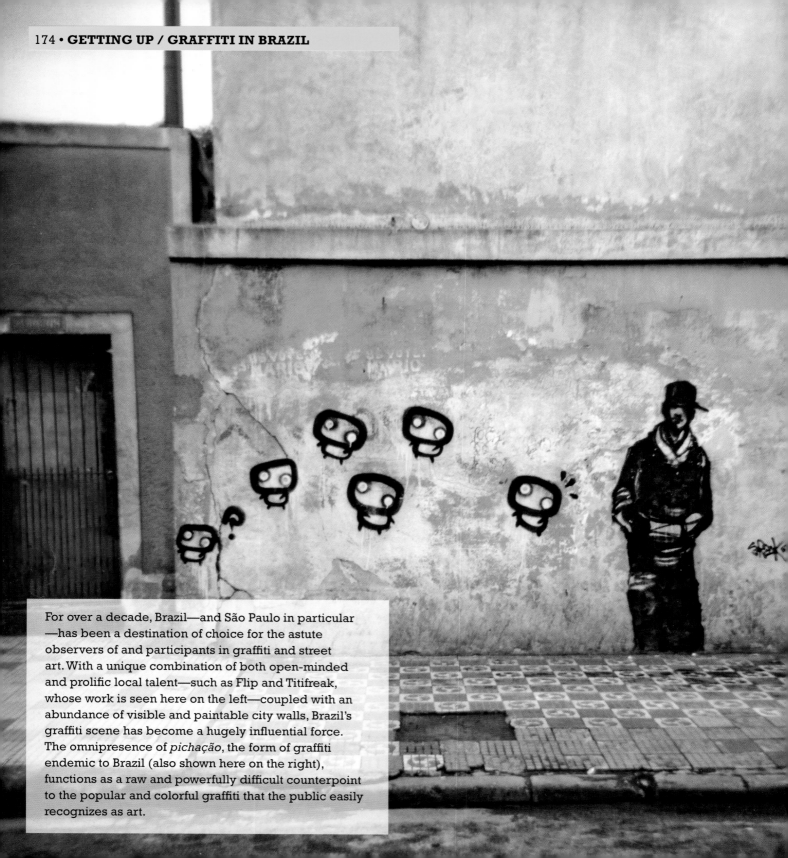

For over a decade, Brazil—and São Paulo in particular—has been a destination of choice for the astute observers of and participants in graffiti and street art. With a unique combination of both open-minded and prolific local talent—such as Flip and Titifreak, whose work is seen here on the left—coupled with an abundance of visible and paintable city walls, Brazil's graffiti scene has become a hugely influential force. The omnipresence of *pichação*, the form of graffiti endemic to Brazil (also shown here on the right), functions as a raw and powerfully difficult counterpoint to the popular and colorful graffiti that the public easily recognizes as art.

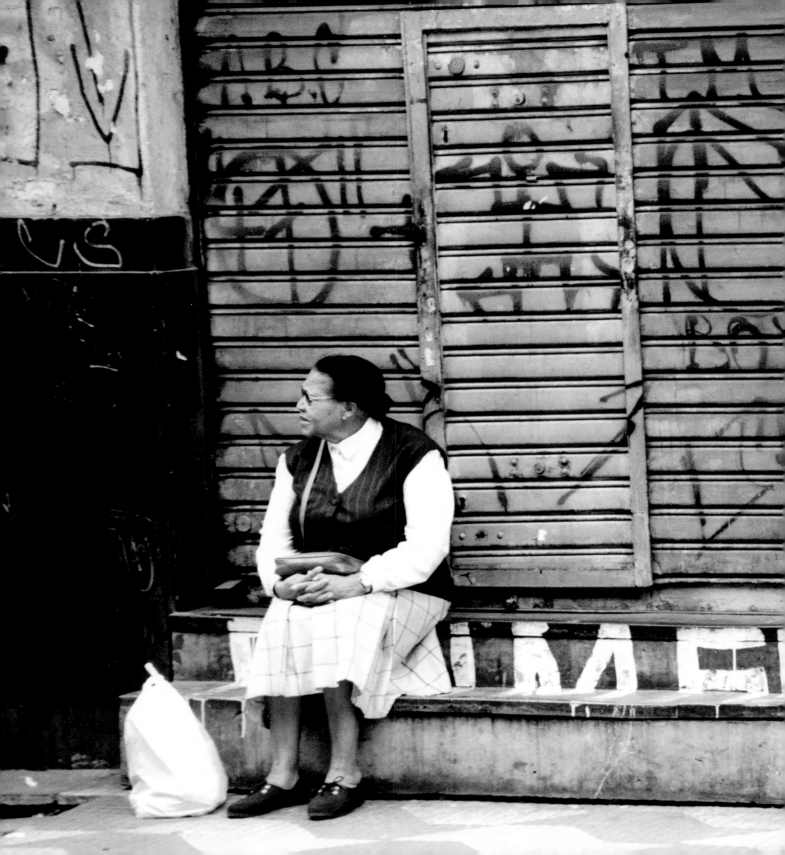

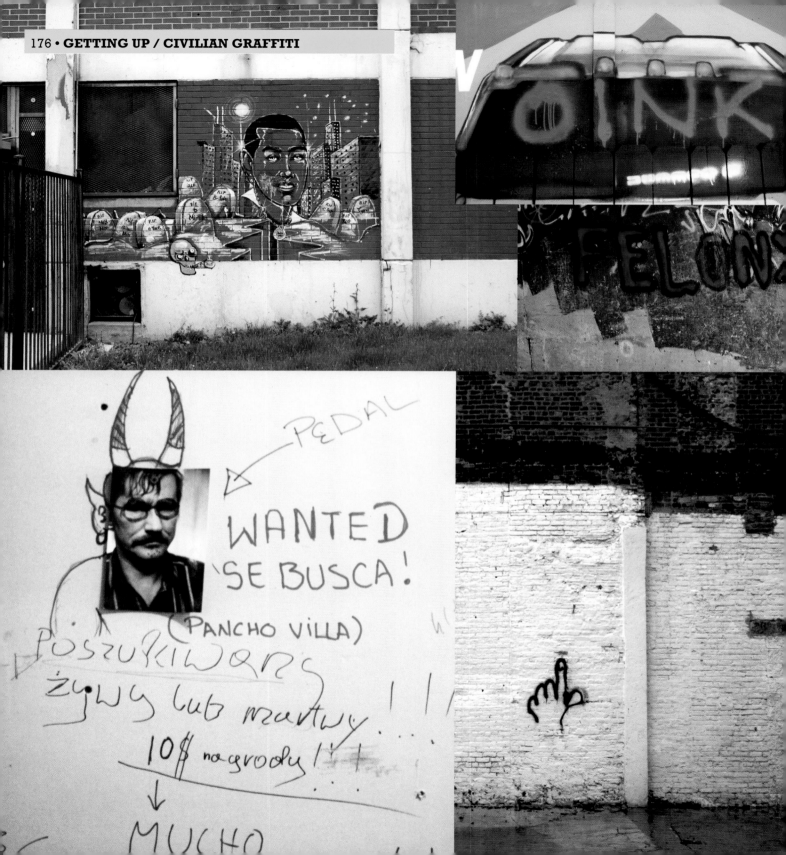

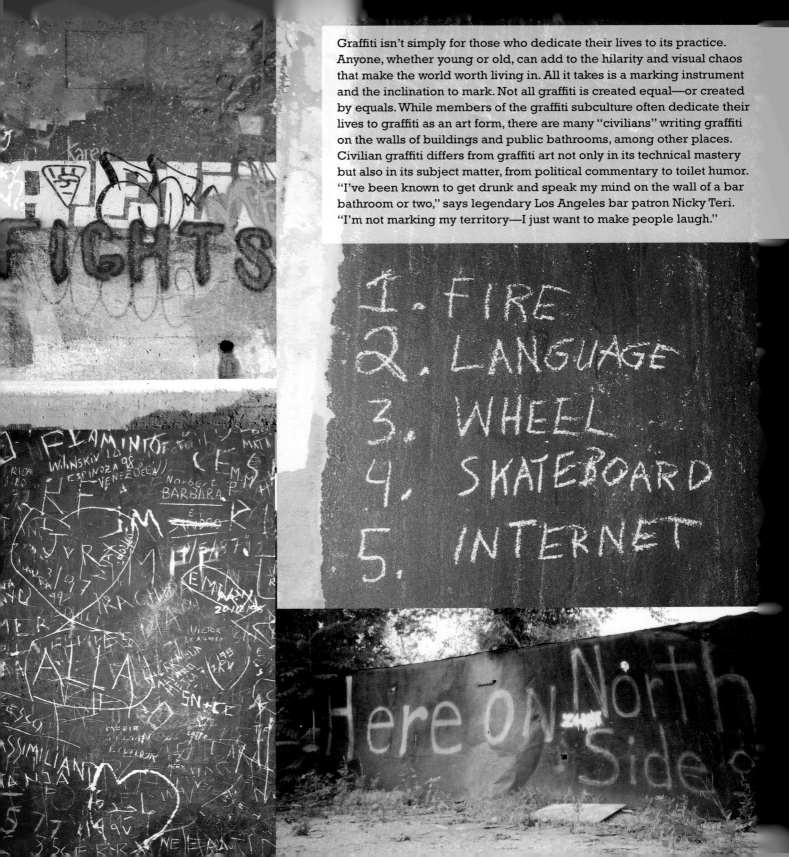

Graffiti isn't simply for those who dedicate their lives to its practice. Anyone, whether young or old, can add to the hilarity and visual chaos that make the world worth living in. All it takes is a marking instrument and the inclination to mark. Not all graffiti is created equal—or created by equals. While members of the graffiti subculture often dedicate their lives to graffiti as an art form, there are many "civilians" writing graffiti on the walls of buildings and public bathrooms, among other places. Civilian graffiti differs from graffiti art not only in its technical mastery but also in its subject matter, from political commentary to toilet humor. "I've been known to get drunk and speak my mind on the wall of a bar bathroom or two," says legendary Los Angeles bar patron Nicky Teri. "I'm not marking my territory—I just want to make people laugh."

1. FIRE
2. LANGUAGE
3. WHEEL
4. SKATEBOARD
5. INTERNET

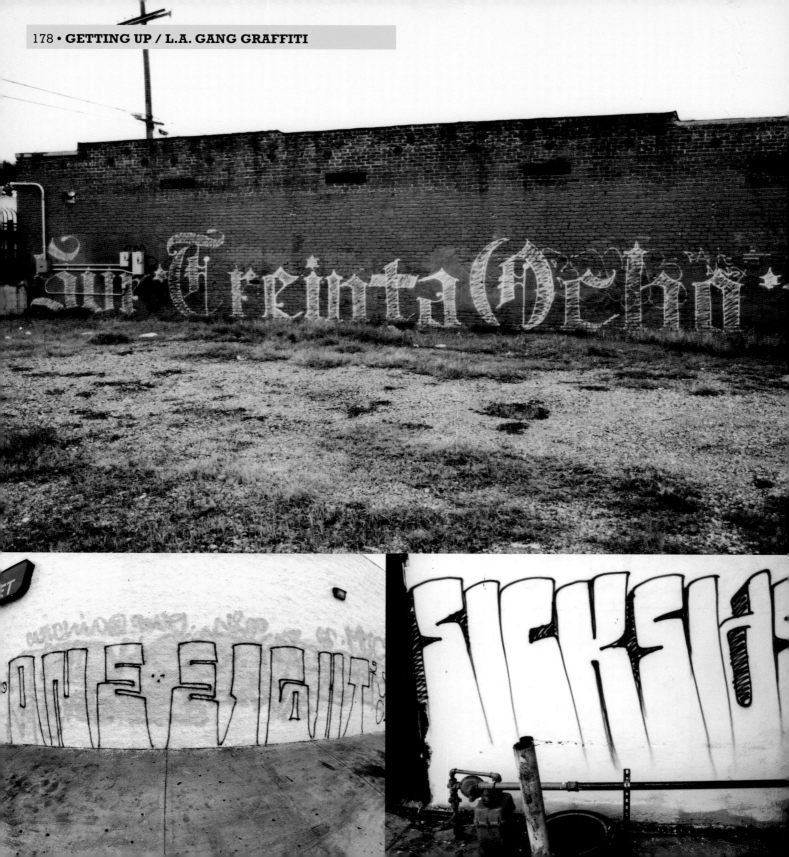

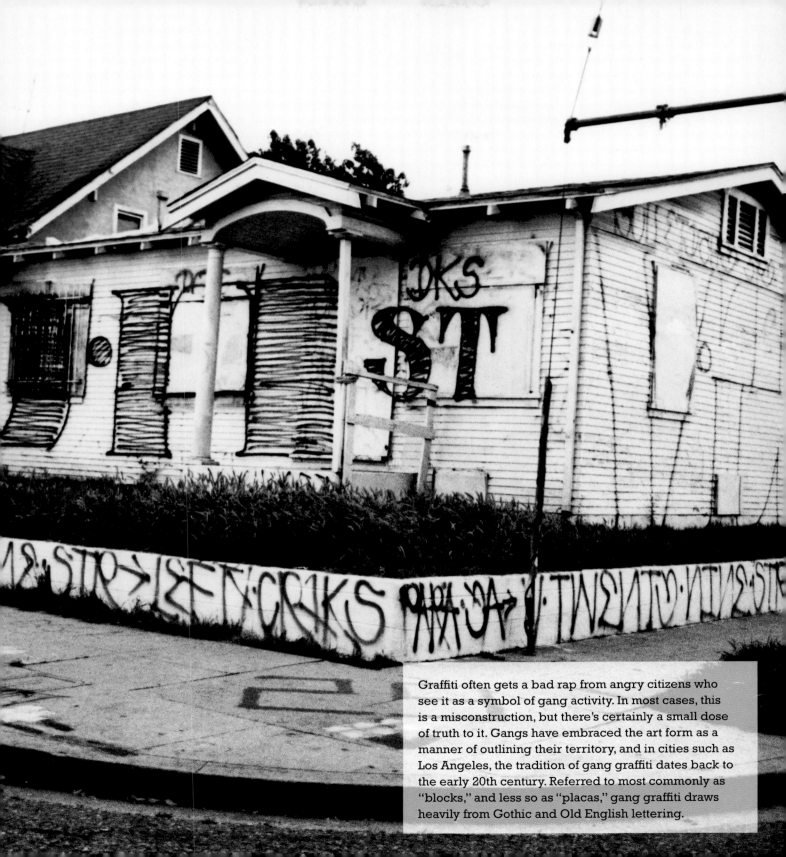

Graffiti often gets a bad rap from angry citizens who see it as a symbol of gang activity. In most cases, this is a misconstruction, but there's certainly a small dose of truth to it. Gangs have embraced the art form as a manner of outlining their territory, and in cities such as Los Angeles, the tradition of gang graffiti dates back to the early 20th century. Referred to most commonly as "blocks," and less so as "placas," gang graffiti draws heavily from Gothic and Old English lettering.

"Being a gangster in L.A., there's a romantic image
of the old school and old things," says famed L.A.
tattoo artist Mister Cartoon. Unlike graffiti done
for art's sake or for individual fame, gang graffiti
is far more straightforward and no-frills. As Mister
Cartoon explains, "It's not done to be pretty; it's
done to put territory down and let you know where
you're entering."

'It's not done to be pretty; it's done to put territory down and let you know where you're entering."
Mister Cartoon

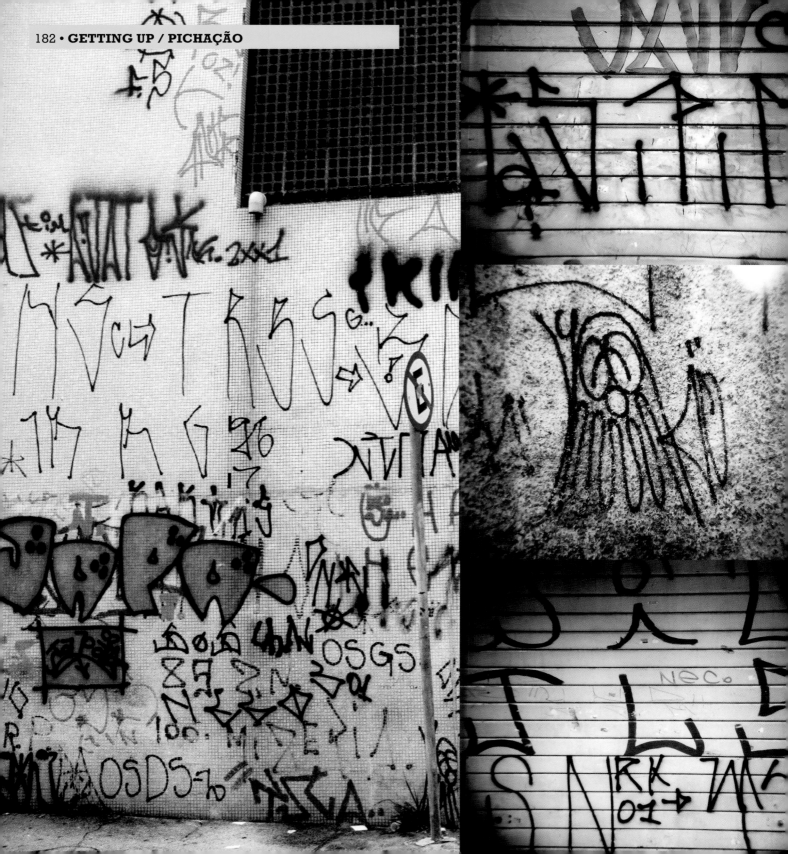

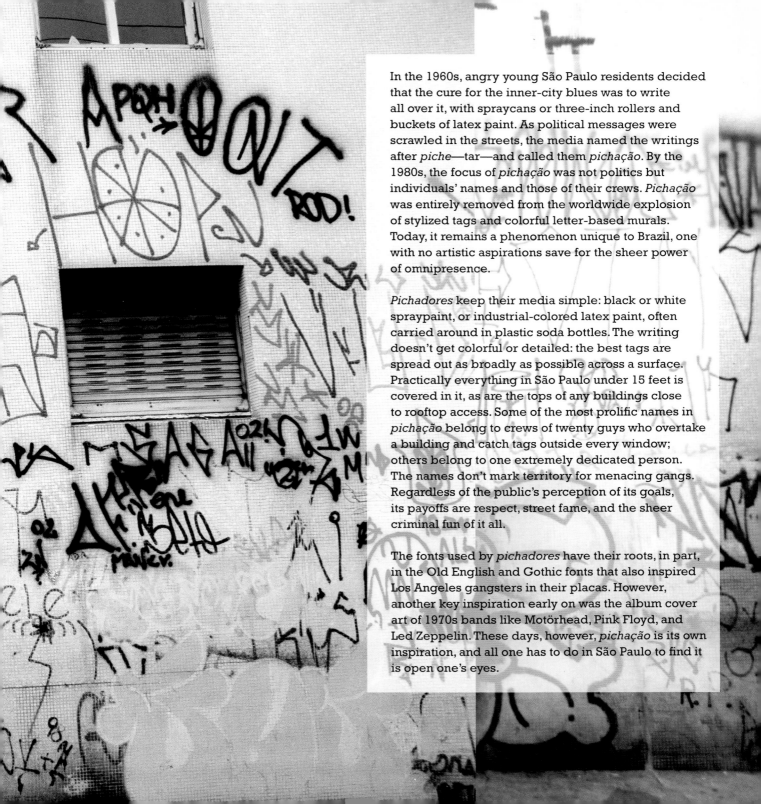

In the 1960s, angry young São Paulo residents decided that the cure for the inner-city blues was to write all over it, with spraycans or three-inch rollers and buckets of latex paint. As political messages were scrawled in the streets, the media named the writings after *piche*—tar—and called them *pichação*. By the 1980s, the focus of *pichação* was not politics but individuals' names and those of their crews. *Pichação* was entirely removed from the worldwide explosion of stylized tags and colorful letter-based murals. Today, it remains a phenomenon unique to Brazil, one with no artistic aspirations save for the sheer power of omnipresence.

Pichadores keep their media simple: black or white spraypaint, or industrial-colored latex paint, often carried around in plastic soda bottles. The writing doesn't get colorful or detailed: the best tags are spread out as broadly as possible across a surface. Practically everything in São Paulo under 15 feet is covered in it, as are the tops of any buildings close to rooftop access. Some of the most prolific names in *pichação* belong to crews of twenty guys who overtake a building and catch tags outside every window; others belong to one extremely dedicated person. The names don't mark territory for menacing gangs. Regardless of the public's perception of its goals, its payoffs are respect, street fame, and the sheer criminal fun of it all.

The fonts used by *pichadores* have their roots, in part, in the Old English and Gothic fonts that also inspired Los Angeles gangsters in their placas. However, another key inspiration early on was the album cover art of 1970s bands like Motörhead, Pink Floyd, and Led Zeppelin. These days, however, *pichação* is its own inspiration, and all one has to do in São Paulo to find it is open one's eyes.

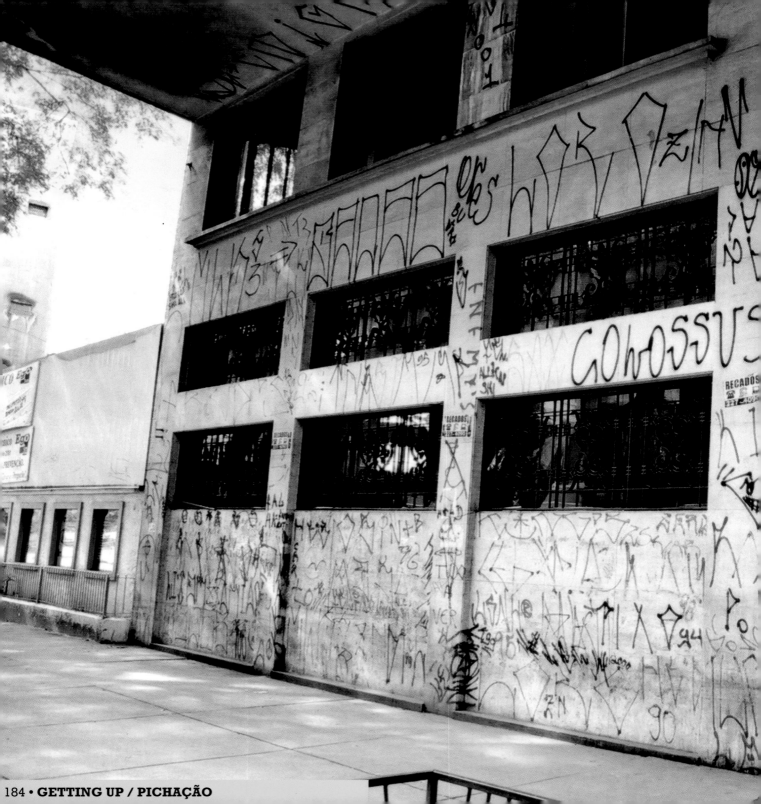

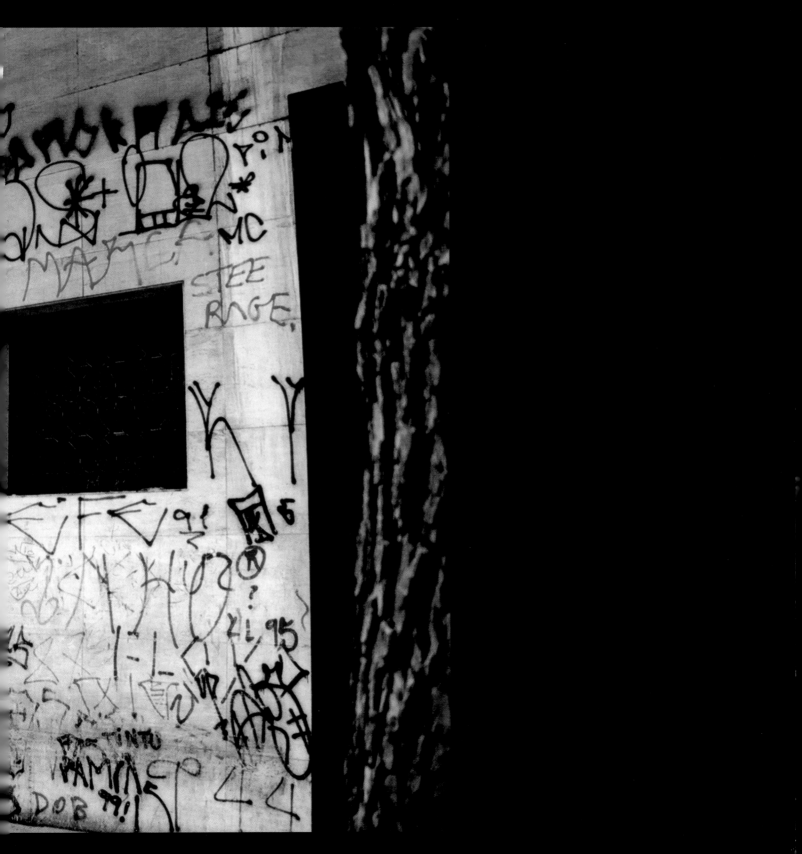

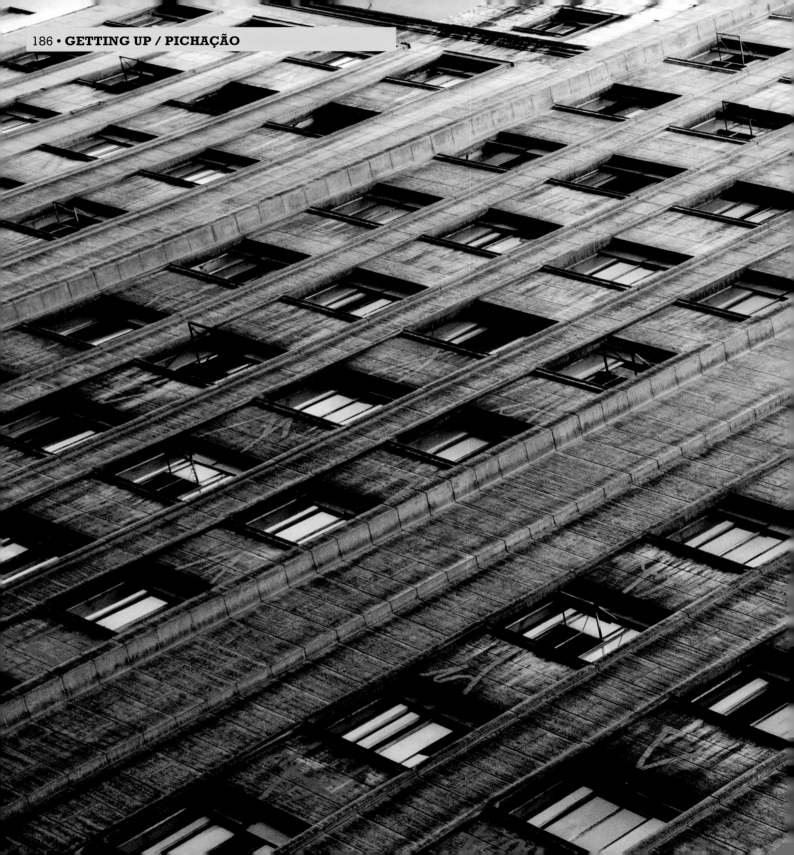

Somewhere between graffiti, murals, and other quasi-legal expression outdoors has emerged a movement that so far eludes any better name than street art. In many ways, "street art" is best defined as artwork done in the streets, illegally, that doesn't quite qualify as graffiti because it doesn't feature the artist's

"I'm happy when I see graffiti writers trying to communicate with people other than us 'graffiti friends'!" Blu

name front and center. Eschewing the name and style formulas of traditional graffiti, but embracing its irreverence and disregard for permission, street art has come to stay around the world alongside the graffiti movement from which it rose. Its media are wide open and still full of possibility. Street art can take the simple form of posters or stickers, or the more complex forms of fully rendered and elaborate sculptural installations or large murals.

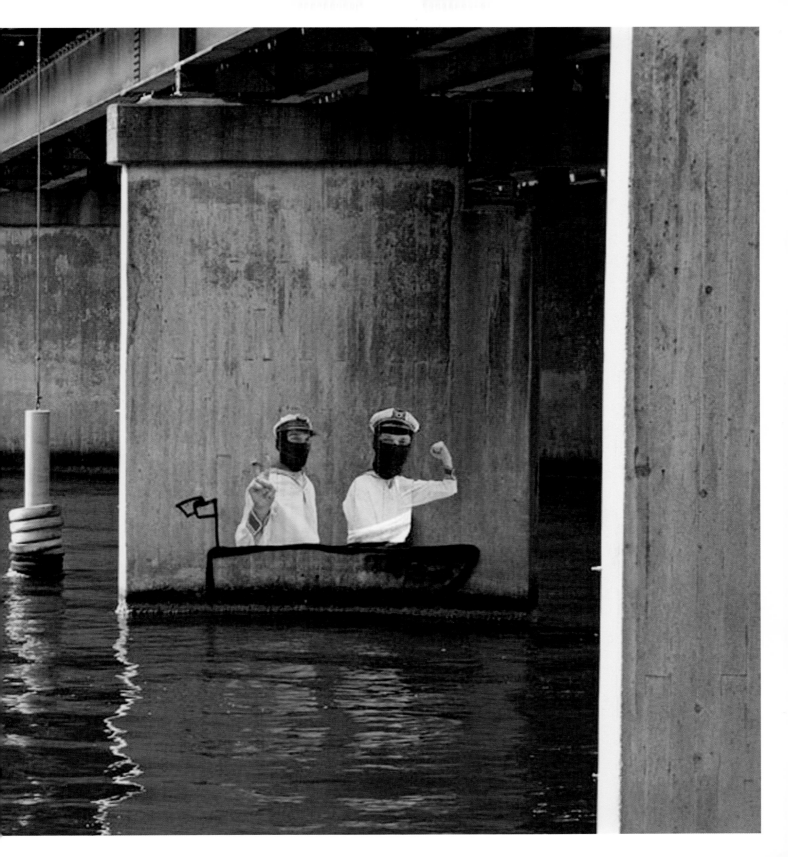

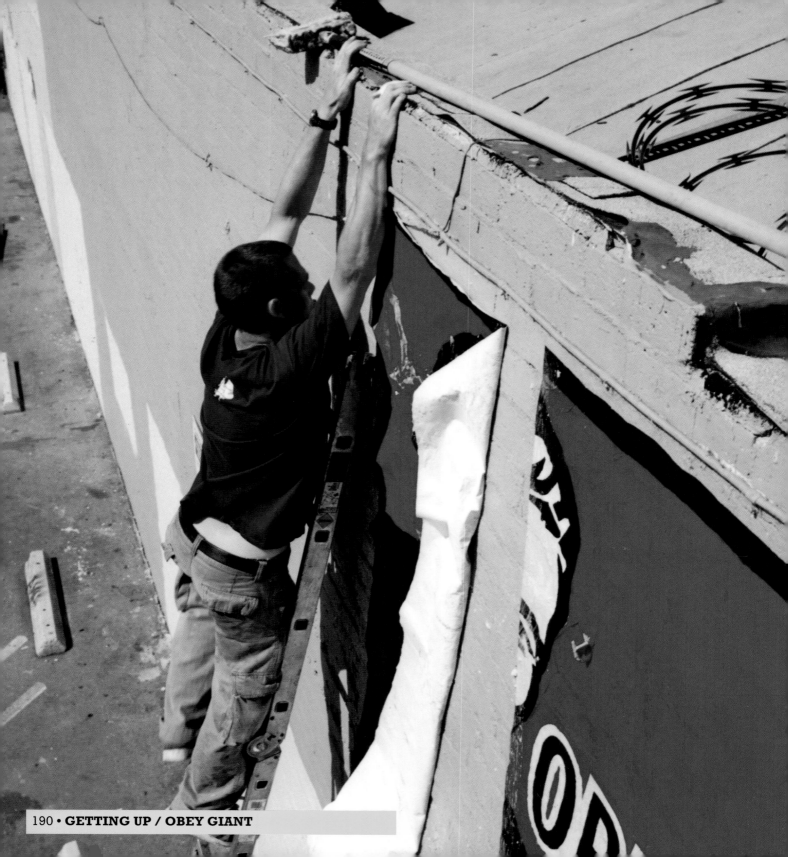

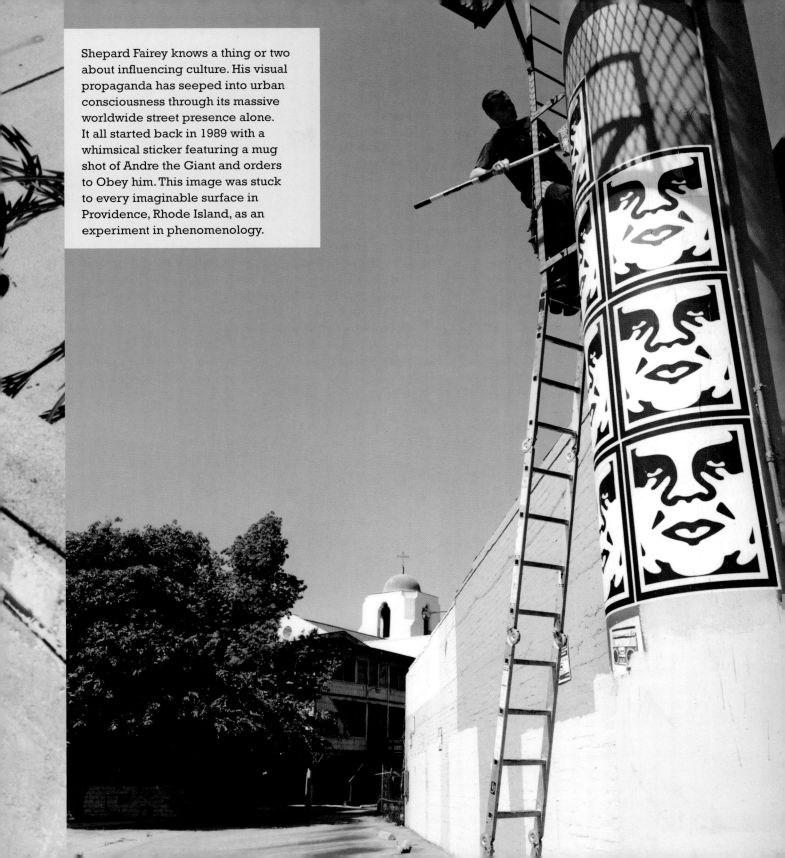

Shepard Fairey knows a thing or two about influencing culture. His visual propaganda has seeped into urban consciousness through its massive worldwide street presence alone. It all started back in 1989 with a whimsical sticker featuring a mug shot of Andre the Giant and orders to Obey him. This image was stuck to every imaginable surface in Providence, Rhode Island, as an experiment in phenomenology.

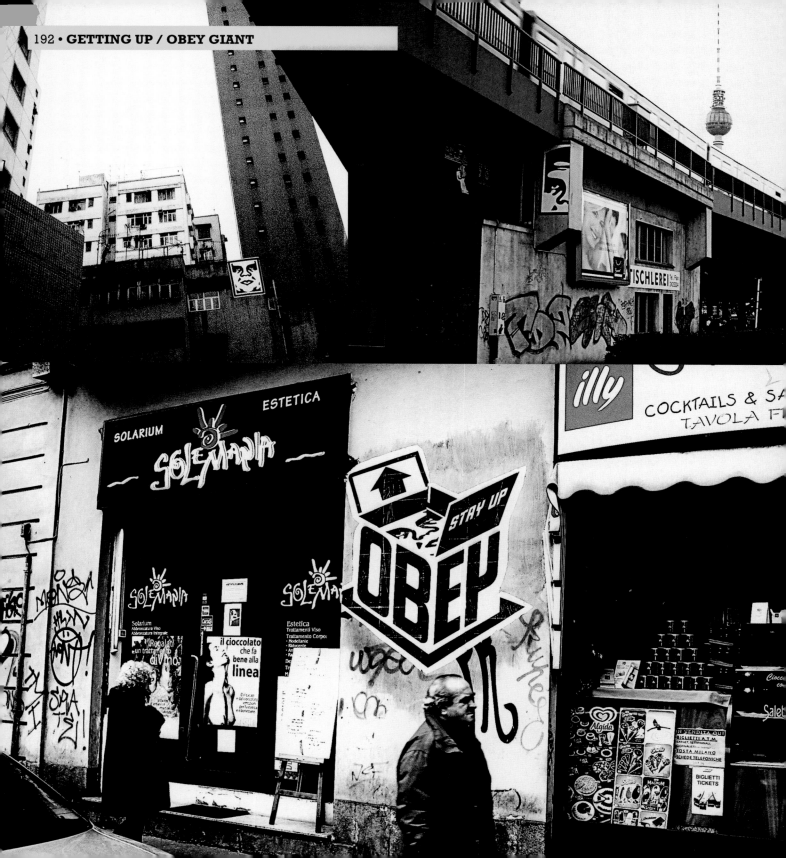

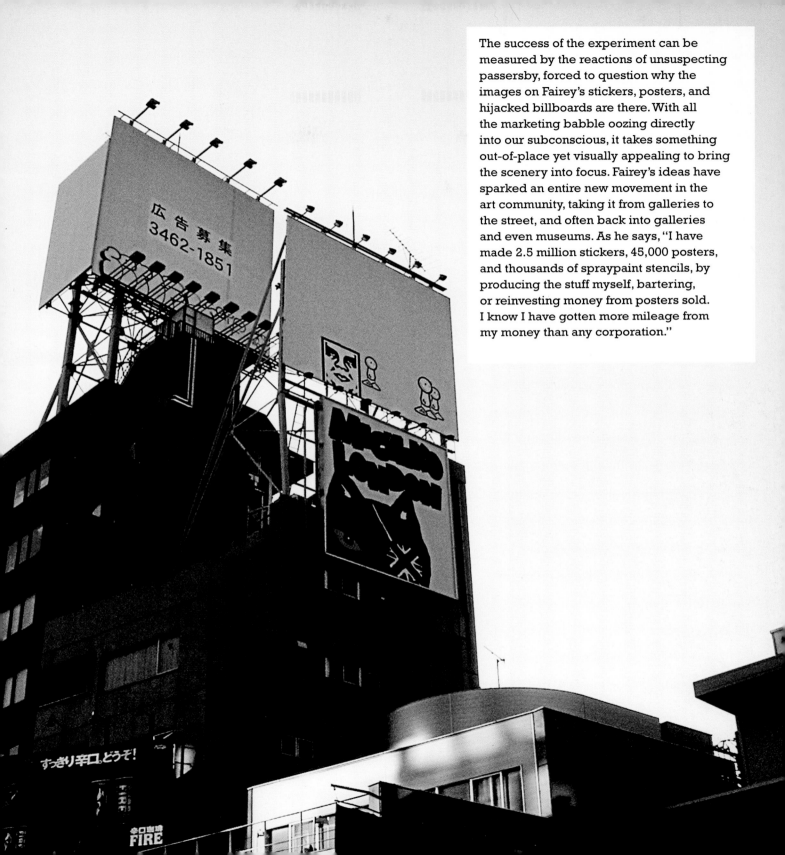

The success of the experiment can be measured by the reactions of unsuspecting passersby, forced to question why the images on Fairey's stickers, posters, and hijacked billboards are there. With all the marketing babble oozing directly into our subconscious, it takes something out-of-place yet visually appealing to bring the scenery into focus. Fairey's ideas have sparked an entire new movement in the art community, taking it from galleries to the street, and often back into galleries and even museums. As he says, "I have made 2.5 million stickers, 45,000 posters, and thousands of spraypaint stencils, by producing the stuff myself, bartering, or reinvesting money from posters sold. I know I have gotten more mileage from my money than any corporation."

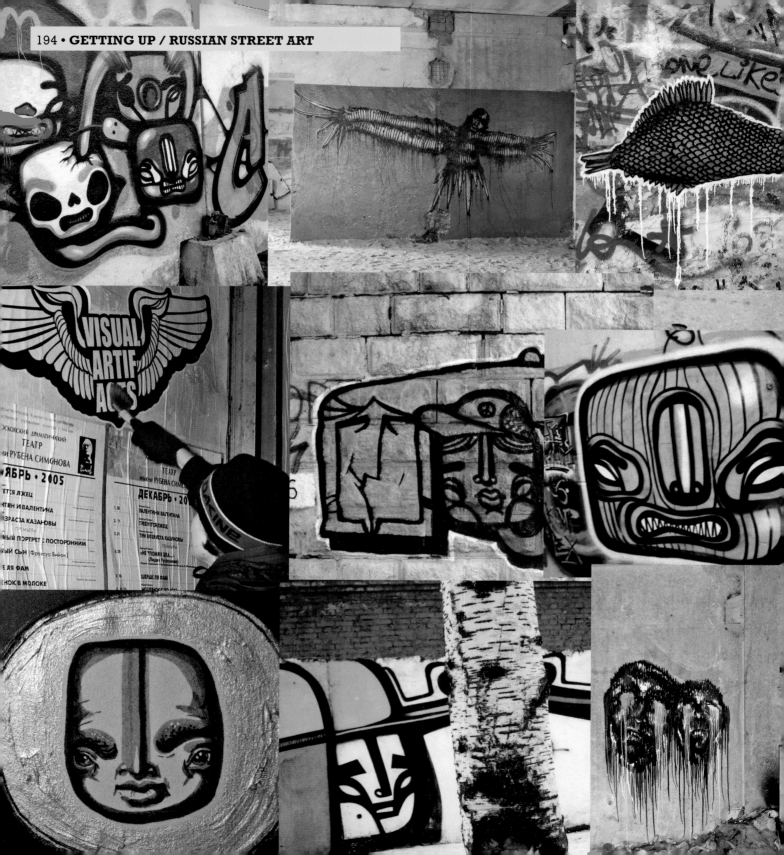

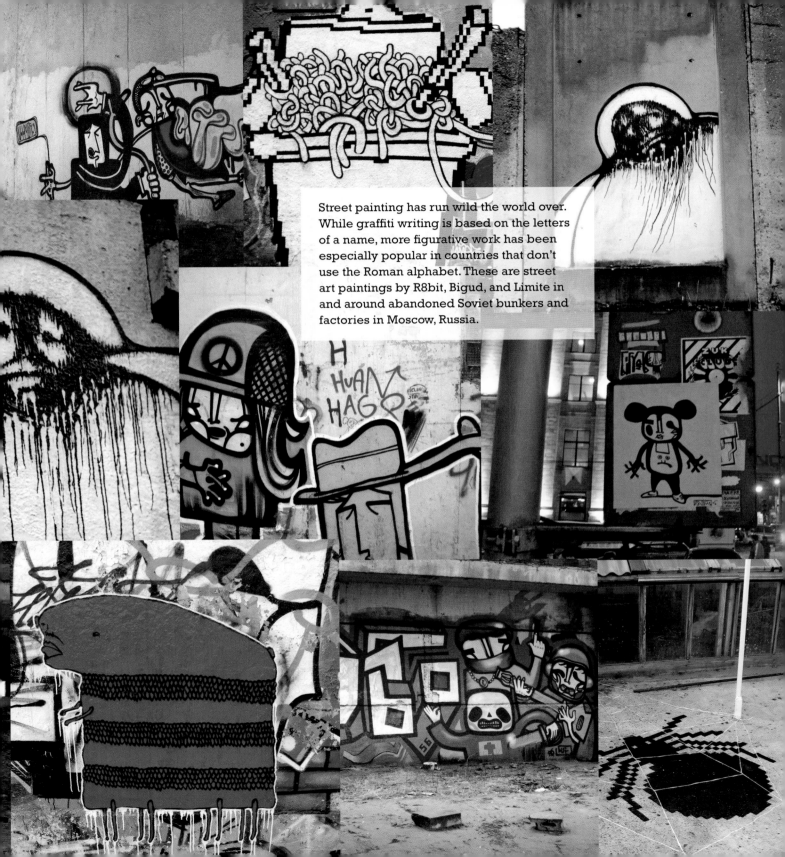

Street painting has run wild the world over. While graffiti writing is based on the letters of a name, more figurative work has been especially popular in countries that don't use the Roman alphabet. These are street art paintings by R8bit, Bigud, and Limite in and around abandoned Soviet bunkers and factories in Moscow, Russia.

British street artist Banksy wastes no words or space in delivering his powerfully ironic messages, which cover a broad range of social and political issues, from homelessness and famine to warmongering. No other artist today can say so much in so few words, not only through his images and phrases but also his guerrilla-style stunts. In 2006, Banksy received press all over the world after he placed a hooded mannequin in a jumpsuit, representing an alleged terrorist being held at the U.S. military's Guantanamo Bay detention facility, inside the confines of the Disneyland theme park. Other past feats include stealthily hanging his own paintings in some of the world's largest art museums and replacing Paris Hilton CDs in record stores with his own "remixed" versions (featuring songs like "Why Am I Famous?"). He has also traveled to parts of the world beset with political struggles, such as Palestine and Chiapas, Mexico, to paint murals in support of the people whom he feels have been wronged by their ruling governments.

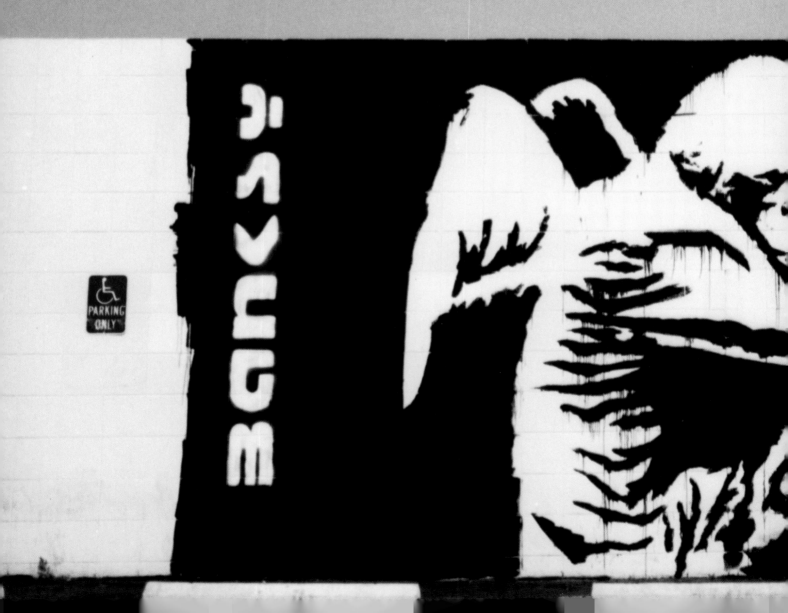

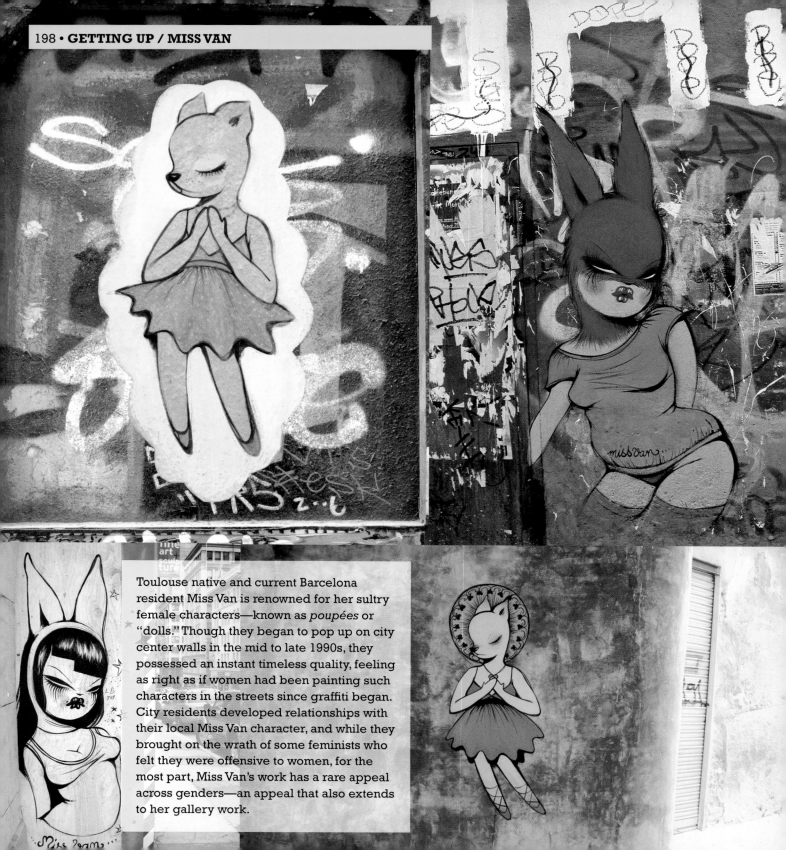

Toulouse native and current Barcelona resident Miss Van is renowned for her sultry female characters—known as *poupées* or "dolls." Though they began to pop up on city center walls in the mid to late 1990s, they possessed an instant timeless quality, feeling as right as if women had been painting such characters in the streets since graffiti began. City residents developed relationships with their local Miss Van character, and while they brought on the wrath of some feminists who felt they were offensive to women, for the most part, Miss Van's work has a rare appeal across genders—an appeal that also extends to her gallery work.

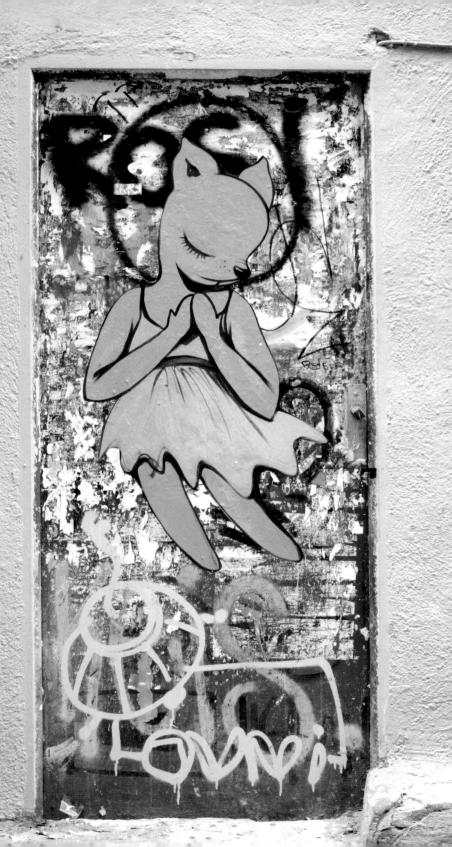

"Lots of people
were passing by on
the streets of Toulouse,
every Sunday, trying
to find a new *poupée*.
It became like a habit."
Miss Van

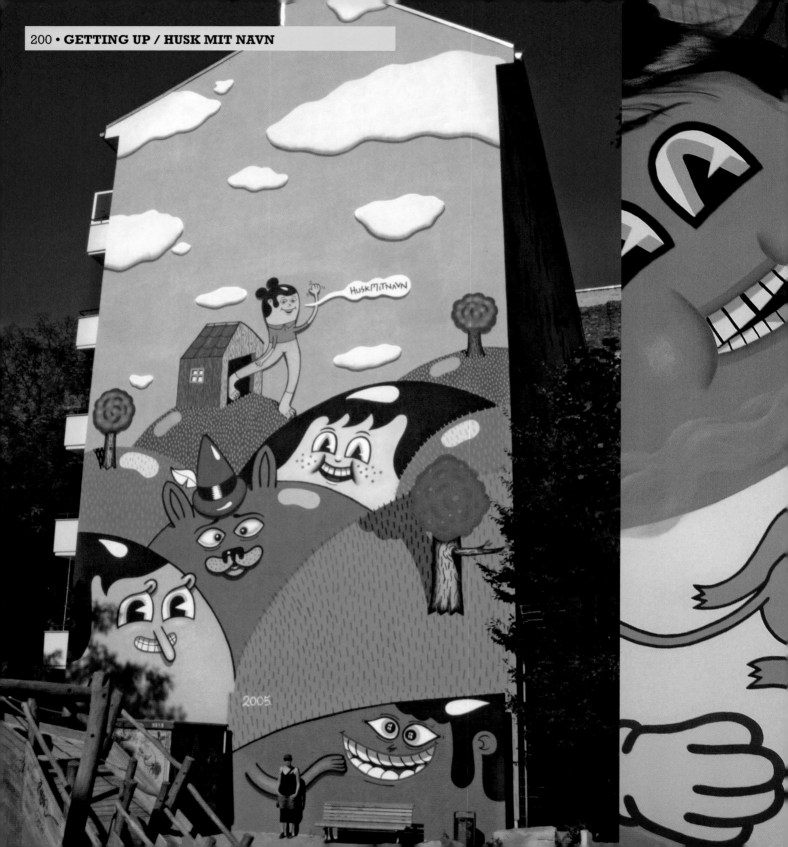

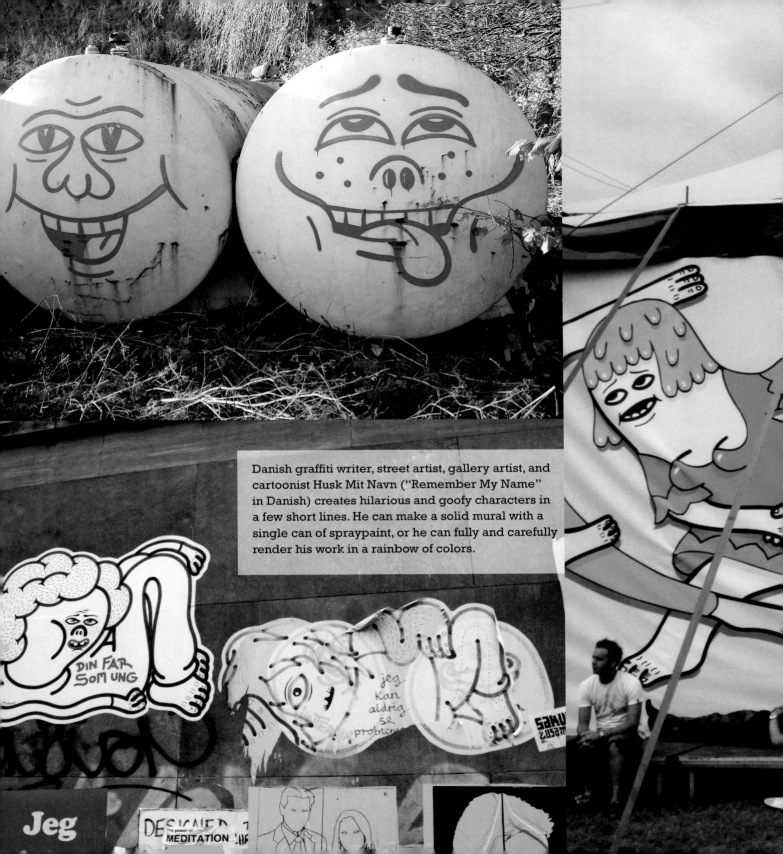

Danish graffiti writer, street artist, gallery artist, and cartoonist Husk Mit Navn ("Remember My Name" in Danish) creates hilarious and goofy characters in a few short lines. He can make a solid mural with a single can of spraypaint, or he can fully and carefully render his work in a rainbow of colors.

DIN FAR SOM UNG

jeg kan aldrig se problem

Jeg

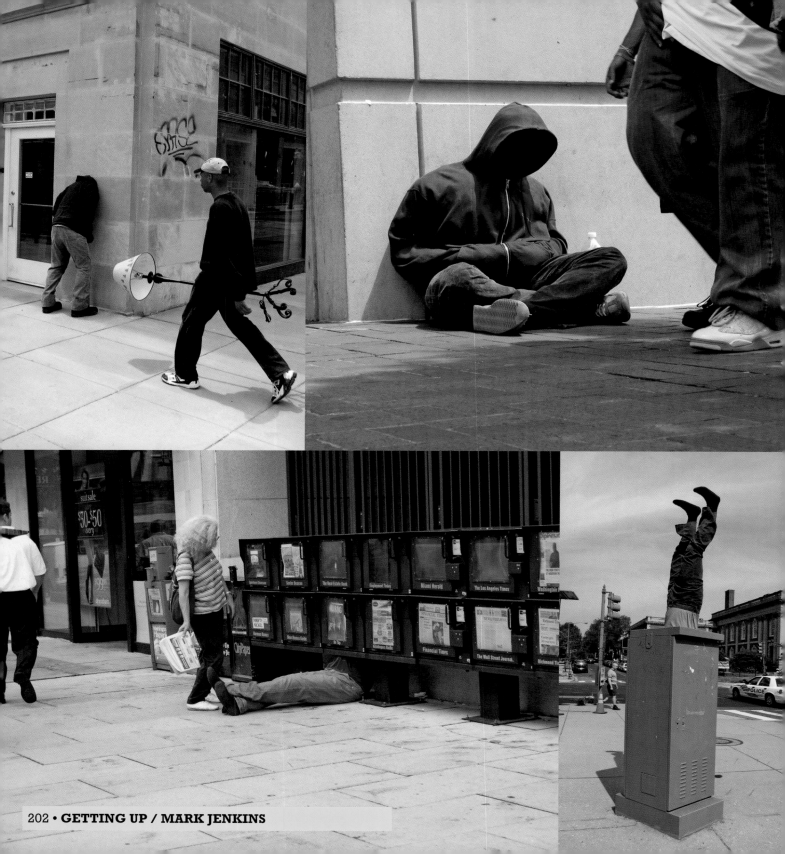

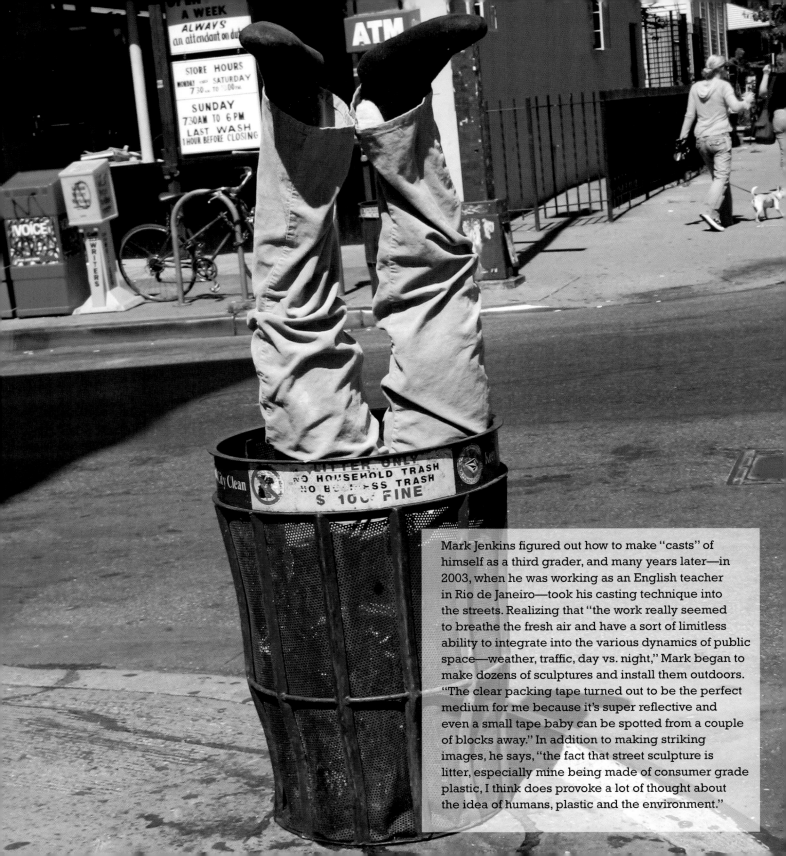

Mark Jenkins figured out how to make "casts" of himself as a third grader, and many years later—in 2003, when he was working as an English teacher in Rio de Janeiro—took his casting technique into the streets. Realizing that "the work really seemed to breathe the fresh air and have a sort of limitless ability to integrate into the various dynamics of public space—weather, traffic, day vs. night," Mark began to make dozens of sculptures and install them outdoors. "The clear packing tape turned out to be the perfect medium for me because it's super reflective and even a small tape baby can be spotted from a couple of blocks away." In addition to making striking images, he says, "the fact that street sculpture is litter, especially mine being made of consumer grade plastic, I think does provoke a lot of thought about the idea of humans, plastic and the environment."

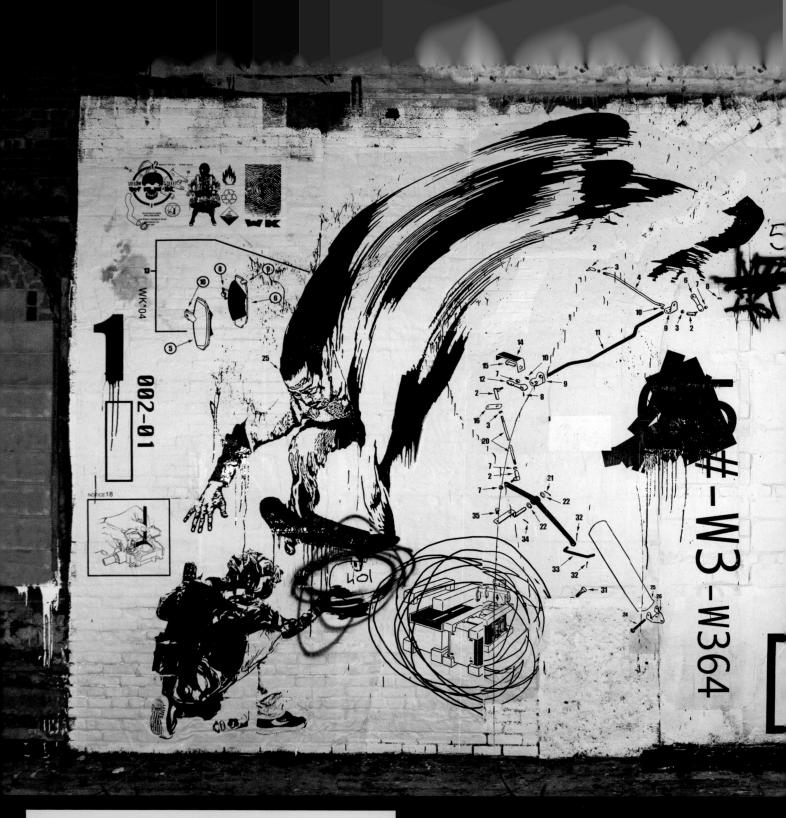

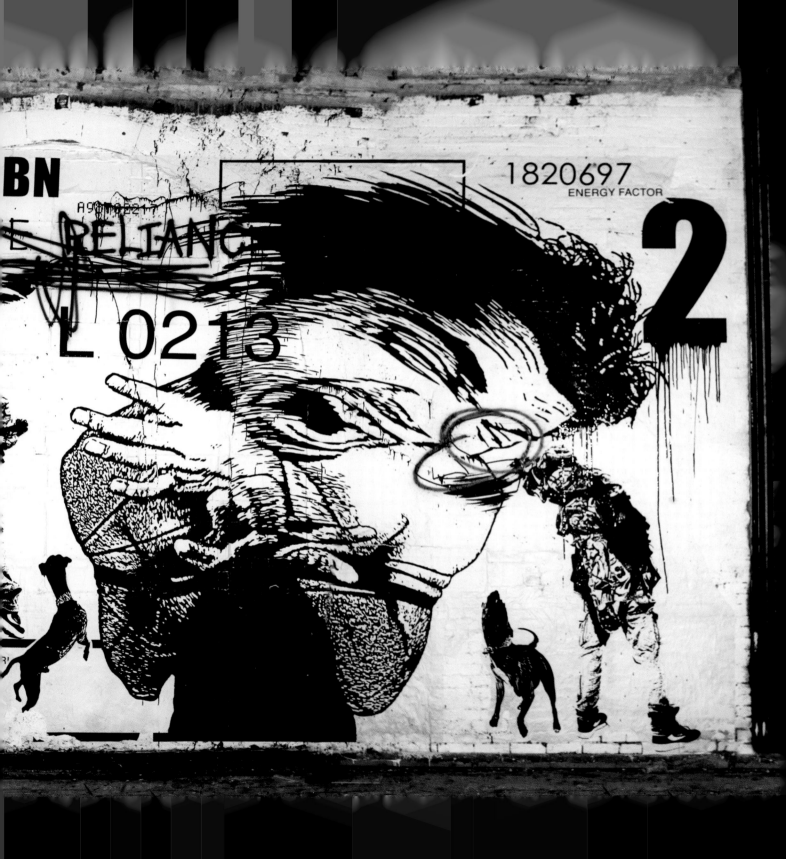

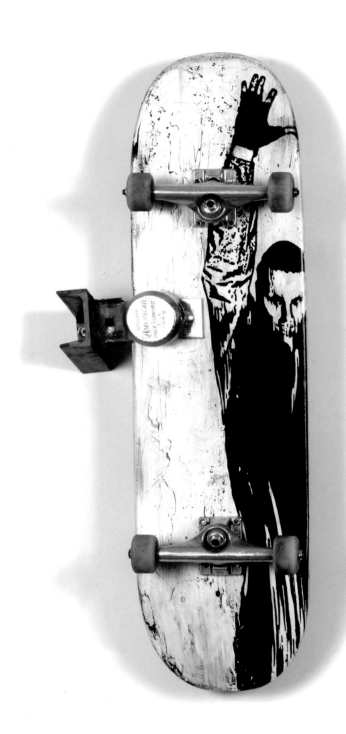
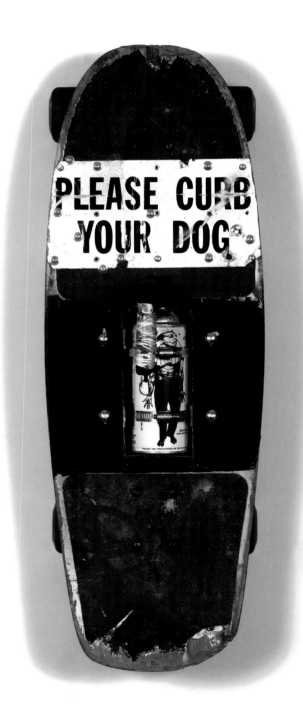

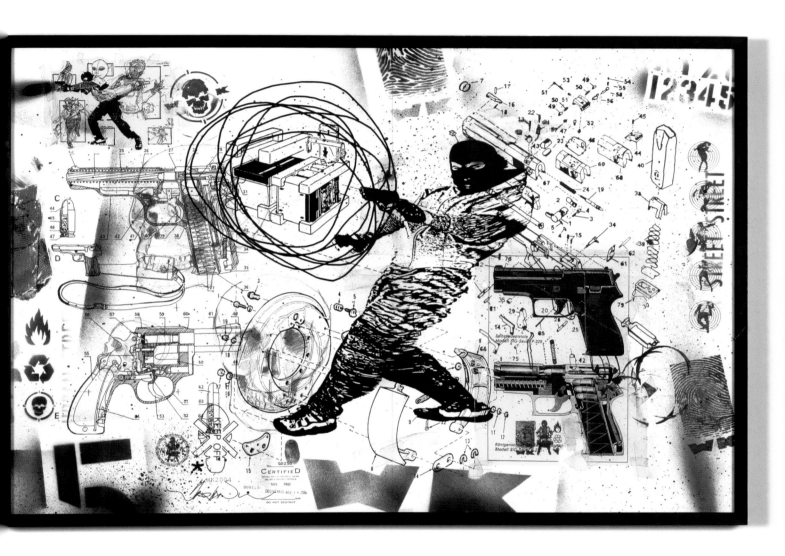

WK Interact is a French artist living in New York City, where he creates both studio and street artworks. His elongated black-and-white images of stretched figures are instantly recognizable, and should you be fortunate enough to stumble upon one, you'll know it a block away.

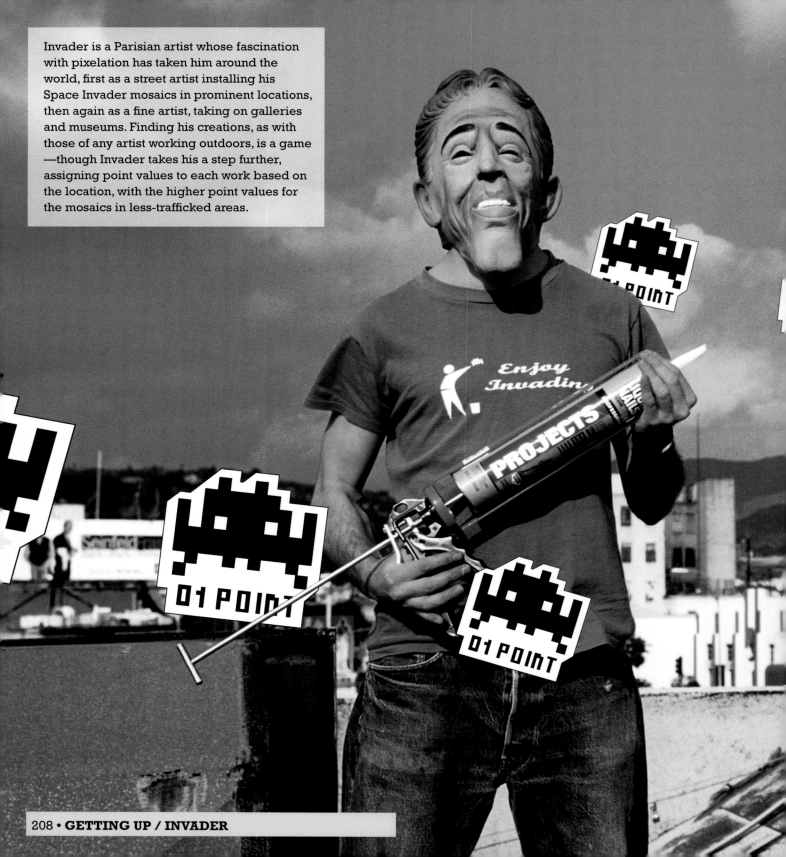

Invader is a Parisian artist whose fascination with pixelation has taken him around the world, first as a street artist installing his Space Invader mosaics in prominent locations, then again as a fine artist, taking on galleries and museums. Finding his creations, as with those of any artist working outdoors, is a game —though Invader takes his a step further, assigning point values to each work based on the location, with the higher point values for the mosaics in less-trafficked areas.

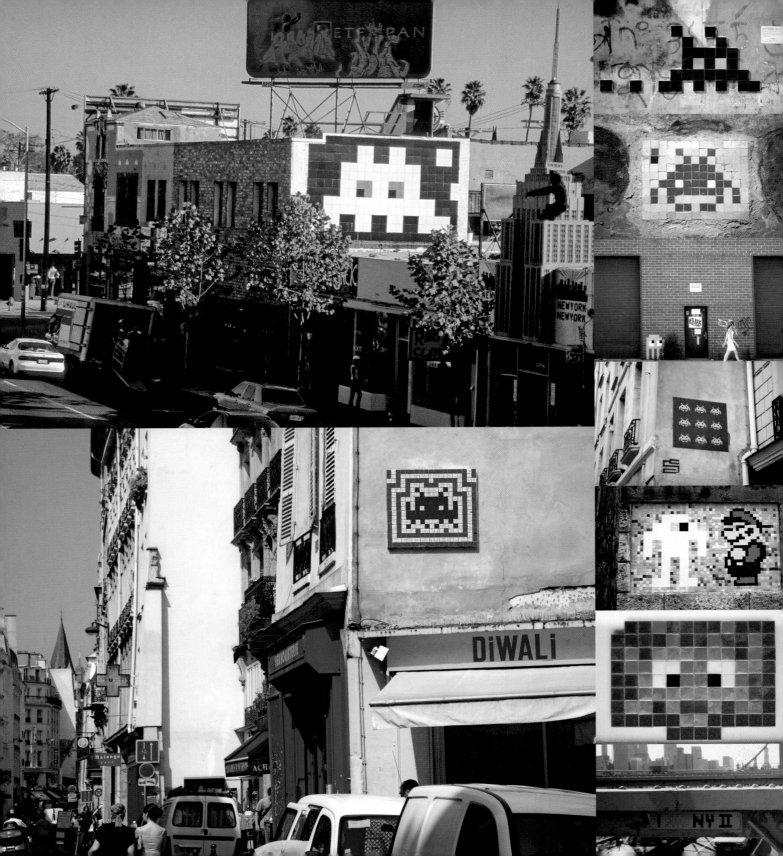

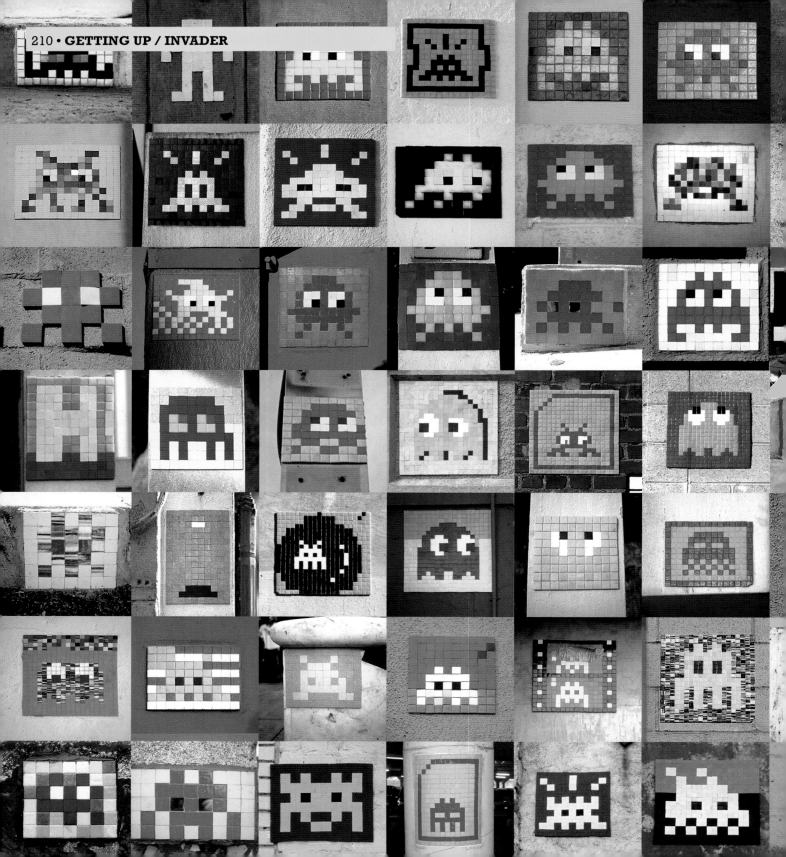

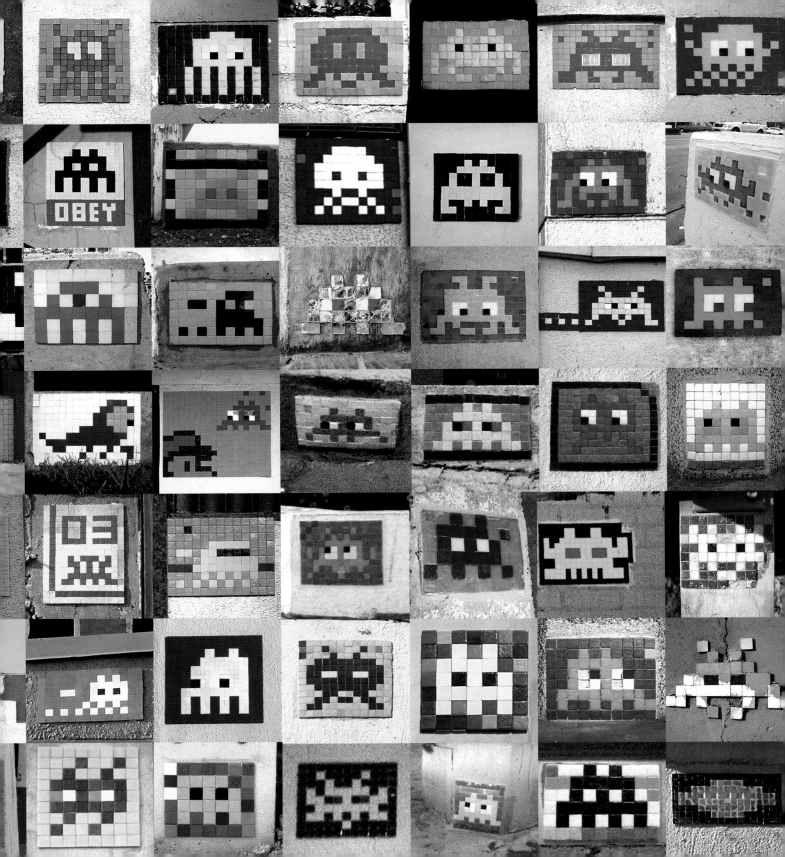

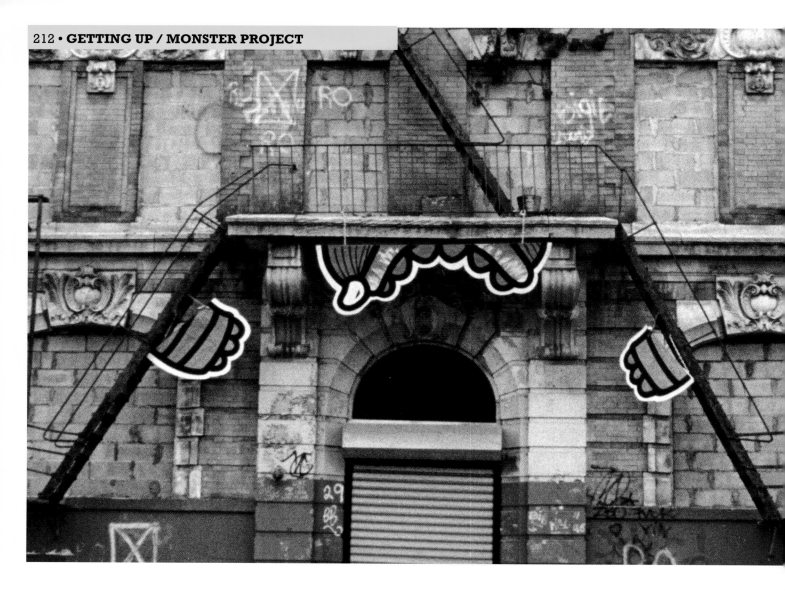

Beginning in late 2000, the Monster Project team has created site-specific installations focusing on the forgotten corners of cities including Boston, New York, and Providence. Often requiring extensive planning and late-night execution, each piece becomes a story, each installation an adventure. No two are exactly the same, as no two locations are ever identical.

The intent of the Monster Project was always to end rather than to go "all city" or to "keep it real." The Monster itself has always been secondary to the location. Ultimately, in that sense, the Project was fatalistic. If people are able to imagine the Monster where it is not, the Project's goal has been fulfilled, and the Monster has become unnecessary.

"Our goal was always to point out the forgotten beauty in the city, those forgotten corners, decrepit walls, and neglected structures of any kind. The places we seek out are the grimy nooks where the Monster can quietly creep into existence."

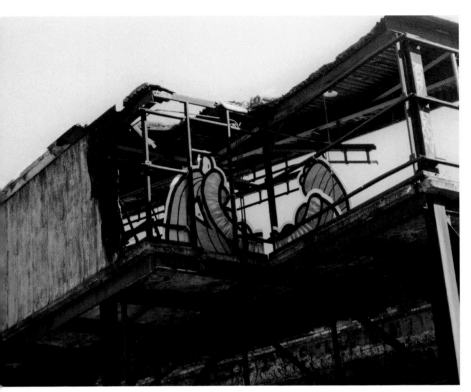
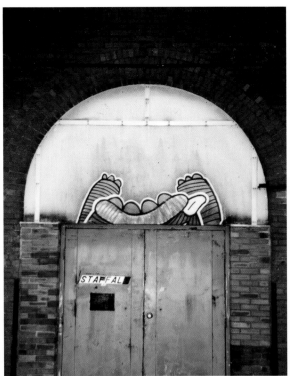

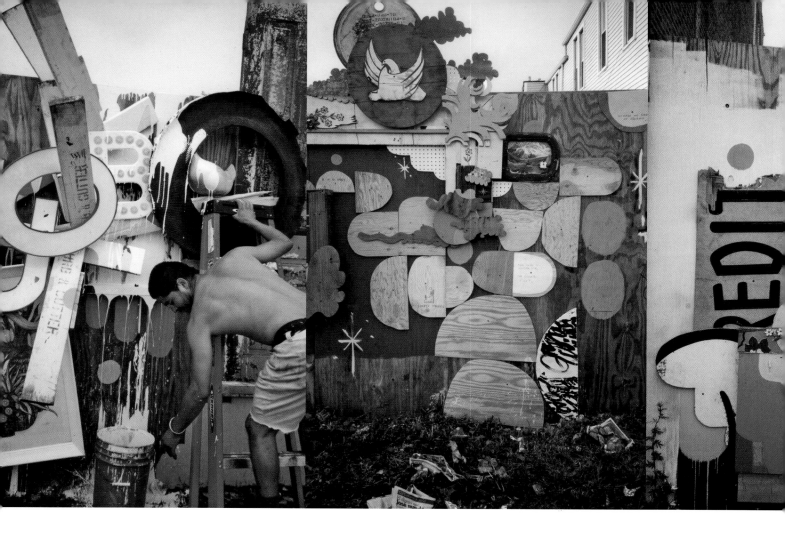

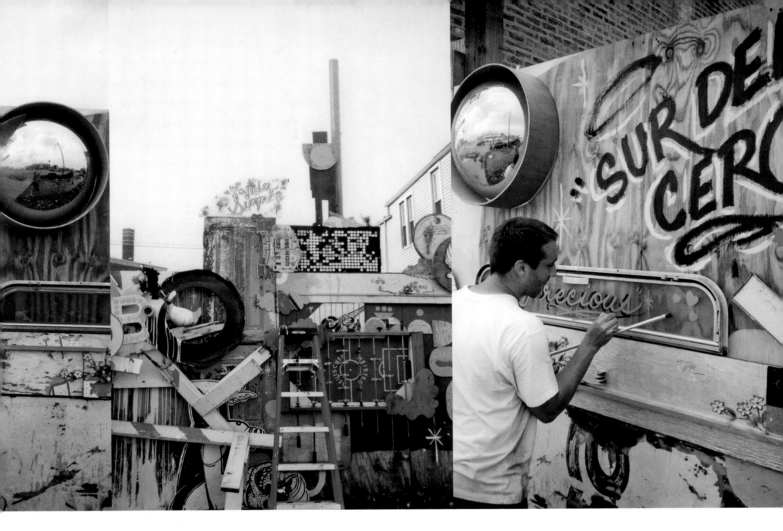

The Chicago artist trio of Juan Chavez, Mike Genovese, and Cody Hudson, along with local friends and numerous visitors, collect found wood and objects and install them on the various surfaces that they paint. In their *Sur del Cero* project, shown here and one of many combinations of mural, installation, and sculpture they have made, they neither waste nor want for materials—a perfect combination for art in the streets.

The trio took their act on the road, bringing a big van to gather found materials. They drove from Chicago to Philadelphia, gathering found objects, turning them into artworks, and installing them along the way to their destination, the Philadelphia artist collective and gallery Space 1026, which exhibited the results of their travels in a 2006 show called "Long Walk Home."

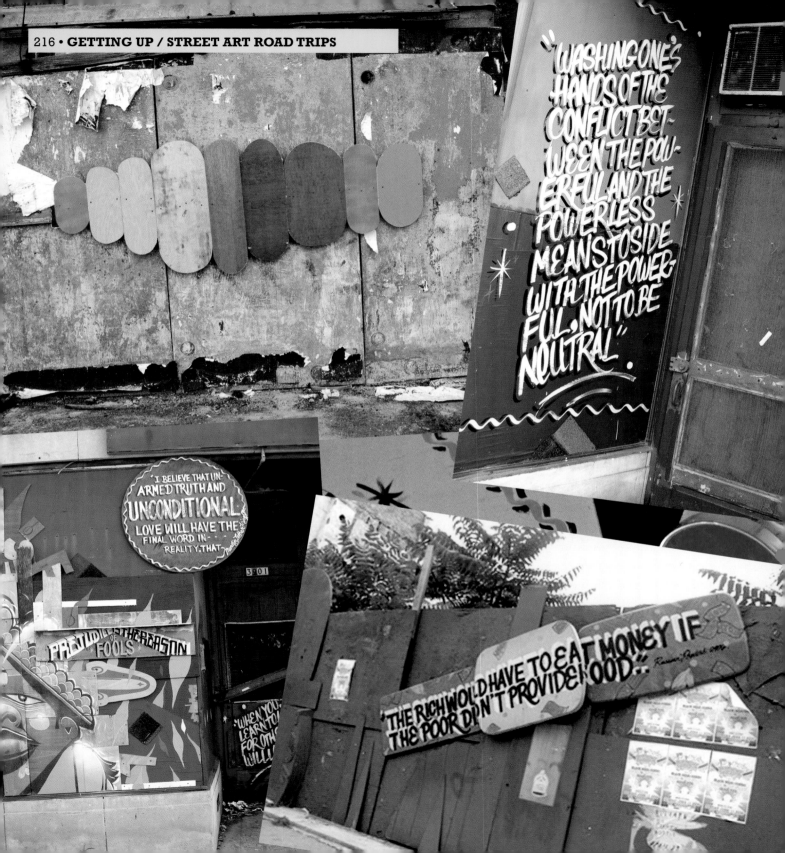

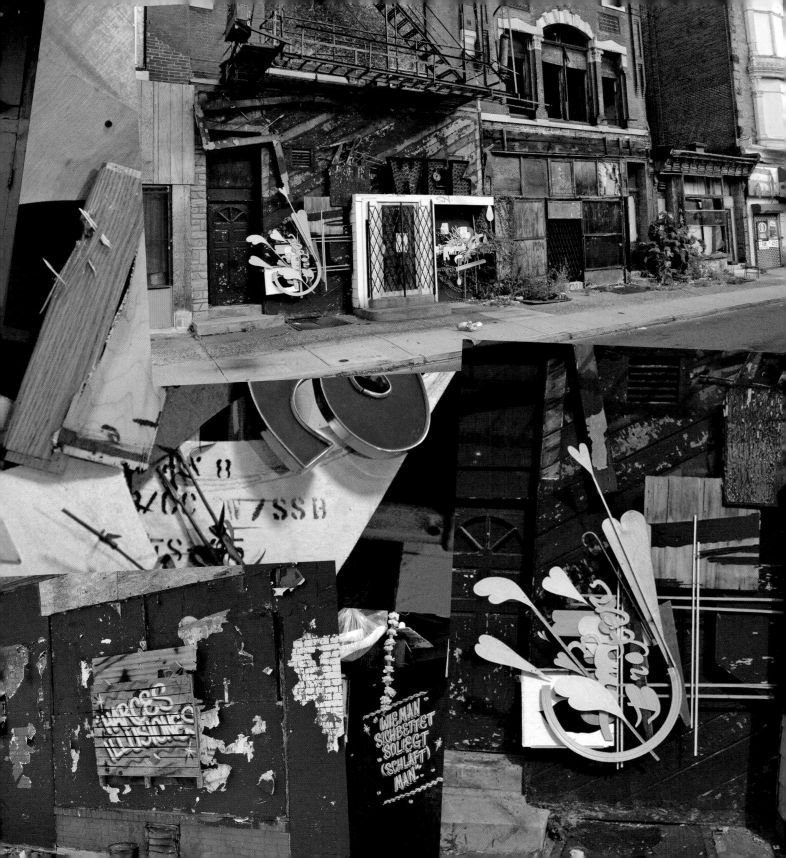

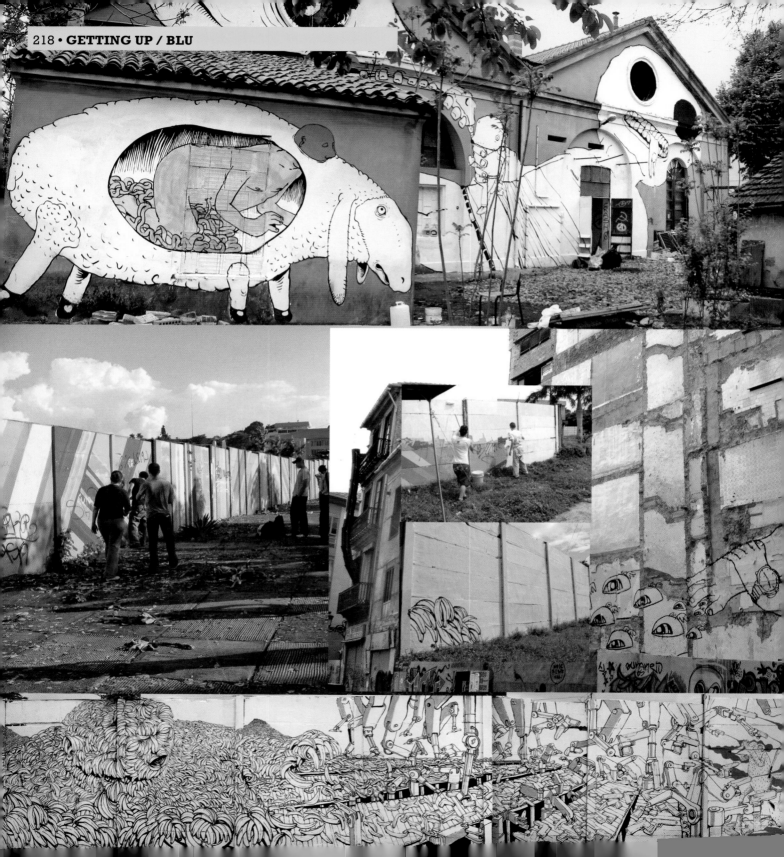

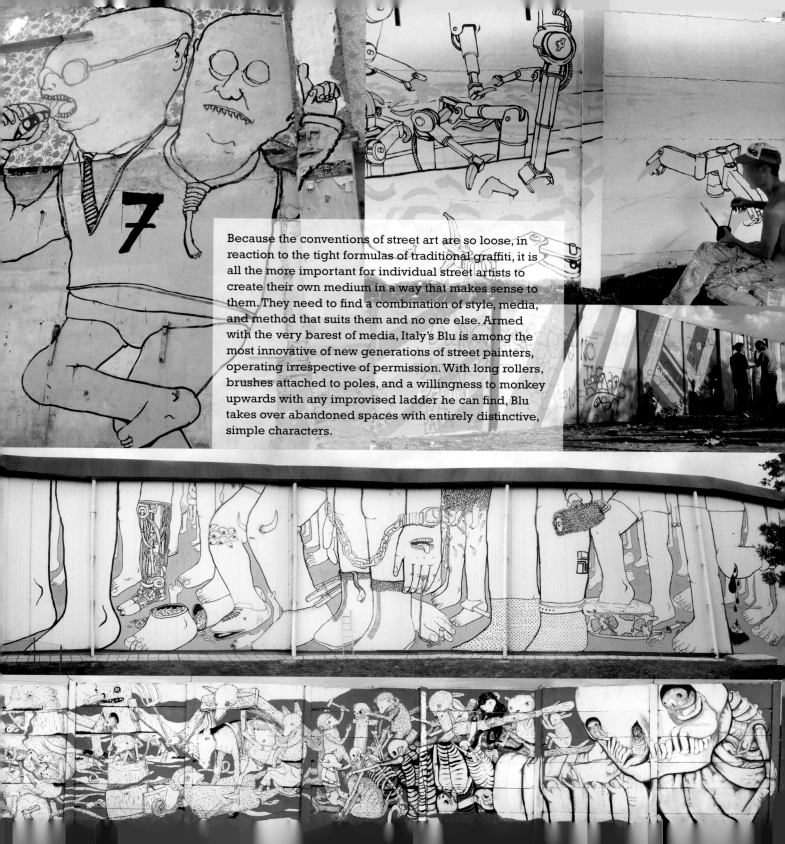

Because the conventions of street art are so loose, in reaction to the tight formulas of traditional graffiti, it is all the more important for individual street artists to create their own medium in a way that makes sense to them. They need to find a combination of style, media, and method that suits them and no one else. Armed with the very barest of media, Italy's Blu is among the most innovative of new generations of street painters, operating irrespective of permission. With long rollers, brushes attached to poles, and a willingness to monkey upwards with any improvised ladder he can find, Blu takes over abandoned spaces with entirely distinctive, simple characters.

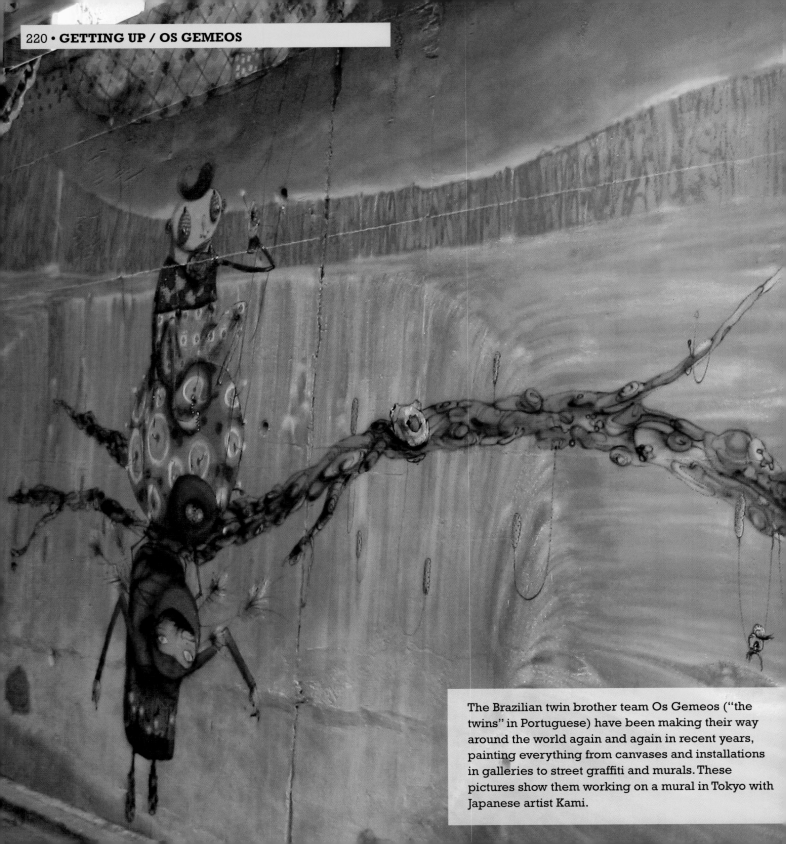

The Brazilian twin brother team Os Gemeos ("the twins" in Portuguese) have been making their way around the world again and again in recent years, painting everything from canvases and installations in galleries to street graffiti and murals. These pictures show them working on a mural in Tokyo with Japanese artist Kami.

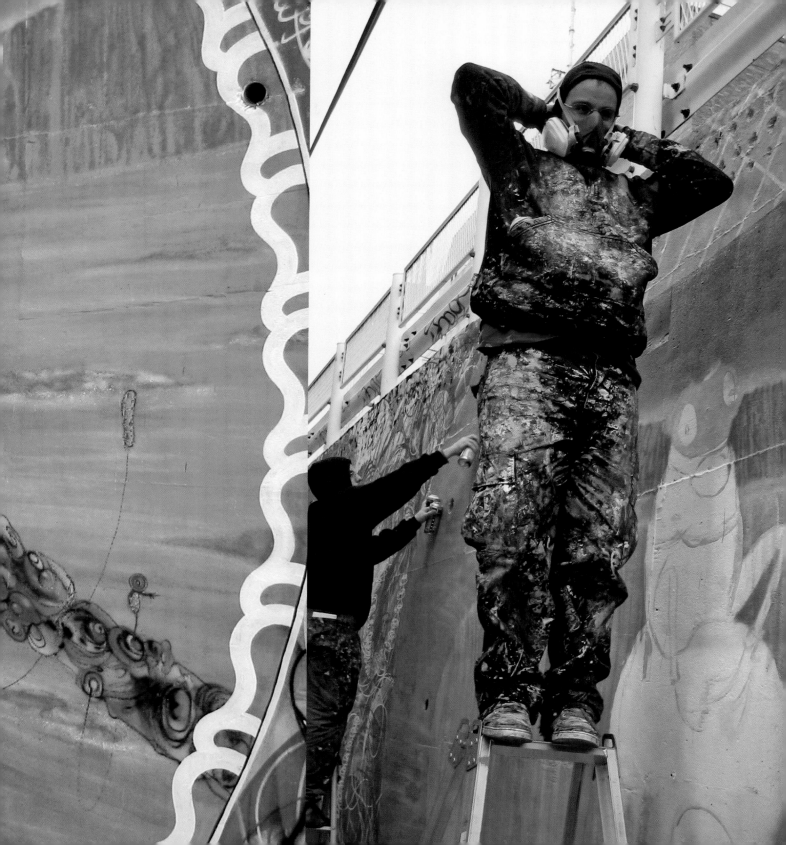

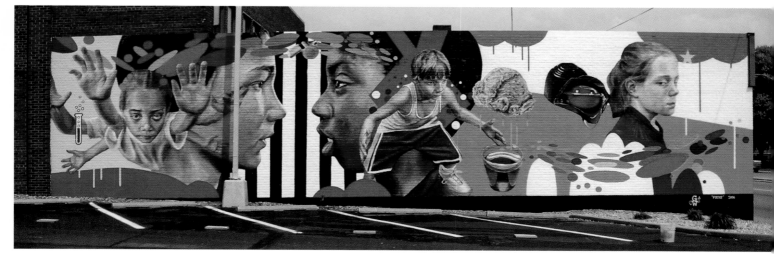

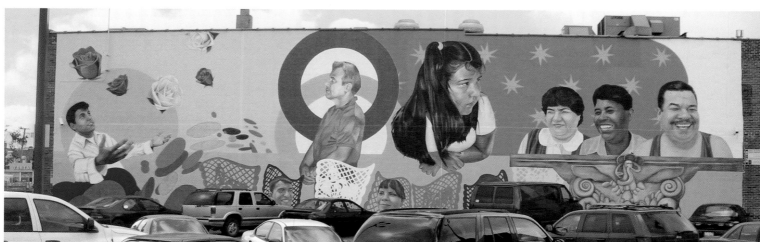

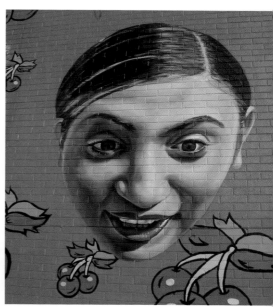

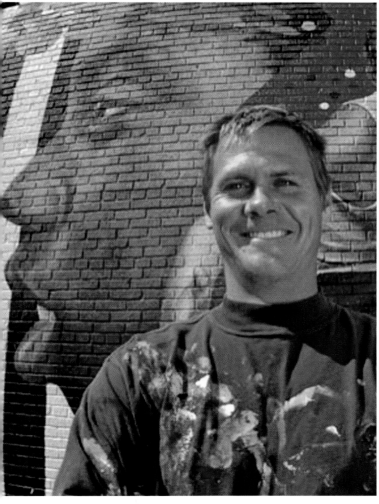

Chicago artist Jeff Zimmermann got his first mural gig by saying yes to a job other artists had turned down: a mural of the Virgin of Guadalupe for a local pastor. It was 1996, and while he had been painting in his apartment for a tiny audience of friends and roommates, suddenly tens of thousands of people saw his mural. He was on his way, but that didn't mean that finding walls to paint would be any less of a pain.

"Getting walls can ruin your self-esteem," he says. "Quite often people just assume you have a scam. Like you just want to fall off your ladder and sue. I go to them, they don't come to me, so there's a lot of rejection. You've got to convince people that they need a piece of public art on their property and that they need to come up with loads of money to fund it. This is easier after you've described in detail the amount of work involved, shown them quality past projects, and explained how the artwork will last around twenty years. Total budget spread out over twenty years equals not a bad deal. My advice would be to avoid projects with an emphasis on decision by committee. Waste of time. Find the yes-or-no person and deal with them alone."

Jeff is white, but since white people like white walls, to put it starkly, Jeff has found a receptive audience in non-white neighborhoods. "In Chicago, most of my work is in Latino, mostly Mexican, neighborhoods. I've also been able to create some work in other cities as well as in Honduras, Puerto Rico, Peru, and Kenya."

With murals being a public artwork, what they depict often becomes a public process as well. "I like to go prospecting in the neighborhood and meeting people," says Jeff. "If you do enough of this some locals will open up to you and then you've gotta become a salesman to convince them to pose for a couple of photos. The people who shoot the best—with the most emotion, expression, etc.—get included in the artwork."

"These paintings don't always read like a mural," Jeff continues, since murals often signify a dull image of community rainbows and hands holding the world. Ultimately, "a person can walk up and look left and right, then immediately say they don't get it. Well, it's not a billboard. Maybe the twentieth time you pass by something will hit you and you'll gain some insight. Isn't that more rewarding?"

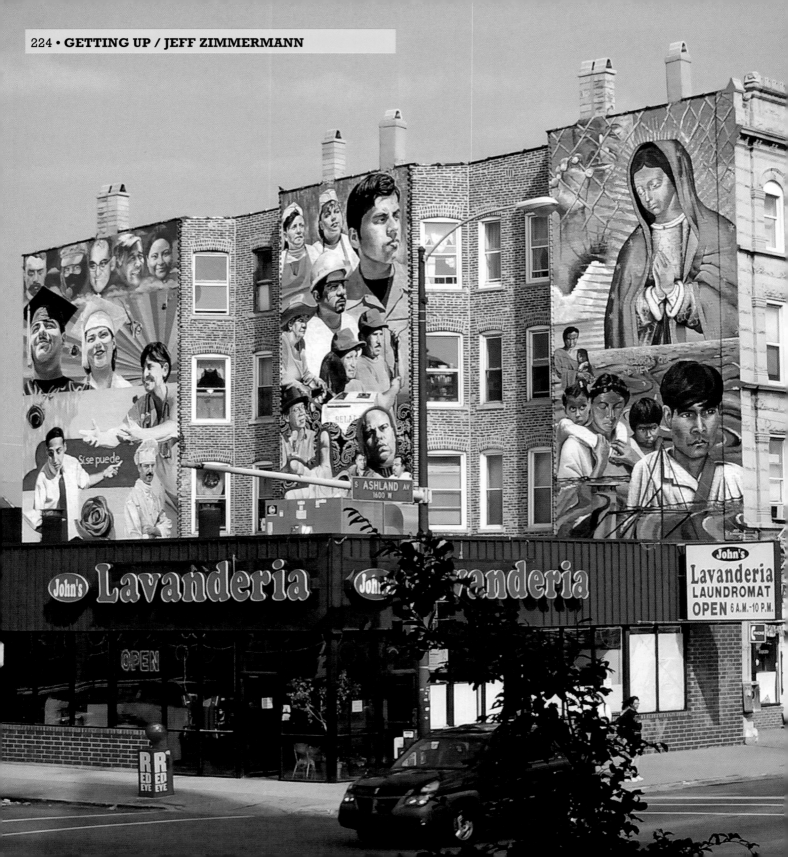

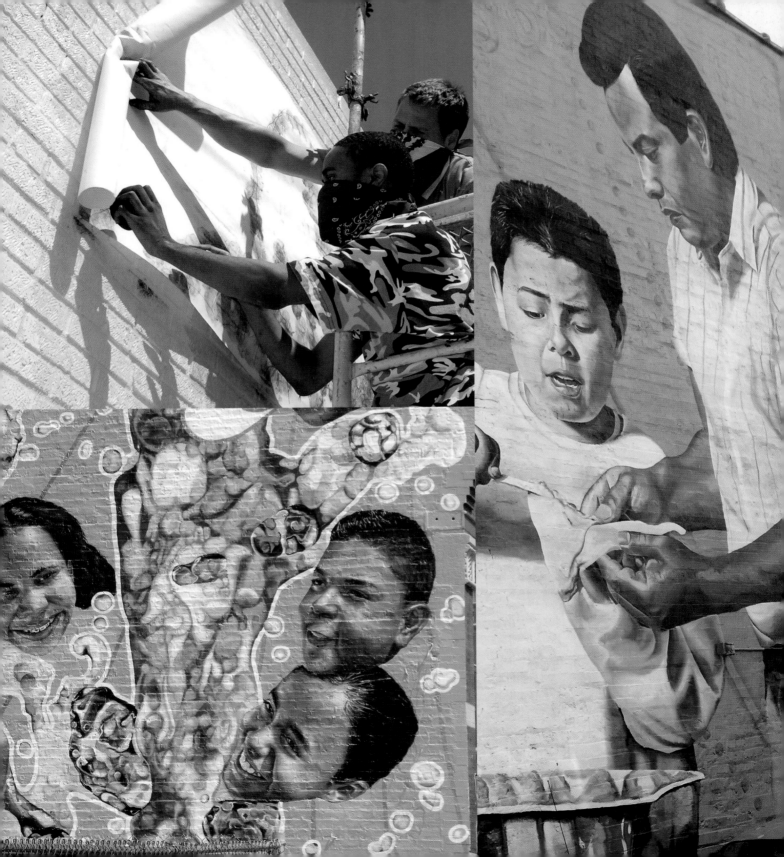

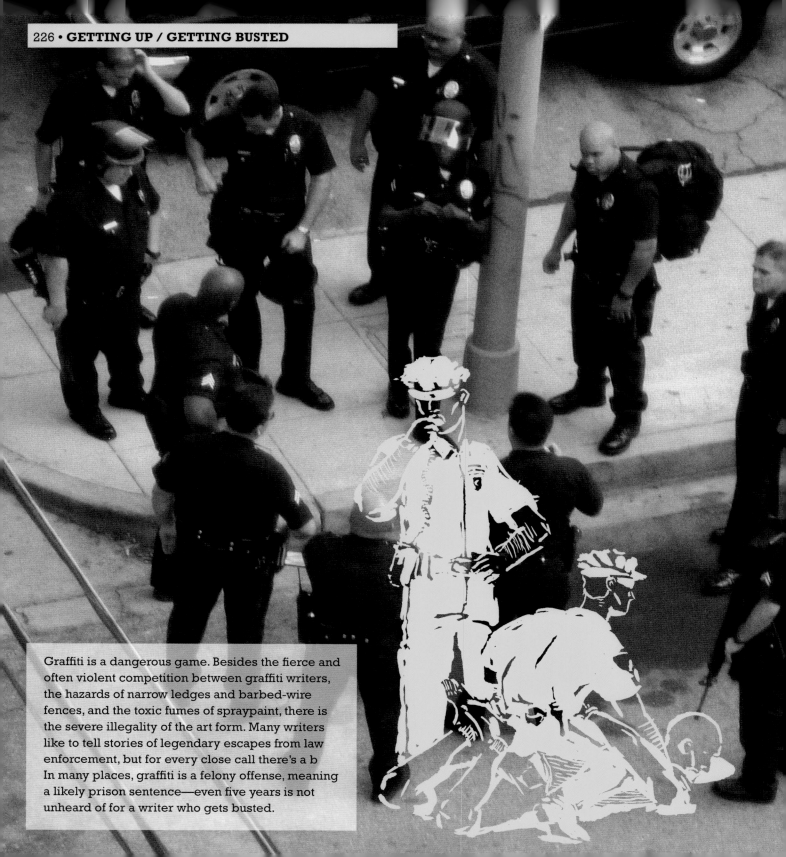

Graffiti is a dangerous game. Besides the fierce and often violent competition between graffiti writers, the hazards of narrow ledges and barbed-wire fences, and the toxic fumes of spraypaint, there is the severe illegality of the art form. Many writers like to tell stories of legendary escapes from law enforcement, but for every close call there's a b In many places, graffiti is a felony offense, meaning a likely prison sentence—even five years is not unheard of for a writer who gets busted.

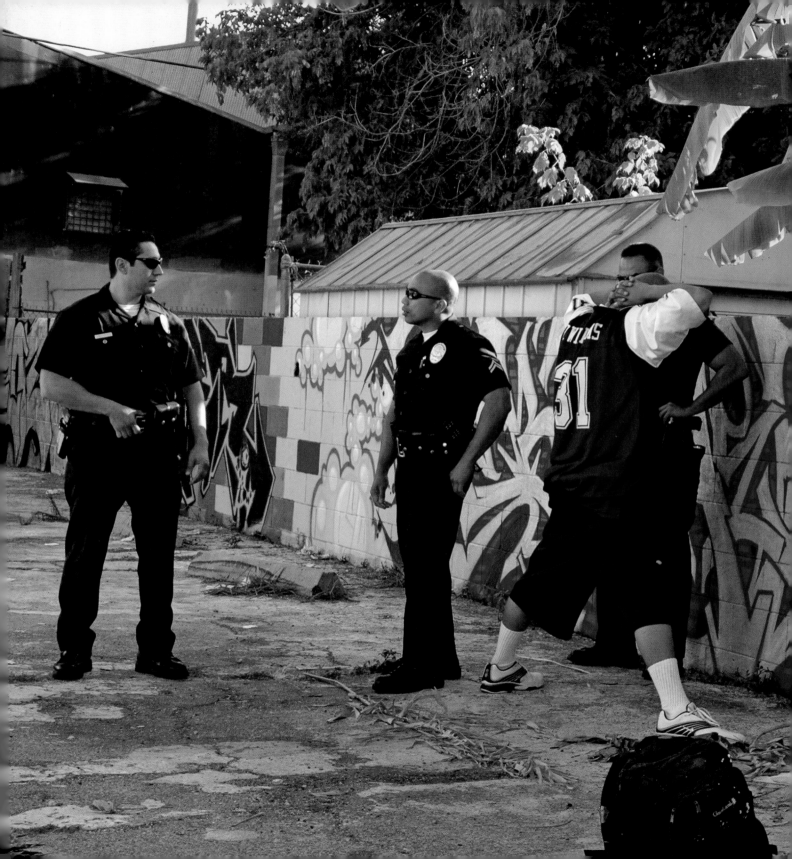

• INSPIRATION

The inspirations of street culture are all around us and often hidden in plain sight. Surprises, folk arts, environments, and all of the places and spaces that beg for a creative improvement bring new ideas.

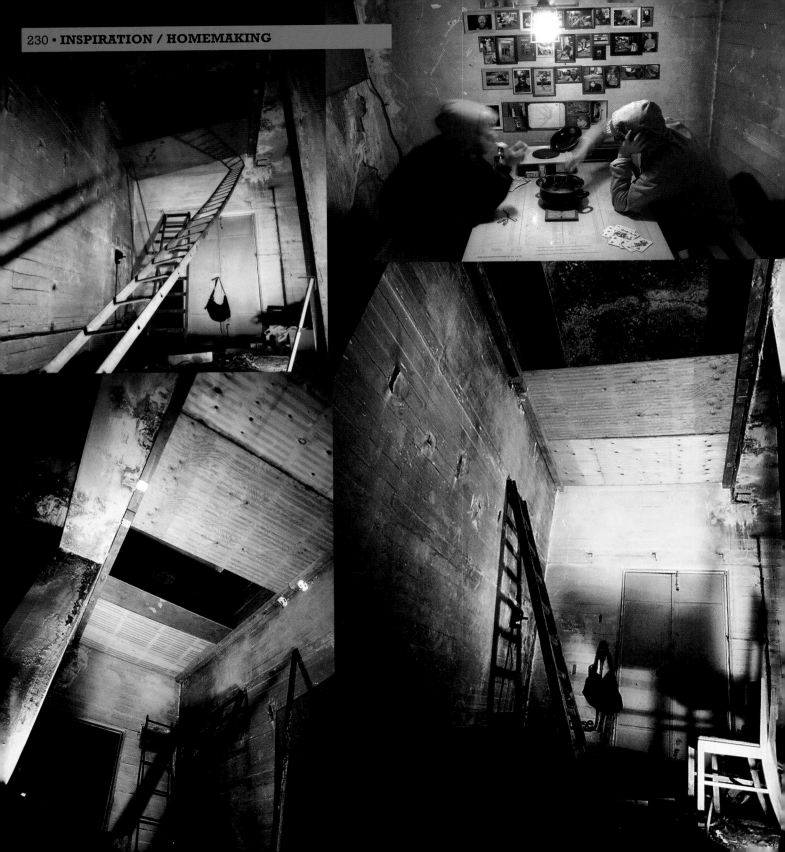

This underground house, named Clandestine Loft, was built in an unused culvert inside the Copenhagen subway system near Copenhagen Central Station. In early 2003, Swedish artist Adams and Danish artist Itso searched for a place to make a home in Copenhagen. Finding this culvert, they set to work, dividing its six meters of height into two floors. Furnishing the house with hammocks made from found mail sacks and stools made from train signage and odd pieces of wood, they would dress like Danish rail workers to avoid suspicion. They ran a very long extension cord to the main station in order to power a small refrigerator, stove, microwave, and lamp, and hung framed photographs of people who hung out at Central Station and whom they had befriended. In February of 2007, the house was discovered by rail workers and was destroyed.

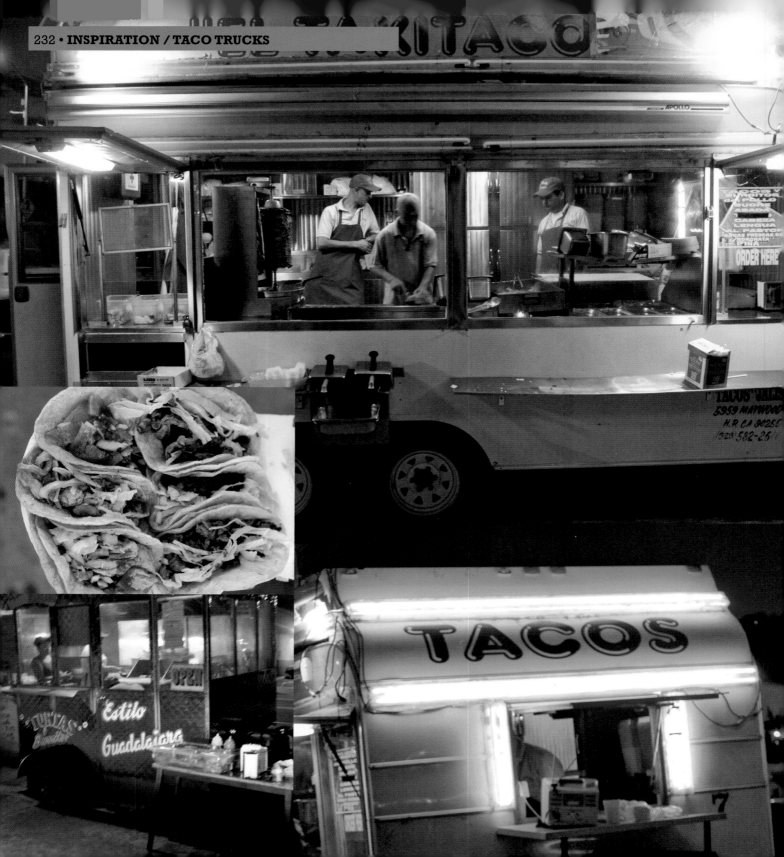

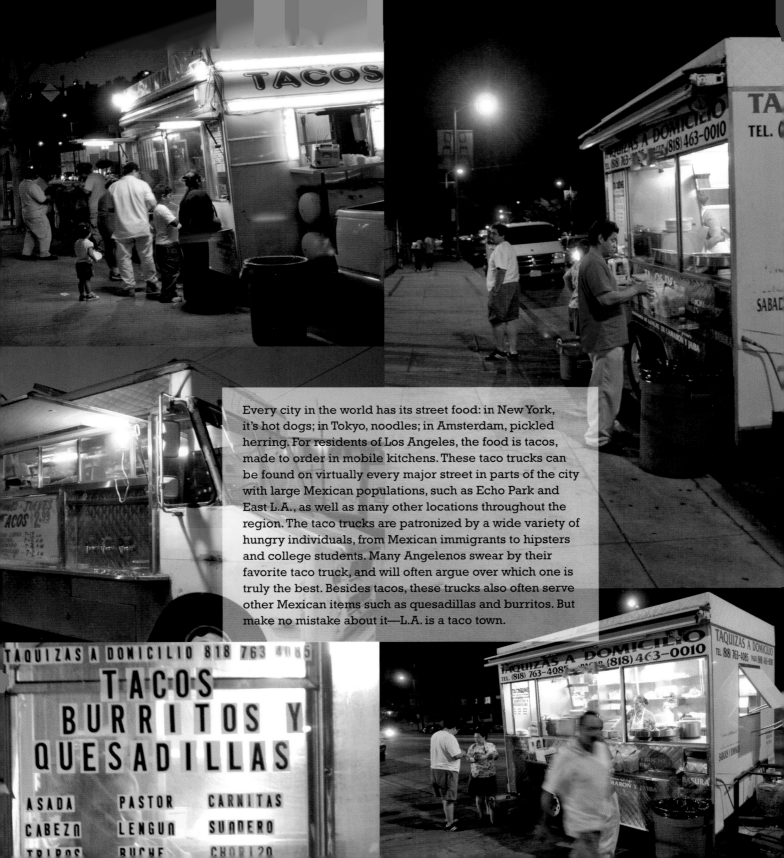

Every city in the world has its street food: in New York, it's hot dogs; in Tokyo, noodles; in Amsterdam, pickled herring. For residents of Los Angeles, the food is tacos, made to order in mobile kitchens. These taco trucks can be found on virtually every major street in parts of the city with large Mexican populations, such as Echo Park and East L.A., as well as many other locations throughout the region. The taco trucks are patronized by a wide variety of hungry individuals, from Mexican immigrants to hipsters and college students. Many Angelenos swear by their favorite taco truck, and will often argue over which one is truly the best. Besides tacos, these trucks also often serve other Mexican items such as quesadillas and burritos. But make no mistake about it—L.A. is a taco town.

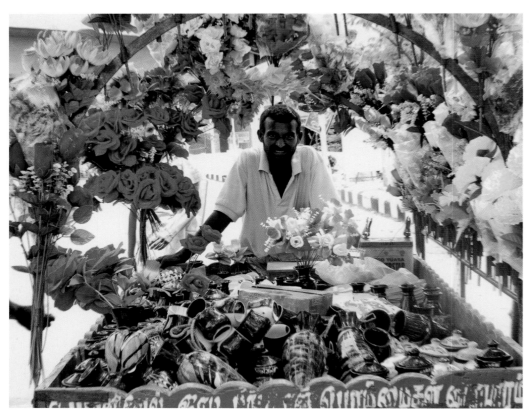
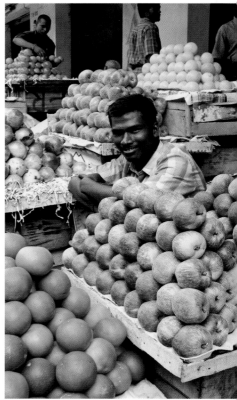
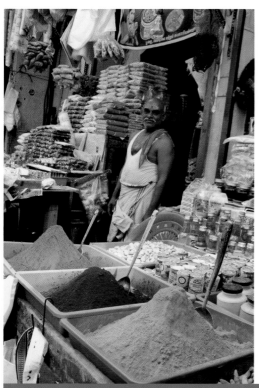
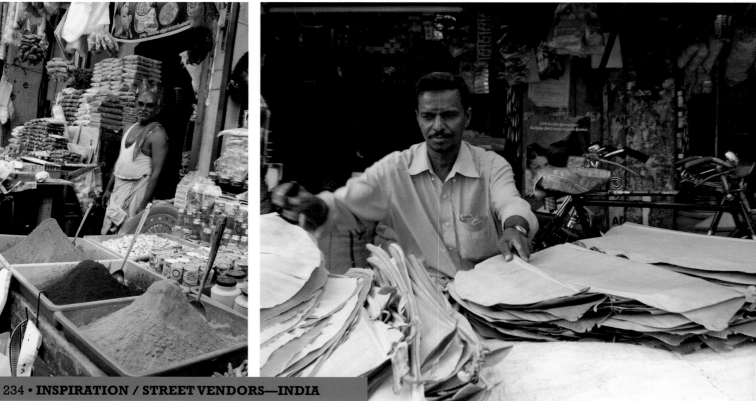

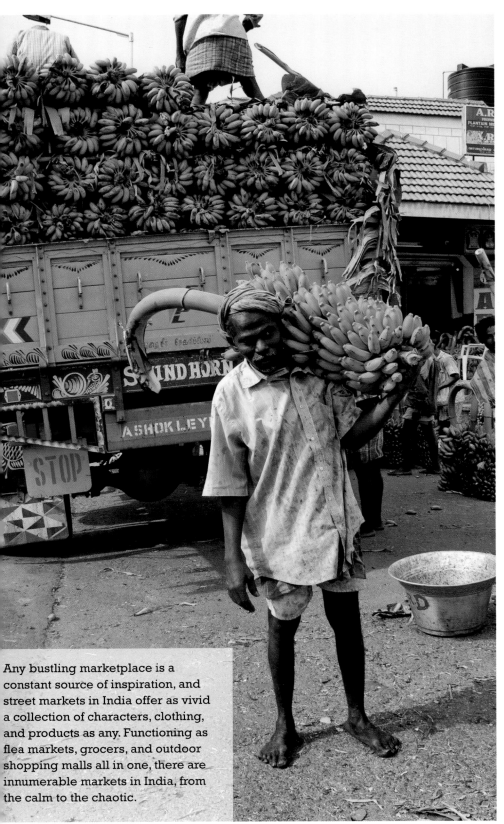

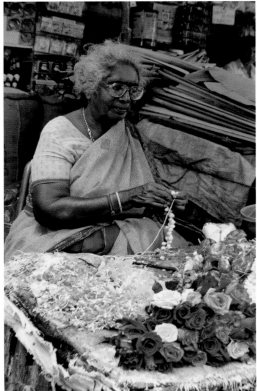

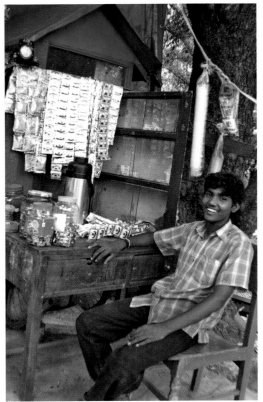

Any bustling marketplace is a constant source of inspiration, and street markets in India offer as vivid a collection of characters, clothing, and products as any. Functioning as flea markets, grocers, and outdoor shopping malls all in one, there are innumerable markets in India, from the calm to the chaotic.

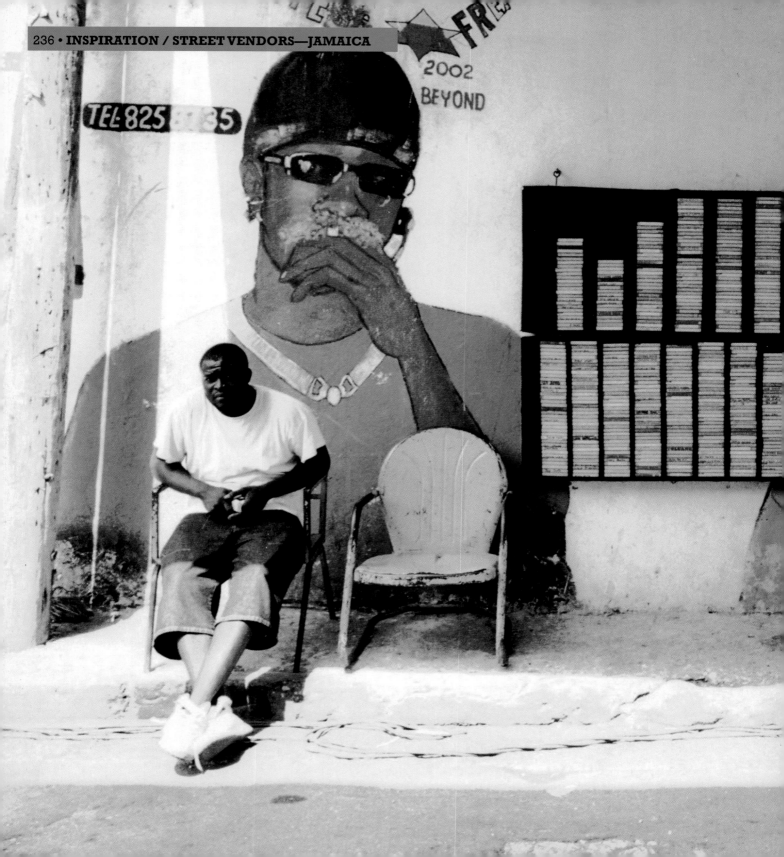

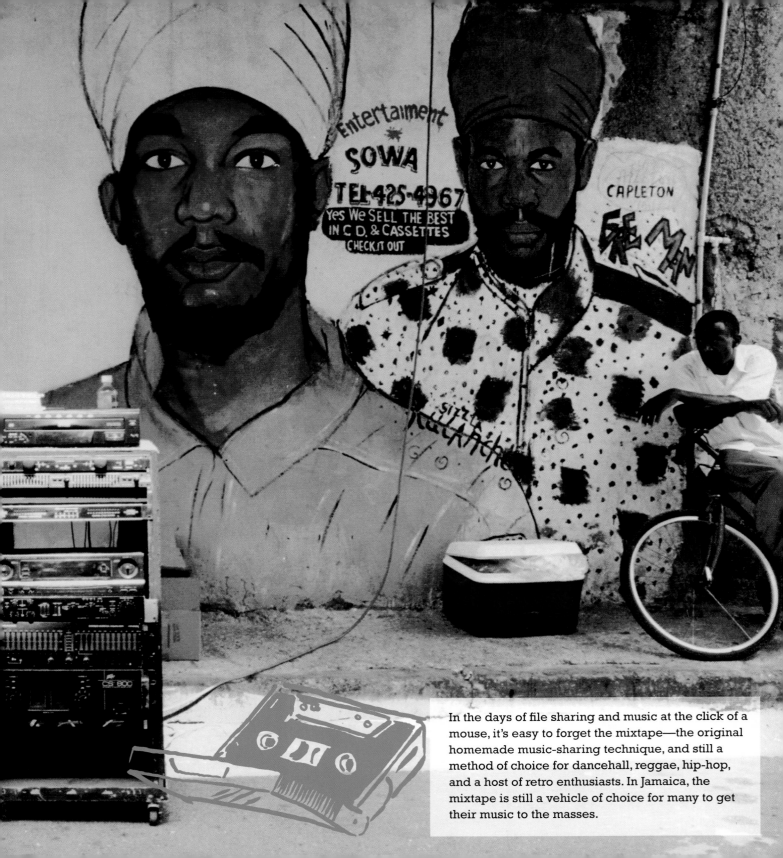

In the days of file sharing and music at the click of a mouse, it's easy to forget the mixtape—the original homemade music-sharing technique, and still a method of choice for dancehall, reggae, hip-hop, and a host of retro enthusiasts. In Jamaica, the mixtape is still a vehicle of choice for many to get their music to the masses.

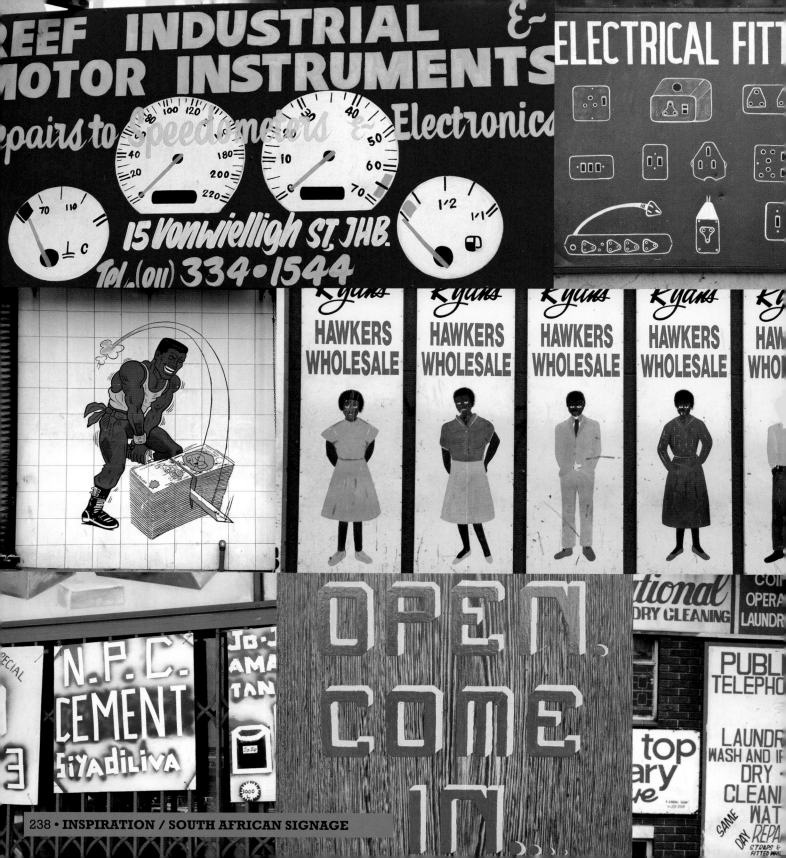

FOR ALL YOUR DENTAL NEEDS

NEW TECHNOLOGY

DOUBLE

+ -40% SOUND IN

PROFESSIONAL SPEAKER REPAIRS

The township streetscapes of South Africa are a hotbed of handpainted signage, as tiny businesses compete with one another. The handpainted sign has enjoyed a renaissance in recent years as the townships experience post-Apartheid economic expansions, and while computers and vinyl have rendered it far less pervasive than before, new artists draw from its traditions as both a craft and a fine art.

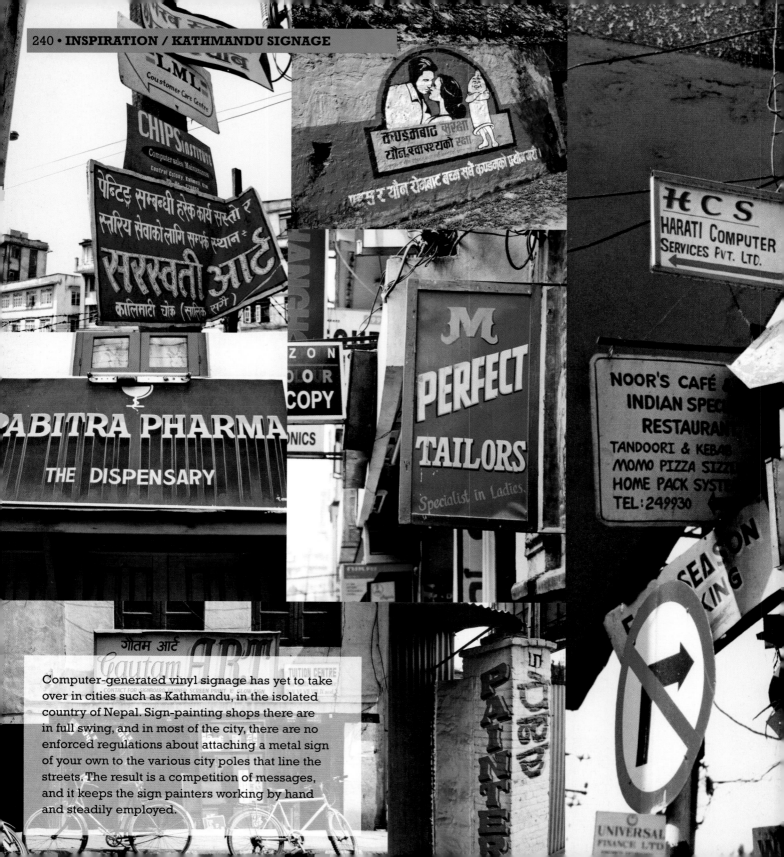

Computer-generated vinyl signage has yet to take over in cities such as Kathmandu, in the isolated country of Nepal. Sign-painting shops there are in full swing, and in most of the city, there are no enforced regulations about attaching a metal sign of your own to the various city poles that line the streets. The result is a competition of messages, and it keeps the sign painters working by hand and steadily employed.

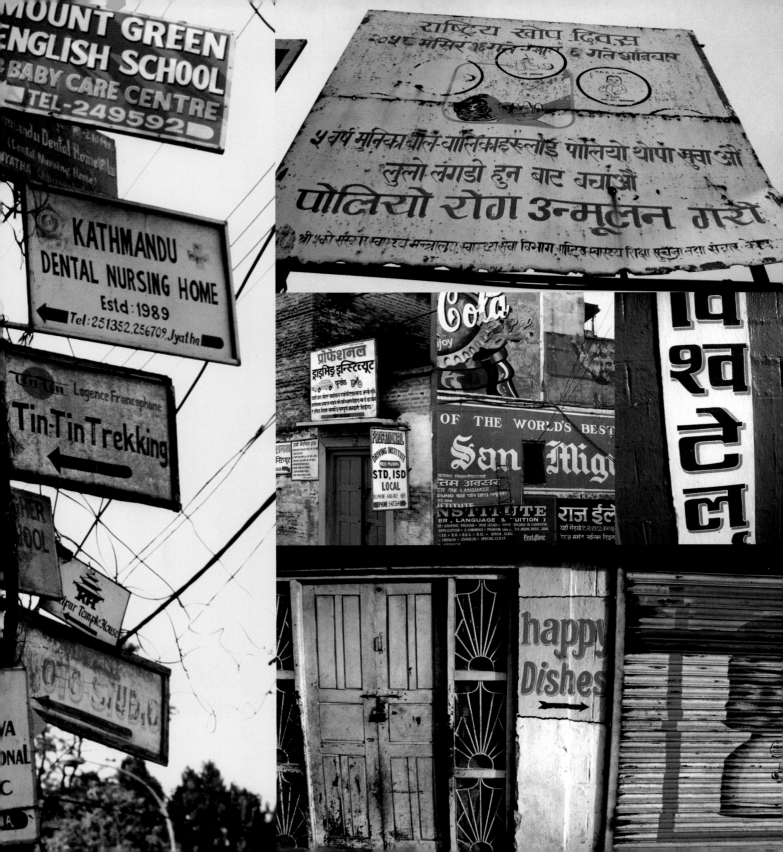

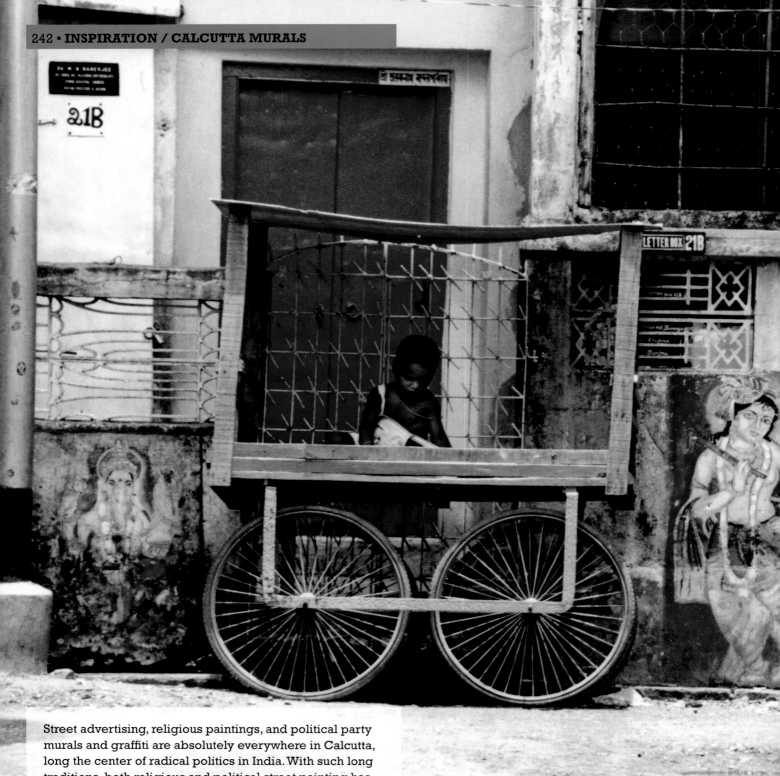

Street advertising, religious paintings, and political party murals and graffiti are absolutely everywhere in Calcutta, long the center of radical politics in India. With such long traditions, both religious and political street painting has become part of the urban landscape in the city to a degree unseen elsewhere in most parts of the world.

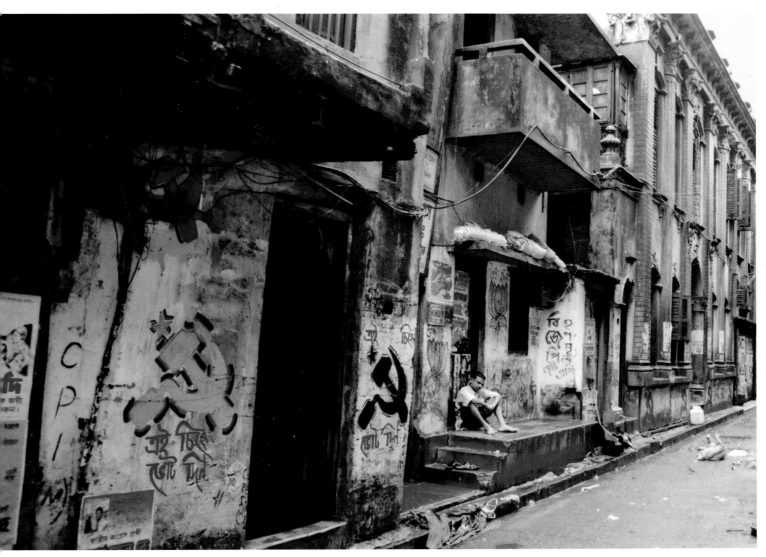

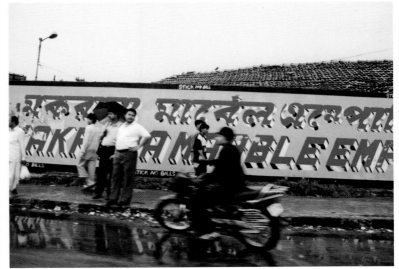

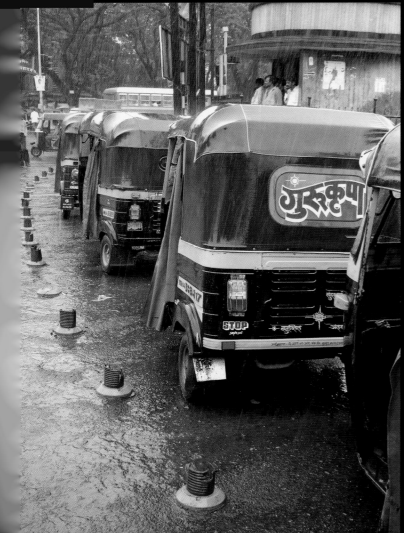

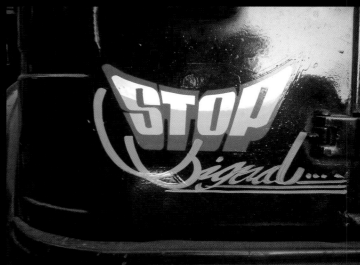

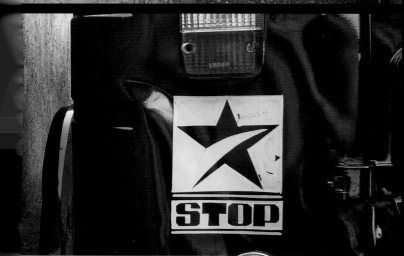

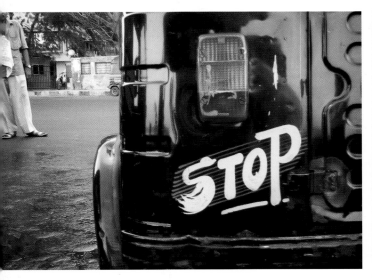

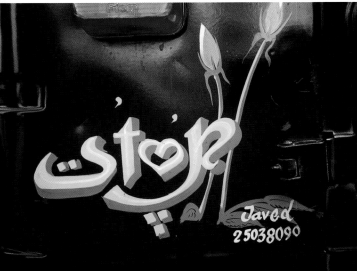

A gigantic metropolis with up to twenty million citizens (depending on when you stop counting), Mumbai, India, is one of the five largest cities on earth, as well as one of the most densely populated, located on an offshore island with a fine harbor. On Mumbai's streets, the chaos of street traffic in South Asia can be perfectly encapsulated in the activity of autorickshaws, the tiny, three-wheeled taxis careening everywhere. Autorickshaws are well-suited to city terrain. Able to dart through the narrow spaces of Mumbai traffic, their open structure gives them alternate doses of fresh air and exhaust fumes. As they are smaller and cheaper than standard taxis and less prestigious to drive or to use, their clientele is generally poorer than most. Unfortunately, as autorickshaws are smaller in size they tend to bear the brunt of any collision. Consequently, a practical safety message on the rear of the carriage has evolved this mode of transport into something of a folk-art medium.

Most signs are out there to sell you something. Operating out of a Coney Island sign shop in Brooklyn, Matt Wright makes signs that advertise the byproducts of the American Dream. And, if you can find him, you might be able to buy those sour grapes and a bottle of hurt that you've always dreamt of.

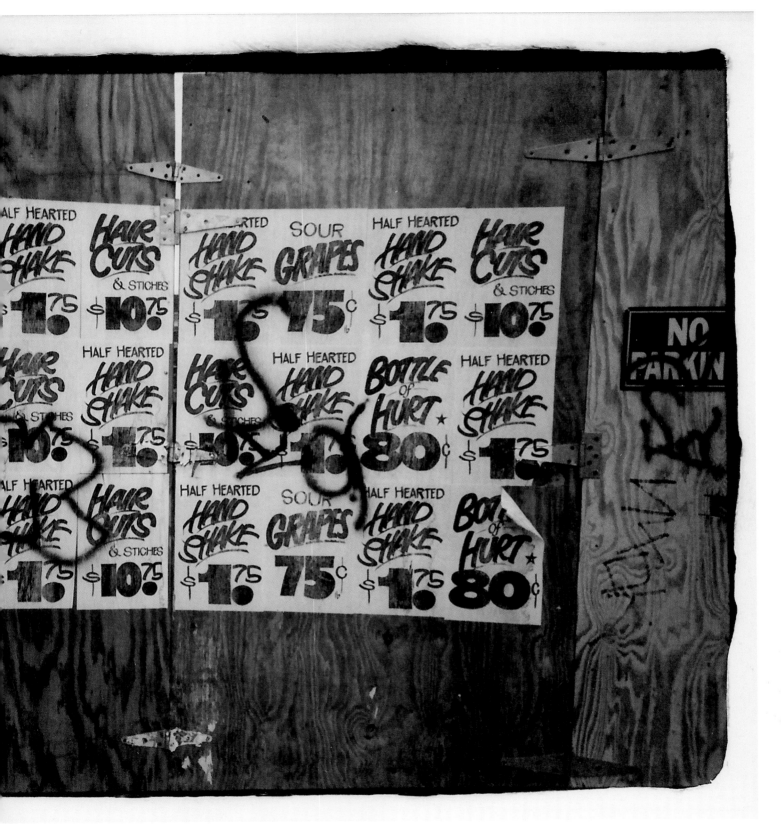

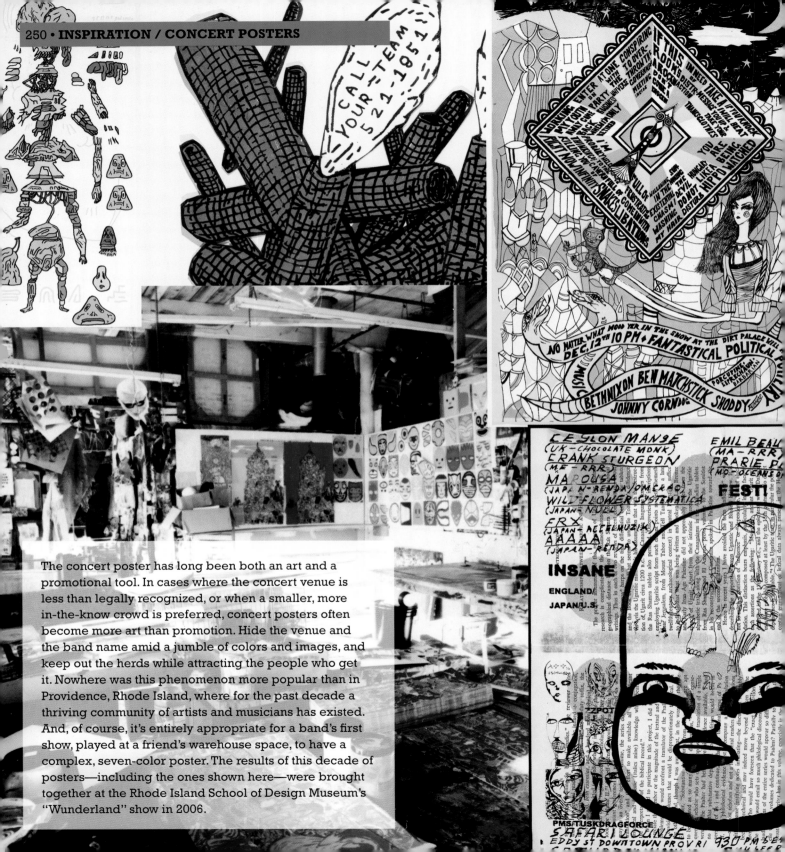

The concert poster has long been both an art and a promotional tool. In cases where the concert venue is less than legally recognized, or when a smaller, more in-the-know crowd is preferred, concert posters often become more art than promotion. Hide the venue and the band name amid a jumble of colors and images, and keep out the herds while attracting the people who get it. Nowhere was this phenomenon more popular than in Providence, Rhode Island, where for the past decade a thriving community of artists and musicians has existed. And, of course, it's entirely appropriate for a band's first show, played at a friend's warehouse space, to have a complex, seven-color poster. The results of this decade of posters—including the ones shown here—were brought together at the Rhode Island School of Design Museum's "Wunderland" show in 2006.

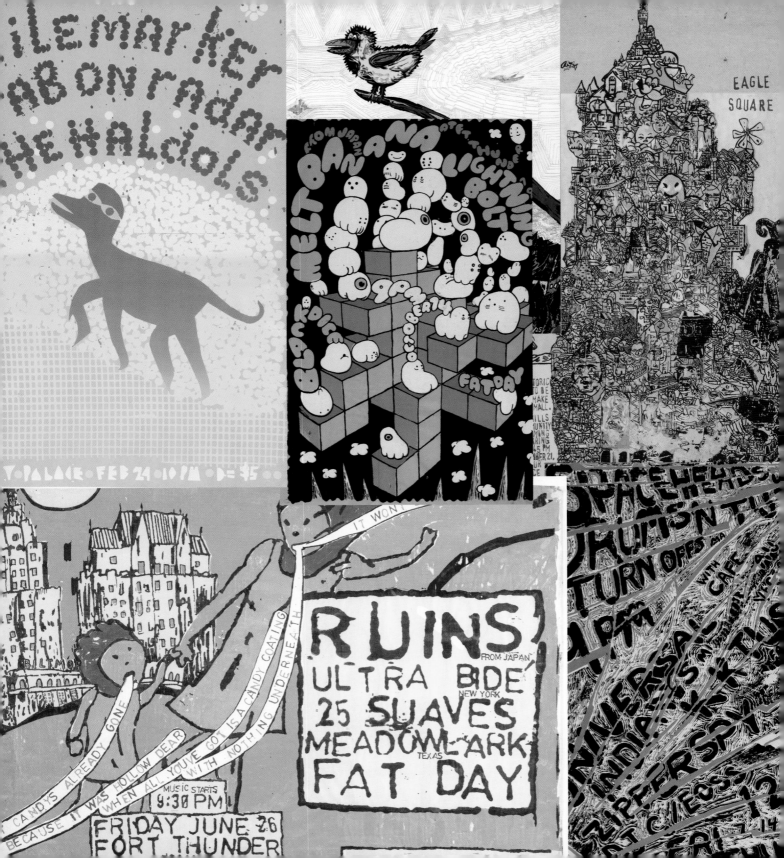

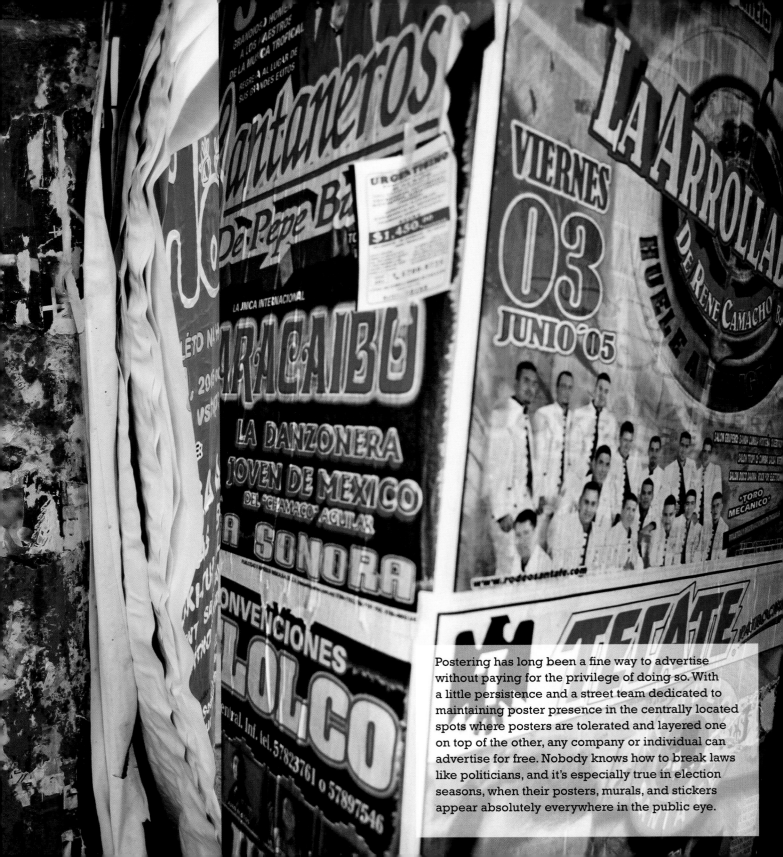

Postering has long been a fine way to advertise without paying for the privilege of doing so. With a little persistence and a street team dedicated to maintaining poster presence in the centrally located spots where posters are tolerated and layered one on top of the other, any company or individual can advertise for free. Nobody knows how to break laws like politicians, and it's especially true in election seasons, when their posters, murals, and stickers appear absolutely everywhere in the public eye.

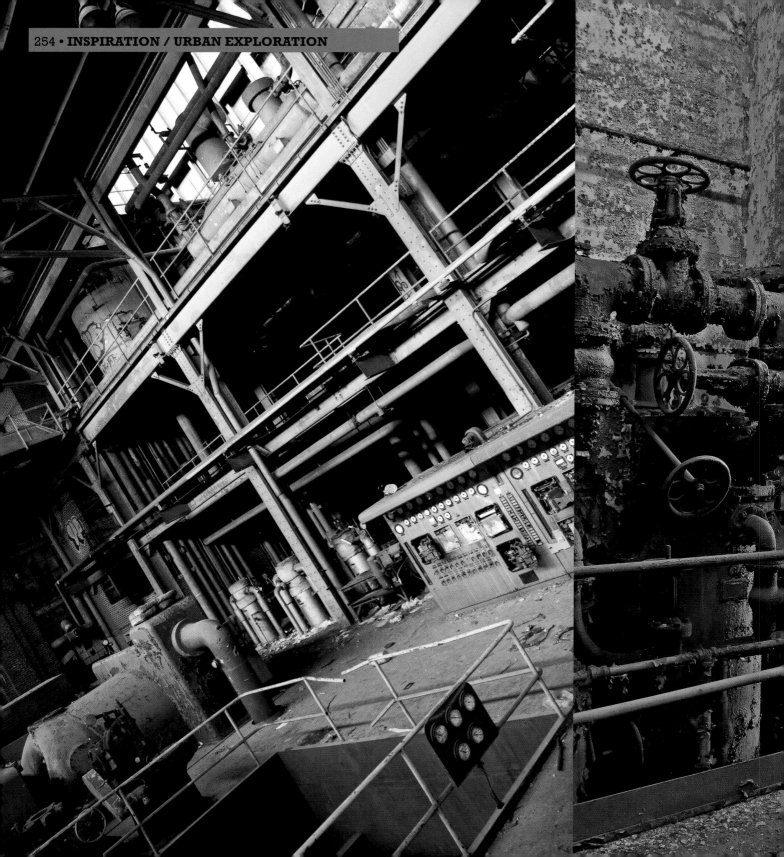

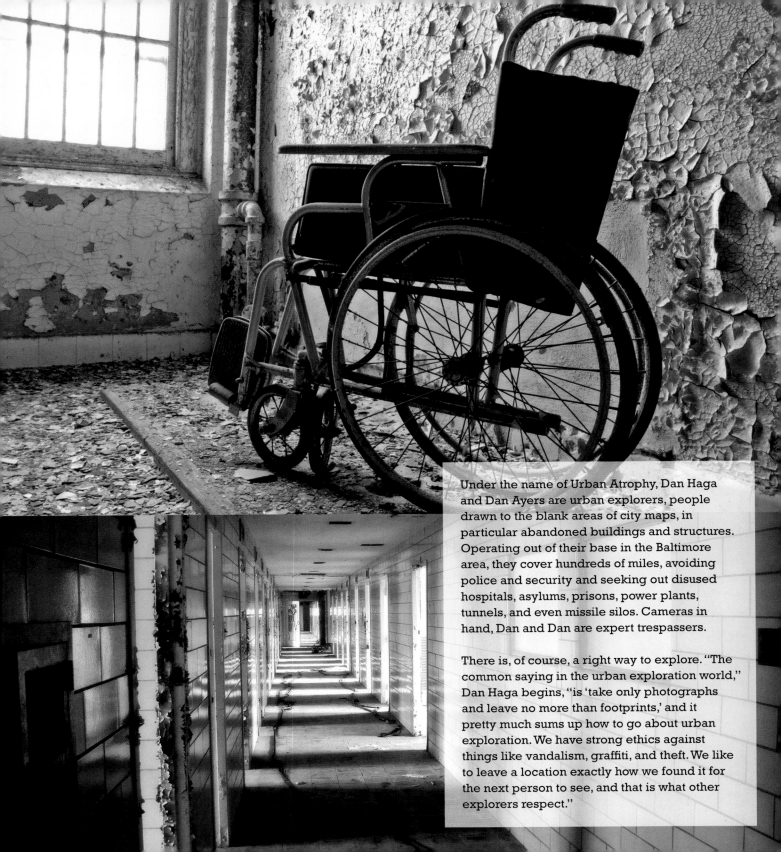

Under the name of Urban Atrophy, Dan Haga and Dan Ayers are urban explorers, people drawn to the blank areas of city maps, in particular abandoned buildings and structures. Operating out of their base in the Baltimore area, they cover hundreds of miles, avoiding police and security and seeking out disused hospitals, asylums, prisons, power plants, tunnels, and even missile silos. Cameras in hand, Dan and Dan are expert trespassers.

There is, of course, a right way to explore. "The common saying in the urban exploration world," Dan Haga begins, "is 'take only photographs and leave no more than footprints,' and it pretty much sums up how to go about urban exploration. We have strong ethics against things like vandalism, graffiti, and theft. We like to leave a location exactly how we found it for the next person to see, and that is what other explorers respect."

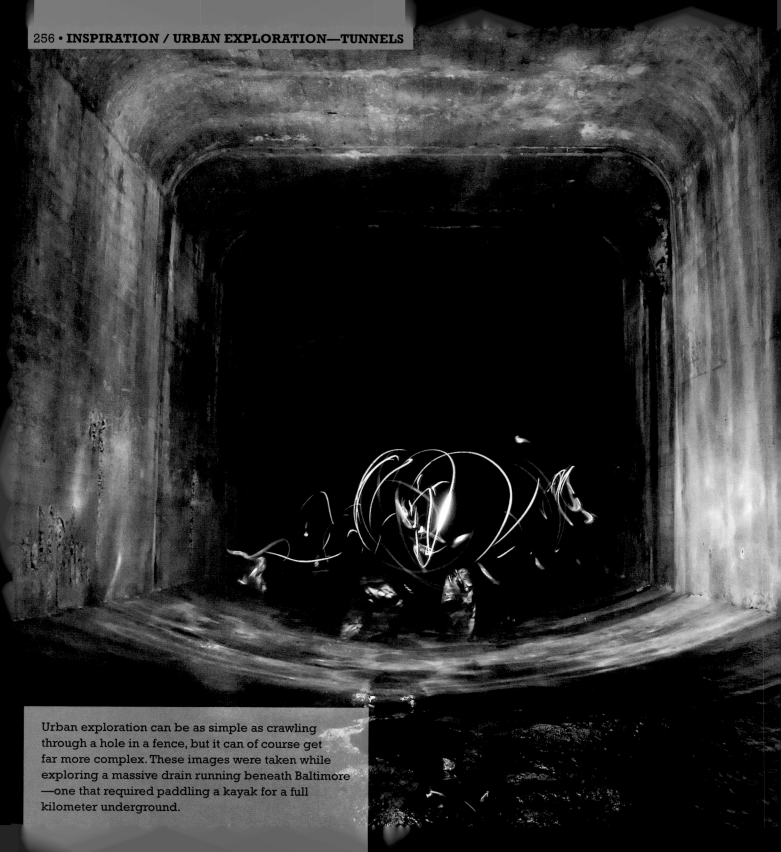

Urban exploration can be as simple as crawling through a hole in a fence, but it can of course get far more complex. These images were taken while exploring a massive drain running beneath Baltimore—one that required paddling a kayak for a full kilometer underground.

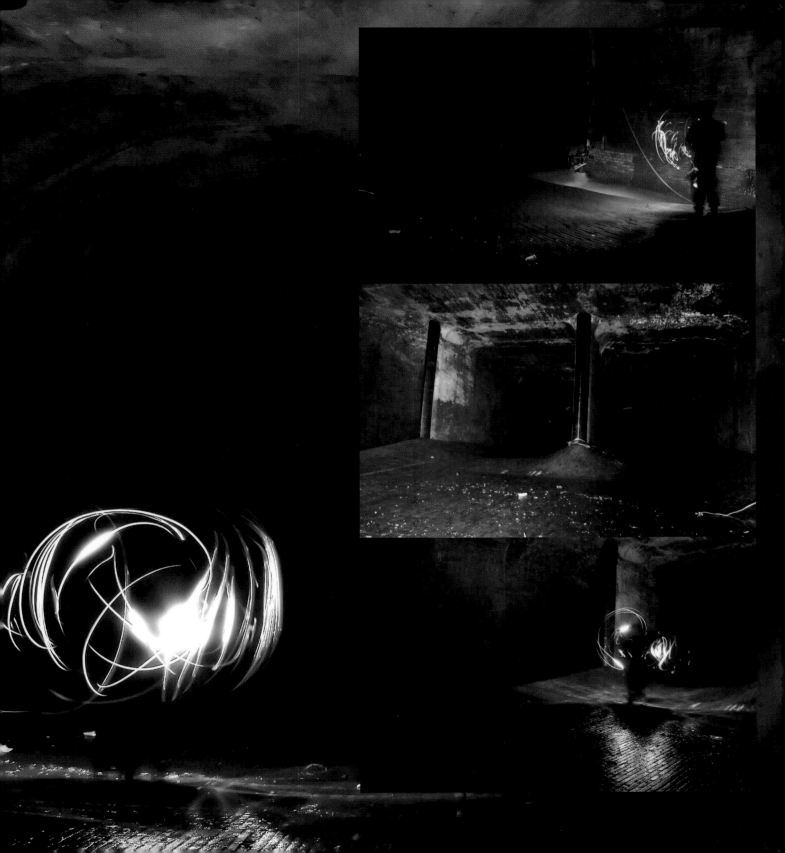

Graffiti has its sacred spaces, and the "Freedom Tunnels" on the West Side of Manhattan certainly qualify. It all began in the 1970s and 1980s when Freedom, an Upper West Side graffiti writer, began to use them as his personal gallery. The tunnels —while illegal to enter and regularly patrolled by police (or worse)—have attracted legions of graffiti writers from around the world.

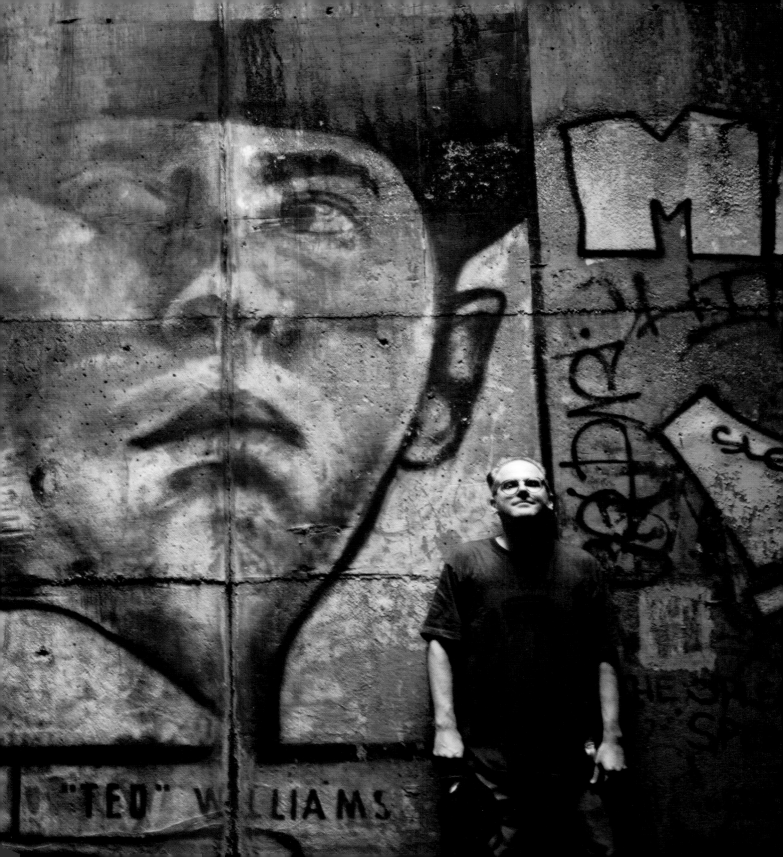

"TED" WILLIAMS

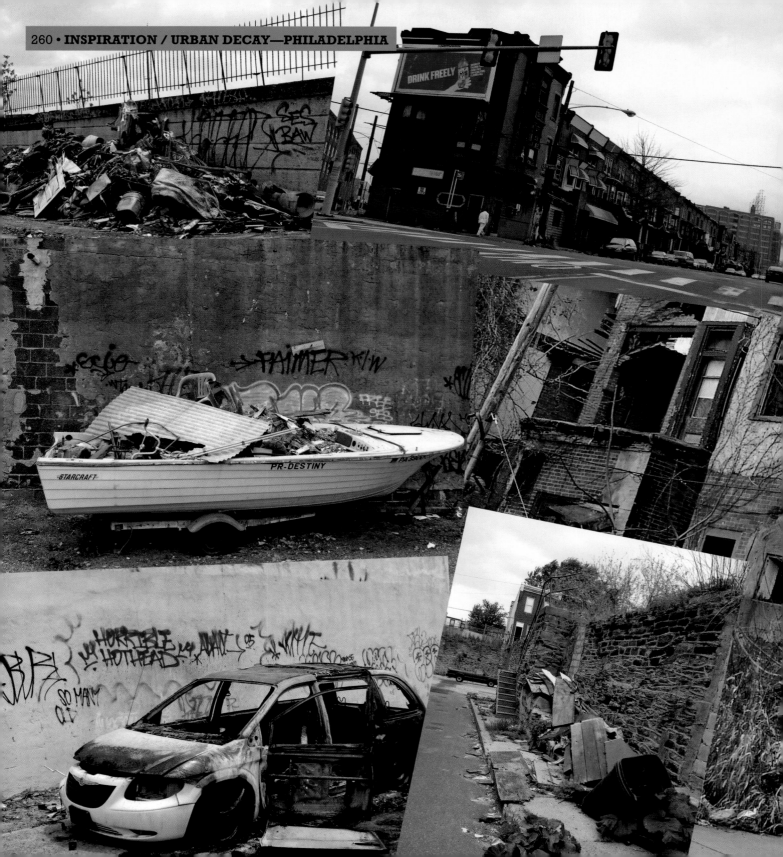

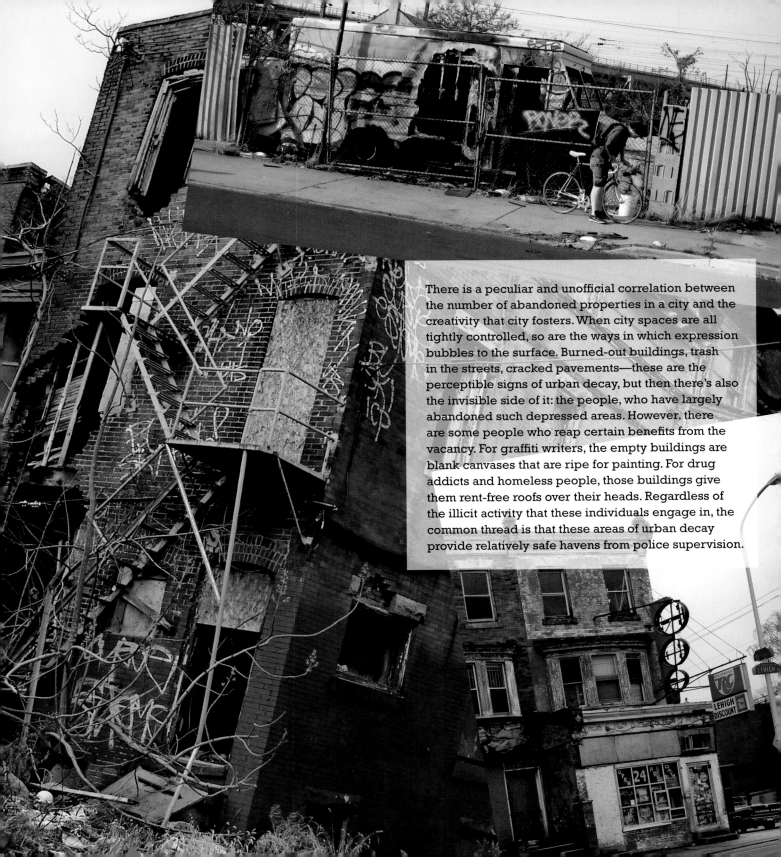

There is a peculiar and unofficial correlation between the number of abandoned properties in a city and the creativity that city fosters. When city spaces are all tightly controlled, so are the ways in which expression bubbles to the surface. Burned-out buildings, trash in the streets, cracked pavements—these are the perceptible signs of urban decay, but then there's also the invisible side of it: the people, who have largely abandoned such depressed areas. However, there are some people who reap certain benefits from the vacancy. For graffiti writers, the empty buildings are blank canvases that are ripe for painting. For drug addicts and homeless people, those buildings give them rent-free roofs over their heads. Regardless of the illicit activity that these individuals engage in, the common thread is that these areas of urban decay provide relatively safe havens from police supervision.

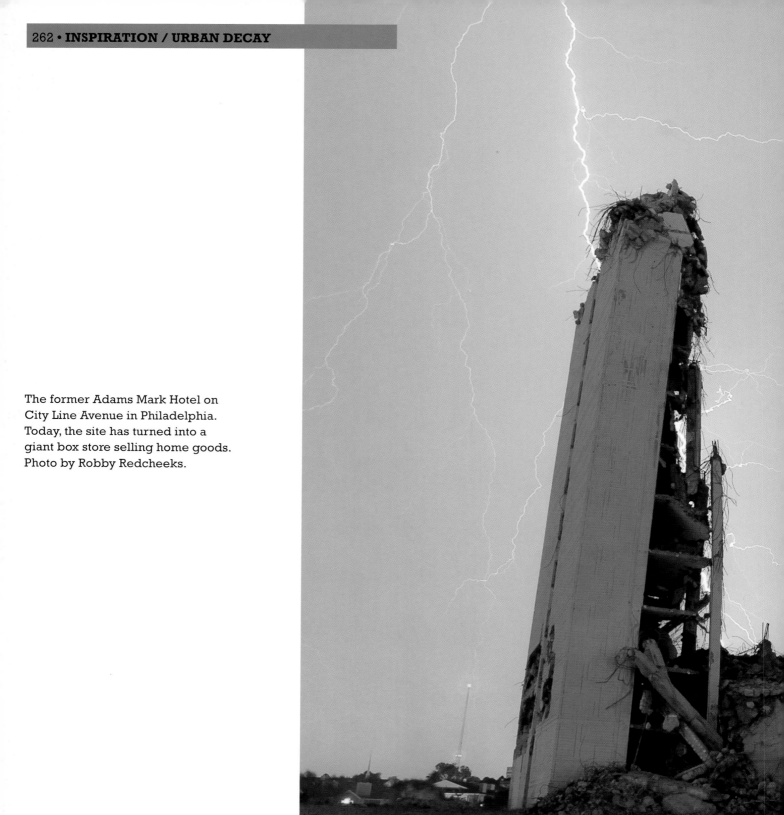

The former Adams Mark Hotel on
City Line Avenue in Philadelphia.
Today, the site has turned into a
giant box store selling home goods.
Photo by Robby Redcheeks.

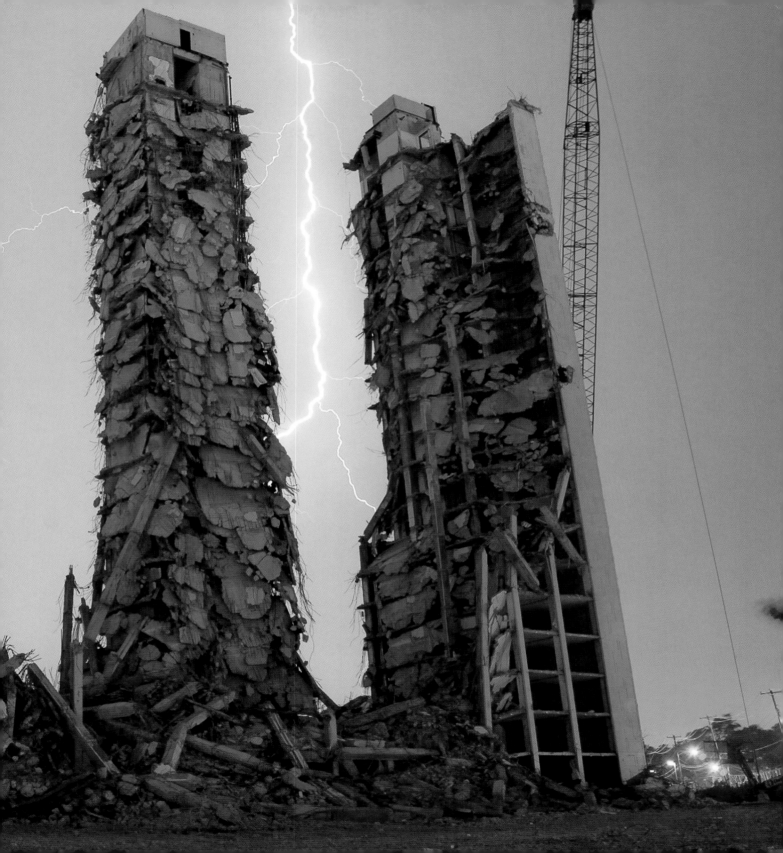

Studio artists can employ every technique available to
them in art schooling to get an appropriately aged and
weathered patina on a surface they wish to paint. Of
course, such spaces abound outdoors—such as in these
images in the busy Thai metropolis of Bangkok—and they
all beckon and inspire the creative people whose artwork
takes them out of doors.

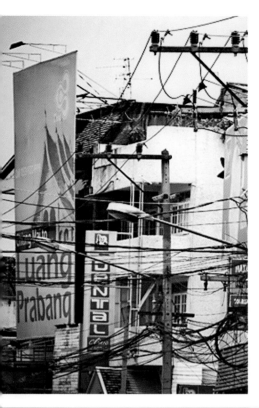

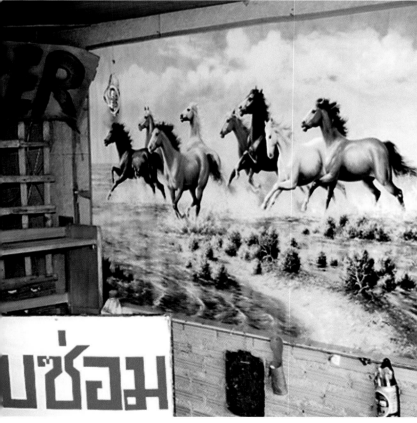

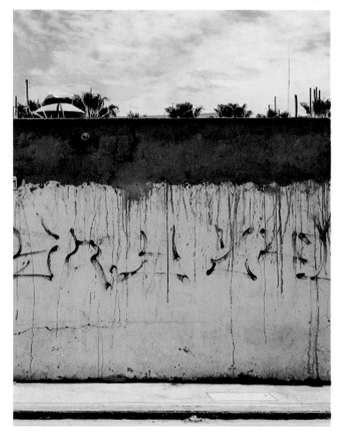

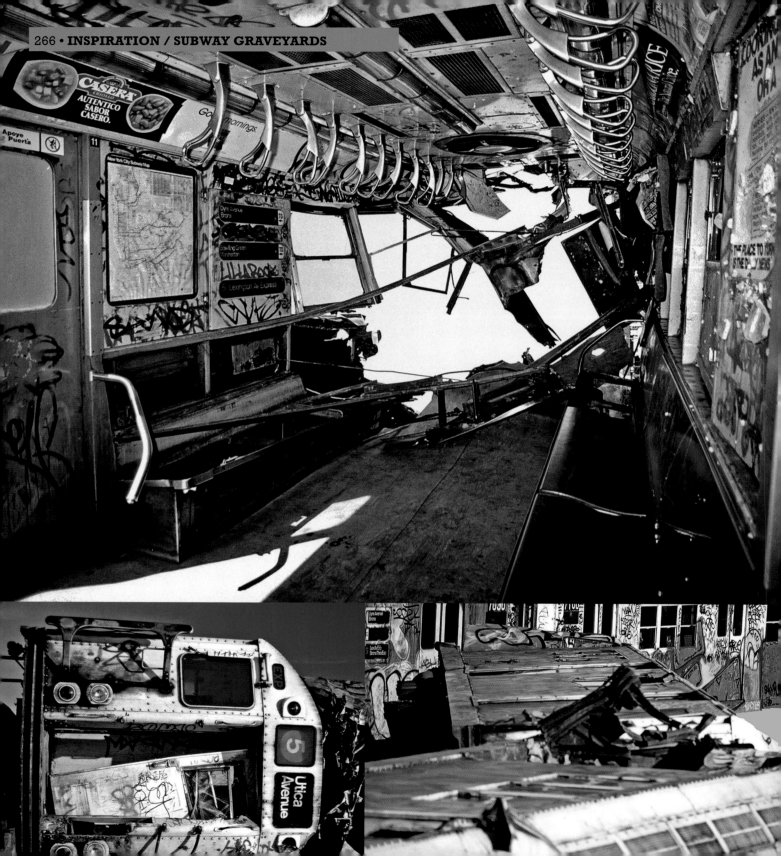

To many, the New York subways are the essence of street culture itself, and the decade of the 1980s, as they gradually became graffiti-free, were the end of the era. Still, not all the trains vanished, as over time the occasional well-preserved subway car would make its last journey to a Brooklyn or New Jersey graveyard for subway trains. The trains, as long as they lasted before heading to a watery grave in a New York harbor for a second career as part of an underwater tidal barrier, were like a museum for graffiti writers around the world. Except, of course, that hardly anyone could resist adding their own touch.

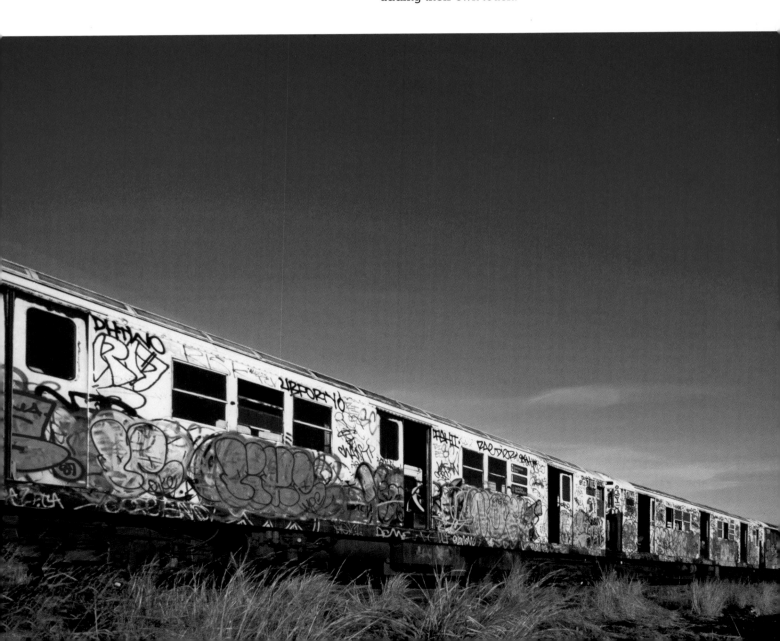

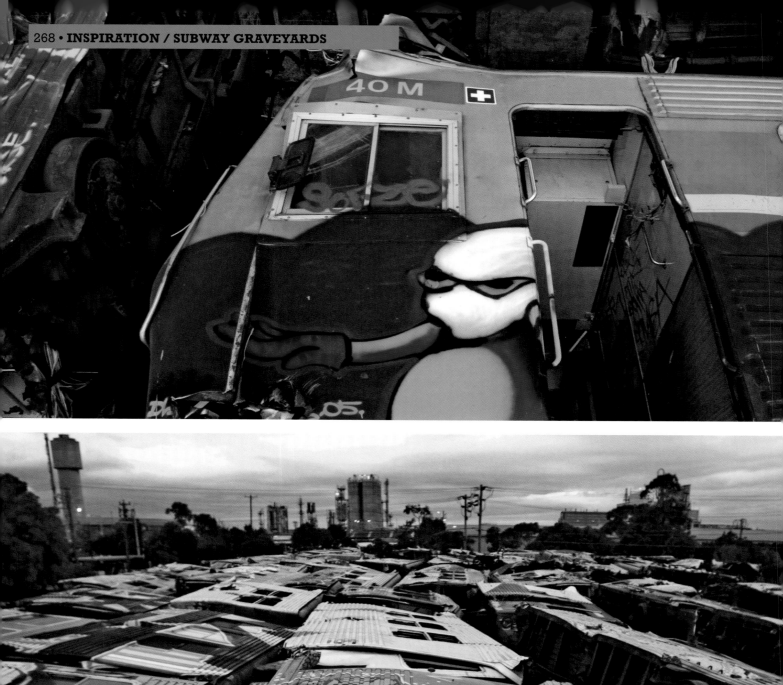

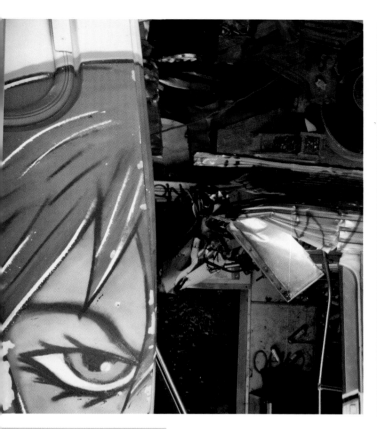

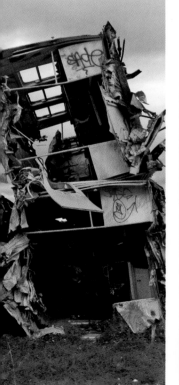

It certainly isn't only New York subway trains that fascinate graffiti writers, as by now practically every single transit system on earth, no matter how hidden, has been painted.

This train graveyard in Melbourne, Australia —coincidentally located in the Brooklyn neighborhood—has been a target of graffiti writers, as have their running trains, of course.

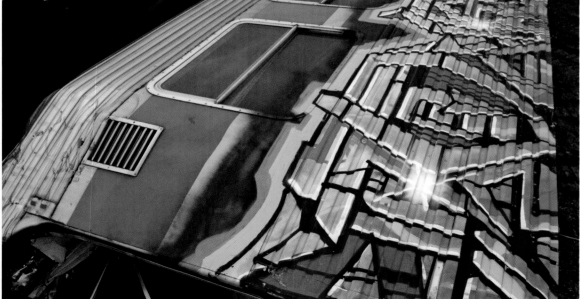

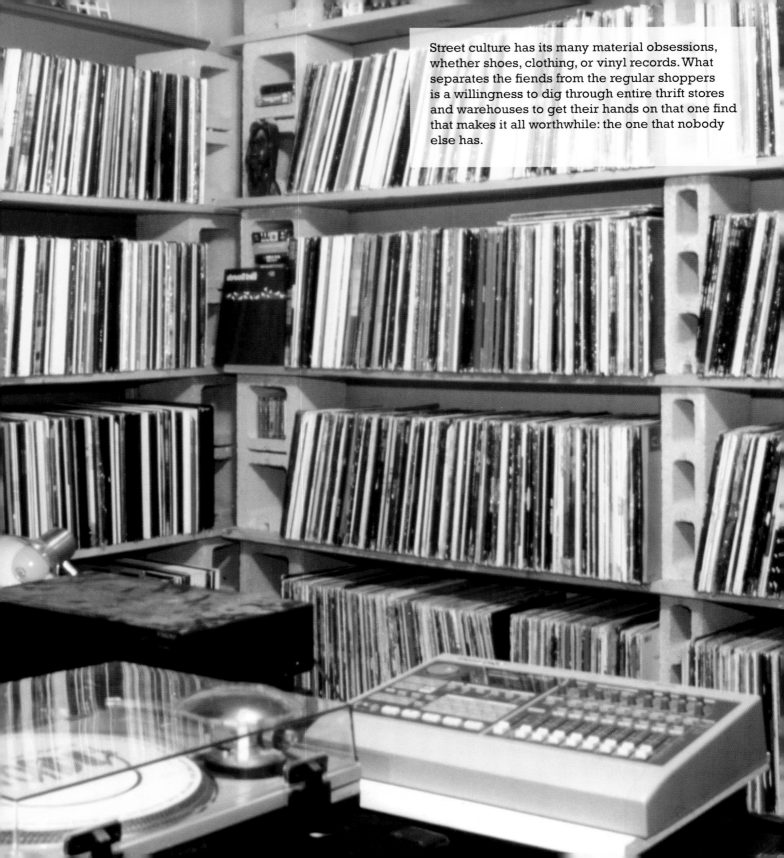

Street culture has its many material obsessions, whether shoes, clothing, or vinyl records. What separates the fiends from the regular shoppers is a willingness to dig through entire thrift stores and warehouses to get their hands on that one find that makes it all worthwhile: the one that nobody else has.

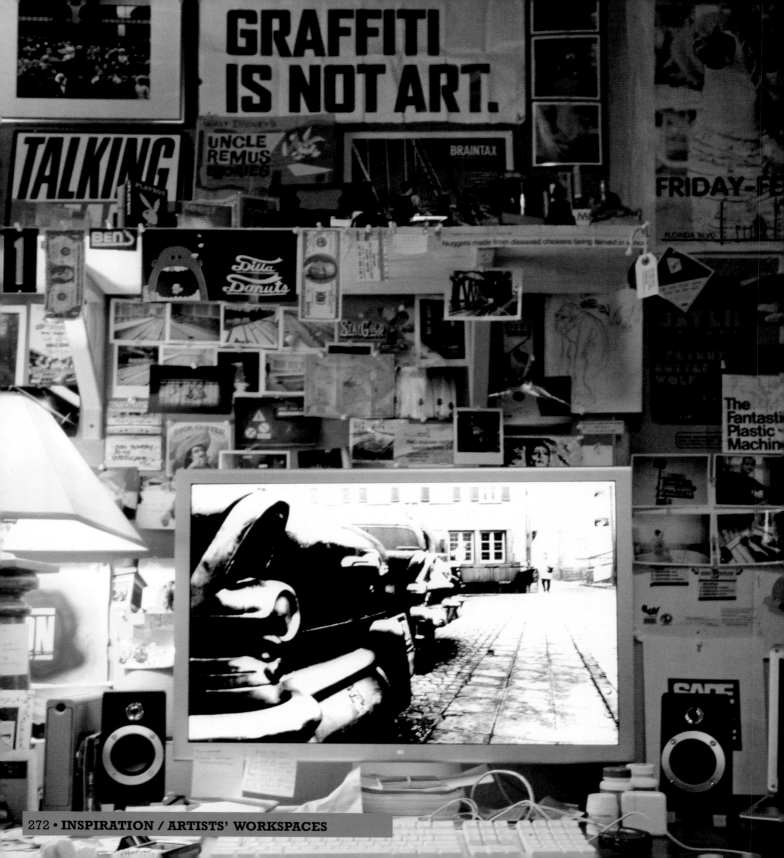

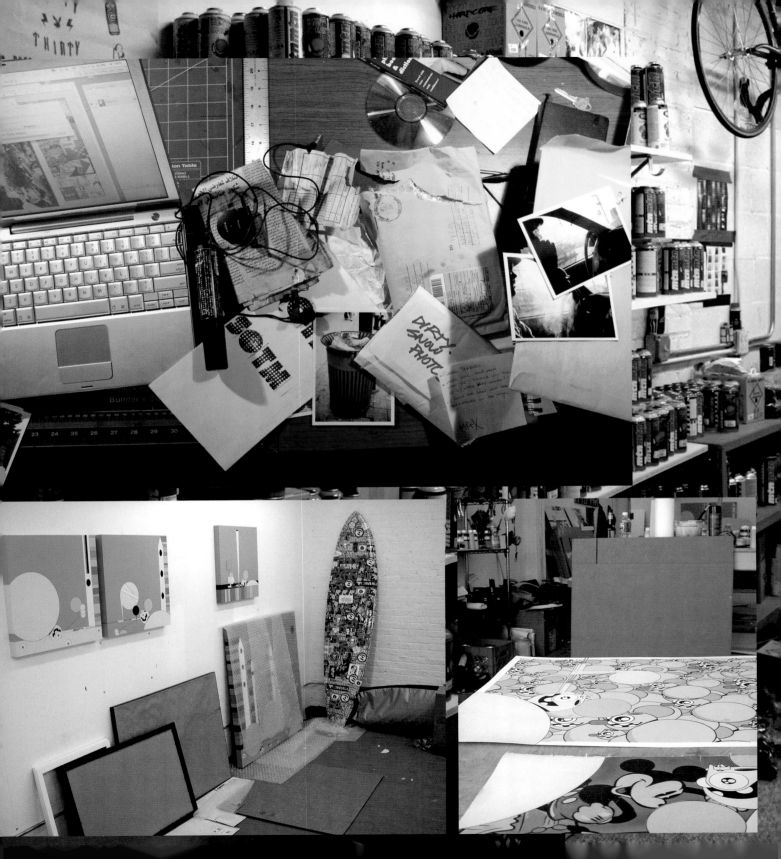

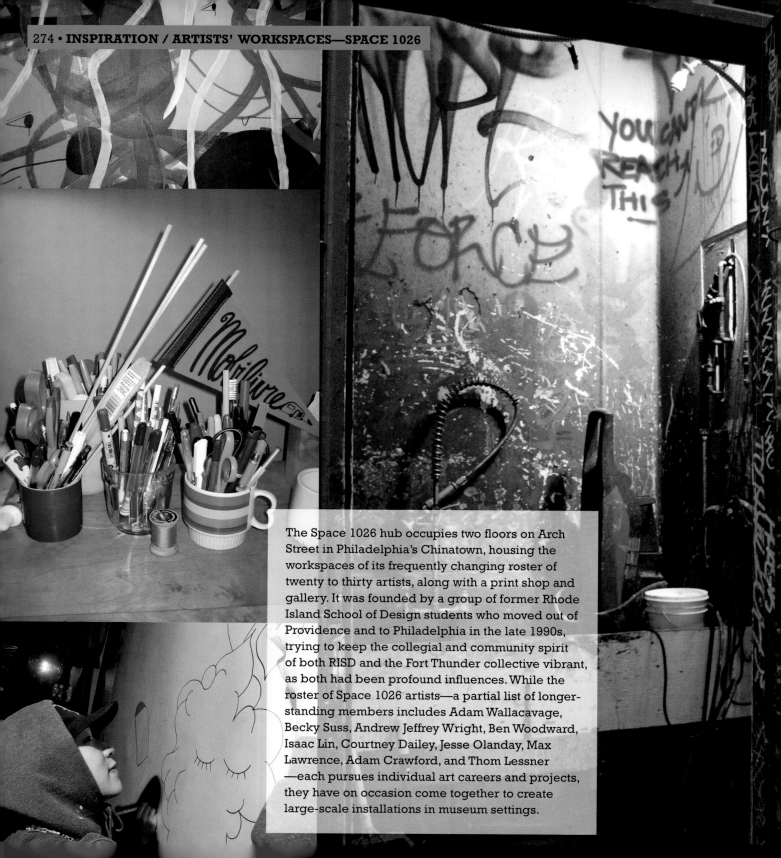

The Space 1026 hub occupies two floors on Arch Street in Philadelphia's Chinatown, housing the workspaces of its frequently changing roster of twenty to thirty artists, along with a print shop and gallery. It was founded by a group of former Rhode Island School of Design students who moved out of Providence and to Philadelphia in the late 1990s, trying to keep the collegial and community spirit of both RISD and the Fort Thunder collective vibrant, as both had been profound influences. While the roster of Space 1026 artists—a partial list of longer-standing members includes Adam Wallacavage, Becky Suss, Andrew Jeffrey Wright, Ben Woodward, Isaac Lin, Courtney Dailey, Jesse Olanday, Max Lawrence, Adam Crawford, and Thom Lessner —each pursues individual art careers and projects, they have on occasion come together to create large-scale installations in museum settings.

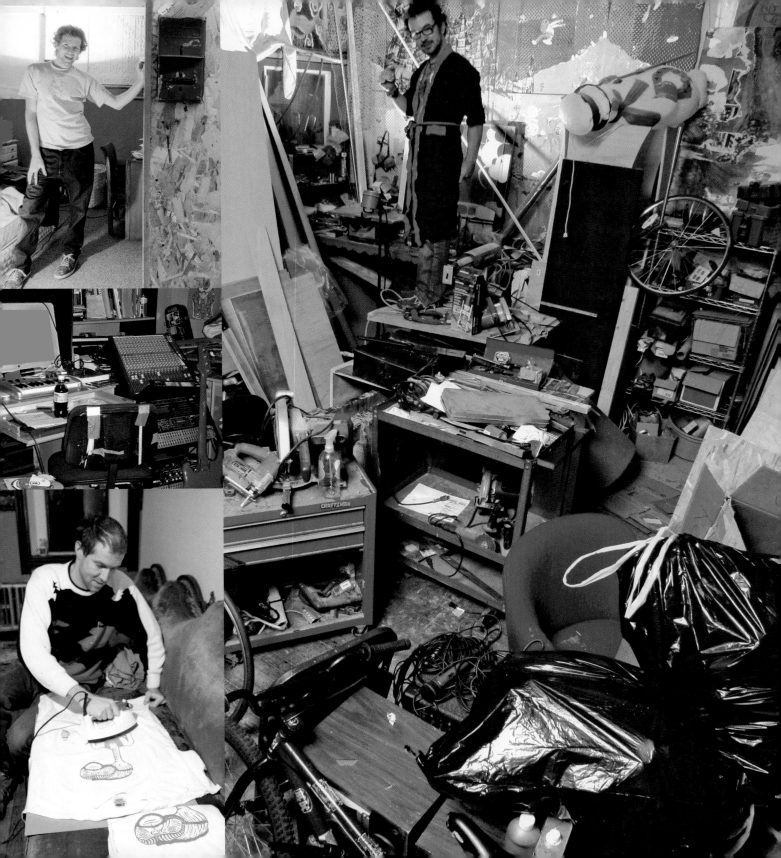

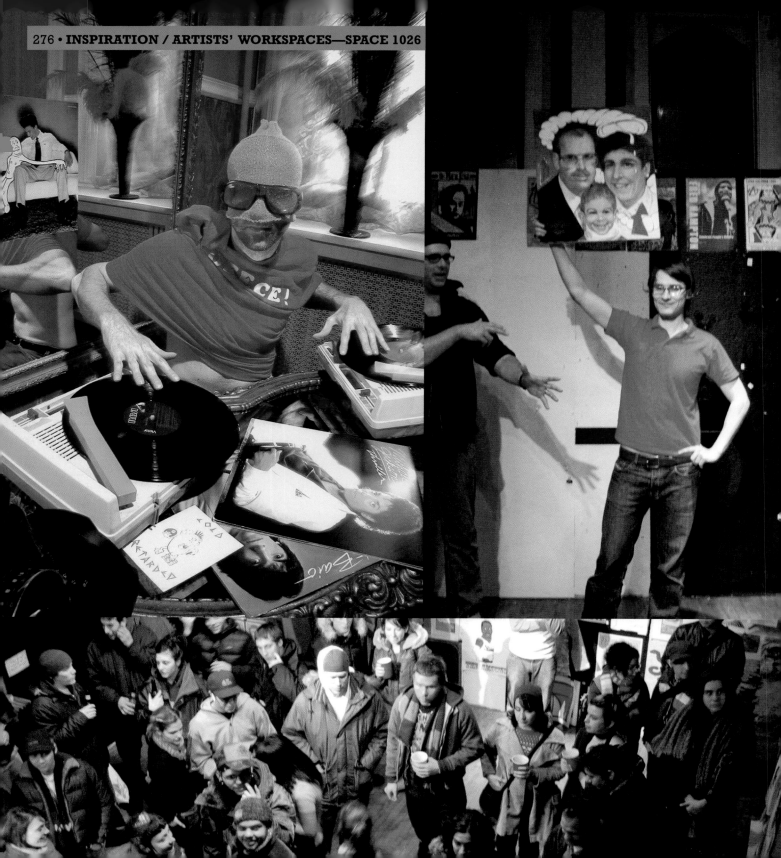

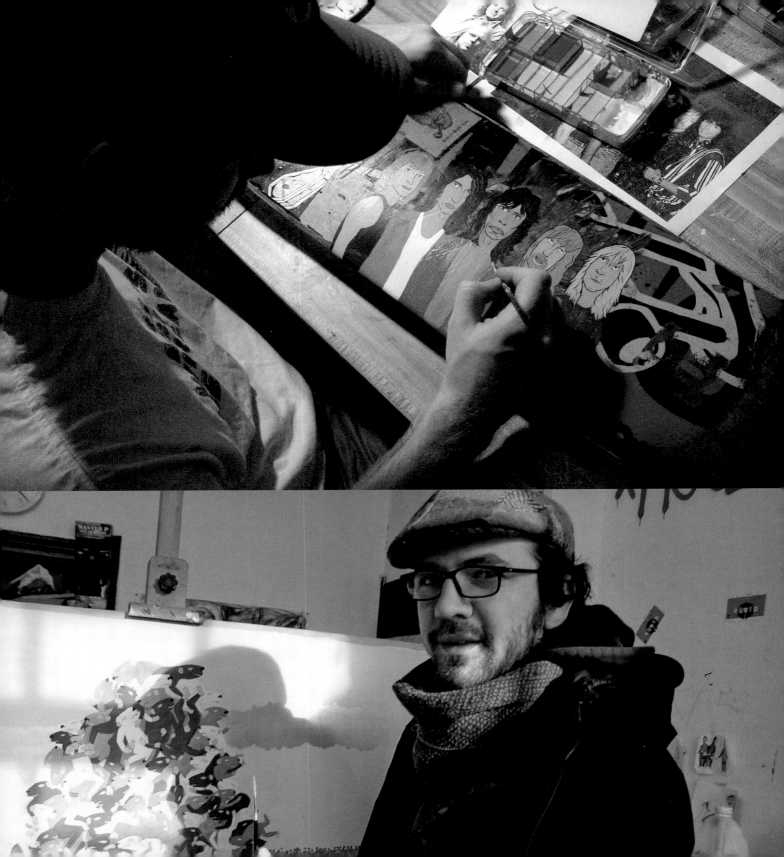

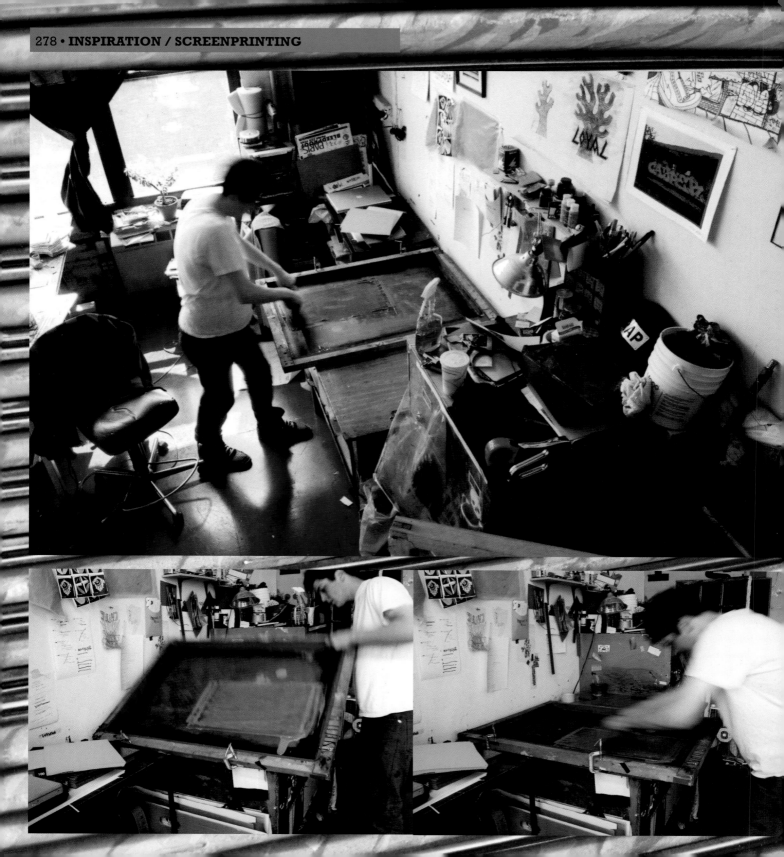

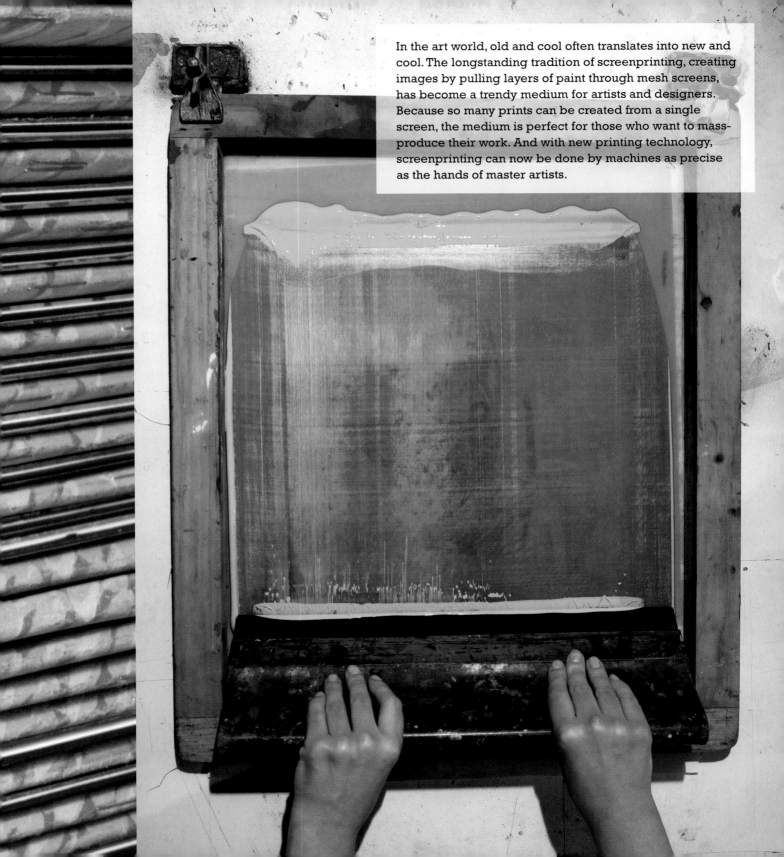

In the art world, old and cool often translates into new and cool. The longstanding tradition of screenprinting, creating images by pulling layers of paint through mesh screens, has become a trendy medium for artists and designers. Because so many prints can be created from a single screen, the medium is perfect for those who want to mass-produce their work. And with new printing technology, screenprinting can now be done by machines as precise as the hands of master artists.

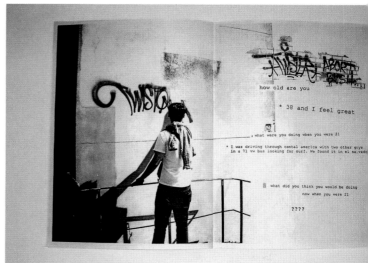

Since the invention of the printing press, way back in the 15th century, people have been able to spread information on their own terms, independent of any authority. Of course, the process became much easier when the photocopier came about in the 1960s, and even more so in recent years with the advent of desktop publishing and copy centers. Fanzines, or just 'zines, have become the unofficial newsletters of virtually every subculture, from music to art to politics. The Do-It-Yourself (DIY) movement that sprang from the punk-rock ethic in the 1970s gave rise over the next thirty years to a vast number of punk 'zines, many of which have since become collectors' items. Today 'zine publishers around the world hold annual 'zine festivals and conferences, where they can trade their wares and discuss new developments in publishing.

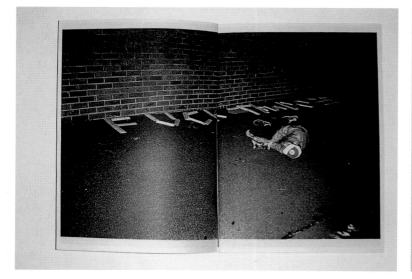

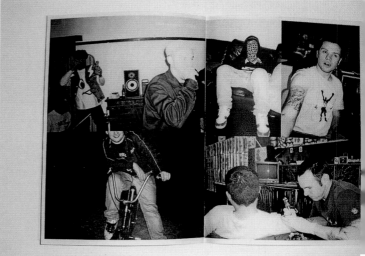

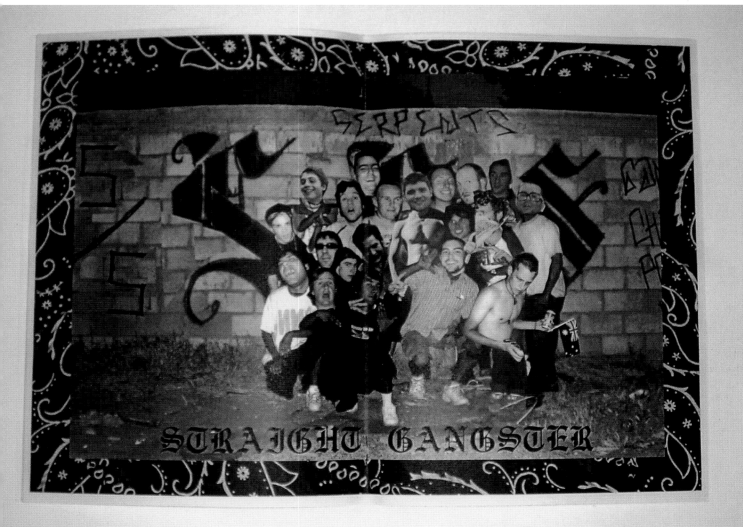

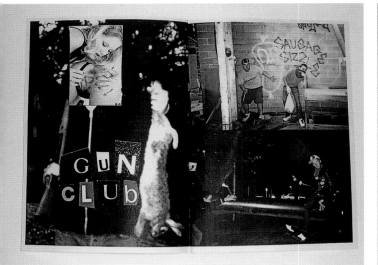

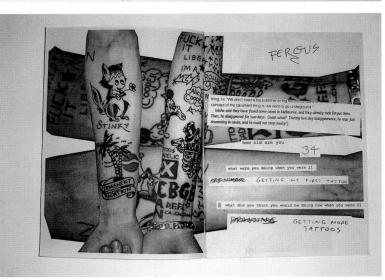

©MMVI CANTAB PUBLISHING
P.O. BOX 381591 CAMBRIDGE, MA 02238
WWW.CANTABPUBLISHING.COM

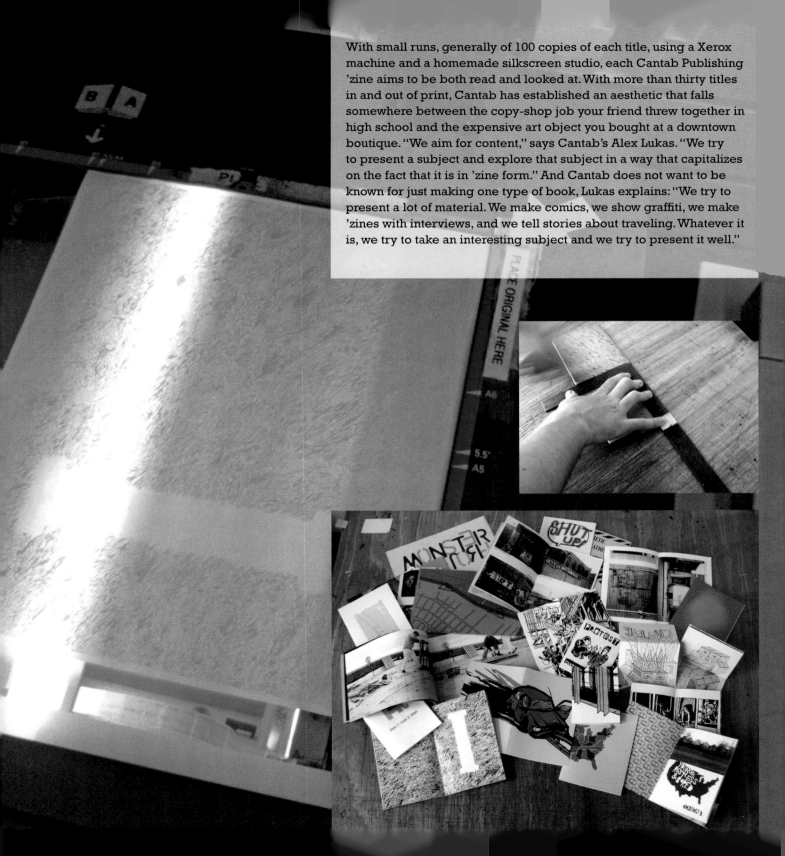

With small runs, generally of 100 copies of each title, using a Xerox machine and a homemade silkscreen studio, each Cantab Publishing 'zine aims to be both read and looked at. With more than thirty titles in and out of print, Cantab has established an aesthetic that falls somewhere between the copy-shop job your friend threw together in high school and the expensive art object you bought at a downtown boutique. "We aim for content," says Cantab's Alex Lukas. "We try to present a subject and explore that subject in a way that capitalizes on the fact that it is in 'zine form." And Cantab does not want to be known for just making one type of book, Lukas explains: "We try to present a lot of material. We make comics, we show graffiti, we make 'zines with interviews, and we tell stories about traveling. Whatever it is, we try to take an interesting subject and we try to present it well."

Though many subcultures grew organically from small gatherings, many have become national and even global phenomena, meaning that someone eventually had to document them—this is the Information Age, after all. The vast number of magazines on newsstands today dedicated to various lifestyles is a testament to both the influence and marketability of subcultures. Some of these magazines grew from 'zines, including the Asian culture publication *Giant Robot* and the feminist journal *Bust*. Others were started by large publishers strictly for their commercial potential, such as Condé Nast's *Lucky*, a magazine dedicated to the culture of shopping. While large commercial magazines may be created as a result of a palpable market demand, independent publications often arise because their publishers feel the desire to share the things that excite them.

"Any subculture with staying power really only has that power as long as people find it cool. If a magazine can give readers some solid evidence that its subject matter is really cool, it'll prolong the shelf life of both that subculture and itself."

Shepard Fairey

...NER

...JASMINE
...ANILLA
...TRAWBERRY

1.95

WELCOME

MasterCard

VISA

WE ACCEPT CHECKS!

HALOGEN 9004
HEAD LAMP
REPLACEMENT
BULB
FROM
$4.95

4-PCS.
Rubber Floor...

JULIO'S (773·292·16...
AUTO PAR...

STARTERS • BRAKE PADS • SPARK PLUGS • SHOCKS FRONT END PARTS • OIL FILTER • ALTERNATORS...

MASTER
CYLINDERS
W/EXCHANGE
FROM:
13.95

HEATER
CORES
FROM
19.95

NEW
RADIATOR
From:
69.95

From:
11.99

Save 13...
FREON...
8.95

AIR
FILTERS

AIR
F...
FROM:
2.59

BELTS
FROM:
3.95

ROTORS
DRUMS
From:
11.95

WHEEL
CYLINDER
From:
9.95

R-134 a
Stop Leak
& Detector
8.95

FULL
INJECTOR
TBI-MULTIPORT
FROM
$**39.95**
X CHANGE

FROM
19.95
THROTTLE
POSITION SENSOR

OXYGEN
SENSOR
FROM
16.95

$**6.95**
$**7.95**
LUCAS
LUCAS
$**2.95**
LUCAS

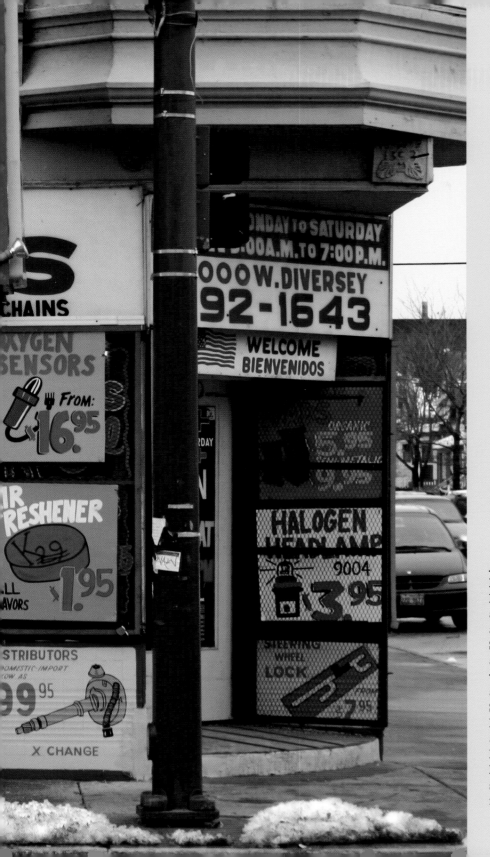

Andy Warhol once said that "good business is the best art." For many businesses, the art of commerce also depends on the art of murals and other paintings or drawings. Some shopkeepers try their hand at embellishing their storefronts, while others hire professional artists to come in and decorate. Small, family-owned stores tend to be the most adorned, using their aesthetically pleasing exteriors to lure customers, but large chains have also begun to beautify their stores. Apparently good art is best for business.

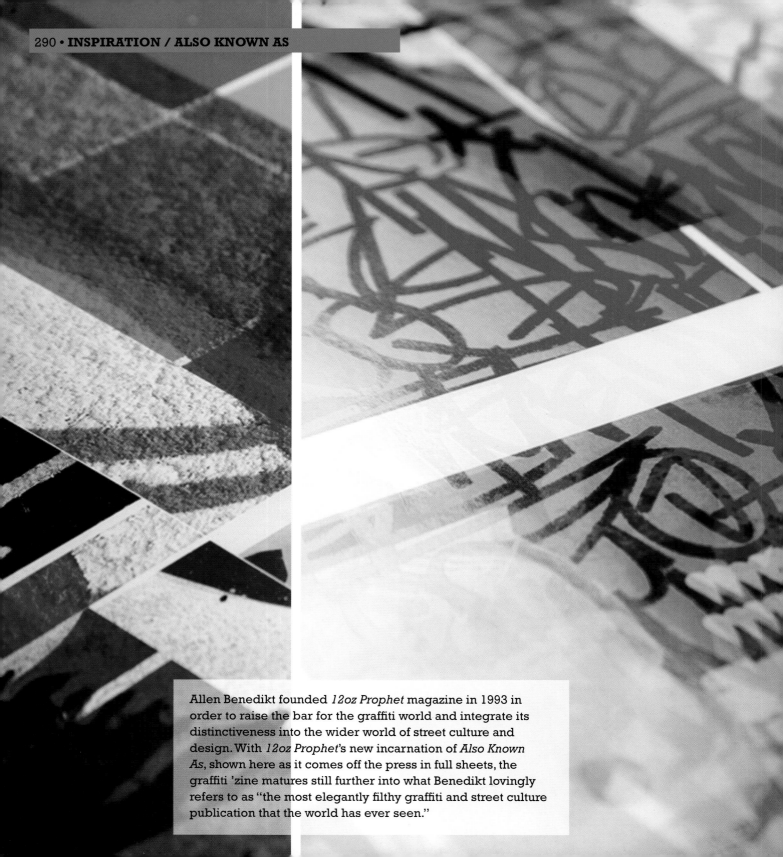

Allen Benedikt founded *12oz Prophet* magazine in 1993 in order to raise the bar for the graffiti world and integrate its distinctiveness into the wider world of street culture and design. With *12oz Prophet*'s new incarnation of *Also Known As*, shown here as it comes off the press in full sheets, the graffiti 'zine matures still further into what Benedikt lovingly refers to as "the most elegantly filthy graffiti and street culture publication that the world has ever seen."

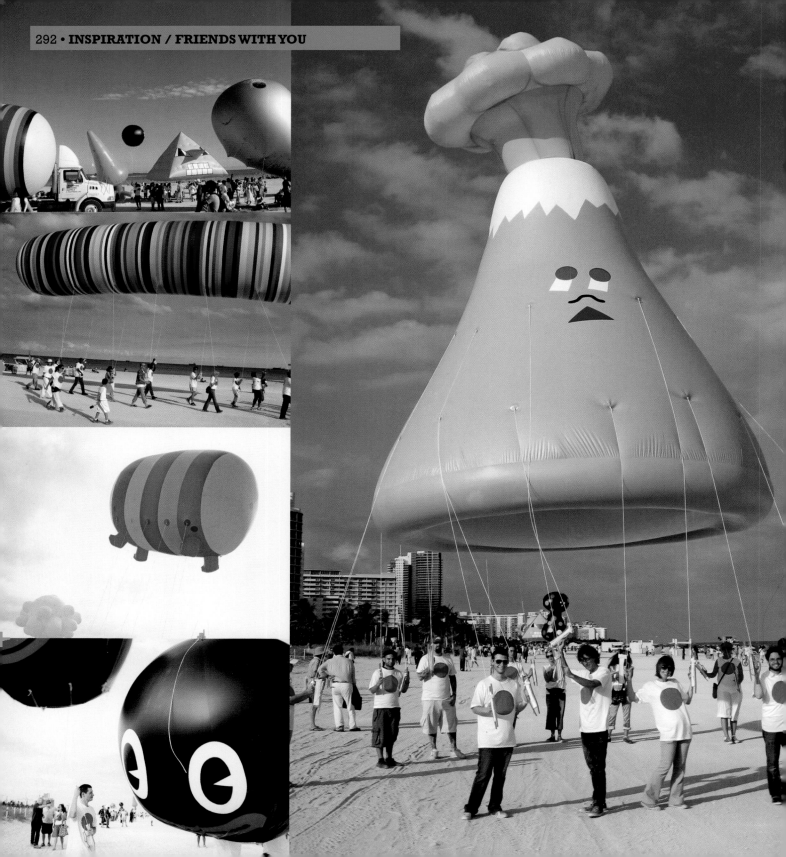

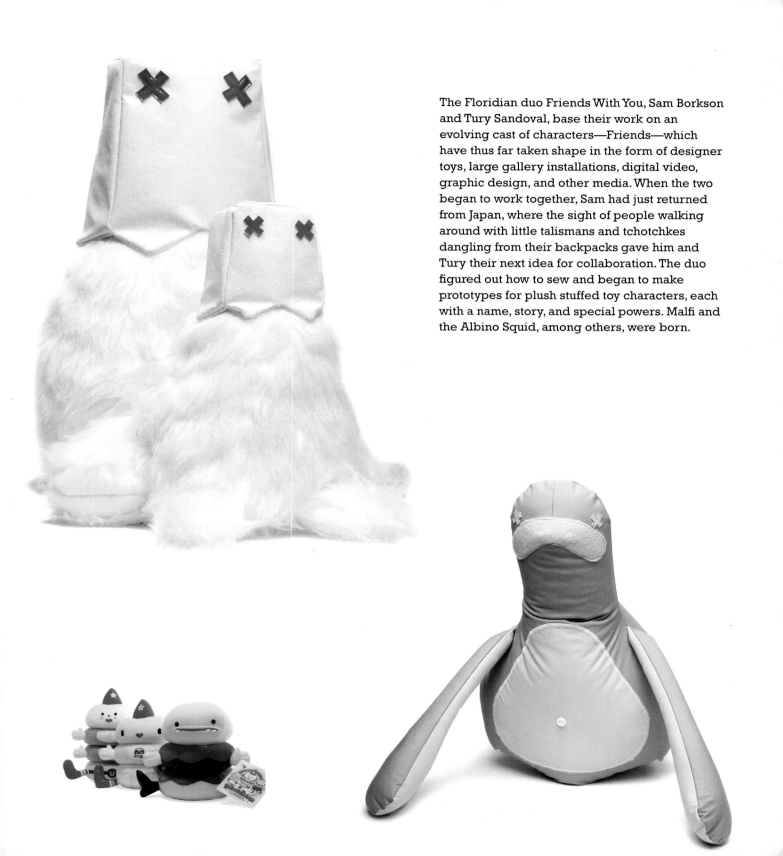

The Floridian duo Friends With You, Sam Borkson and Tury Sandoval, base their work on an evolving cast of characters—Friends—which have thus far taken shape in the form of designer toys, large gallery installations, digital video, graphic design, and other media. When the two began to work together, Sam had just returned from Japan, where the sight of people walking around with little talismans and tchotchkes dangling from their backpacks gave him and Tury their next idea for collaboration. The duo figured out how to sew and began to make prototypes for plush stuffed toy characters, each with a name, story, and special powers. Malfi and the Albino Squid, among others, were born.

It's not so easy for painters to carry their easels in their pockets, or for potters to hide their kilns in their socks. Unlike such artists, graffiti writers lack the luxury of working in safe, private environments, but because they're constantly on the go, they turn to the most portable instrument of art: the marker. While spraypaint is ideal for large-scale works, the convenience and precision of the paint or ink marker—whether assembled in a factory or by the graffiti writer—make it the medium of choice for smaller things such as tags, often written on stickers that are then applied to various surfaces.

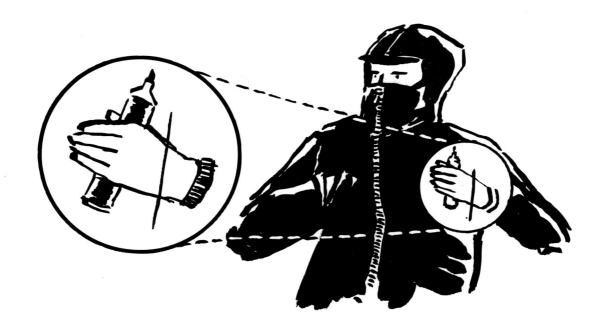

Baseball fans have their trading cards. Music lovers have their records. Collecting is an important way for people to connect to the subcultures they love. Graffiti has its material obsessions, with its most basic tool of the trade being the most obvious. Unlike most other kinds of paint, spraypaint is an absolute pain to mix in order to customize colors, leaving graffiti writers quite dependent on the seasonal color offerings of the paint companies. Colors, like anything else, are subject to fashion, and are frequently discontinued. Because of this, there is a class of graffiti writers who specialize in scouring paint stores for the old and discontinued paints in long-unavailable colors. Always keen on aesthetics, writers look for not only the rarest cans but also the ones with the most beautiful or quirkiest designs and logos. The choice of whether to use the paints or keep them intact as a part of a collection is, of course, up to the individual.

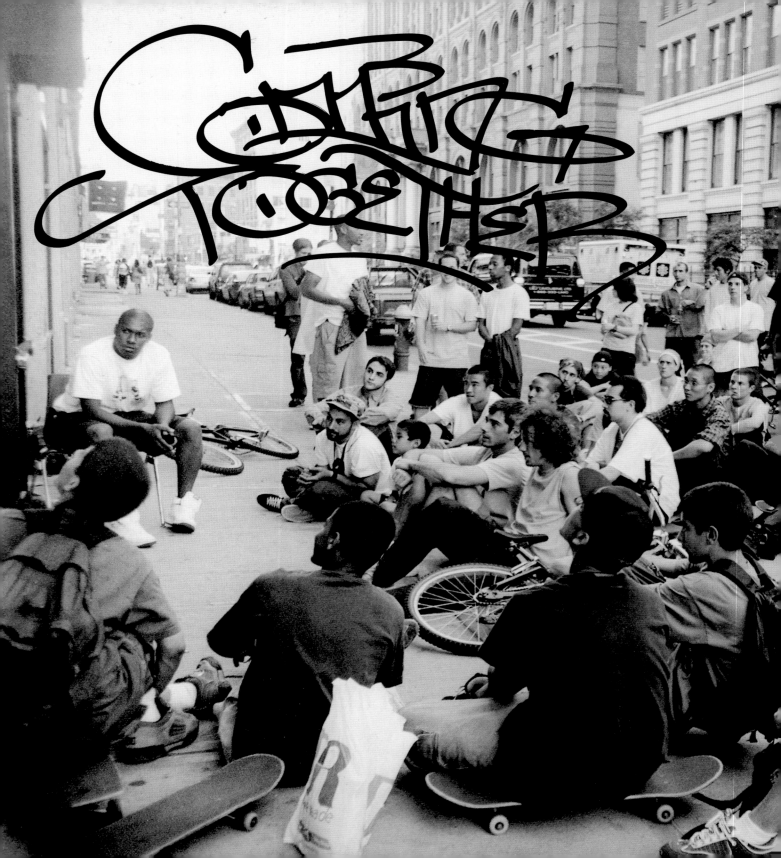

A show, a protest, an art opening—there is always something going on. In the end, street culture is about people, and the more we get together, the more we see who we truly are. Yell, scream, sing along, posture, preen, and network—it takes a crowd.

• COMING TOGETHER

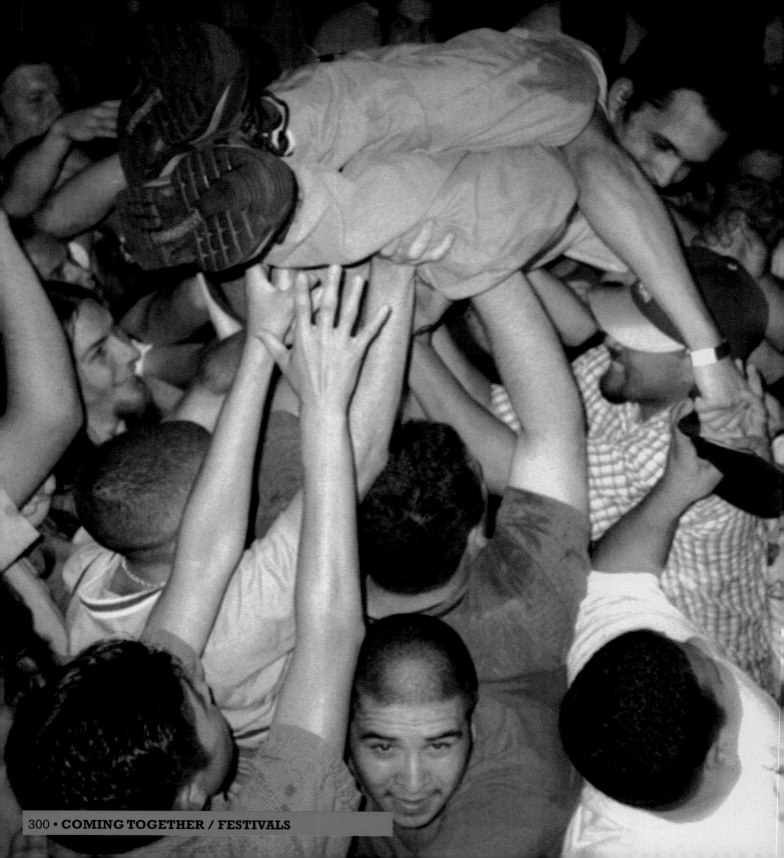

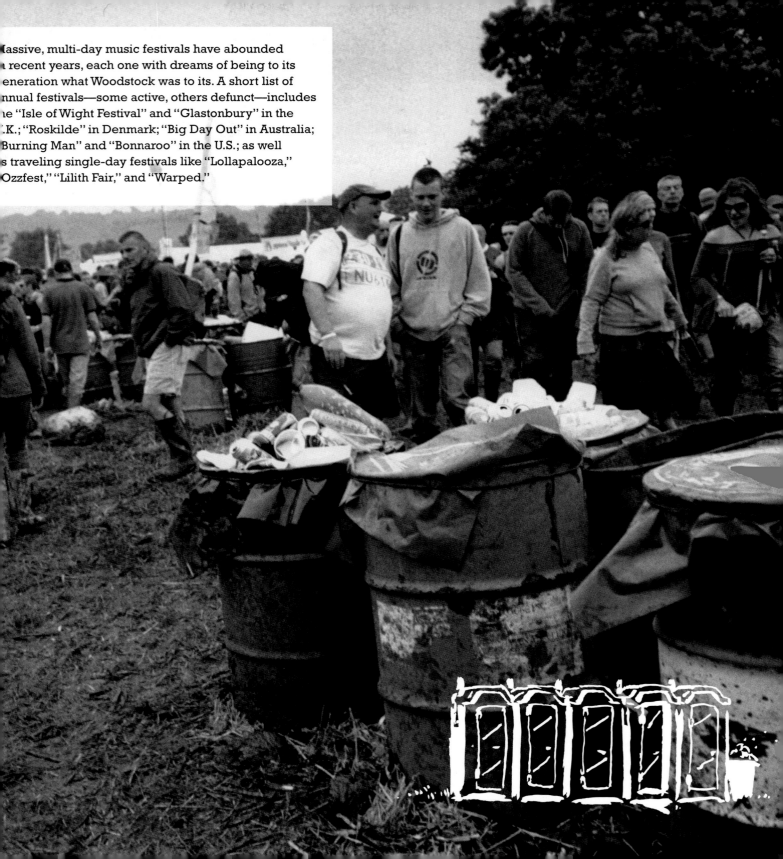

Massive, multi-day music festivals have abounded in recent years, each one with dreams of being to its generation what Woodstock was to its. A short list of annual festivals—some active, others defunct—includes the "Isle of Wight Festival" and "Glastonbury" in the U.K.; "Roskilde" in Denmark; "Big Day Out" in Australia; "Burning Man" and "Bonnaroo" in the U.S.; as well as traveling single-day festivals like "Lollapalooza," "Ozzfest," "Lilith Fair," and "Warped."

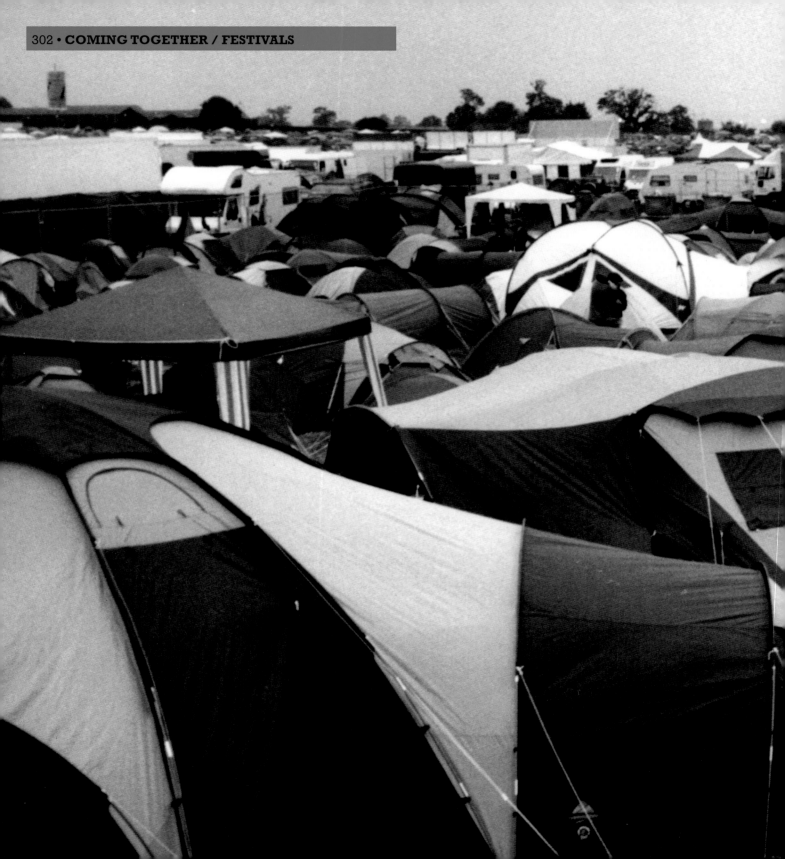

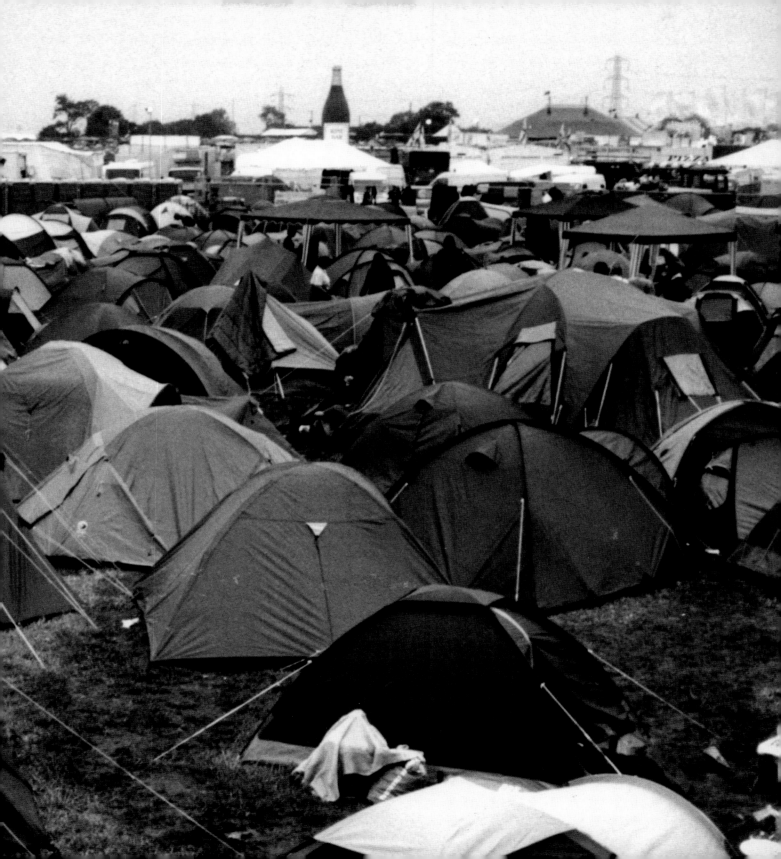

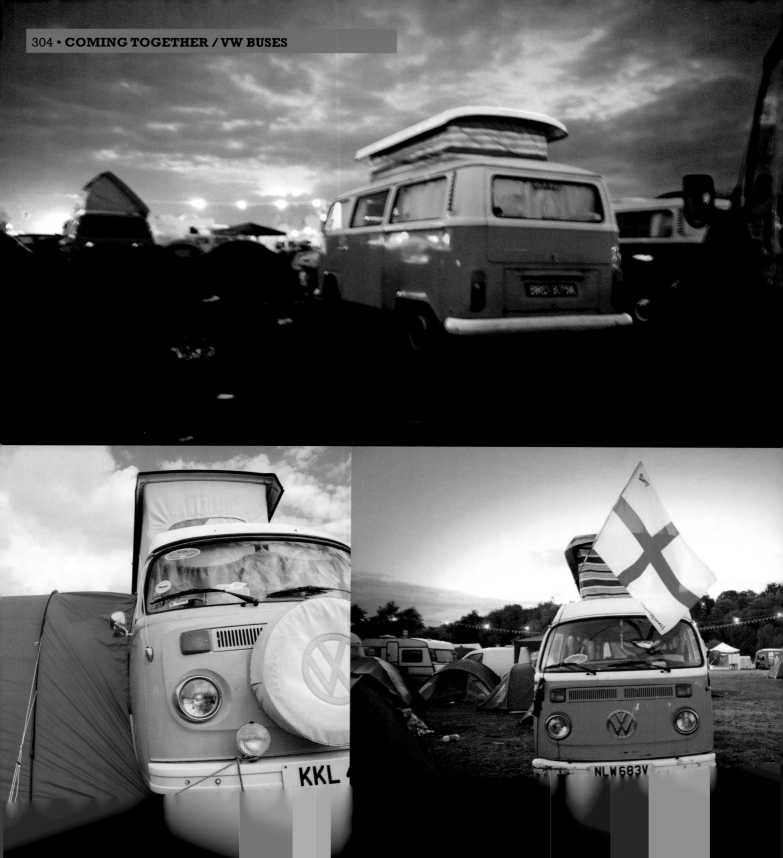

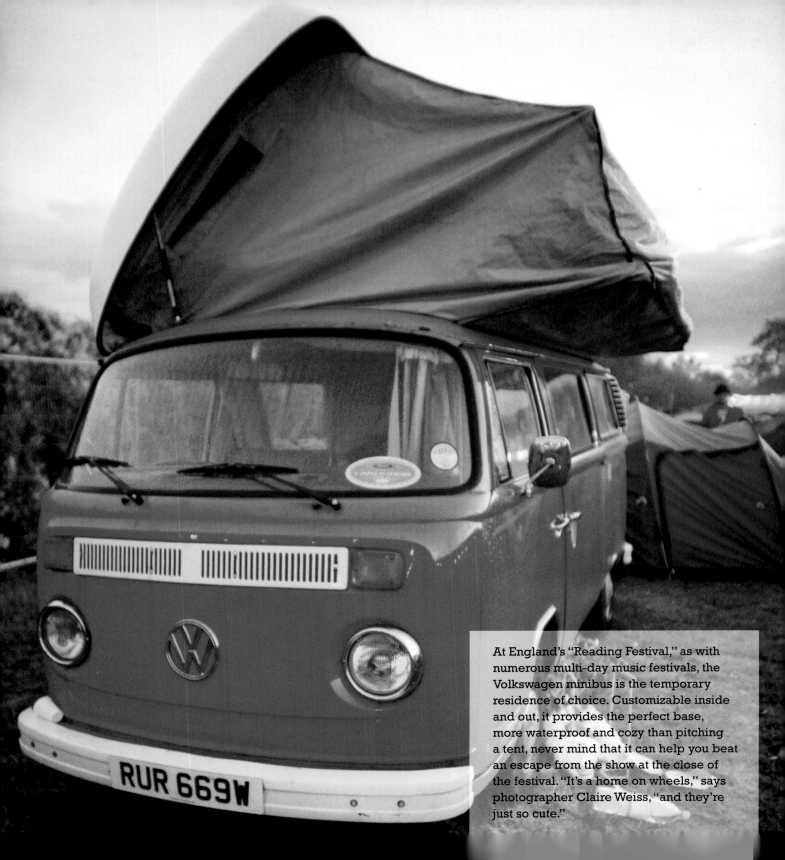

At England's "Reading Festival," as with numerous multi-day music festivals, the Volkswagen minibus is the temporary residence of choice. Customizable inside and out, it provides the perfect base, more waterproof and cozy than pitching a tent, never mind that it can help you beat an escape from the show at the close of the festival. "It's a home on wheels," says photographer Claire Weiss, "and they're just so cute."

RUR 669W

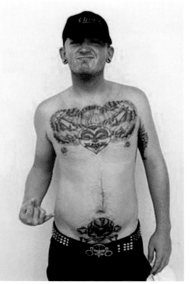

"These mostly come from walking around at huge music festivals. Each kid grabbed my attention for some reason, some obvious, some not…. One of these kids was in a little makeshift jail at a festival, having been busted for something or other. This was the only frame I got off before some security guard yelled at me—try to guess which kid it was."
Dan Monick

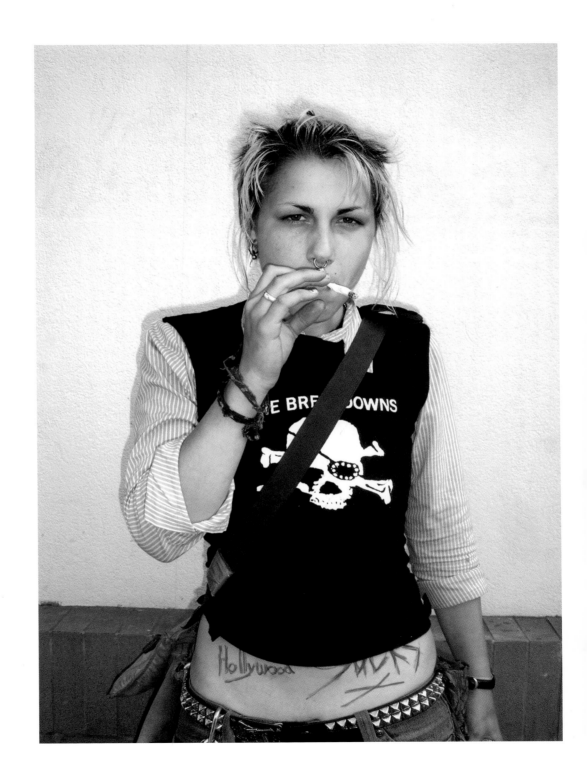

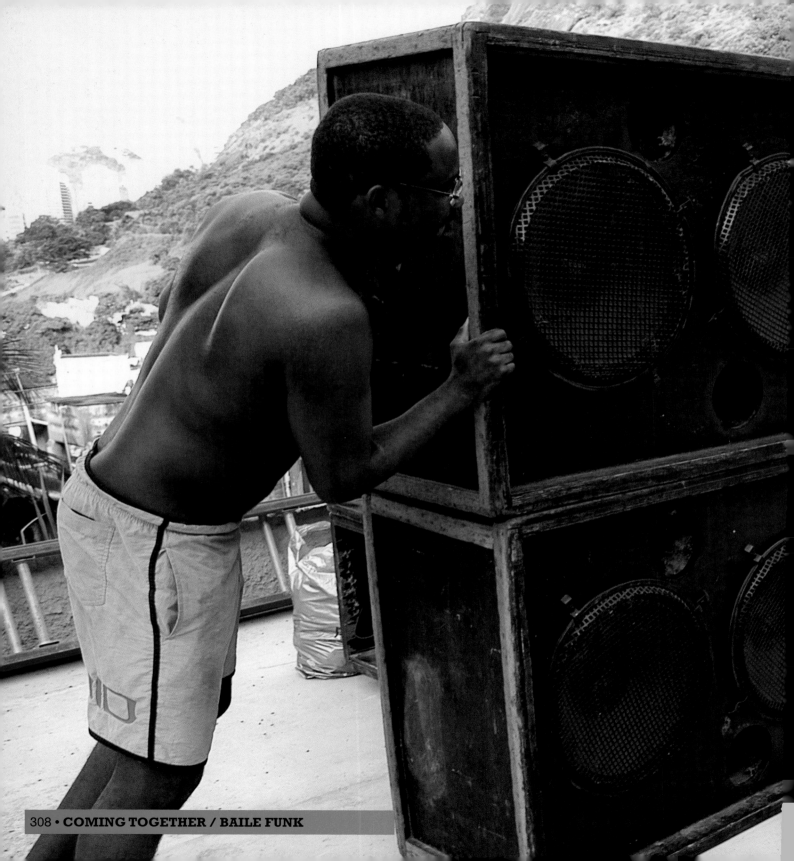

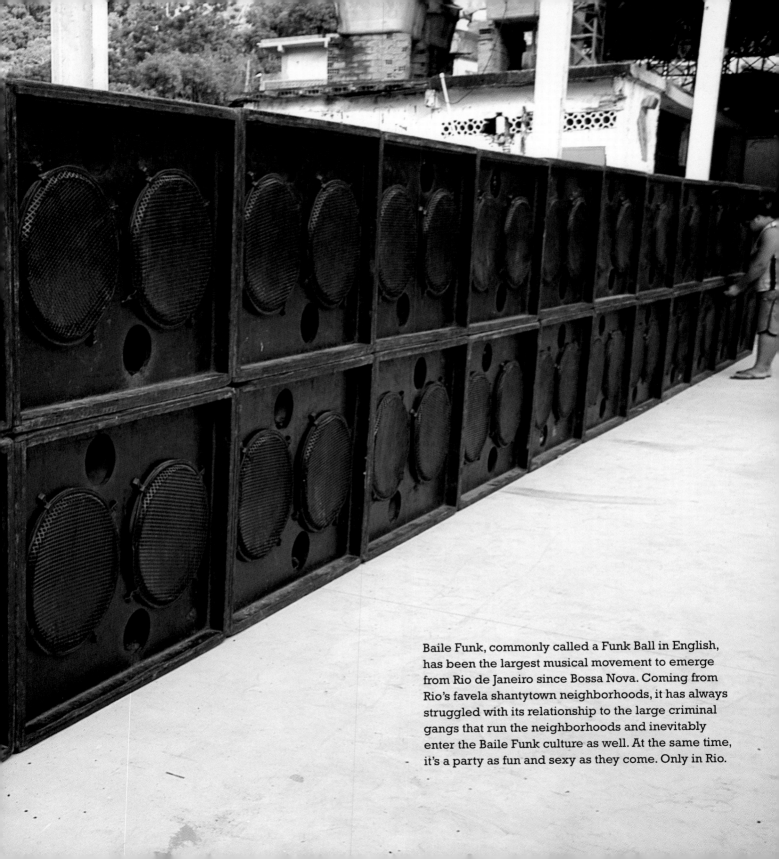

Baile Funk, commonly called a Funk Ball in English, has been the largest musical movement to emerge from Rio de Janeiro since Bossa Nova. Coming from Rio's favela shantytown neighborhoods, it has always struggled with its relationship to the large criminal gangs that run the neighborhoods and inevitably enter the Baile Funk culture as well. At the same time, it's a party as fun and sexy as they come. Only in Rio.

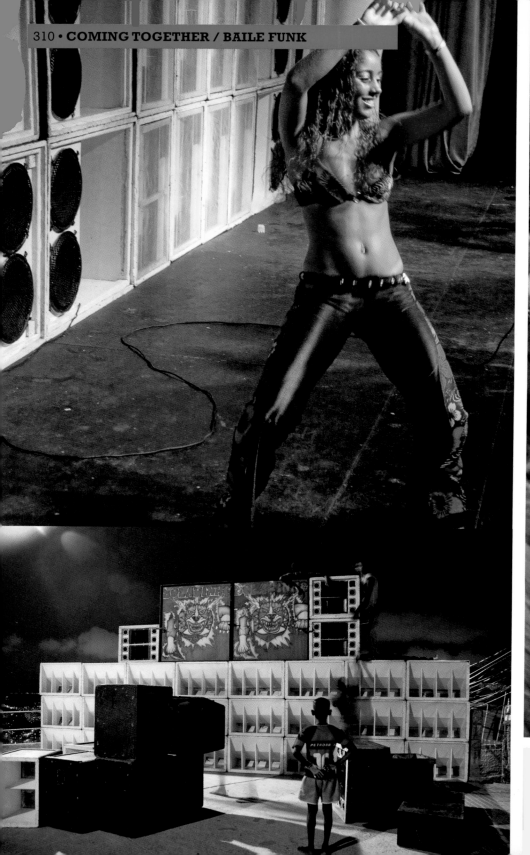

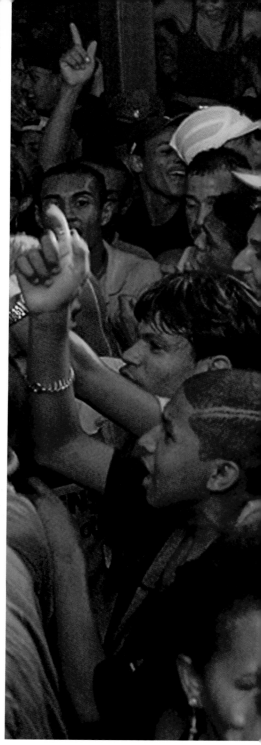

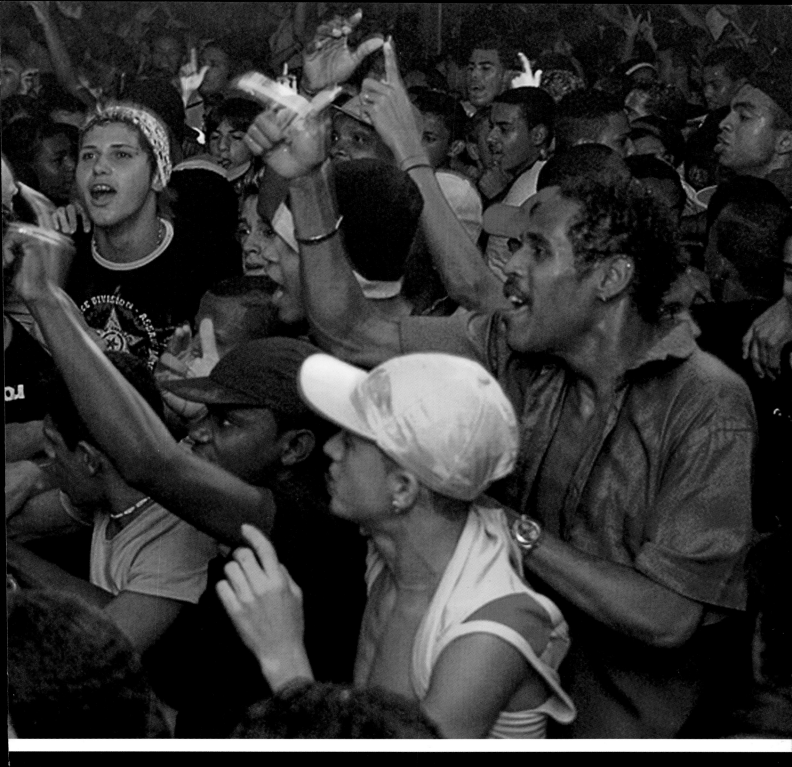

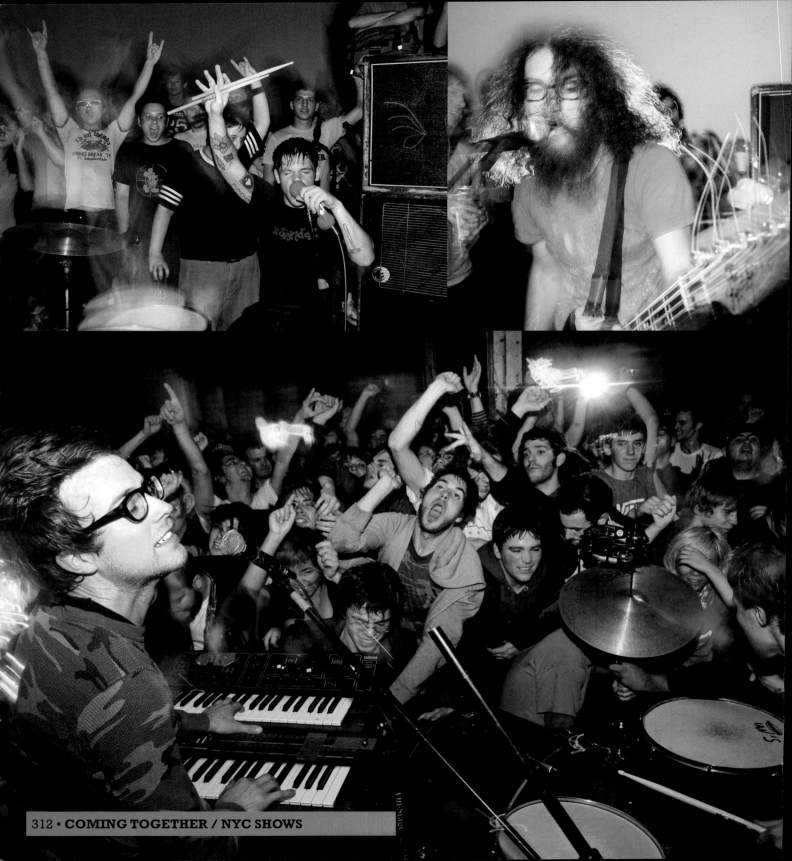

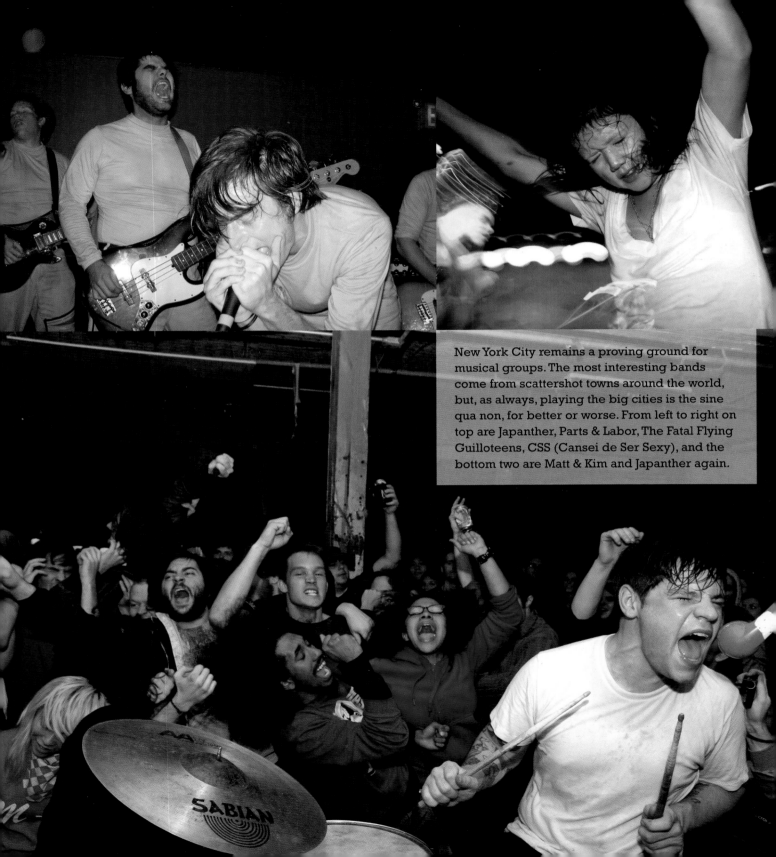

New York City remains a proving ground for musical groups. The most interesting bands come from scattershot towns around the world, but, as always, playing the big cities is the sine qua non, for better or worse. From left to right on top are Japanther, Parts & Labor, The Fatal Flying Guilloteens, CSS (Cansei de Ser Sexy), and the bottom two are Matt & Kim and Japanther again.

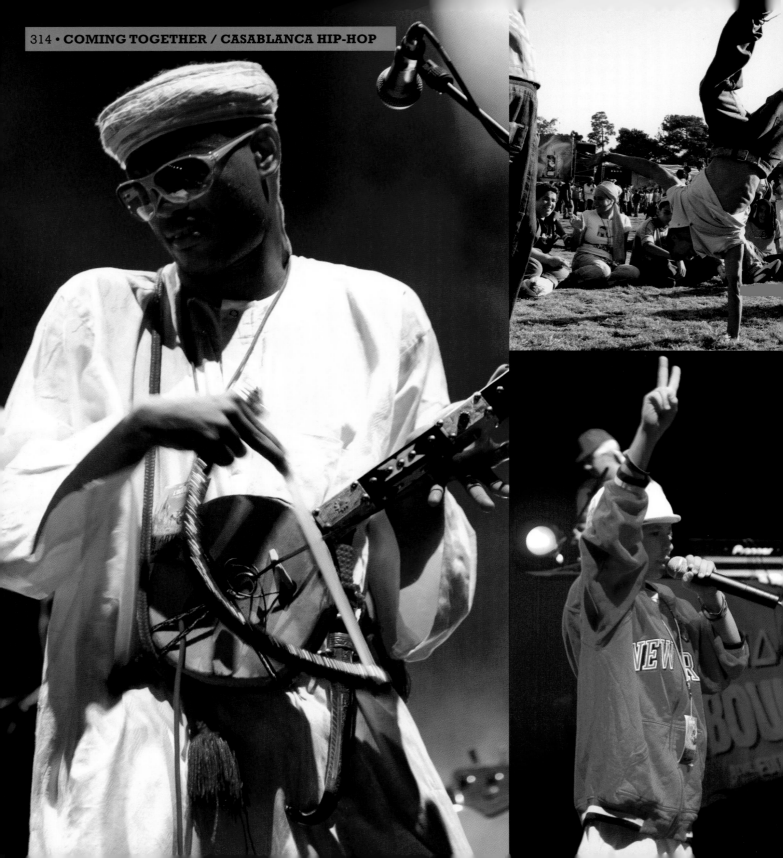

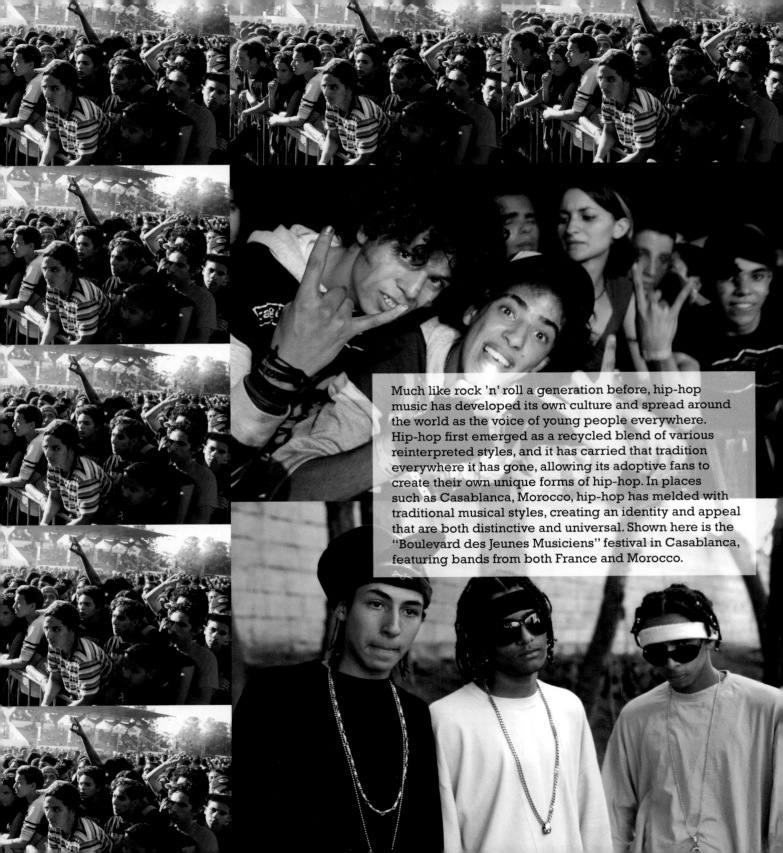

Much like rock 'n' roll a generation before, hip-hop music has developed its own culture and spread around the world as the voice of young people everywhere. Hip-hop first emerged as a recycled blend of various reinterpreted styles, and it has carried that tradition everywhere it has gone, allowing its adoptive fans to create their own unique forms of hip-hop. In places such as Casablanca, Morocco, hip-hop has melded with traditional musical styles, creating an identity and appeal that are both distinctive and universal. Shown here is the "Boulevard des Jeunes Musiciens" festival in Casablanca, featuring bands from both France and Morocco.

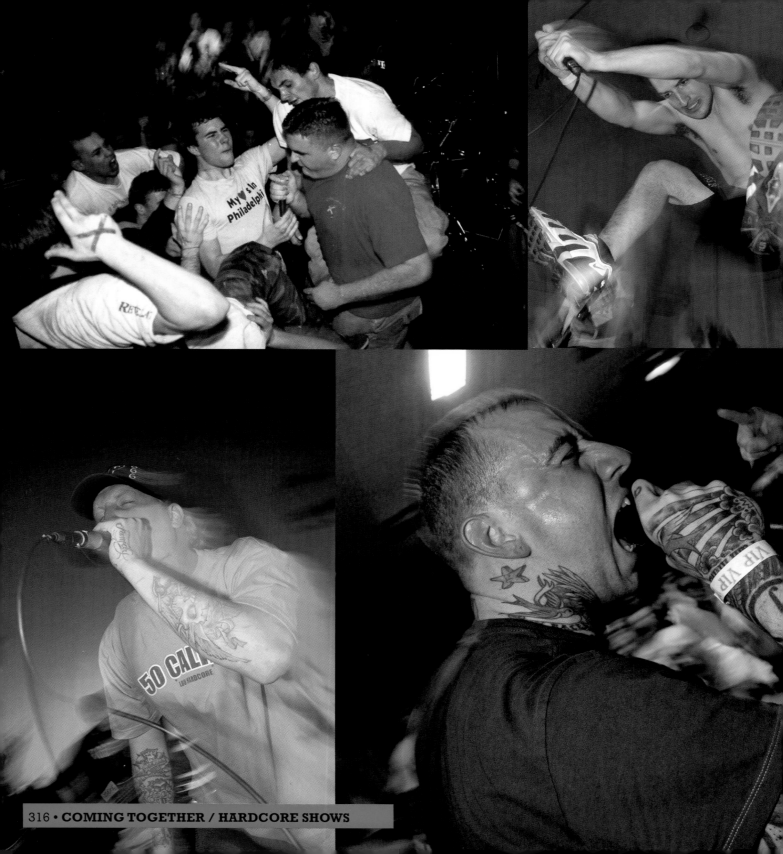

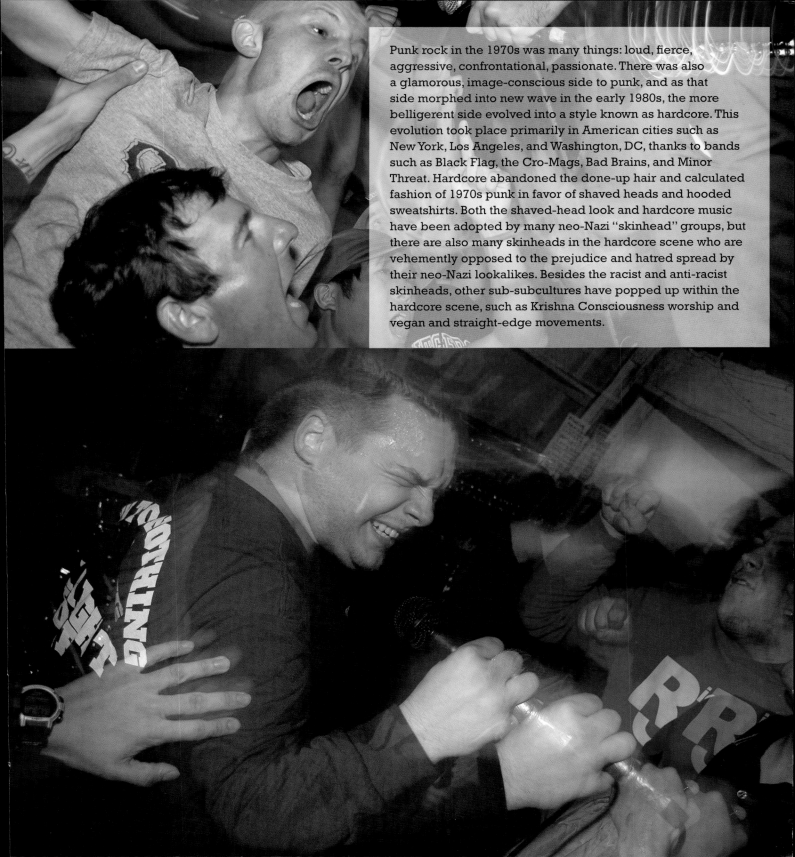

Punk rock in the 1970s was many things: loud, fierce, aggressive, confrontational, passionate. There was also a glamorous, image-conscious side to punk, and as that side morphed into new wave in the early 1980s, the more belligerent side evolved into a style known as hardcore. This evolution took place primarily in American cities such as New York, Los Angeles, and Washington, DC, thanks to bands such as Black Flag, the Cro-Mags, Bad Brains, and Minor Threat. Hardcore abandoned the done-up hair and calculated fashion of 1970s punk in favor of shaved heads and hooded sweatshirts. Both the shaved-head look and hardcore music have been adopted by many neo-Nazi "skinhead" groups, but there are also many skinheads in the hardcore scene who are vehemently opposed to the prejudice and hatred spread by their neo-Nazi lookalikes. Besides the racist and anti-racist skinheads, other sub-subcultures have popped up within the hardcore scene, such as Krishna Consciousness worship and vegan and straight-edge movements.

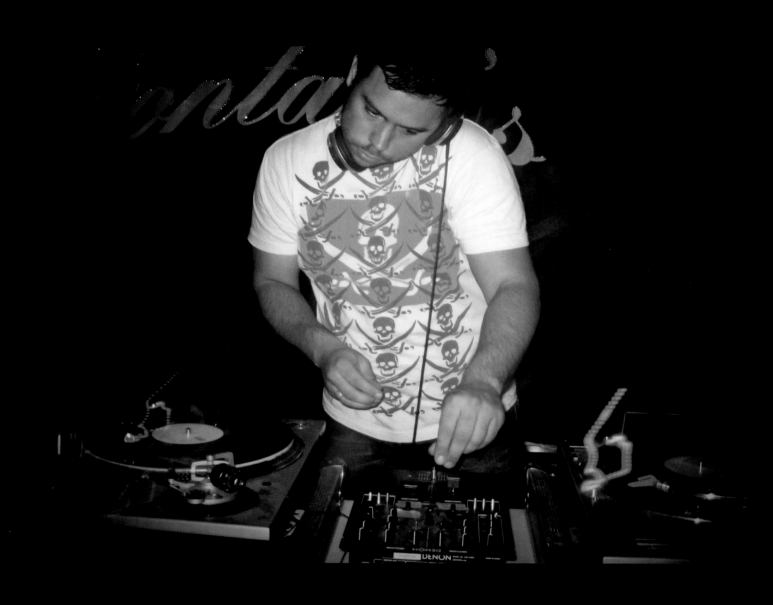

A party just isn't a party without music, and the quality of that music often determines the quality of the party. Enter the DJ. With an unofficial degree in crowd psychology, the expert DJ knows exactly which tracks can get people dancing and which ones can get them romancing. During the nascence of hip-hop in New York City, DJs were the chiefs of crews that would compete to see who could rock a party the hardest. The most skillful and coordinated of those DJs could transform their turntables into musical instruments by manipulating the records by hand—what we know today as "scratching." DJing once meant spending years building a record collection and having the muscle to haul heavy crates of vinyl to parties. Nowadays, with the development of digital music technology, virtually anyone with a CD or MP3 collection can be a DJ. The only requirement is to know how to move a crowd.

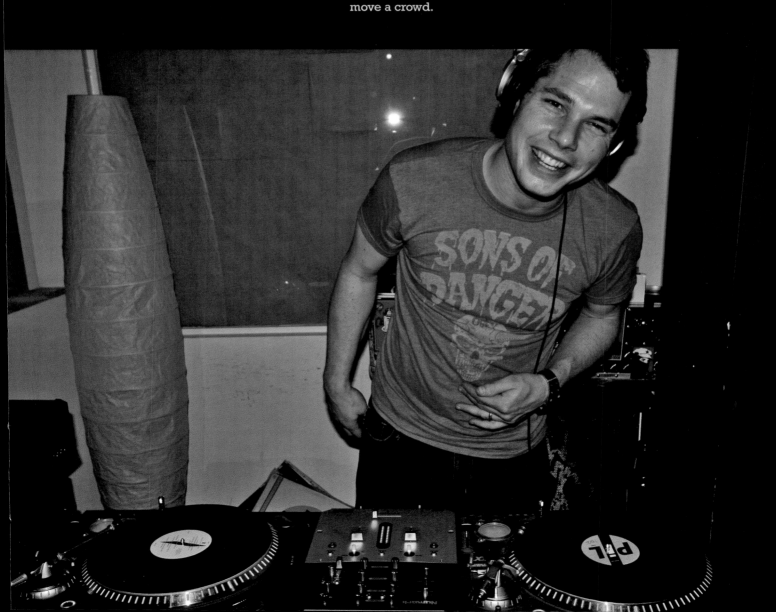

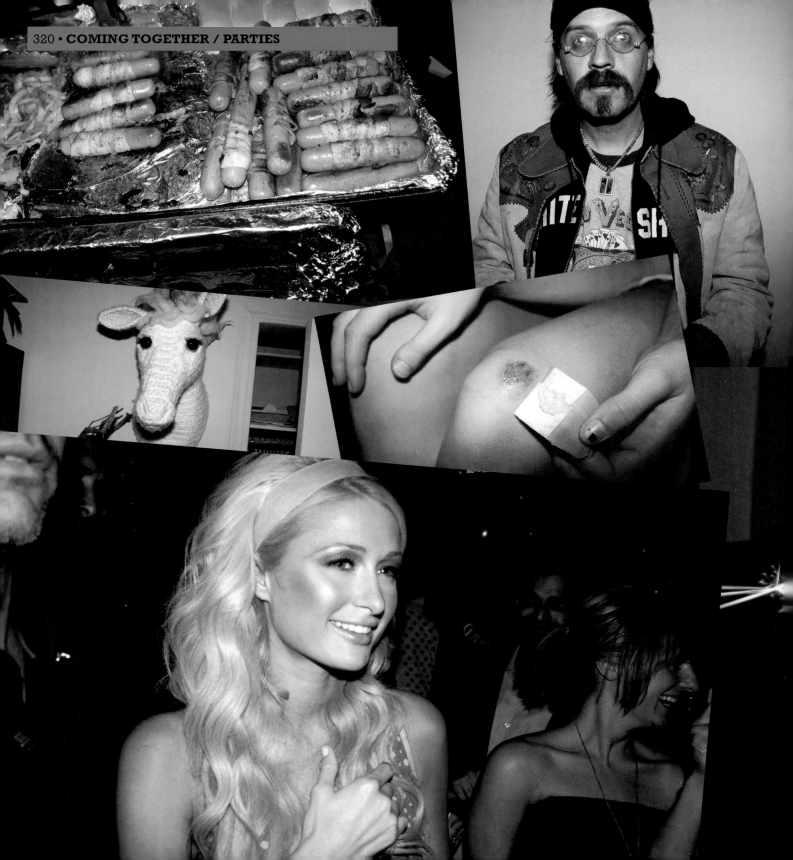

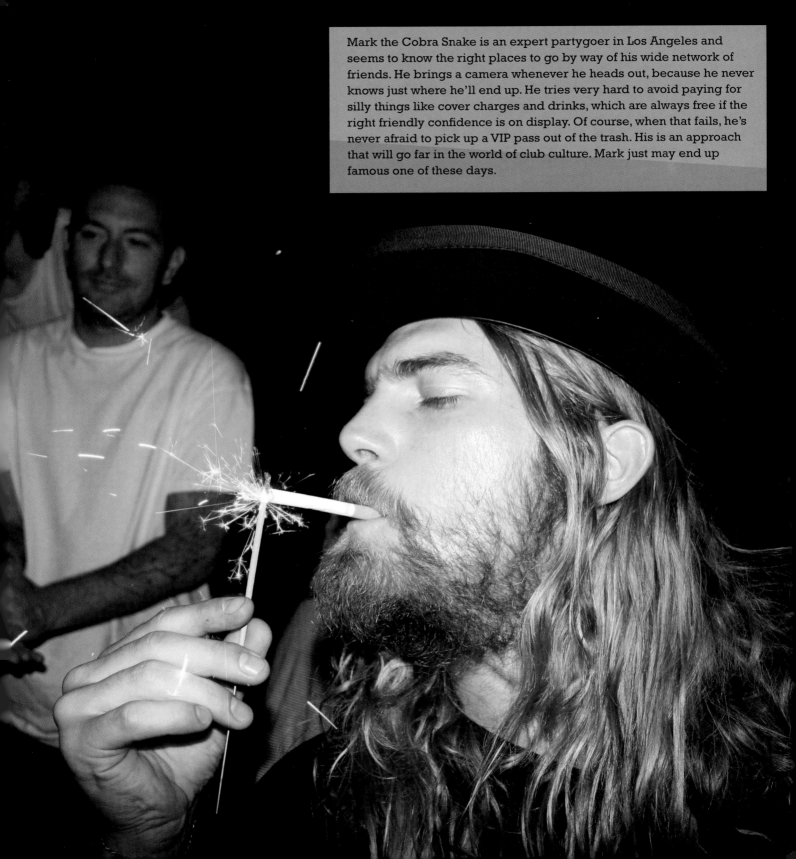

Mark the Cobra Snake is an expert partygoer in Los Angeles and seems to know the right places to go by way of his wide network of friends. He brings a camera whenever he heads out, because he never knows just where he'll end up. He tries very hard to avoid paying for silly things like cover charges and drinks, which are always free if the right friendly confidence is on display. Of course, when that fails, he's never afraid to pick up a VIP pass out of the trash. His is an approach that will go far in the world of club culture. Mark just may end up famous one of these days.

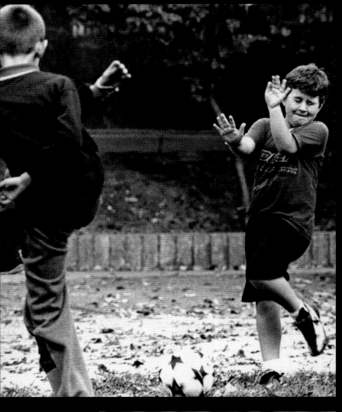
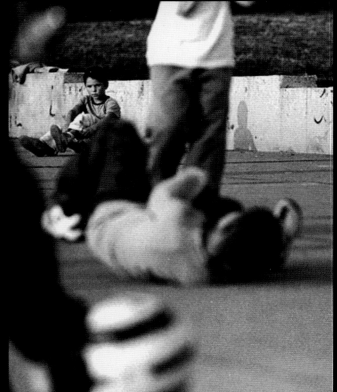
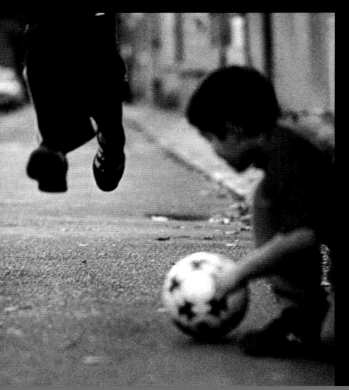
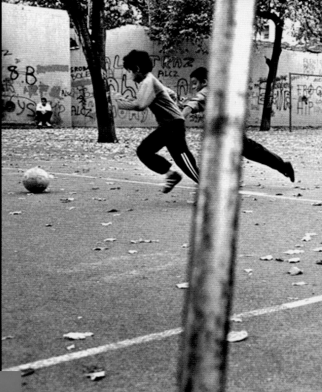

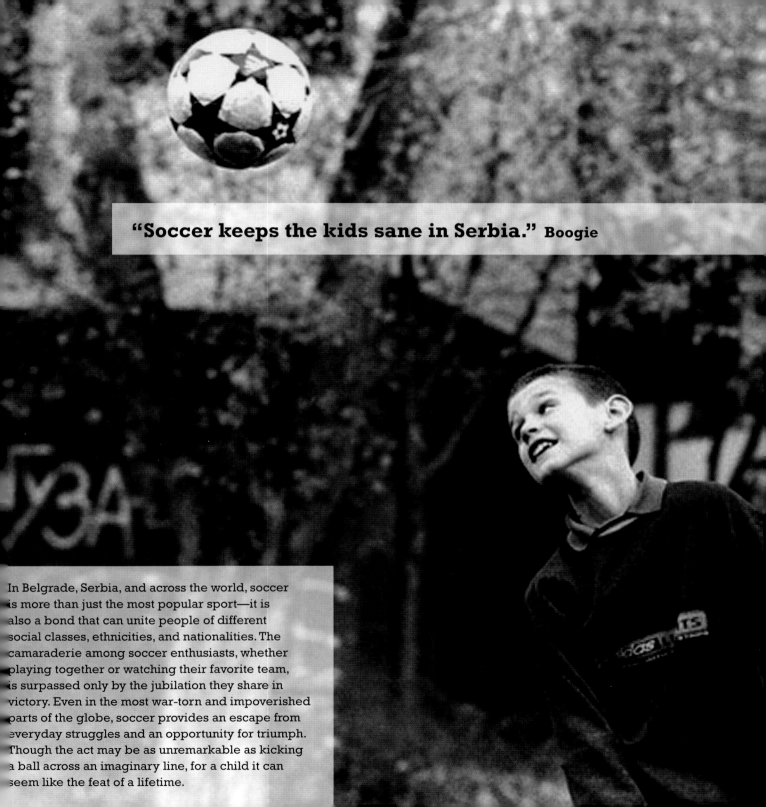

"Soccer keeps the kids sane in Serbia." Boogie

In Belgrade, Serbia, and across the world, soccer is more than just the most popular sport—it is also a bond that can unite people of different social classes, ethnicities, and nationalities. The camaraderie among soccer enthusiasts, whether playing together or watching their favorite team, is surpassed only by the jubilation they share in victory. Even in the most war-torn and impoverished parts of the globe, soccer provides an escape from everyday struggles and an opportunity for triumph. Though the act may be as unremarkable as kicking a ball across an imaginary line, for a child it can seem like the feat of a lifetime.

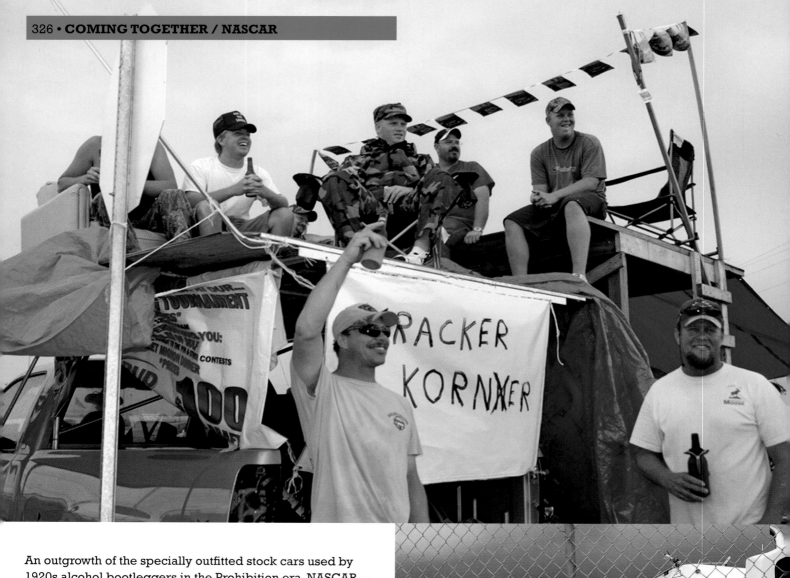

An outgrowth of the specially outfitted stock cars used by 1920s alcohol bootleggers in the Prohibition era, NASCAR— the foremost organization of stock car racing—has a reputation in the United States as having a proudly redneck and working-class fanbase. Whatever truth there is to that, these fans make that reputation a bit more complicated, however proudly they embrace their stereotype. Passes to the infield (the area inside the race track's loop) at these major NASCAR races cost thousands of dollars, and the recreational vehicles that fill them for the duration of the race are often million-dollar-plus behemoths.

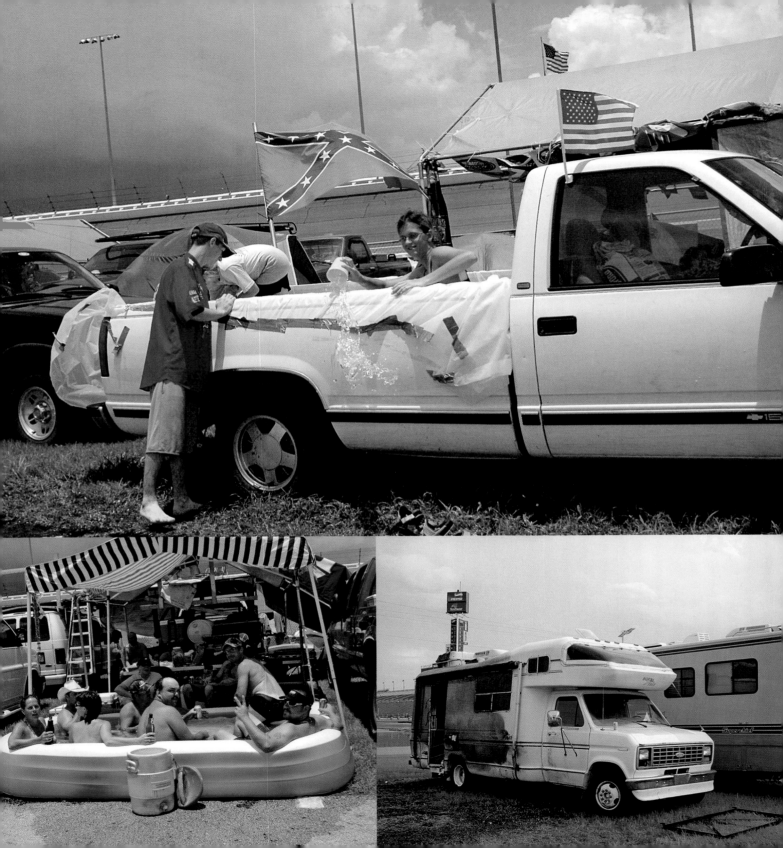

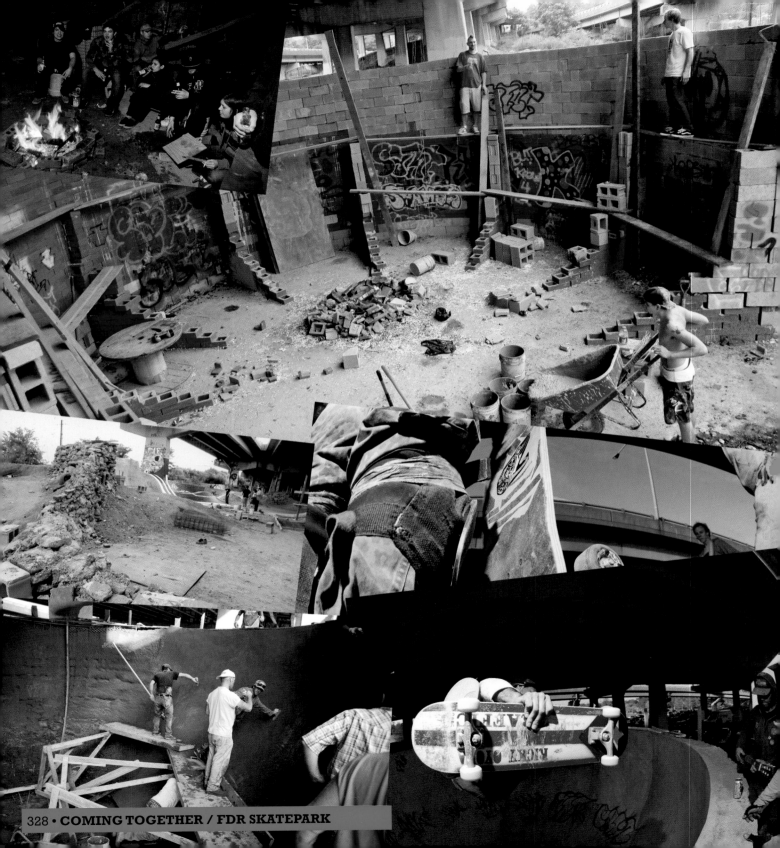

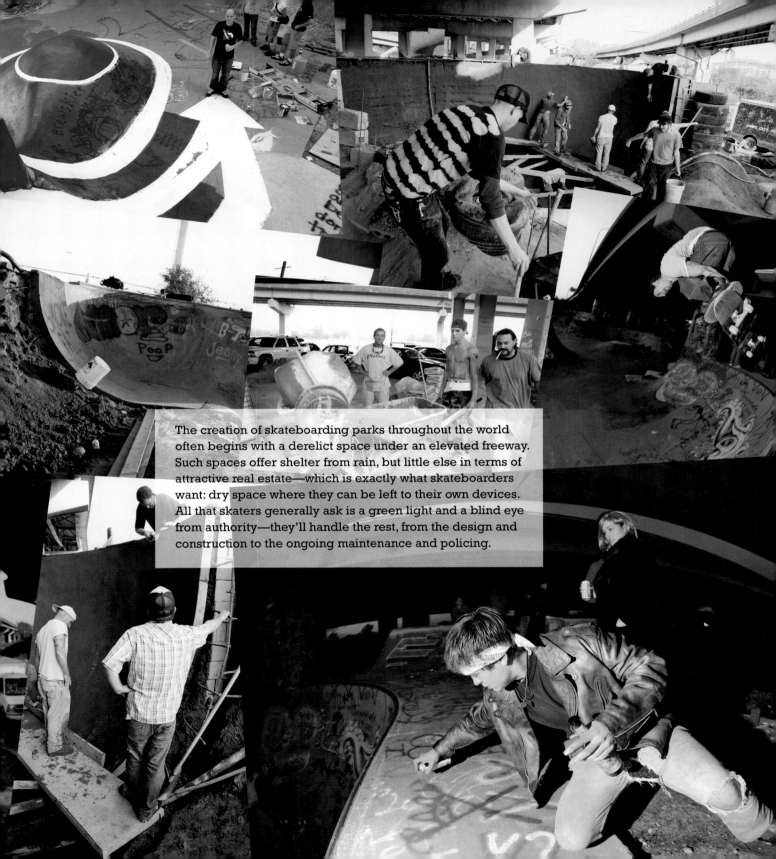

The creation of skateboarding parks throughout the world often begins with a derelict space under an elevated freeway. Such spaces offer shelter from rain, but little else in terms of attractive real estate—which is exactly what skateboarders want: dry space where they can be left to their own devices. All that skaters generally ask is a green light and a blind eye from authority—they'll handle the rest, from the design and construction to the ongoing maintenance and policing.

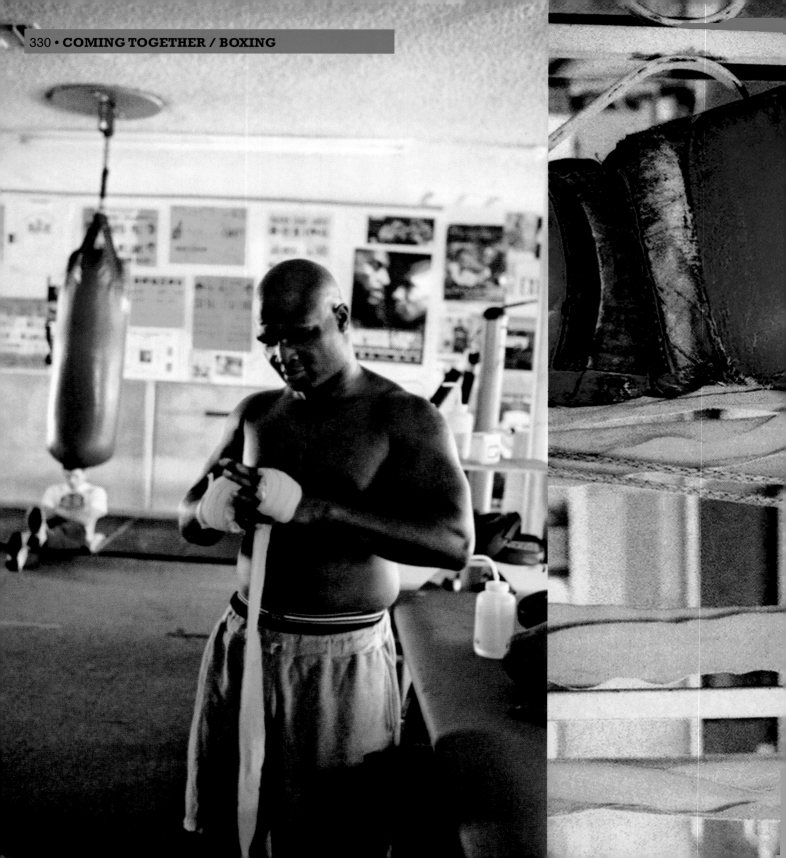

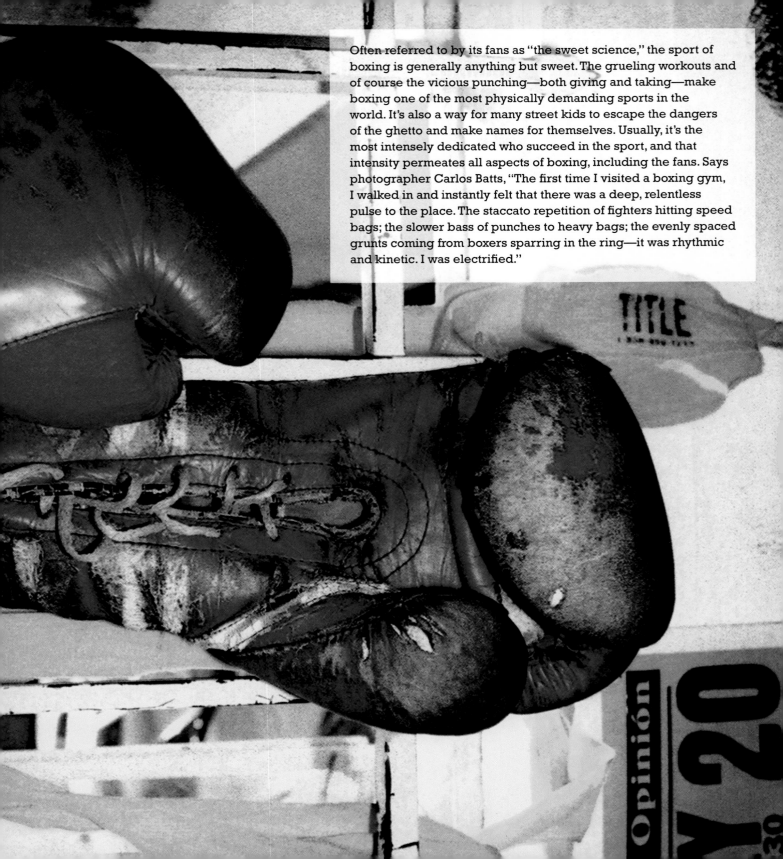

Often referred to by its fans as "the sweet science," the sport of boxing is generally anything but sweet. The grueling workouts and of course the vicious punching—both giving and taking—make boxing one of the most physically demanding sports in the world. It's also a way for many street kids to escape the dangers of the ghetto and make names for themselves. Usually, it's the most intensely dedicated who succeed in the sport, and that intensity permeates all aspects of boxing, including the fans. Says photographer Carlos Batts, "The first time I visited a boxing gym, I walked in and instantly felt that there was a deep, relentless pulse to the place. The staccato repetition of fighters hitting speed bags; the slower bass of punches to heavy bags; the evenly spaced grunts coming from boxers sparring in the ring—it was rhythmic and kinetic. I was electrified."

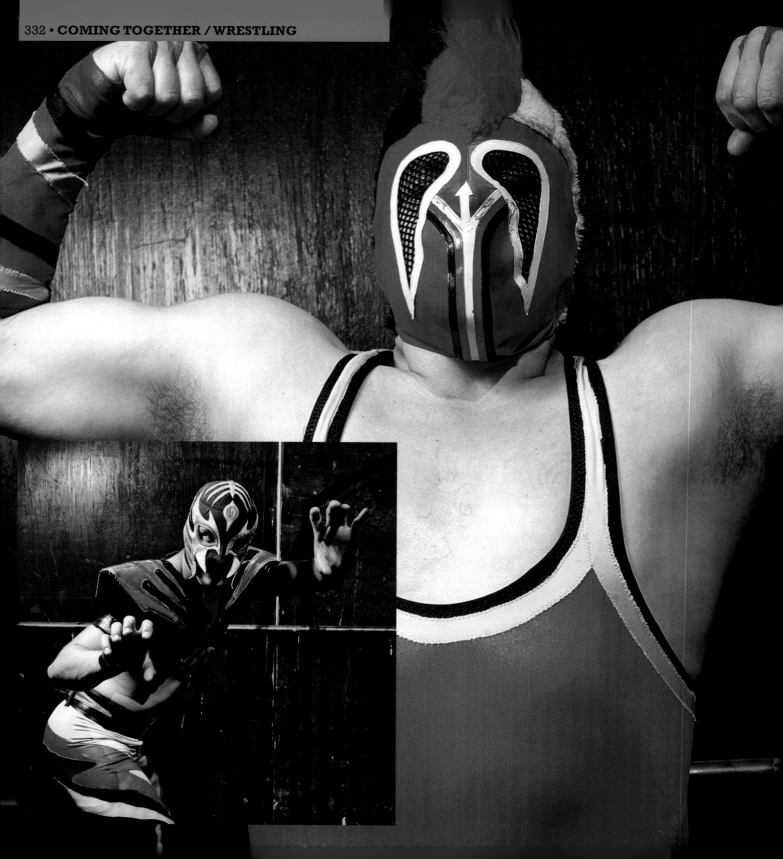

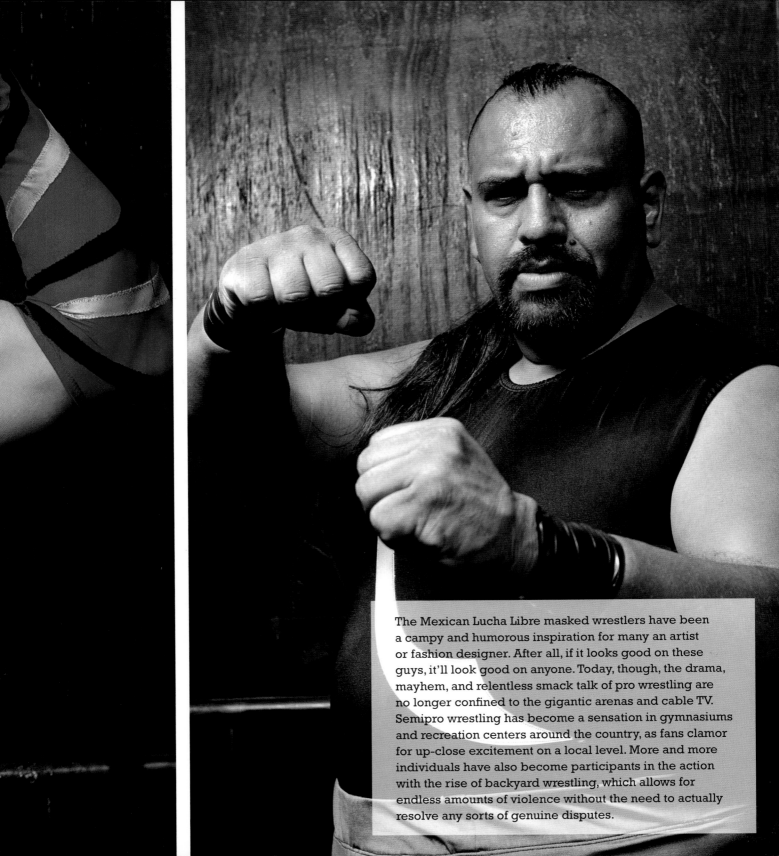

The Mexican Lucha Libre masked wrestlers have been a campy and humorous inspiration for many an artist or fashion designer. After all, if it looks good on these guys, it'll look good on anyone. Today, though, the drama, mayhem, and relentless smack talk of pro wrestling are no longer confined to the gigantic arenas and cable TV. Semipro wrestling has become a sensation in gymnasiums and recreation centers around the country, as fans clamor for up-close excitement on a local level. More and more individuals have also become participants in the action with the rise of backyard wrestling, which allows for endless amounts of violence without the need to actually resolve any sorts of genuine disputes.

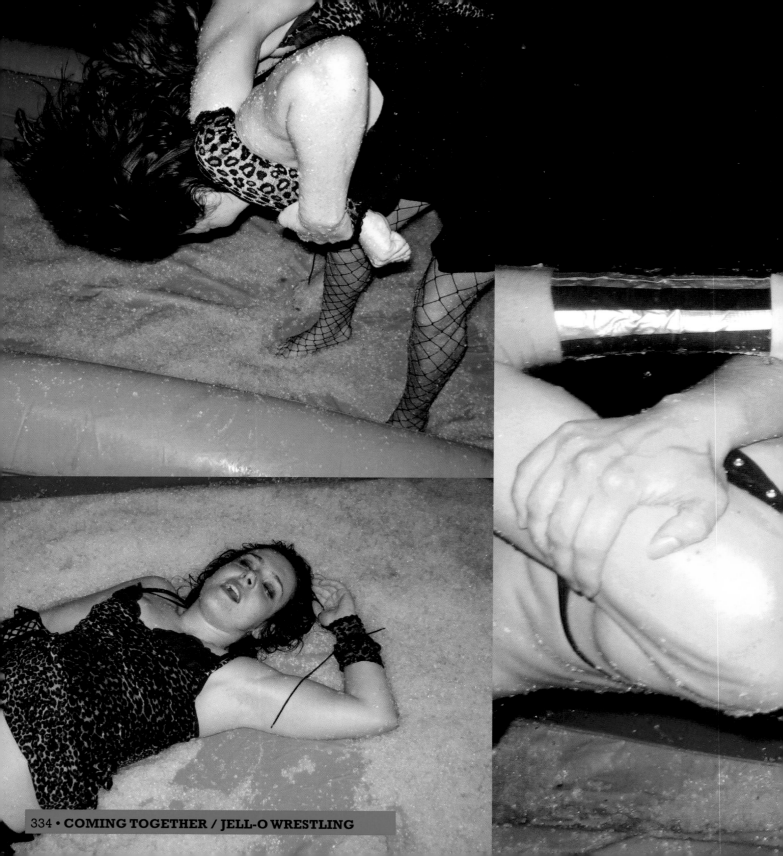

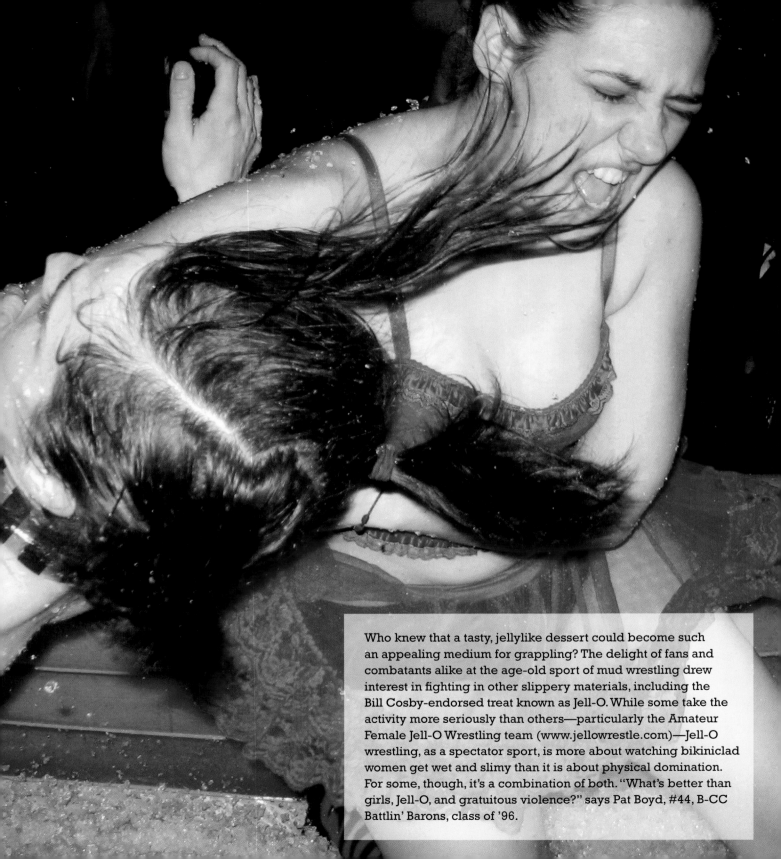

Who knew that a tasty, jellylike dessert could become such an appealing medium for grappling? The delight of fans and combatants alike at the age-old sport of mud wrestling drew interest in fighting in other slippery materials, including the Bill Cosby-endorsed treat known as Jell-O. While some take the activity more seriously than others—particularly the Amateur Female Jell-O Wrestling team (www.jellowrestle.com)—Jell-O wrestling, as a spectator sport, is more about watching bikiniclad women get wet and slimy than it is about physical domination. For some, though, it's a combination of both. "What's better than girls, Jell-O, and gratuitous violence?" says Pat Boyd, #44, B-CC Battlin' Barons, class of '96.

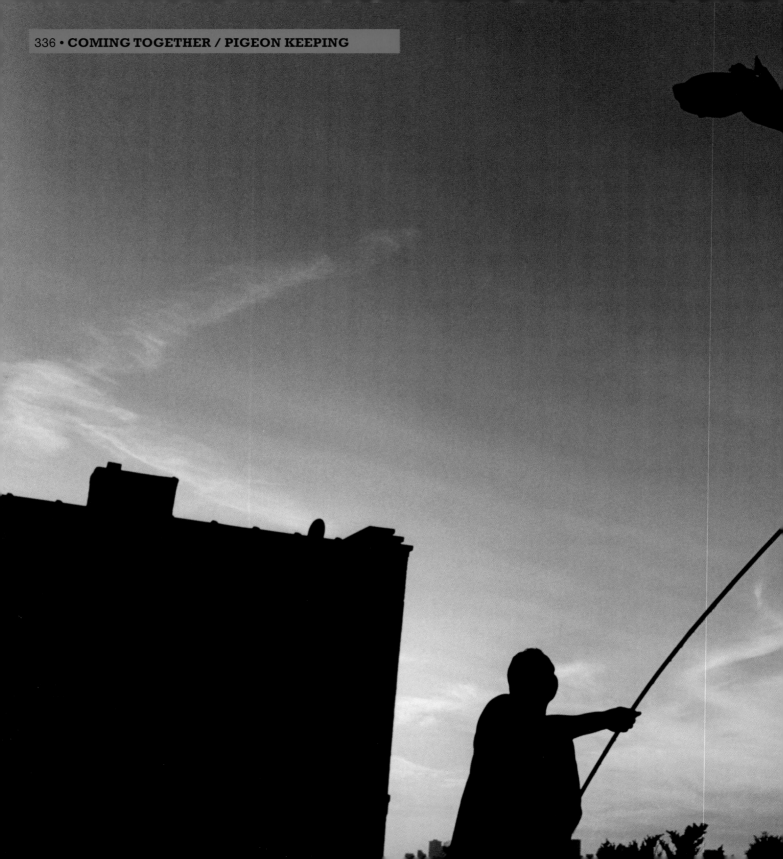

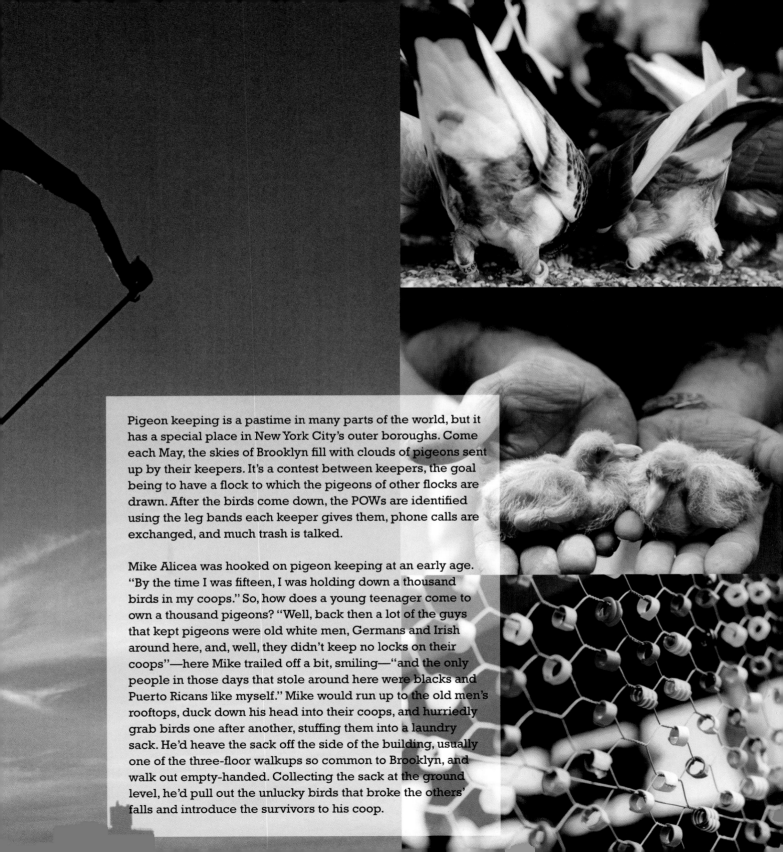

Pigeon keeping is a pastime in many parts of the world, but it has a special place in New York City's outer boroughs. Come each May, the skies of Brooklyn fill with clouds of pigeons sent up by their keepers. It's a contest between keepers, the goal being to have a flock to which the pigeons of other flocks are drawn. After the birds come down, the POWs are identified using the leg bands each keeper gives them, phone calls are exchanged, and much trash is talked.

Mike Alicea was hooked on pigeon keeping at an early age. "By the time I was fifteen, I was holding down a thousand birds in my coops." So, how does a young teenager come to own a thousand pigeons? "Well, back then a lot of the guys that kept pigeons were old white men, Germans and Irish around here, and, well, they didn't keep no locks on their coops"—here Mike trailed off a bit, smiling—"and the only people in those days that stole around here were blacks and Puerto Ricans like myself." Mike would run up to the old men's rooftops, duck down his head into their coops, and hurriedly grab birds one after another, stuffing them into a laundry sack. He'd heave the sack off the side of the building, usually one of the three-floor walkups so common to Brooklyn, and walk out empty-handed. Collecting the sack at the ground level, he'd pull out the unlucky birds that broke the others' falls and introduce the survivors to his coop.

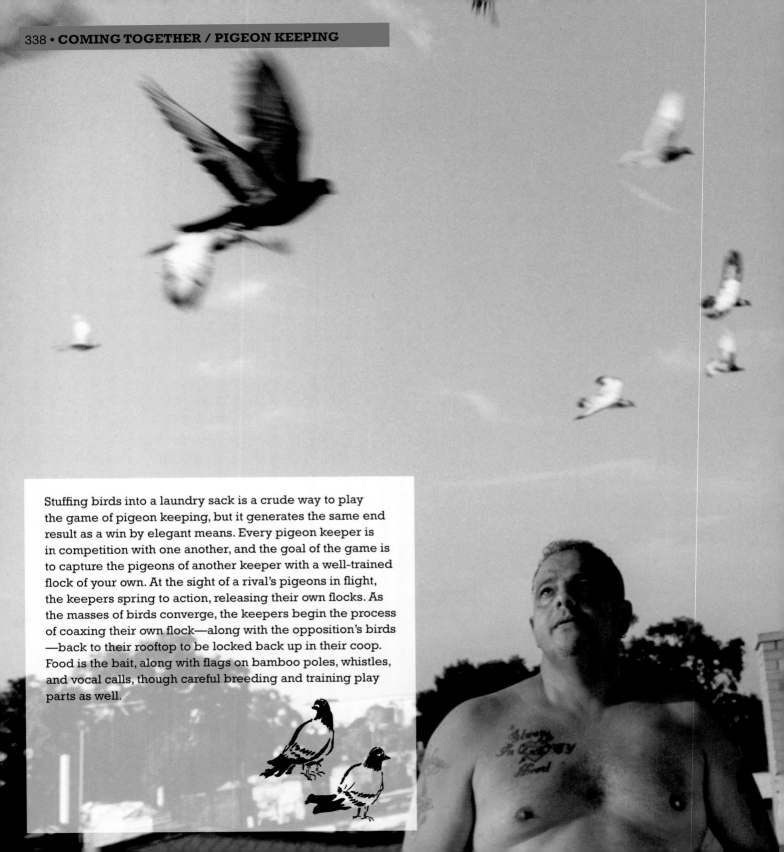

Stuffing birds into a laundry sack is a crude way to play the game of pigeon keeping, but it generates the same end result as a win by elegant means. Every pigeon keeper is in competition with one another, and the goal of the game is to capture the pigeons of another keeper with a well-trained flock of your own. At the sight of a rival's pigeons in flight, the keepers spring to action, releasing their own flocks. As the masses of birds converge, the keepers begin the process of coaxing their own flock—along with the opposition's birds —back to their rooftop to be locked back up in their coop. Food is the bait, along with flags on bamboo poles, whistles, and vocal calls, though careful breeding and training play parts as well.

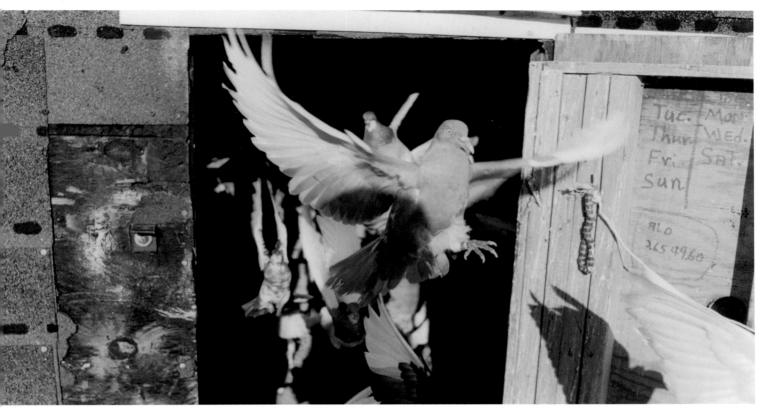

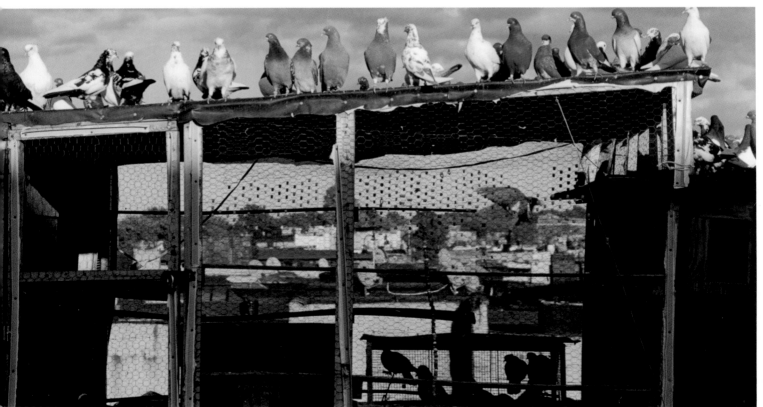

"We have our unique skills, but we use them in a way that we build a collective identity through our work, rather than uniting just in name."

Jordan Nickel

The street art collective known as We Are Supervision has left an indelible mark on cities across America, changing the urban aesthetic through its unique method of turning urban blankness into landscapes. The crew are also known for their photography, and the photos from their adventures around the country show how they've both interpreted and altered the environment around them. Besides simply creating art, We Are Supervision observe the crazy world they live in, finding art everywhere, and documenting it honestly and authoritatively. They have also managed to forge an identity as a team, rather than a collection of individuals. For the collective, there would be no "Supervision" without the "We." According to Jordan Nickel, one of its founding members, "We can't say that anything we do is 'mine' or 'yours,' because we've built this creative vision together. We have our unique skills, but we use them in a way that we build a collective identity through our work, rather than uniting just in name."

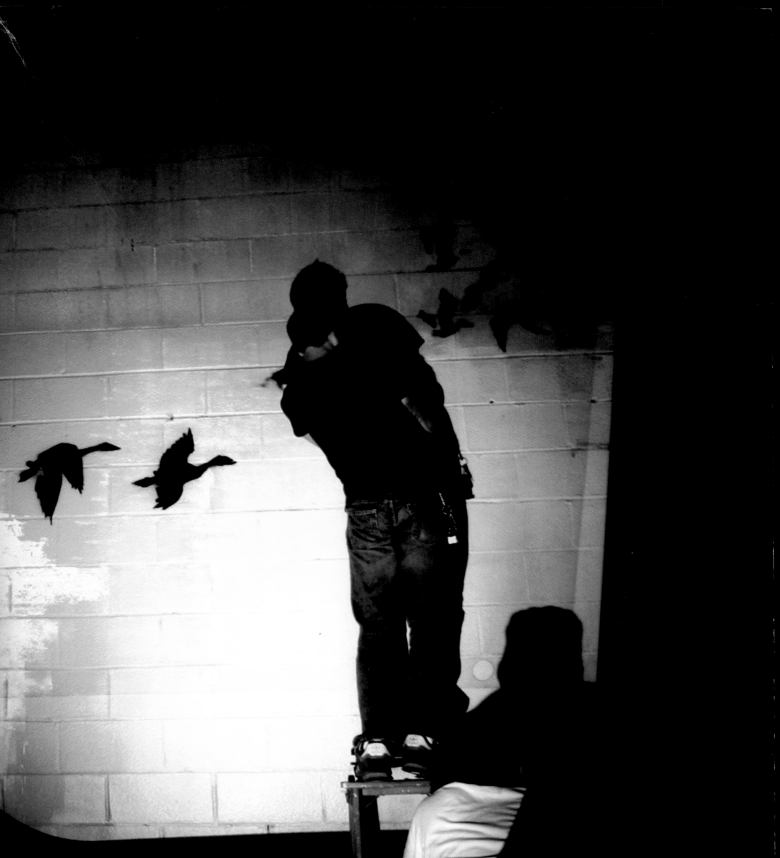

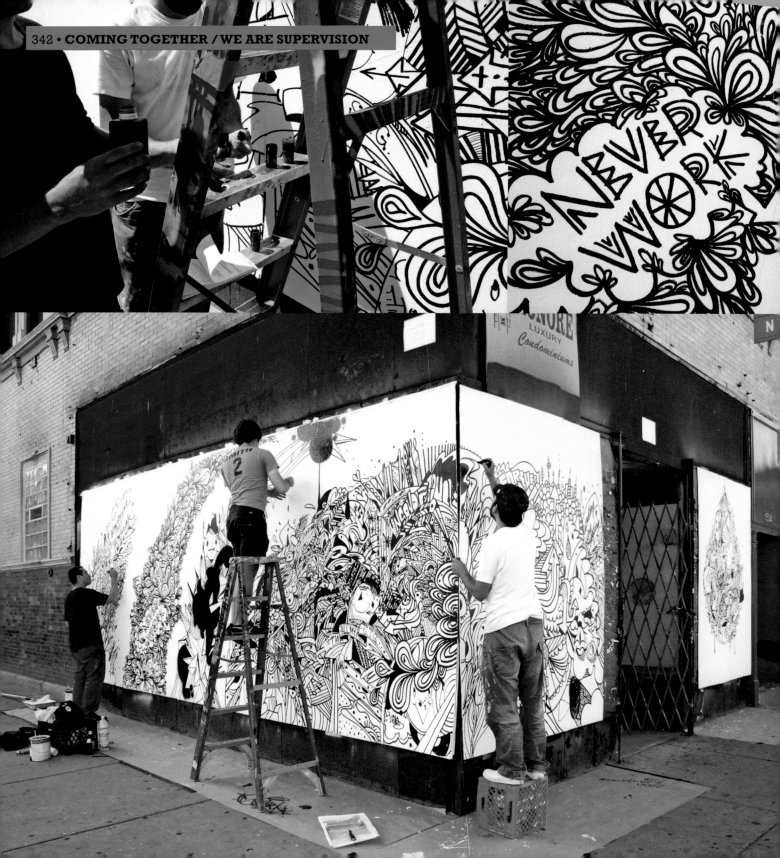

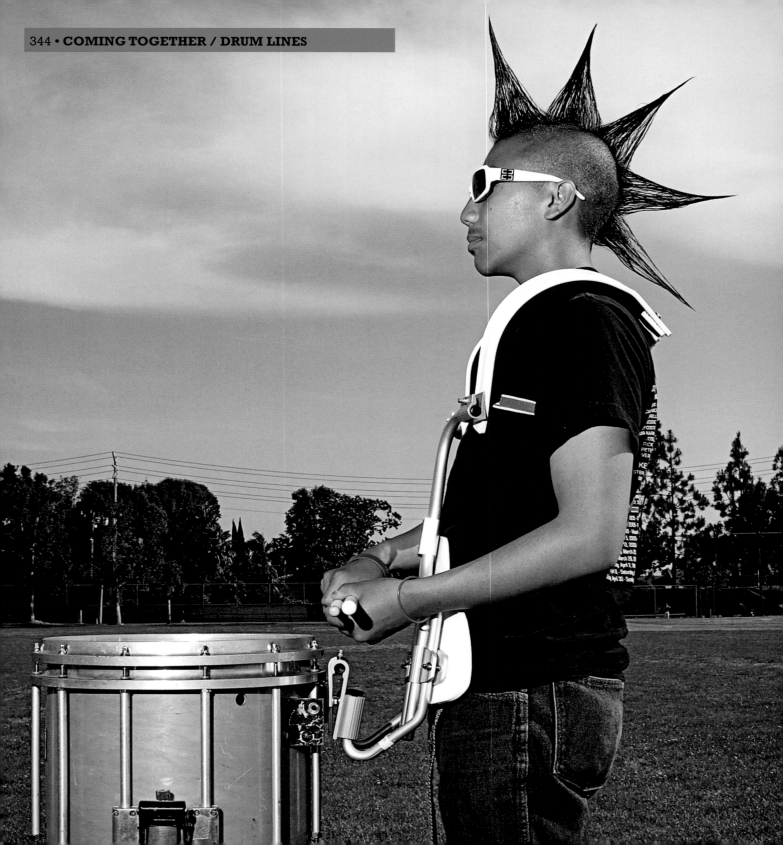

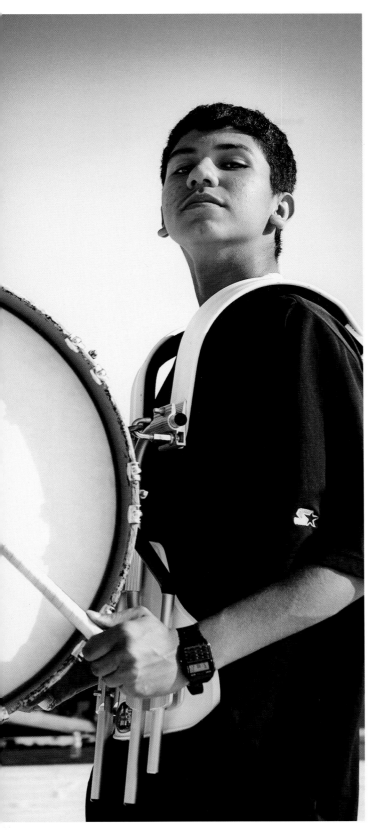

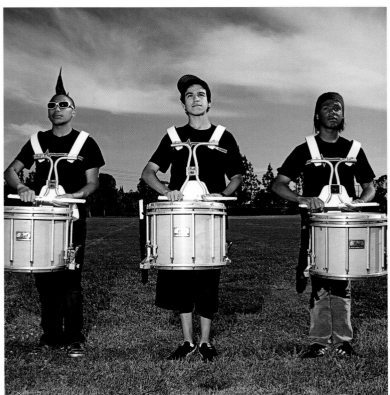

Popular in the U.S. and Japan, drum lines are made up of the marching percussion and sideline percussion sections of a marching band. Drum lines blend music performance, marching, dance, and theater. Most drum lines are connected to high schools, and marching band season runs from October to November or December, with national championships in April. Because of their connection to high schools, drum lines are the de facto training ground for many musicians who eventually go on to any rhythm-driven musical genre, from hip-hop on down.

Drum line performances usually take place in auditoriums and gymnasiums as percussion ensembles looked for ways to maintain their skills during the winter months when performing outdoors on football fields was not practical. If you're in a drum line, you'll most likely be playing snare drums, tenor drums, bass drums, cymbals, xylophones, or marimbas. Vibraphones, tambourines, chimes, and timpani are also commonplace. Sometimes you'll find kids playing unconventional instruments such as trashcans, barrels, pipes, and brooms. Set design is a key aspect of drum line performance, and painted floor coverings and backdrops are often used to portray a story as the group performs the music in and around various props.

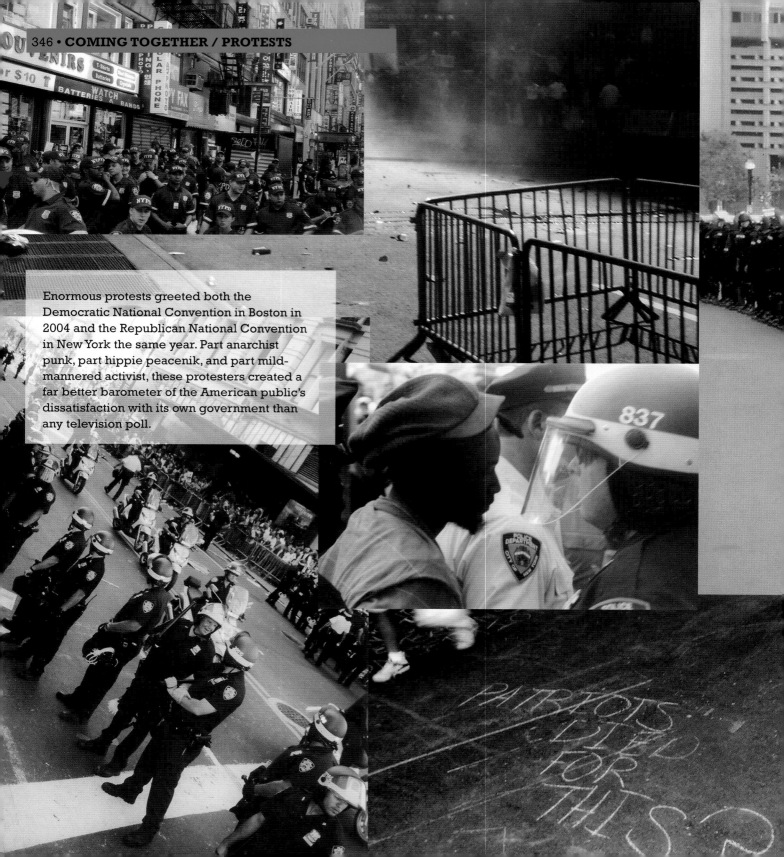

Enormous protests greeted both the Democratic National Convention in Boston in 2004 and the Republican National Convention in New York the same year. Part anarchist punk, part hippie peacenik, and part mild-mannered activist, these protesters created a far better barometer of the American public's dissatisfaction with its own government than any television poll.

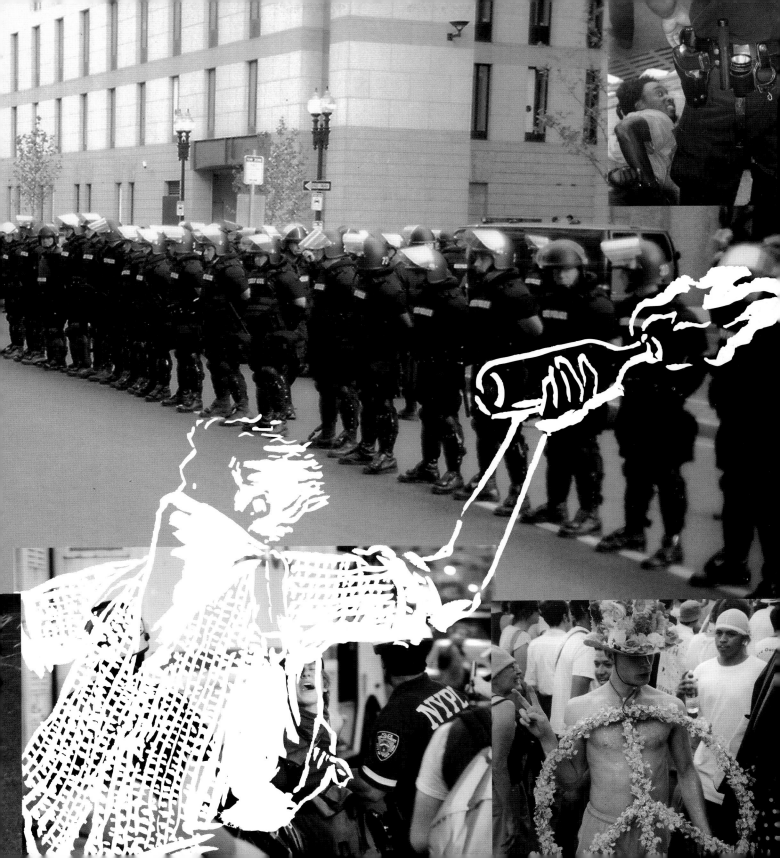

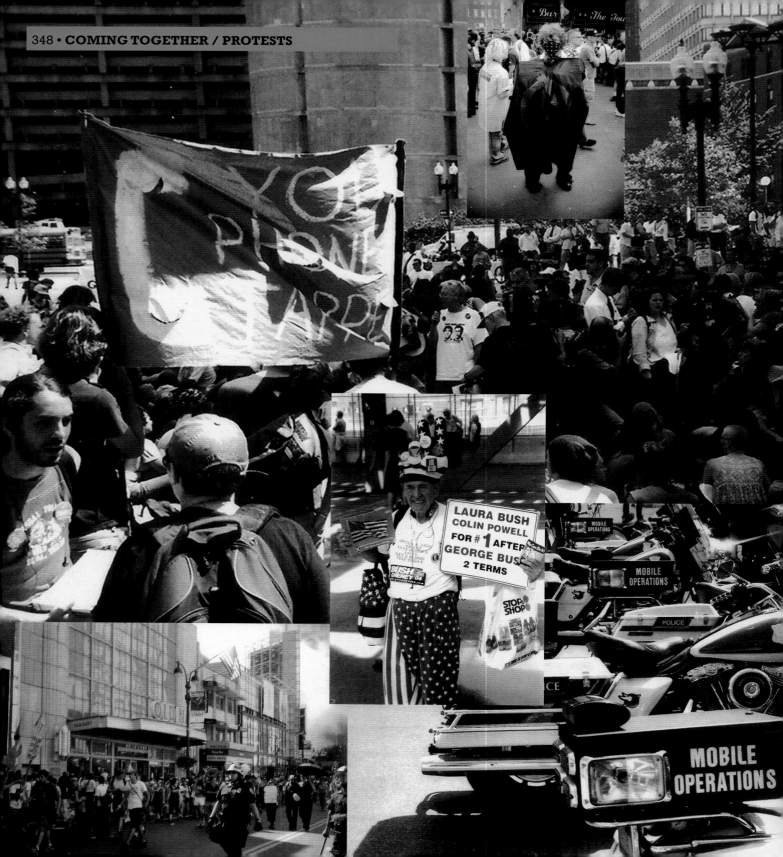

LAURA BUSH
COLIN POWELL
FOR #1 AFTER
GEORGE BUSH
2 TERMS

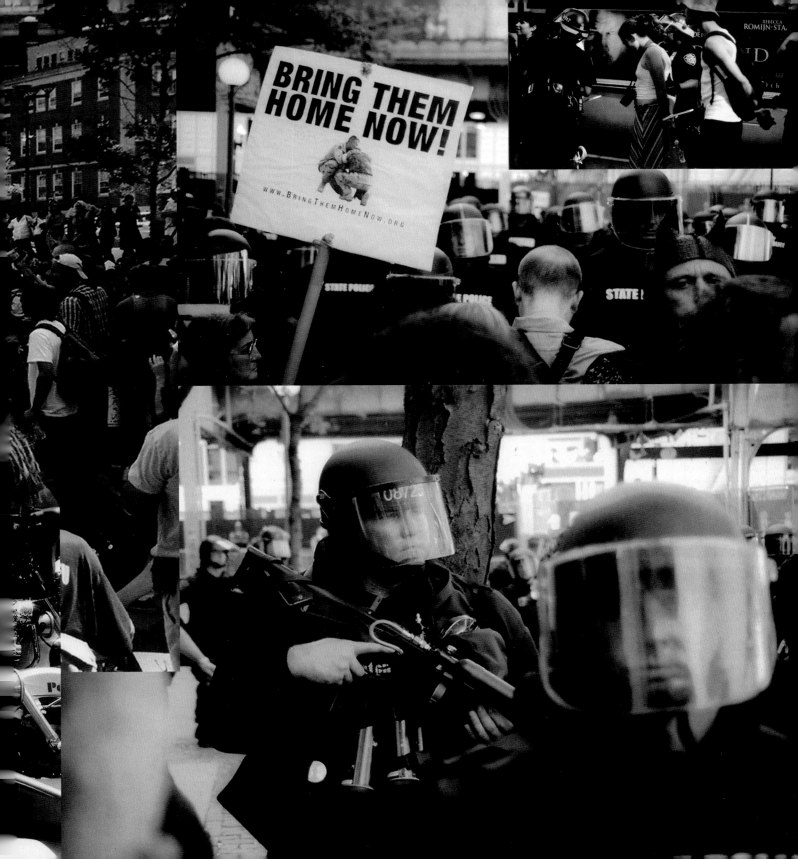

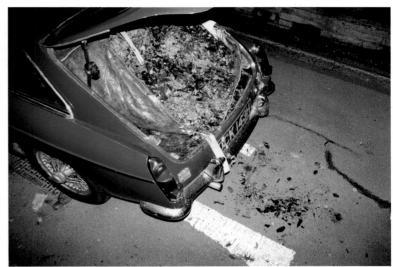

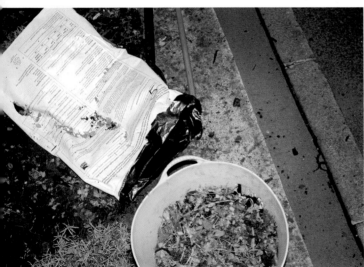

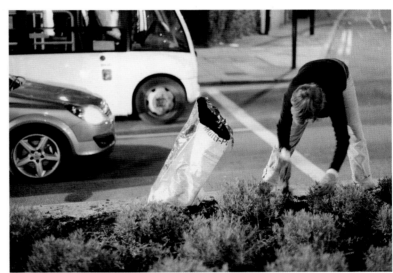

Within the concrete and asphalt of the city, it's often a pleasant surprise to find even the smallest patch of green space. Some cities have beautification projects that are responsible for bursts of flora, but others have groups of private citizens—called "guerrilla gardeners"—to thank for the greenery. Though their work is illegal, guerrilla gardeners almost always find a positive response from their compatriots. Even the public officials forced to turn a blind eye can't help but sneak a peek over their shoulders at the landscaping that brings new charm to the urban aesthetic.

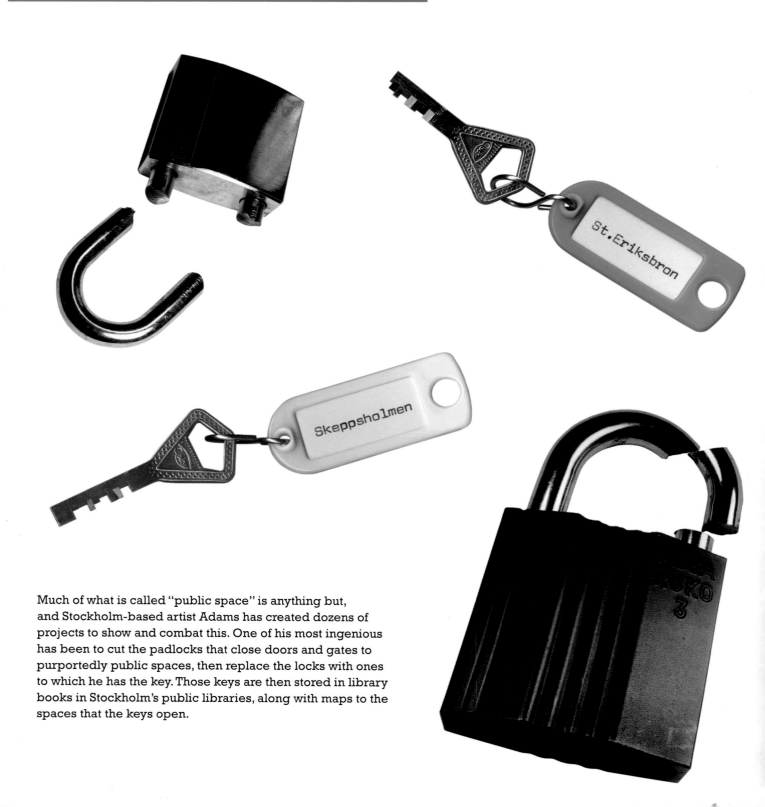

Much of what is called "public space" is anything but, and Stockholm-based artist Adams has created dozens of projects to show and combat this. One of his most ingenious has been to cut the padlocks that close doors and gates to purportedly public spaces, then replace the locks with ones to which he has the key. Those keys are then stored in library books in Stockholm's public libraries, along with maps to the spaces that the keys open.

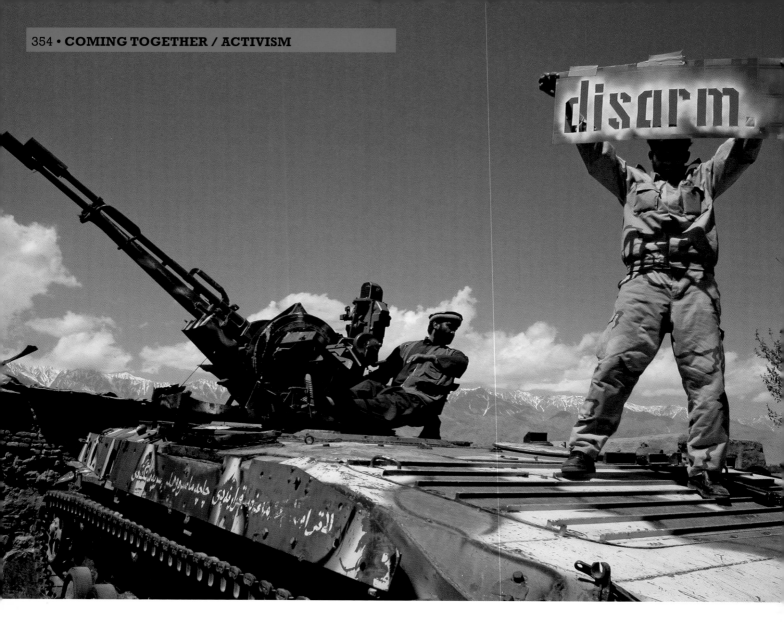

Traveling to war-torn places throughout Asia, the Middle East, and the Balkan states, Brian Liu signs his life away and accompanies teams of land mine removers, photographing and filming as he goes. In Kabul, Afghanistan, he cut a metal stencil with the word "Disarm," and handed it out to local cops and kids to spraypaint the word on torched-out tank and wall carcasses.

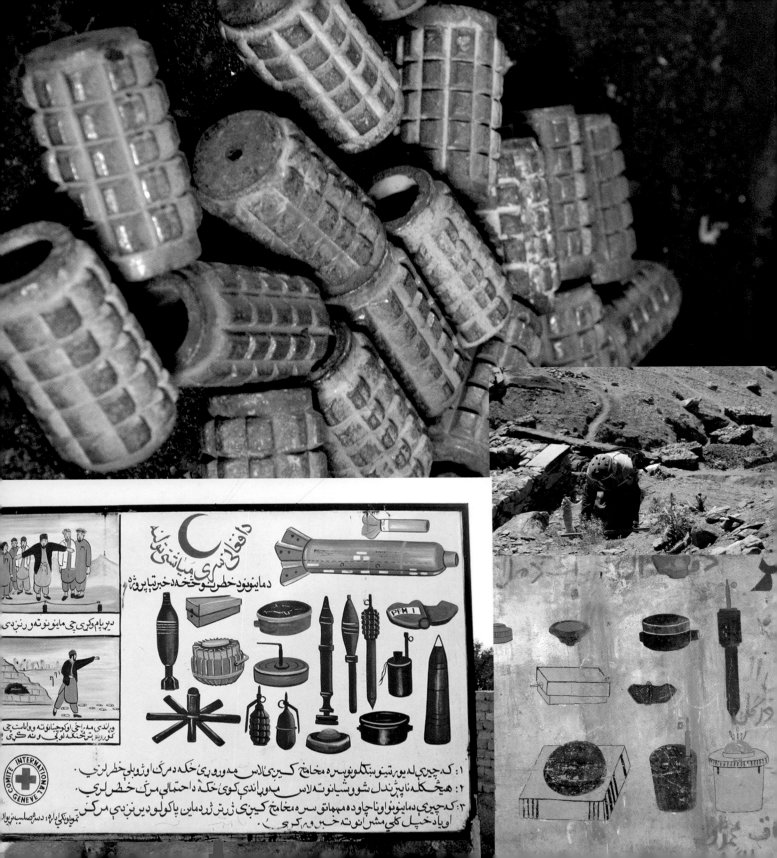

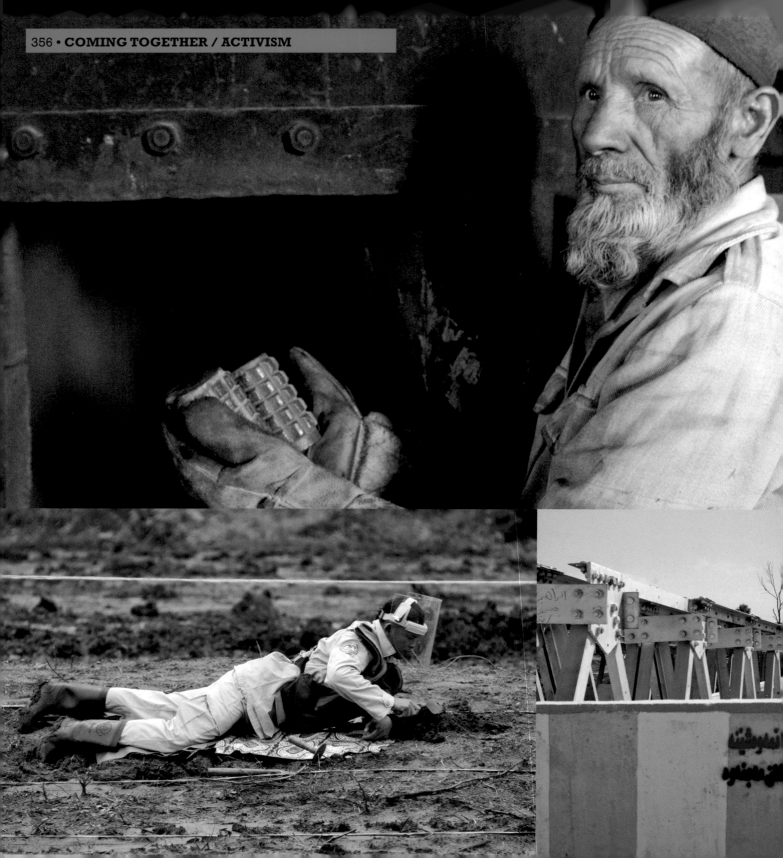

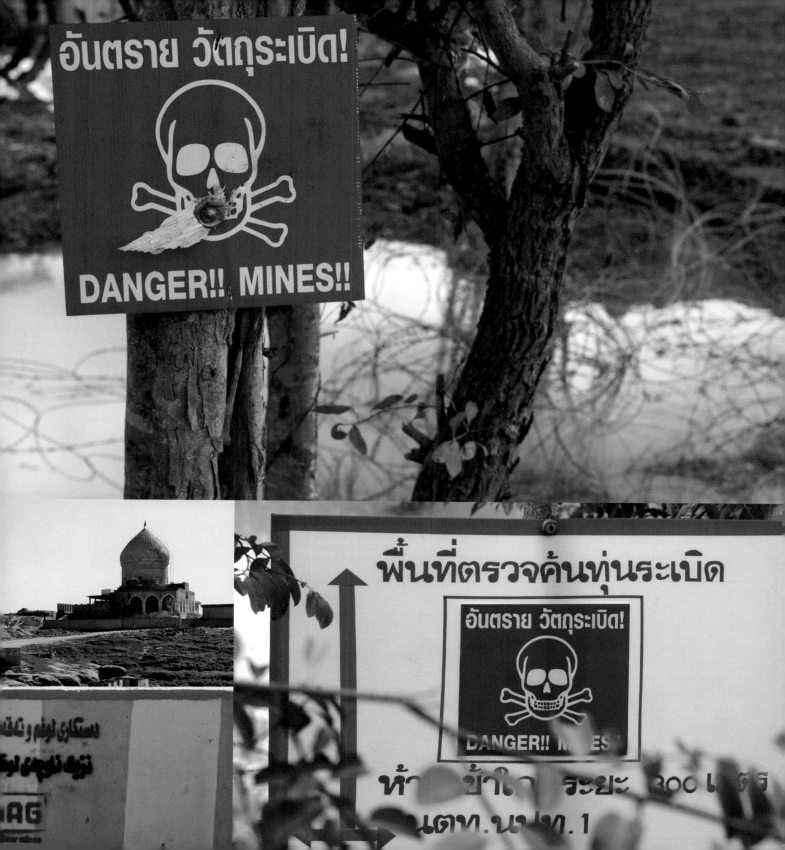

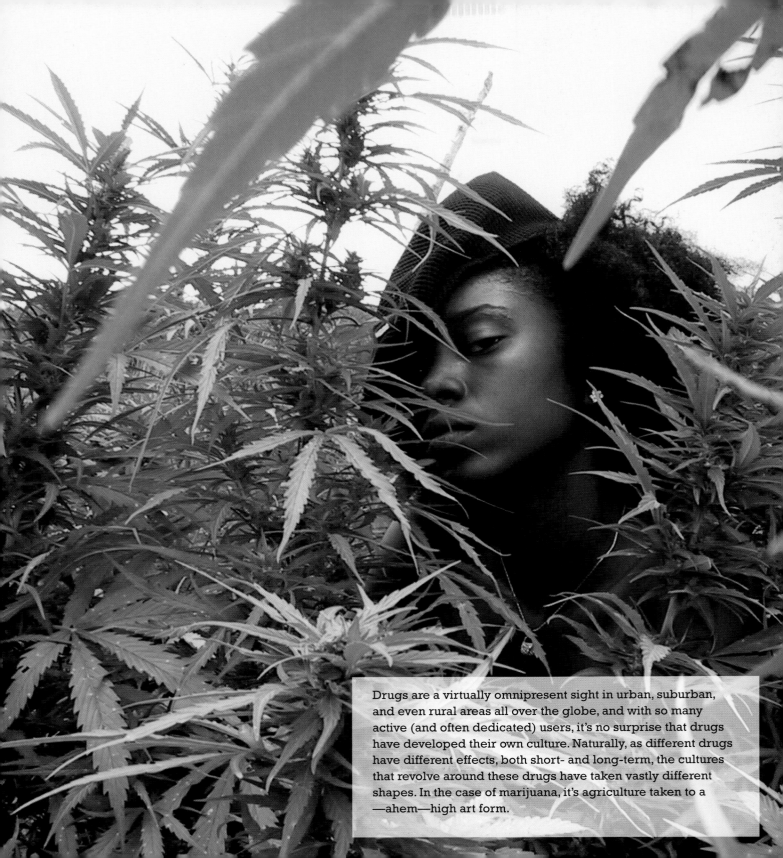

Drugs are a virtually omnipresent sight in urban, suburban, and even rural areas all over the globe, and with so many active (and often dedicated) users, it's no surprise that drugs have developed their own culture. Naturally, as different drugs have different effects, both short- and long-term, the cultures that revolve around these drugs have taken vastly different shapes. In the case of marijuana, it's agriculture taken to a —ahem—high art form.

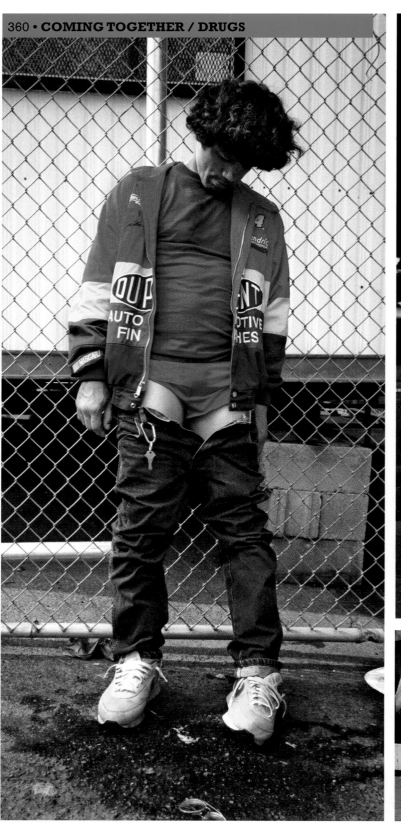

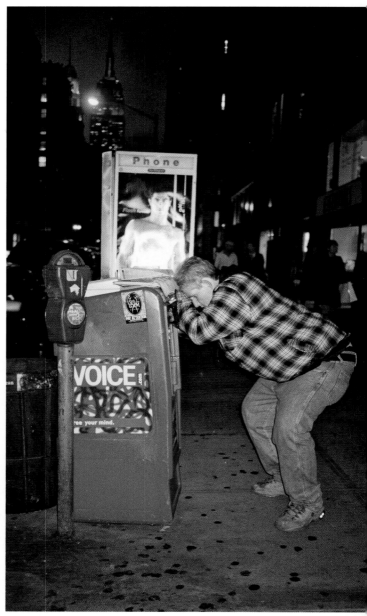

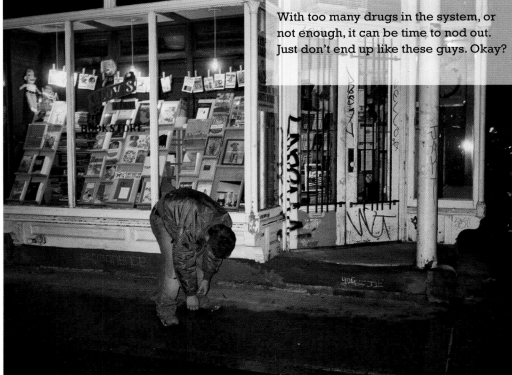

With too many drugs in the system, or not enough, it can be time to nod out. Just don't end up like these guys. Okay?

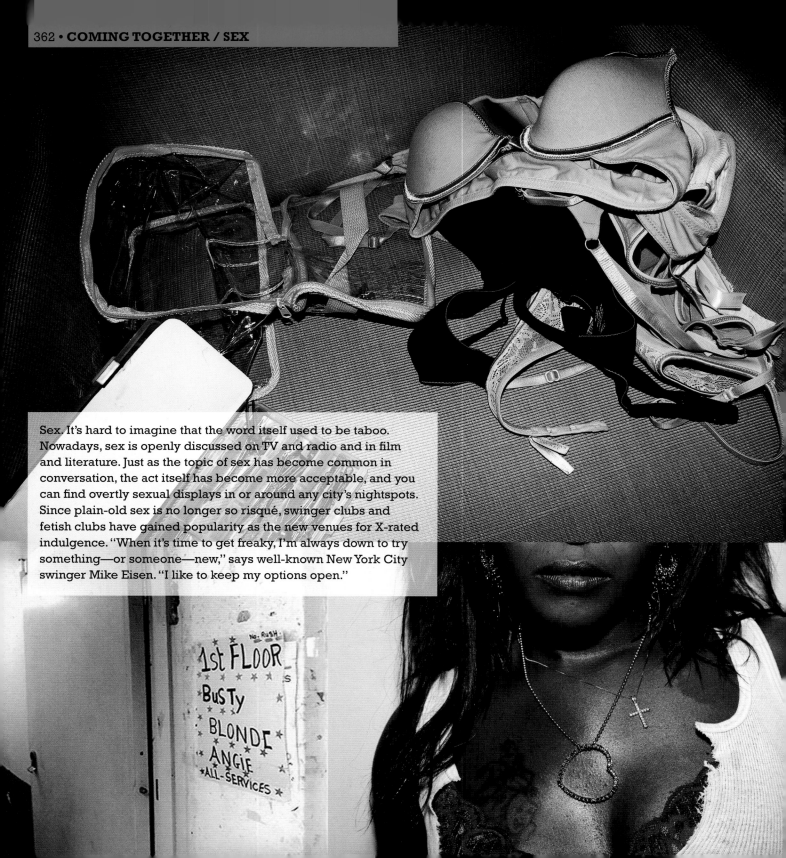

Sex. It's hard to imagine that the word itself used to be taboo. Nowadays, sex is openly discussed on TV and radio and in film and literature. Just as the topic of sex has become common in conversation, the act itself has become more acceptable, and you can find overtly sexual displays in or around any city's nightspots. Since plain-old sex is no longer so risqué, swinger clubs and fetish clubs have gained popularity as the new venues for X-rated indulgence. "When it's time to get freaky, I'm always down to try something—or someone—new," says well-known New York City swinger Mike Eisen. "I like to keep my options open."

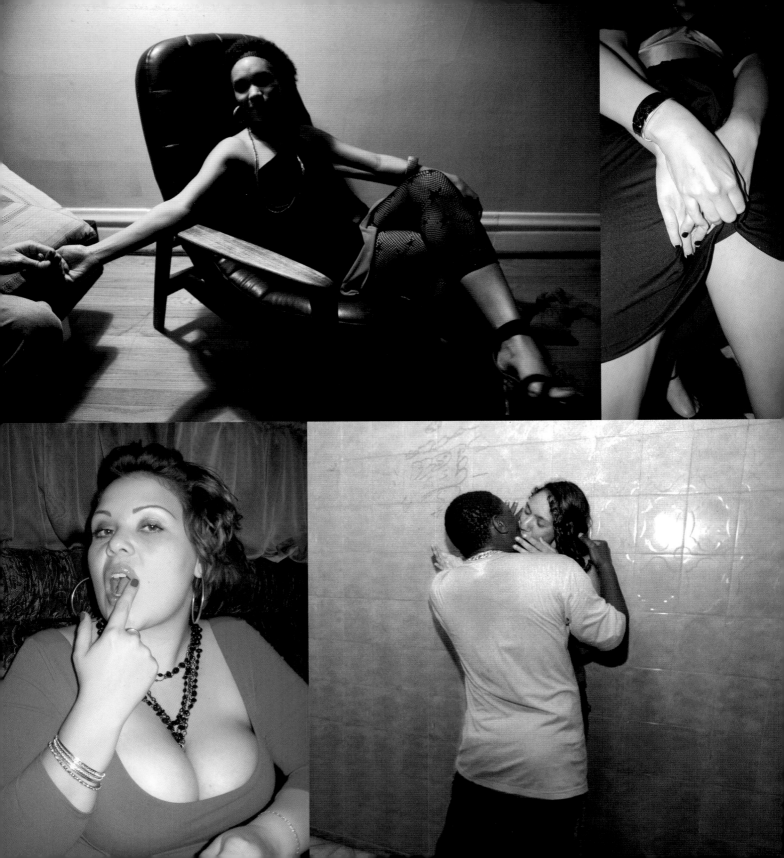

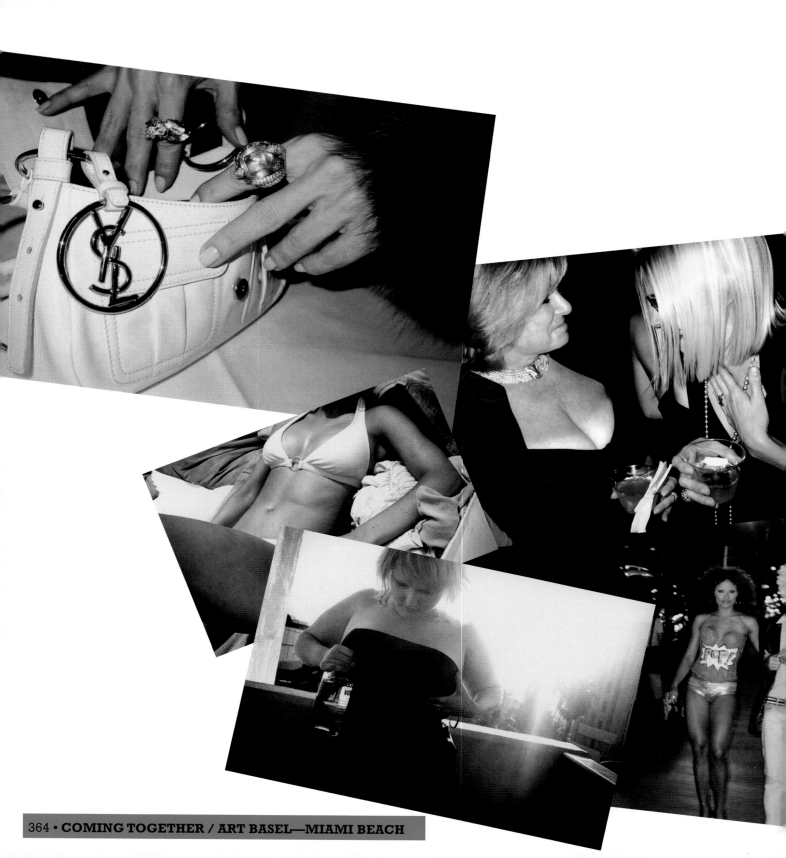

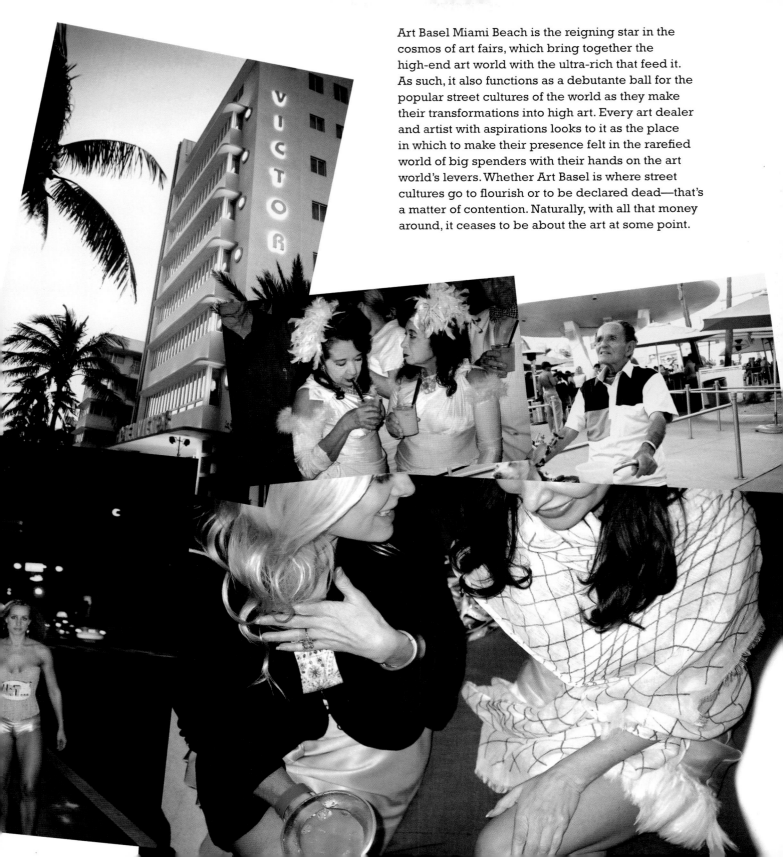

Art Basel Miami Beach is the reigning star in the cosmos of art fairs, which bring together the high-end art world with the ultra-rich that feed it. As such, it also functions as a debutante ball for the popular street cultures of the world as they make their transformations into high art. Every art dealer and artist with aspirations looks to it as the place in which to make their presence felt in the rarefied world of big spenders with their hands on the art world's levers. Whether Art Basel is where street cultures go to flourish or to be declared dead—that's a matter of contention. Naturally, with all that money around, it ceases to be about the art at some point.

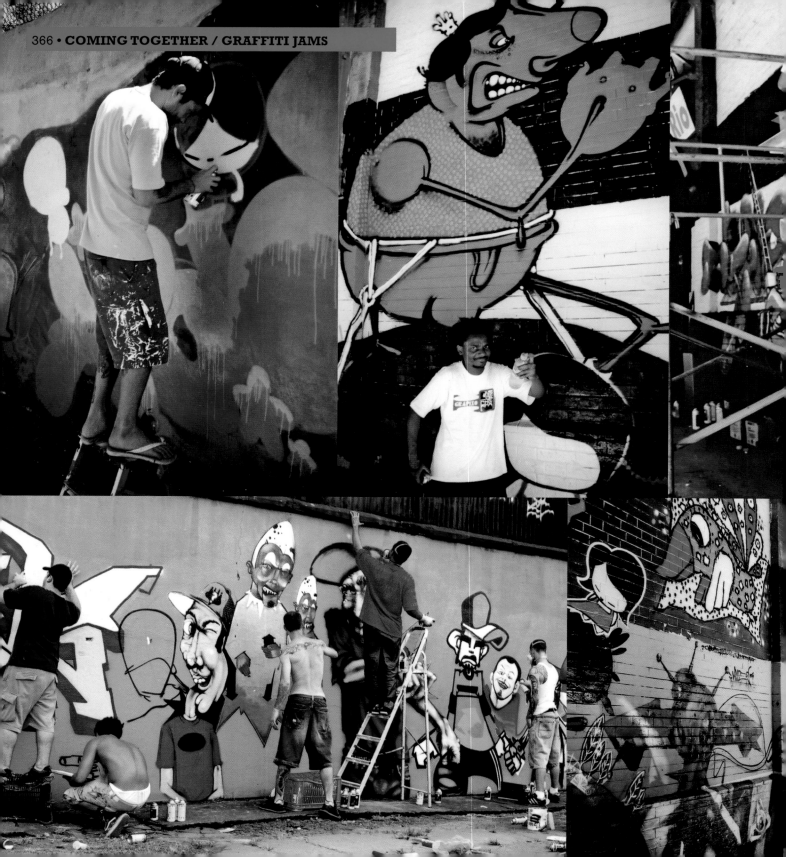

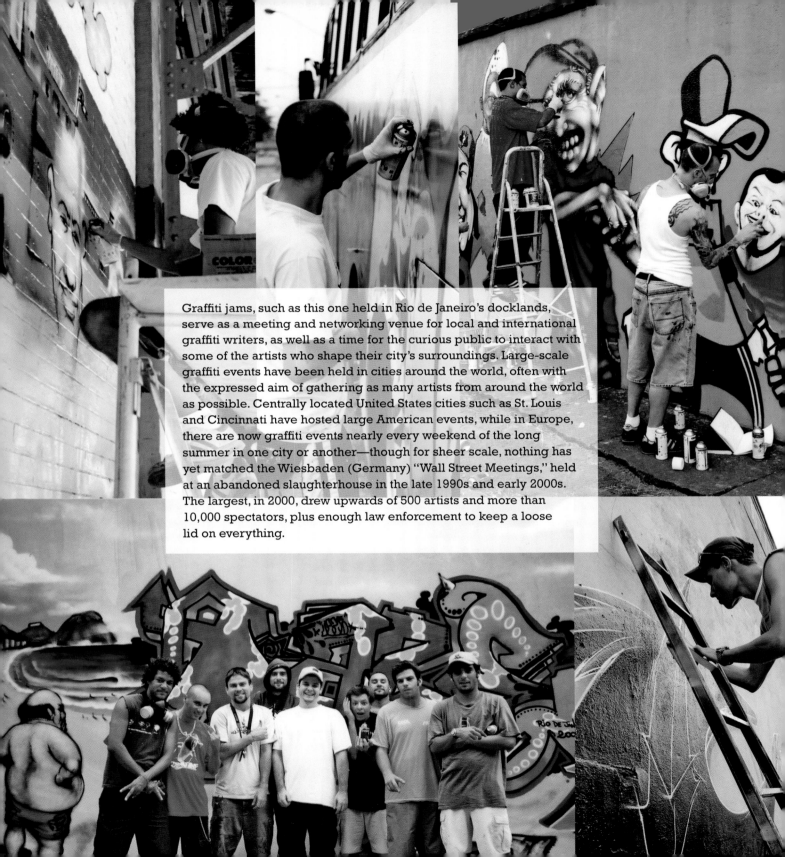

Graffiti jams, such as this one held in Rio de Janeiro's docklands, serve as a meeting and networking venue for local and international graffiti writers, as well as a time for the curious public to interact with some of the artists who shape their city's surroundings. Large-scale graffiti events have been held in cities around the world, often with the expressed aim of gathering as many artists from around the world as possible. Centrally located United States cities such as St. Louis and Cincinnati have hosted large American events, while in Europe, there are now graffiti events nearly every weekend of the long summer in one city or another—though for sheer scale, nothing has yet matched the Wiesbaden (Germany) "Wall Street Meetings," held at an abandoned slaughterhouse in the late 1990s and early 2000s. The largest, in 2000, drew upwards of 500 artists and more than 10,000 spectators, plus enough law enforcement to keep a loose lid on everything.

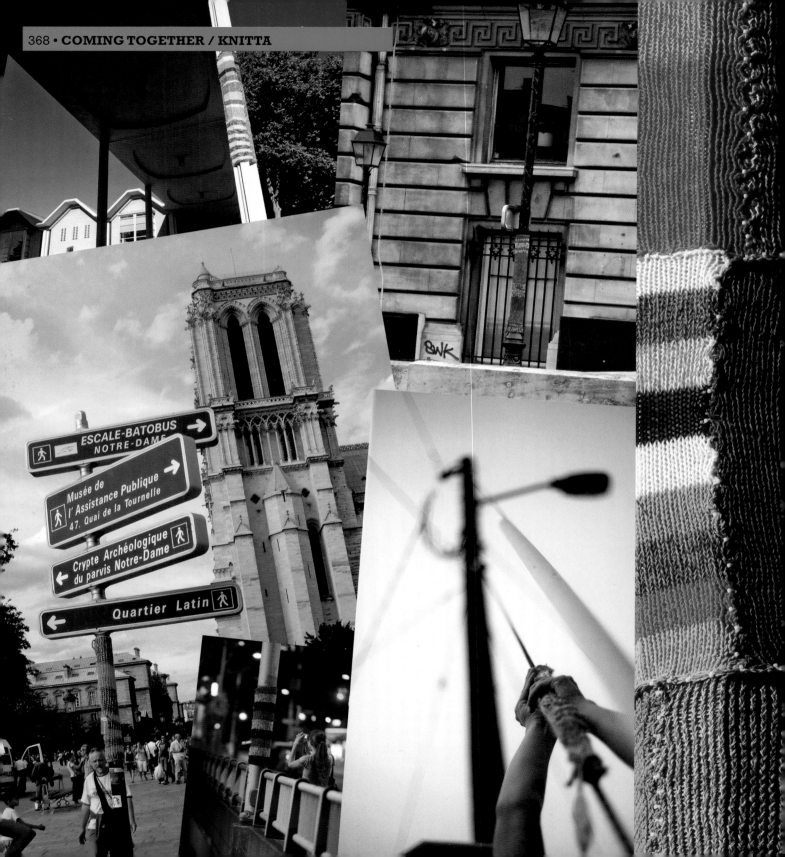

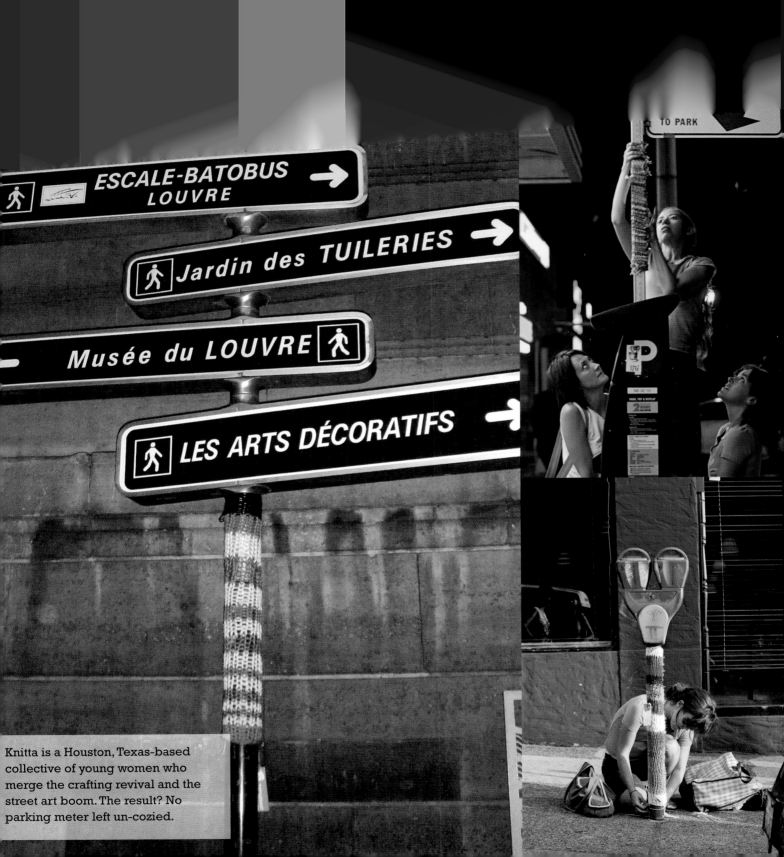

Knitta is a Houston, Texas-based collective of young women who merge the crafting revival and the street art boom. The result? No parking meter left un-cozied.

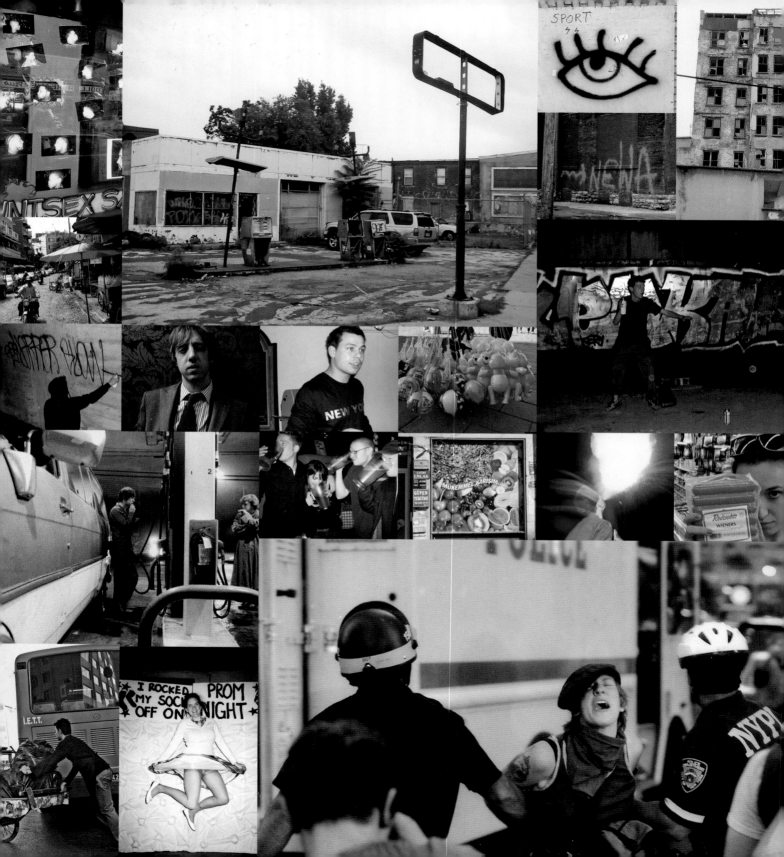

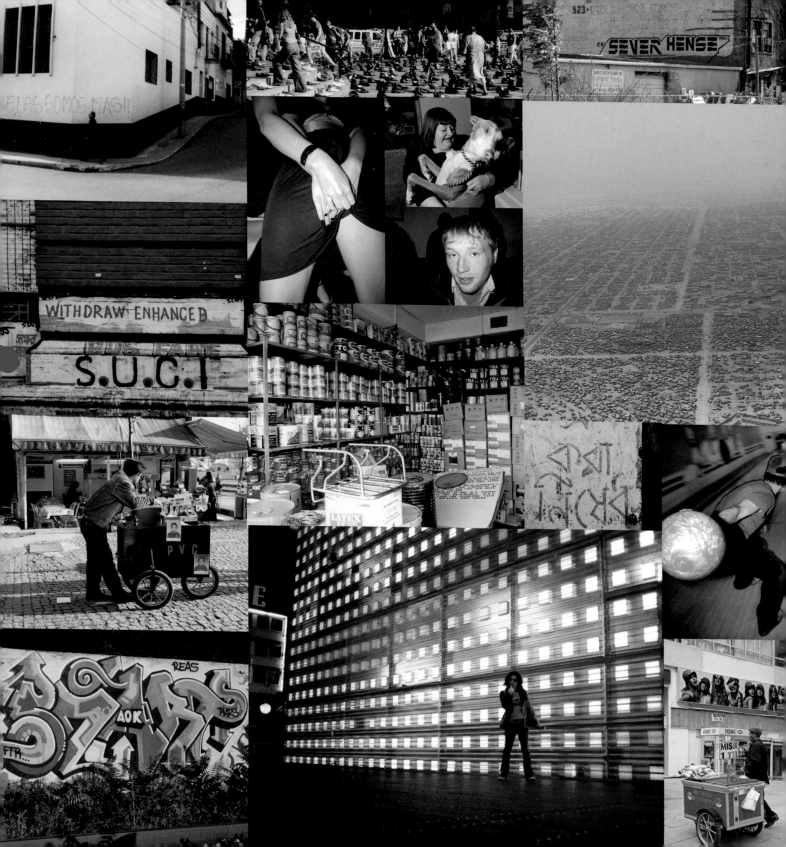

FAQ
WHERE CAN I...

...look to find out the latest happenings in popular and street culture on a general level?

www.swindlemagazine.com

www.coolhunting.com

www.beinghunted.com

www.thebrilliance.com

www.arkitip.com/intelligence

www.hypebeast.com

www.agendainc.com

www.spinemagazine.com

Each of these sites features a broad range of news, write-ups, and upcoming events, as well as links to many more sites of interest.

...find out more about goings-on in fashion and clothing?

www.superfuture.com

www.clawmoney.com

www.thecobrasnake.com

These sites (along with the general ones listed above) cover fashion on global or regional levels.

...find more information about skateboarding, monster bikes, and so on?

www.blacklabelnyc.com

www.skateboardingsucks.com

www.haveboard.com

These sites feature discussions, links, and events.

...look to find the latest in both graffiti and street art?

www.12ozprophet.com

www.woostercollective.com

www.theartwheredreamscometrue.com

www.artcrimes.com

www.obeygiant.com

www.garagemagazine.net

These sites are huge repositories of photographs, discussion, and information relating to art in the streets.

...find collections of interesting and esoteric culture?

www.tinyvices.com

www.hustlerofculture.com

www.megawordsmagazine.com

With unusual features and links, these sites give individual windows on the culture of today.

...find information on parties, concerts, and other urban get-togethers?

www.lastnightsparty.com

www.newstoday.com

www.turntablelab.com

www.ameobarecords.com

Featuring upcoming events and links to even more lists of upcoming events, as well as photos of past parties and so on. Some also have extensive shopping selections.

rther Reading

ousters:
w.adbusters.org

ger Gastman, Darin Rowland, and Ian Sattler,
ight Train Graffiti, Thames & Hudson: London,
6

stan Manco, Lost Art, and Caleb Neelon, *Graffiti
sil*, Thames & Hudson: London, 2005

signs: www.myspace.com/nusign

hony Smyrski, *Public Wall Writing in Philadelphia*

INDLE Magazine:
w.swindlemagazine.com

lerground Productions:
w.underground-productions.se

Contributors

Adams: *Photographs on pages 230–231,
352–353*

Atome: www.atome.com.au
Photographs on pages 170–171

Aves: *Photographs on pages 162–163*

Carlos Batts is a photographer, filmmaker,
and curator living in Los Angeles.
www.carlosbatts.com
*Photographs on pages 12–13, 26–27, 226,
330–331, 362–363, 370–371*

David Bean is a Nashville-based
photographer.
www.visualreserve.com
Photographs on pages 264–265

Travis Beard has been a working and
traveling photojournalist based in
Australia for the past nine years.
www.argusphotography.com
Photographs on pages 26–27, 268–269

Allen Benedikt is a publisher, designer, and
creative alpha male based in New York City.
www.akanyc.com
*Photographs on pages 62–63, 130–131,
140–141, 290–291*

Jean Berry is a youth culture and underground music journalist and photographer born in 1980 and living between France and Morocco.
indyjean@gmail.com
www.flickr.com/photos/indyjean/sets/
Photographs on pages 314–315, 318

Blu: www.blublu.org
Photographs on pages 218–219

Angela Boatwright is a photographer living in New York City, where she runs Killer of Giants, a matchmaking service for artists and like-minded sponsors.
www.killerofgiants.com
Photographs on pages 26–27, 31, 46–47, 124–125, 138–139, 190–191, 258–259

Boogie was born and raised in Belgrade, Serbia, moving to New York City in 1998. He travels the world photographing drug addicts, gangsters, sad city scenes, and the occasional group of youngsters playing soccer in Belgrade, to which he returns every year.
www.artcoup.com
Photographs on pages 26–27, 324–325

Philip Buehler is a photographer and Woody Guthrie historian in New York.
www.modern-ruins.com
Photographs on pages 266–267

Ceaze gets busy on walls and paints graffiti and tattoos up and down the East Coast of the United States and around the world.
www.theseventhletter.com
Photographs on pages 18–19, 143

Tristan Ceddia is an Australian artist and designer
www.serpspress.com
Photographs on pages 280–281

Cense paints a lot.
Photographs on pages 156–157

Con is still at it.
Photographs on pages 156–157

D30 paint trains.
Photographs on pages 154–155

Daniela Dacorso is a photographer based in Rio de Janeiro, Brazil.
danidacorso@hotmail.com
Photographs on pages 16–17, 308–311, 362–363

Dalek is a Brooklyn-based artist and designer.
www.dalekart.com
Photographs on pages 18–19, 272–273

Day 19 is a photography team comprised of husband and wife Jeremy and Claire Weiss. They are based in Los Angeles.
www.day19.com
Photographs on pages 8–9, 26–27, 304–305

aze (Chris Ellis) is an artist and photographer from New York City with a ng for Brazil.
rw.dazeworld.com
Photographs on pages 366–367

ndy Dembo is a New York City-based lependent strategic marketing and trend nsultant who finesses innovative collaborations tween visual artists and corporations.
rw.coolhunting.com
otographs on pages 220–221

bey Drucker is a photographer based New York.
rw.abbeydrucker.com
otographs on pages 301–303, 364–365

Englund is a Swedish photographer.
rw.perenglund.com
otographs on pages 68–69

b Erickson is a Philadelphia-based artist photographer.
rw.roberickson.com
otographs on pages 88–91

epard Fairey: www.obeygiant.com
otographs on pages 192–193

ron Farley is a photographer living in Los geles. He shoots photos because he is addicted.
rw.aaronfarley.com

Photographs on pages 36, 38, 83, 84–85, 110, 332–333, 344–345, 370–371

Todd Fisher lives and works in New York.
www.toddfisher.net
Photographs on pages 360–361

Friends With You: www.friendswithyou.com
Photographs on pages 26–27, 292–293

Garage Magazine is an Italian graffiti concern.
www.garagemagazine.net
Photographs on pages 152–153

Mike Genovese is a Chicago-based mixed media artist. www.genovesestudios.com
Photographs on pages 214–217

Mike Giant: www.mikegiant.com
Photographs on pages 8–9, 18–19, 26–27, 40–41, 150–151, 160–161, 248–249

Chris Glancy grew up in a tiny trailer in south Florida, and now lives in a Los Angeles apartment of the same size.
www.ephemeroi.com/clients/visualsniper
Photographs on pages 2–3, 8–9, 26–27, 54–55

Valerie Green: www.valeriegreen.la
Photograph on page 67

Histo is a wandering graffiti writer.
Photographs on pages 14–15

Cody Hudson is a Chicago-based artist and designer.
www.struggleinc.com
Photographs on pages 214–217

Husk Mit Navn: www.huskmitnavn.com
Photographs on pages 200–201

Inti is a Santiago-based graffiti writer.
Photographs on pages 172–173

Invader: www.space-invaders.com
Photographs by Invader and SCS on pages 208–211

Isto is a Copenhagen artist.
Photographs on pages 230–231

Malcolm Jacobson is a Stockholm-based author and editor of *Underground Productions.*
www.dokument.org
Photographs on pages 188–189

Malia James photographs musicians and gardeners in the UK and elsewhere.
www.maliajames.com
Photographs on pages 350–351

Jase is up on tens of thousands of freight trains.
www.infamythemovie.com
Photographs on pages 156–157

Mark Jenkins: www.xmarkjenkinsx.com
Photographs on pages 202–203

Nik Jung is a Los Angeles photographer.
www.nikolausjung.com
Photographs on pages 102–103

Colby Katz was born in Washington, DC, went to New York University, and lives in Fort Lauderdale, Florida.
www.colbykatz.com
Photographs on pages 44–45

Kem 5: *Photographs on pages 158–159*

Keramik: *Photographs on pages 164–165*

Knitta: www.knittaplease.com
Photographs on pages 368–369

John LaCroix runs Medicine Agency, a design and marketing company in the Bay Area.
www.medicineagency.com
Photographs on pages 301, 326–327

Leigh Ledare is a photographer living and working in New York City, currently enrolled in the MFA Visual Arts program at Columbia University.
www.tinyvices.com
Photographs on pages 106–107

Brian Liu runs the Washington, DC, design firm Toolbox DC.
www.toolboxdc.com
Photographs on pages 354–357

manda Lopez is a Los Angeles otographer.
rw.amandalopezphoto.com
otographs on pages 26–27, 252–253

ex Lukas is an artist and publisher from mbridge, Massachusetts. He also did the drawings attered throughout this book.
rw.cantabpublishing.com
otographs on pages 278–279, 282–283

rk the Cobra Snake is a Los geles-based photographer.
rw.thecobrasnake.com
otographs on pages 70–71, 320–323,)–371

ri Memolo is a Washington, DC, otographer. www.rosinaphotography.com
otographs on pages 76–77, 232–233, 1–297

ss Van: www.missvan.com
otographs on pages 198–199

n Monick is a photographer and curator ng in Los Angeles.
rw.danmonick.com
otographs on pages 26–27, 64–67, 196–197, 1, 306–307, 319

nster Project: www.cantabpublishing.com
otographs on pages 212–213

Dominic Neitz: www.dominicneitz.com
Photograph on page 67

Newa is still around.
Photographs on pages 18–19

Estevan Oriol is a Los Angeles-based photographer, filmmaker, and fashion executive.
www.estevanoriol.com
Photographs on pages 26–27, 56–59, 108–109, 112–117, 178–181

R8bit creates and documents street art and graffiti in Moscow.
www.visualartifacts.ru
Photographs on pages 194–195

Kurnal Rawat is part of the founding duo of Grandmother India, a design and creative house based in Mumbai, India.
www.grandmotherindia.com
Photographs on pages 246–247

Rebel is 100% Brooklyn.
Photographs on pages 8–9, 60–61, 150–151

Robby Redcheeks is a Philadelphia-based photographer.
www.robbyredcheeks.com
Photographs on pages 42–43, 262–263, 270, 316–317

Remio runs around the world and writes on it.
Photographs on pages 156–157

Revok continues to blow the doors off graffiti's possibilities.
www.revok1.com
Photographs on pages 22–23, 142, 144–145, 150–151

Peter Dean Rickards is a Jamaican photographer.
www.afflictedyard.com
72–73, 358–359

Travis Roozee is a "Colombophile" living in Brooklyn.
www.travisroozee.com
Photographs on pages 336–339

Saber: www.saberone.com
Photographs on pages 146–147, 150–151

Tod Seelie is a photographer living in Brooklyn, New York. He has rafted the Mississippi.
www.todseelie.com
Photographs on pages 98–101, 312–313, 334–335

Ryan Shea-Pare is an artist and designer in Boston.
www.hiremeimtalented.com
Photographs on pages 346–349, 370–371

Bryan Sheffield shoots tons of musicians.
www.bryansheffield.com
Photographs on pages 370–371

Eliot Shepard: www.eliotshepard.com
Photographs on page 82

Yuri Shibuya is a Tokyo-based photographer and 'zine-maker.
www.yurishibuya.com
Photographs on pages 86–93, 236–237, 244–245, 298–299

Skeptik works with the CIA in Langley, Virginia.
Photographs on pages 370–371

Fred Skinner is a retiree living in Jacksonville, Florida. He lived in Pakistan from 1994 to 1996.
Photographs on pages 74–75, 97, 118–121

Smith has never slowed down.
Photographs on pages 156–157

Space 1026: www.space1026.com
Photographs on pages 274–277

The Squid + MFG is a Los Angeles concern.
www.danceright.net
Photographs on pages 78–79

Peter Tannenbaum is a photographer based in the Boston area.
www.petertannenbaum.com
Photographs on pages 284–287

nja **Teri** lives in Los Angeles with the
st boyfriend in the world. He spoils her.
e has a dog that is not the brightest.
uns into walls.
w.swindlemagazine.com
otographs on pages 8–9

omer: www.infamythemovie.com
otographs on pages 166–167

o **Tall Jahmal** has been capturing life around
n as a hedge bet against rapid memory loss.
w.TooTallJahmal.com
otographs on pages 26–27, 227

ban Atrophy is the Baltimore-based
ploration team of Dan Haga and
n Ayers.
w.urbanatrophy.com
otographs on pages 254–257

ck **Valenzuela** is a photographer living
Bangkok.
w.rickv.com
otographs on pages 80–81

son **Vaughn** is a Los Angeles photographer.
w.jasonvaughnart.com
otographs on pages 26–27

rth **Walker** founded Orange Juice Design in
rban, South Africa, and publishes
usi magazine.

www.ijusi.com
Photographs on pages 122–123, 238–239

Adam Wallacavage is a photographer and artist
from Philadelphia. He makes chandeliers.
www.monstersizemonsters.com
Photographs on pages 24–25, 32, 35, 48–49,
274–277, 279, 328–329

We Are Supervision:
www.wearesupervision.com
Photographs on pages 4–11, 26–27, 94–97,
126–129, 132–133, 176–177, 272–273, 288–289,
340–343, 362–363

Craig Wetherby is a New York-based
photographer.
www.craigwetherby.com
Photographs on pages 50–53

WK Interact: www.wkinteract.com
Photographs on pages 204–207

Yes 2 is a graffiti writer from the Bronx.
Photographs on pages 168–169

Zekis is a Chilean graffiti writer now
living in Brooklyn.
Photographs on pages 172–173

Jeff Zimmermann: www.jazim.com
Photographs on pages 222–225

Roger Gastman:

www.swindlemagazine.com

Roger Gastman has been involved in the arts since he was a 14-year-old graffiti writer in the Washington, DC, area. Since then, he has spent over fifteen years at the organizational forefront of the street and graffiti art movement, helping it reach mainstream audiences. He has founded and published two of the most respected pop culture magazines of the last decade—*While You Were Sleeping* and *SWINDLE* (co-publisher)—as well as more than a dozen highly sought-after art books.

He has worked with internationally recognized artists, produced films and commercials and helped a diverse list of multi-national automotive, beverage, food, footwear, fashion, cellular, and gaming companies deliver their brand messages with authenticity and style. In 2005, Gastman was supervising producer and creative consultant for the feature-length graffiti documentary *Infamy*, and is currently working on several film projects, including *Brandalism*, a documentary that looks at the connection between art and corporate culture.

With deep roots in the worlds of graffiti and street art, Gastman is a trusted mediator between the underground art scenes and mainstream culture. He has facilitated the donation of graffiti artifacts to the Corcoran Gallery of Art in Washington, DC. As a leading expert on the history of graffiti, Gastman has held educational speaking engagements at universities and major museums across the country.

For over a decade, Gastman has nurtured the careers of artists, overseeing the maturation of underground art scenes into legitimate facets of contemporary society. He has been called a doub[le] agent. By remaining on the cutting-edge while respecting the history of street culture, Gastman and his team of media professionals continue to b[e] trusted by artists and commercial clients alike to showcase work with credibility and respect.

Roger's photographs appear on pages 8–9, 26–27, 150–151

Caleb Neelon:

www.theartwheredreamscometrue.com

Born in 1976 in Boston and based in neighboring Cambridge, Caleb is an artist, writer, and educator. Caleb's artwork has appeared in galleries across the United States and on walls in Kathmandu, Reykjavik, Bermuda, Calcutta, São Paulo, and across Europe. He is co-author of *Graffiti Brasil*, author/illustrator of the children's book *Lilman Makes a Name for Himself*, and has written for and edited several others. He is an editor at *SWINDLE*.

Caleb's artwork has been featured in dozens of magazines and books around the world. He has been a contributing writer to *Tokion*, *Print*, *Juxtapoz*, *Lodown*, *On The Go*, *12oz Prophet*, and several other magazines and journals. Corporate clients of Caleb's have included Nike, EA Sports, Sprite, Helio, Clarks, and Scion. He

s lectured at several colleges and universities, :luding Harvard Law School and his alma mater, ᵉ Harvard Graduate School of Education. He ᵴlikes winter weather.

leb's photographs appear on pages 8–9, 26–27, *4–135, 148–149, 164–165, 174–175, 182–187,* *0–243, 366–367, 370–371, 382–383*

,thony Smyrski:
ᵥw.smyrskicreative.com

,thony Smyrski is an art director, design ᵢnsultant, and independent book and magazine blisher. He has worked on a wide variety design projects including *Megawords* and *√INDLE* magazines, numerous books for R77, ᵢngko, PowerHouse, and Thames & Hudson, and s a core clientele based in both the cultural and ᵢmmercial worlds. He continues to work with a ᵧge roster of nationwide and international clients :luding Philagrafika, Deitch Projects, Steve ᵥwers, Maysles Films, The Rosenbach Museum d Library, Motorola, The Philadelphia Institute Contemporary Art, DALEK, The Jonathan Levine ᵢlery, and Creative Time.
 In 2005 Smyrski, along with partner Dan ᵢrphy, co-founded the critically acclaimed ᵢgazine *Megawords*. In 2007 they published a ok entitled *Public Wall Writing in Philadelphia*, d continue to expand their exploration of the ᵢan environment through print, sound, and film. ₃o in 2005, with Max Lawrence, he co-founded

Free News Projects, an independent publishing company releasing books and music, such as a retrospective of work by the stained glass artist Judith Schaechter, several limited edition artist book projects, a retrospective of collective Space 1026, vinyl picture disc music recordings with artists such as Dalek, Blacklisted, ManMan, and Jim Houser, and has several other projects forthcoming.

Anthony's photographs appear on pages 8–9, 20–21, *26–27, 39, 104–105, 228–229, 252–253, 260–261,* *272–277, 370–371*

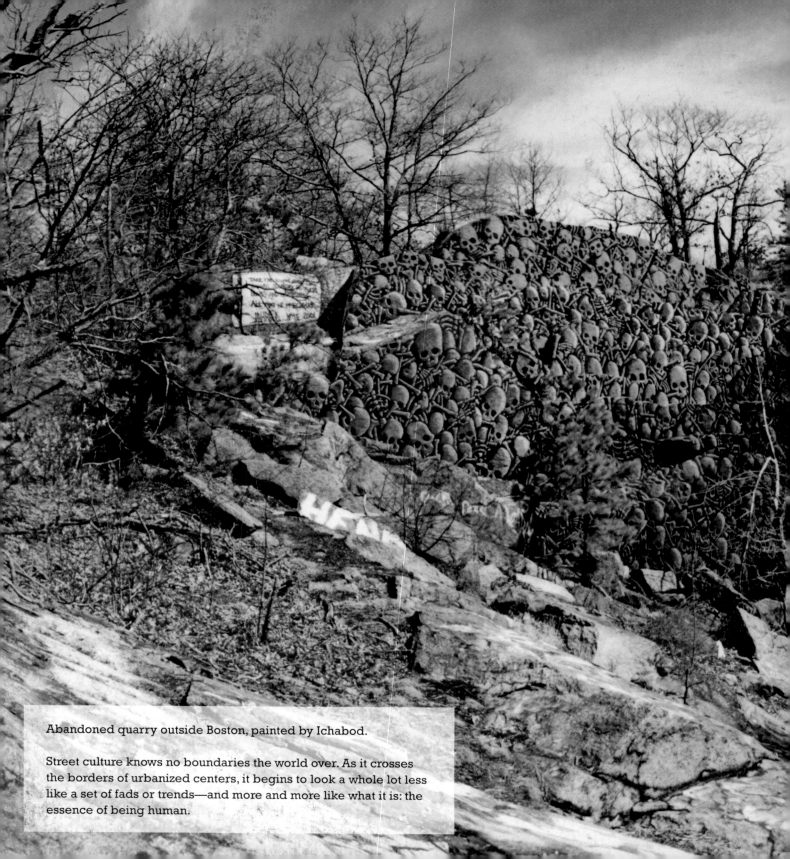

Abandoned quarry outside Boston, painted by Ichabod.

Street culture knows no boundaries the world over. As it crosses the borders of urbanized centers, it begins to look a whole lot less like a set of fads or trends—and more and more like what it is: the essence of being human.

Roger Gastman thanks:

In no order other than the first...Bethesda, Sonja, Mom, Ian Sattler, Ian Mazie, Tone (in Tone we Trust), Day19, Leon Catfish, Dan Monick, Harley, avocado eggrolls, Pro-Football, Houstons, Chonkey, Caleb, Tone again, artichokes on the grill, REVOK, Blackula, Estevan Oriol, Noah for finding Tone, Thames & Hudson, Brownie Sundaes across the world, Ben's Chili Bowl, END, taco trucks, Justin—Pat—Andy—Jay—Chris (there you have it, your names in print), BB of SE, Fat Rich, Melanie for putting up with Jeff, David Lopes, Mr. Fairey, Justin Van Hoy, Mac & Cheese, Eric Dorfman, the girl across the street at McKinley, Bob Chinn's fish jacket, Cheese (all kinds except Bleu), Law & Order SVU/CI, T-shirts from swap meets in Chicago, Smyrski Creative, R. Shook, Tone in a shark suit (dream), all the photographers inside, Gino's East, Aaron Farley, chocolate cake, James Marshall, Gabe for eating chicken fingers for a job, Police in Bethesda for busting our parties, We Are Supervision, R. Colman, Nicky, Eisen, and all the people that are going to be mad at me for forgetting their names.

Caleb Neelon thanks:

My family, Ellen, Annie and Ursie, Alex Lukas, Roger, Sonja, and Tony, Team *SWINDLE*, all of the photographers who stepped up and got us images, Skeptik, Chris (take care of yourself), MS Cambridge, Charlie's, Harvard, the Circle T kids, my goldfish, CNBC, Peter Tannenbaum, White Walls, Space 1026, Thames & Hudson, coffee and dessert, people who offer me opportunities, and everyone who answers their email.

Anthony Smyrski thanks:

My mother (RIP) and father, the city of Philadelph, Matt Gallagher and the Gallagher family, Paul Butterly, Mikey, Dominic Palermo, Dan Murphy, Casey Huckel, Dean, Joe Hardcore, George Hirsch, Palmer, Scruff, Josh, Dempsey, Weird Jesse, Brett, Thai, Steve and Jay Bush, Dan Stone (RIP), the rest of DEK, Space 1026, Melissa Farley, Sam Schwartz, Becky Suss, Max Lawrence, Ben Woodward, Adam Wallacavage, Sonja, Roger, Nickey, Harley, and Wesley Eisold.

7400 59

0038I3347